THE STUDIO READER

THE STUDIO READER

ON THE SPACE OF ARTISTS

EDITED BY **MARY JANE JACOB**
AND **MICHELLE GRABNER**

School of the Art Institute of Chicago
..
University of Chicago Press
CHICAGO AND LONDON

Mary Jane Jacob is professor of sculpture and executive director of exhibitions at the School of the Art Institute of Chicago, and the coeditor of *Buddha Mind in Contemporary Art* and *Learning Mind: Experience into Art*.

Michelle Grabner is professor in and chair of the Department of Painting and Drawing at the School of the Art Institute of Chicago and codirector of The Suburban, a gallery in Oak Park, Illinois.

The School of the Art Institute of Chicago gratefully acknowledges the generous support for this book provided by the William and Anne Hokin Exhibition Research Fund.

The University of Chicago Press, Chicago 60637
The University of Chicago Press, Ltd., London
© 2010 by The School of the Art Institute of Chicago
All rights reserved. Published 2010

Rights to individual essays in this volume are retained by their authors.

19 18 17 16 15 14 13 12 3 4 5

ISBN-13: 978-0-226-38959-2 (cloth)
ISBN-10: 0-226-38959-6 (cloth)
ISBN-13: 978-0-226-38961-5 (paper)
ISBN-10: 0-226-38961-8 (paper)

Library of Congress Cataloging-in-Publication Data

 The studio reader : on the space of artists / edited by Mary Jane Jacob and Michelle Grabner.
 p. cm.
 Includes index.
 ISBN-13: 978-0-226-38959-2 (cloth : alk. paper)
 ISBN-13: 978-0-226-38961-5 (pbk. : alk. paper)
 ISBN-10: 0-226-38959-6 (cloth : alk. paper)
 ISBN-10: 0-226-38961-8 (pbk. : alk. paper)
 1. Artists' studios. 2. Art—Philosophy. I. Jacob, Mary Jane. II. Grabner, Michelle.
N8520.S78 2010
702.8—dc22

 2010003778

CONTENTS

- ix *Foreword by Lisa Wainwright*
- xi *Preface by Mary Jane Jacob*
- 1 *Introduction by Michelle Grabner*

The Studio as Resource

- 17 Buzz Spector
- 21 Rochelle Feinstein
- 23 Shana Lutker, "Index: Dream Studio, 2003–2006"
- 28 Michael Smith, "Recipe: Perfect Studio Day"
- 30 John Baldessari, "In Conversation"

The Studio as Set and Setting

- 39 Howard Singerman, "A Possible Contradiction"
- 47 Frances Stark
- 49 Robert Storr, "A Room of One's Own, a Mind of One's Own"
- 63 Bruce Nauman, "Setting a Good Corner"
- 68 Michael Peppiatt and Alice Bellony-Rewald, "Studios of America"
- 80 Annika Marie, "Action Painting Fourfold: Harold Rosenberg and an Arena in Which to Act"
- 87 Kimsooja
- 88 Barry Schwabsky, "The Symbolic Studio"

The Studio as Stage

- 99 David J. Getsy, "The Reconstruction of the Francis Bacon Studio in Dublin"
- 104 Art & Language, "Art & Language Paints a Picture"

- 119 David Reed
- 121 Thomas Lawson
- 125 Charline von Heyl
- 126 Svetlana Alpers, "The View From the Studio"
- 150 Rodney Graham, "Studio"
- 153 Joe Scanlan, "Post–Post Studio"
- 154 Carolee Schneemann, "The Studio, June 22, 2009"
- 156 Daniel Buren, "The Function of the Studio"
- 163 Daniel Buren, "The Function of the Studio Revisited: Daniel Buren in Conversation"
- 166 Carrie Moyer
- 169 Marjorie Welish
- 170 Marjorie Welish, "The Studio Visit"
- 181 Marjorie Welish, "The Studio Revisited"

The Studio as Lived-In Space

- 195 Mary Bergstein, "The Artist in His Studio: Photography, Art, and the Masculine Mystique"
- 217 Rachel Harrison
- 219 Lynn Lester Hershman, "The Studio Present"
- 220 Brenda Schmahmann, "Cast in a Different Light: Women and the 'Artist's Studio' Theme in George Segal's Sculpture"
- 237 Karl Haendel
- 239 Brian Winkenweder, "The Kitchen as Art Studio: Gender, Performance, and Domestic Aesthetics"
- 251 Glenn Adamson, "Analogue Practice"
- 259 Amy Granat, "1107"
- 261 David Robbins
- 264 James Welling, "Polaroids, 1976"

The Studio as Space and Non-Space

- 269 Jon Wood, "Brancusi's 'white studio'"
- 285 James Welling, "Paris, 2009"
- 286 Caroline A. Jones, "Post-Studio/Postmodern/Postmortem"

- 302 Courtney J. Martin, "The Studio and the City: S.P.A.C.E. Ltd. and Rasheed Araeen's *Chakras*"
- 311 Katy Siegel, "Live/Work"
- 317 Suzanne Lacy, "Beyond Necessity: The Street as Studio"
- 321 Walead Beshty, "Studio Narratives"
- 332 Andrea Bowers
- 336 Judith Rodenbeck, "Studio Visit"
- 341 Lane Relyea, "Studio Unbound"

- 351 *List of Contributors*
- 360 *Illustration Credits*
- 363 *Index*

FOREWORD Lisa Wainwright

As the art world careens this way and that, and its many institutions, markets, and audiences adapt and adjust, supporting it all is the generative activity of studio practice. The studio is a space and a condition wherein creative play and progressive thinking yield propositions for reflecting on who we are—individually and collectively—and where we might go next. Such propositions take myriad forms depending on the nature of the artists and the materials at their disposal, but what is common to all studio practice is the process of working through an idea as a method of thinking and making. To truly liberate the imagination is to have the space and freedom to reflect, critique, and innovate, key processes for introducing change and advancing democratic ideals. *The Studio Reader*, in pulling aside the curtain on the world of art, reveals something of these fundamental activities.

Schools of art and design like ours, the School of the Art Institute of Chicago, truly base their pedagogy in studio practice. The value of evolving an idea through the push-and-pull of a medium—be it physical, digital, language-based, or otherwise—empowers the learner. In studio courses, knowledge is vigorously batted about both materially and conceptually, for creative testing through making remains essential to knowing. Learning through experience means acquiring multiple orders of skill. It is a form of research that follows a path of unfolding ideas as the hand and body, as well the mind, learn. And it can yield surprising and powerful results. This educational strategy is thus significant, not only for producing artists and designers, but for undergraduate education in general.

What might we all "know" if we worked in the studio for a time? What can we learn—about ourselves, about the world—through this particular experience of doing? At the School of the Art Institute, we have pursued this course for nearly a century and a half: in childhood programs, in early college training for high school students, and, of course, in our deep and broad undergraduate and graduate programs. While not all alumni work as artists, all are informed by their experience in and with art-making. The ability

to research, conceptualize, and model ideas, the command of a critical discourse grounded in the realm of visual representation, and the flexibility and adaptability learned in the studio are invaluable resources in an exploding global semiosphere.

The role of the art school—and at its core studio practice—is perhaps needed now more than ever. As we have seen throughout civilization, only if we preserve places for individual thought and expression, for unconventional perspectives and productive failures, can society flourish. Only then will we place skilled artists and designers in the world to continue the studio method of critical and humane engagement.

PREFACE

Mary Jane Jacob

Making has been the modality of the Art Institute from its inception. Its incorporation papers, drafted in 1879, commit it to the "founding and maintenance of schools of art and design," "the formation and exhibition of collections of objects of art," and, finally, "the cultivation and extension of the arts of design by any appropriate means."[1] In fulfilling this mission, nothing occupies a more central and enduring role than the artist's studio. Even when the making is not so visible, it is always present. The back story is always there. Take one of the Art Institute's greatest masterpieces, *A Sunday on La Grande Jatte* (1884–1886, 1888/1889) by Georges Seurat. In a work painted in the years between its start and its completion—*Models* of 1886–1888—we sense its presence in the artist's mind and see it in his working environment, reminding us that the studio is the generative space.

Today the Sullivan Galleries sit between the Art Institute as school and as museum—a teaching, research, and presenting program through which we continue our mission as we engender a space for making and display that is engaged and invested. This occurs in the form of exhibitions, artists' projects, collaborative programs, and publications by which students, faculty, the public, and the field can further conversations around art and, especially, art-making.

We are delighted to be working with the University of Chicago Press on the publication of *The Studio Reader*, a book that aims to be a companion—perhaps even an inspiration—for artists, art students, and art educators now and into the future. For these readers, the studio is more than a physical place, even more than a mental space; it is a necessity of being.

What does it mean to be *in* the studio? What is the space of the studio in the artist's practice and life? Is it there that artists realize their own artistic agency and self? Does creative potential originate in the studio or only take form there?

We see here, through artists' images and words, some of the many ways the studio functions and the many forms it can take. We hear about its role

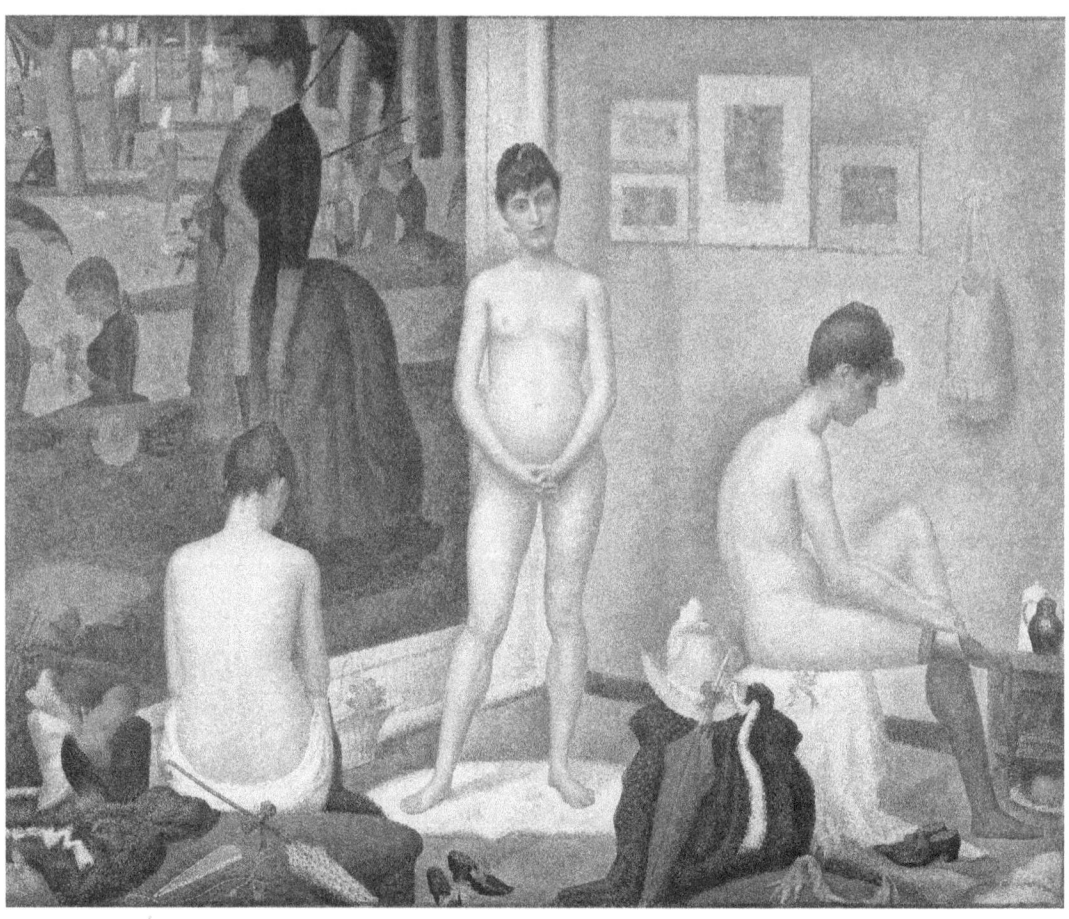

Georges Seurat, *Models*, 1886–1888.

as a place where they work, live, display, archive, and store art. Despite shifts in artistic practices, sites, and modes of production that might lead us to suspect the studio is irrelevant—obsolete—it remains a place where artists go or long to return to, something they have or seek to obtain. As a way of maintaining process, participating in a discourse, and not losing that sometimes elusive or vulnerable identity of being an artist, the studio endures.

That there is today a broad interest in reexamining this seminal space is evidenced by the new and insightful texts offered here, along with a selection of past critical essays. Our goal in compiling this volume has been to revisit the studio and resituate it in contemporary times. Given the personal nature of the subject, we felt it vitally important that the book include artists' own reflections on the nature of the studio as it relates to their habits of mind and working processes. The intimate portraits they have created, in words and images, allow us to be a part of this place.

This book was initiated and edited with my valued colleague Michelle Grabner and is an enduring part of a wider inquiry into the artist's studio that she launched. Along with art historian Annika Marie (who also appears as an author here), Grabner organized a major exhibition entitled "Picturing the Studio," which took place at the School of the Art Institute of Chicago's Sullivan Galleries from December 2009 to February 2010. Evolving from the breadth and meaning of the contemporary studio, it was assembled around notions of the studio as defined by time, space, and research or study, as well as by making; it probed the studio as workshop, lab, factory, sanctum, lounge, home, and social network. Going to the heart of the enterprise of the art world, it allowed visitors to view late twentieth- and early twenty-first-century works through the lens of the studio. For this reason, the College Art Association designated "Picturing the Studio" the centerpiece of its 98th annual conference. Evolving from this exhibition, these same galleries were transformed into temporary studios in summer 2010, simultaneously offering working space to artists from here and away and enabling visitors to observe, converse, and participate in programs with resident artists. This "living exhibition" was an attempt to further confront the myths that the texts in this book challenge and illuminate.

With my coeditor, Michelle Grabner, who contributed the excellent introduction that follows, I would like to thank especially School of the Art Institute of Chicago assistant curator Kate Zeller, who acted as assistant editor. Her performance is professionally outstanding and, indeed, no finer collaborator could be found. She was joined in this task at the School by graduate curatorial assistants Joe Iverson, who ably served as editorial assistant for rights and reproduction, and Rachel M. Wolff, who oversaw registrarial aspects of "Picturing the Studio," as well as research assistant Peter Ribic. As always, the work of the School's Department of Exhibitions is enabled by the fine work of director of exhibitions Trevor Martin and associate director Todd Cashbaugh. For their continuing role in supporting the programs of the School of the Art Institute and for enabling artists' studios statewide to thrive, we also thank the Illinois Arts Council, a state agency. At the University of Chicago Press we greatly benefited from our collaboration with Matt Avery, Anthony Burton, Joel Score, Jill Shimabukuro, and Christopher Westcott. For me, it has also been essential to have as a guide Susan M. Bielstein, executive editor at the University of Chicago Press, who saw the worth of this publication and with wisdom and great experience steered it to realization.

[1] Incorporation document, May 24, 1879, quoted in the Art Institute of Chicago's *General Catalogue of Sculpture, Paintings and Other Objects June, 1910.*

Matt Keegan, *Work from Home*, 2008.

INTRODUCTION **Michelle Grabner**

A skylight illuminated the master's studio; falling directly on the canvas fastened to the easel and as yet marked by only three or four strokes of white paint, daylight failed to penetrate the dark corners of this huge room, though stray reflections in the gloom picked out a silvery gleam on a suit of armor hanging on the wall, suddenly glistening on the carved cornice of a venerable sideboard holding odd pieces of crockery, or spangled points of light upon the coarse texture of some old brocade draperies lying in broken folds. Plaster lay-figures, limbs and bodies of classical goddesses lovingly polished by the kiss of centuries, littered shelves and console tables. Countless sketches, studies in three colors of crayon, red chalk, or pen-and-ink, covered the walls up to the ceiling. Boxes of paint in powder and tubes, jars of oil and turpentine, and a series of overturned stools left only a narrow path by which to reach the aureole cast by the skylight around Porbus's pale face and the strange visitor's ivory cranium.

HONORE DE BALZAC, "The Unknown Masterpiece" (1837)

The seventeenth-century studio that beguiles young Nicolas Poussin in Balzac's short story, revealing to him "art's material operation," is that of the neoclassical painter François Porbus. It is a mysterious place, vast and dark, littered with ancient props and the evidence of disciplined work. Porbus's atelier is the germ of the modern studio. It initiates a site and a frame of production for Piet Mondrian's Neo-Plastic experiment at 26, rue du Départ, Jackson Pollock's East Hampton barn, Constantin Brancusi's white atelier, Josef Albers's workshops, Thomas Lawson's "skylit rooms," Charline von Heyl's "alchemic laboratory," and David Robbins's three laptops and green upholstered swivel chair in his ranch home on Milwaukee's north shore.

The auratic tradition of the modernist studio designated it as a place set aside for the production of autonomous work—the site, often, of disengaged artistic labor, where, in isolation, discrete aspects of artistic competence

were explored and refined. Yet the modernist studio was not always a solitary lair shut off from the world. It also functioned as a place of instruction, a hub for social exchange and collective work.

The studio, on this model, is a "room of privilege," a domain of male authorship that is determinedly undomestic. From seventeenth-century Europe to mid-twentieth-century America to the present day, modernism's romantic studio tradition has nurtured the production of individualism. Porbus's studio on the rue des Grands-Augustins, with its jars of paint and holy light, is a representation of artistic originality, the place where creativity unfolds. Here, in his Left Bank studio, the great man displays his skill. Yet he has neither the heroic genius of Frenhofer, the "strange visitor," nor the godlike creativity of the street's future tenant. A century later, in 1937, it became the site of Picasso's studio, and there he produced *Guernica*.

Some years before the writing of Balzac's story, Théodore Géricault painted *Portrait of an Artist in His Studio*, a sensuous portrayal of his assistant that underscores the archetype of the romantic studio by depicting the mind at work, not the hands. Géricault's subject sits staring out at the viewer, his arm and hand supporting a ponderous head. A single daubed palette on the wall behind him is the only evidence of painterly activity; on a shelf above it are a skull and two anatomical plaster casts. But for these few familiar props, this space, with its rough-cut ceiling joists, could be any sooty eighteenth- or nineteenth-century interior room. Here the studio is a metaphor, insinuating the "artist's sense of purpose and posture outside of society; in the studio he is isolated from the world of ordinary men, that he might realize his genius."[1] The painting also splendidly illustrates Svetlana Alpers's thesis that "the realities of the studio are elusive, but they are also determining and astonishingly long-lived in European painting."[2]

Michel de Certeau's metaphor of the motionless train car as "a sort of god undone" is apt when examining the space of the contemporary studio.[3] The romantic studio encoded in individual creation is also in a continuous state of becoming undone. The workshops of William Morris and the Bauhaus, Frank Lloyd Wright's home and studio, Warhol's factory, Beuys's pedagogical experiments, the decentered practice of Fluxus, and the antistudio positions of the 1960s and 1970s shaped a catchall post-studio conditioned on the traditional "European studio ideal."[4] For example, Daniel Buren's seminal 1971 essay "The Function of the Studio," reprinted in this volume, maintains the studio's status as a unique space of production while also calling for its disintegration: "The work is made in a specific place which it cannot take into account. All the same, it is there that it was ordered, forged, and only there may it be truly said to be in place."

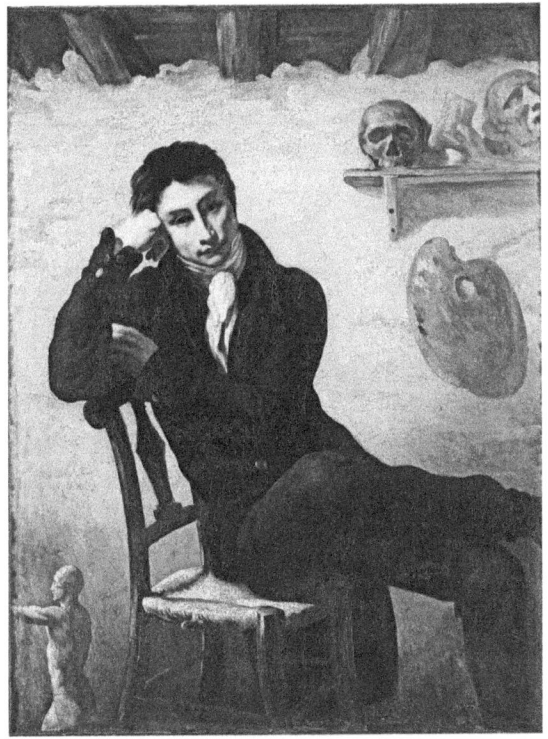
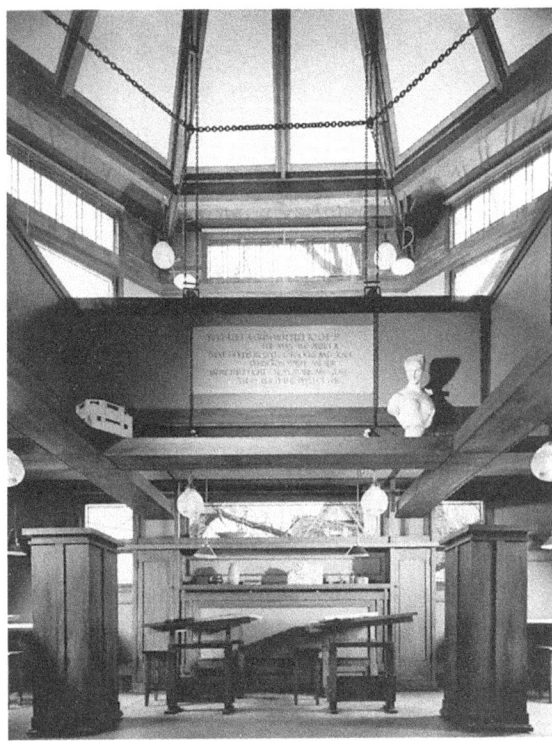

Theodore Gericault, *Portrait of an Artist in His Studio*, ca.1820.

Frank Lloyd Wright Home and Studio, drafting room, Oak Park, Illinois, 1889/1898.

Buren's post-studio analysis of site and intention is parallel to a pragmatic framing of the studio as a site of attention. In John Dewey's 1908 essay "Does Reality Possess Practical Character?" he states:

Awareness means attention, and attention means crisis of some sort in an existent situation; a forking of the roads of some material, a tendency to go this way and that. It represents something the matter, something out of gear, or in some way menacing, insecure, problematic and strained. It is in the facts of the situation as transitive facts; the emotional or "subjective" disturbance is part of the larger disturbance.[5]

Like Buren's insistence that a work of art belongs solely to the studio, falling victim to "a mortal paradox from which it cannot escape since its purpose implies a progressive removal from its own reality, from its origin," the studio as a site of attention employs crisis and contradiction in defining ways.

Mapping the trajectory of the modern studio is equivalent to mapping artistic style, propriety, and invention. As mentioned above, *Guernica*, that twentieth-century political masterwork, sprang from perhaps the same attic studio as Porbus's dedicated, if comparatively lifeless, renderings of nature

in the seventeenth century. The willed trope of the individual artist's studio, commencing from Enlightenment values of self-determination, shifting its emphasis from reasoned humanism to inspired self-expression in the Romantic era, and becoming the critical measure of authenticity for the Abstract Expressionists, persists today both in popular culture and in artistic practice. While many cultural forums and related sites opened their doors, rejecting creative solitude, these venues—the social studios, salons, workshops, and factories—did not fully disperse authorship and the notion of a privileged site of production. The creative master remained intact, as did the studio, despite being dislocated or inhabited by others. The postmodern studio, however, is analogous to bricolage, ad hoc and fractured, no longer the sole site of artistic enterprise; this shape-shifting studio "affirms these recognitions and helps resist the objectification of multiple experiences into narrative systems which, through patterns of power/knowledge, too often organize difference into hierarchy, or essentialize its energies into a cultural formula inflected by linearity."[6] As Certeau elaborates:

Everyone goes back to work at the place he has been given, in the office or the workshop. The incarceration-vacation is over. For the beautiful abstraction of the prison are substituted the compromises, opacities and dependencies of a workplace. Hand-to-hand combat begins again with a reality that dislodges the spectator without rails or windowpanes. There comes to an end the Robinson Crusoe adventure of the traveling noble soul that could believe itself intact because it was surrounded by glass and iron.[7]

Perhaps equally pertinent to a contemporary examination of the studio and its potential is Certeau's analysis of "places" and "spaces." The former he defines as distinct locations whose constituent elements are "beside" one another, stabilized in accordance with rules and laws that govern what is "proper." A space, on the other hand, "exists when one takes into consideration vectors of direction, velocities, and time variables." Certeau employs a simple analogy in which space is "like a word when it is spoken, that is, when it is caught in the ambiguities of an actualization, transformed into a term dependent upon different conventions, situated as the act of a present (or of a time), and modified by the transformations caused by successive contexts."[8]

"The romance of the studio topos is always promising to return," writes Caroline Jones in her influential text *Machine in the Studio*. The present volume examines that assertion, identifying contemporary examples of the inherited individual-studio model, while also upending it with arguments, theories, and observations contributed by working artists, art historians, and

critics. Appraising the studio as an instrument, as a state of mind, as a site of attention, but primarily as "a practiced place," this anthology atomizes and reconfigures the idea of a conventional (proper) studio.

Anthologies are by nature retrospective, and in this sense *The Studio Reader* is an archeological undertaking. Yet it strives also to be forward-looking, charting imaginative rather than dogmatic evaluations of the artist's studio. At its most basic level, *The Studio Reader* addresses the question What are the active conditions that define the studio in contemporary practice? Oscar Wilde locates the studio as a place of seduction and decay, transformation and creation. Today the studio can also be more prosaic, idealized, clandestine, and complex than Wilde's romantic atelier, but still, unless it is a practiced place, no physical room or demiurgic attitude can qualify as a studio.

"Rather than simply making claims about or *for* the studio, I am interested in the constraints it offers, offered, because the challenge to the studio in recent times is not Warhol's factory model but the greater world outside it," writes Svetlana Alpers in her essay "The View from the Studio." Examining European painting practices from the seventeenth through the first half of the twentieth century, she asks, What is the relationship of the painter to reality as seen in the frame of the work place? What is kept outside the studio and what is let in in the practices of Vermeer, Degas, and Cézanne? Michael Peppiatt and Alice Bellony-Rewald take a very different, descriptive approach to assessing the studio and its relationship to practice in their essay "Studios of America," which maps the shift from the traditional European studio model, "plush, well-filled ateliers" such as those of New York's West Tenth Street studio building, erected in the 1850s, to the 1930s, when former factory buildings downtown begin to provide large amounts of inexpensive workspace. William Merritt Chase's bustling and luxurious studio of the 1880s (complete with exotic birds), Arshile Gorky's isolated Union Square haunt, and Jackson Pollock's East Hampton barn mark the progression from room to attic to loft—the studio that became an archetype with regard to American painting. "In this bare modern room," these authors observe, "palette and easel, punch and mallet would look like heirlooms."

The chaos of Francis Bacon's studio at 7 Reece Mews in South Kensington, carefully reconstructed and permanently housed in Dublin's Hugh Lane Gallery, commemorates the painter's mythic mad genius. Secured in a Plexiglas vitrine, the now static studio preserves unabridged Bacon's collection of studio paraphernalia: easels, clotted taborets, cans of muddied brushes, heaps of source material. The artwork, however, has been removed from this doppelganger. "For all of the assiduous reconstruction of the space, the studio is present less as a workspace than as a social space," observes David Getsy

in his critical essay. Similarly, Jon Wood's contribution, "Brancusi's 'white studio,'" elaborates on the beginnings of the famed studio. Examining the years 1916 to 1927, Wood gathers together a collection of historical examples and theories that factor into Brancusi's "highly successful conceit" of the white studio.

The contested role of woman in the artist's inner sanctum is also addressed. In "The Artist in His Studio: Photography, Art, and the Masculine Mystique,'" Mary Bergstein demonstrates how Alexander Liberman's and Brassaï's mid-twentieth-century photographs of artists in their studios, many including eroticized female nudes, served to reinforce masculine authority in the creative process, equating virility with artistic genius and fixing the atelier as an enchanted place "where domestic norms were suspended or reversed in favor of independence and self-expression." The photographers, Bergstein writes, "evidently took pleasure in steeping themselves in the environment of artists' studios. And the material legend was constructed through an exchange between the artist and the art photographer." Meanwhile, Brenda Schmahmann's "Cast in a Different Light: Women and the 'Artist's Studio' Theme in George Segal's Sculpture" locates Segal's body-cast motifs as antithetical to the modernist trope conflating the nude model with nature. Insofar as "Segal plays with levels of reality, upsetting distinctions between the actual model and her representation," Schmahmann writes, "his works do not in fact create a sense that the woman's body is raw material imbued with cultural life through the hand of the artist."

In "The Kitchen as Art Studio: Gender, Performance, and Domestic Aesthetics," Brian Winkenweder surveys the gender implications of art practice in the home and in the everyday. Navigating Joseph Beuys's and John Cage's blind spots, he suggests that, in their democratic positions, kitchen praxis is both provocative and problematic.

Judith Rodenbeck's "Studio Visit" maps the museum as a discursive site in post-studio practice, leading us through a historical trajectory of unfolding studio conceptions, from Gustave Courbet to Andrea Fraser. By critically examining Corin Hewitt's 2008 *Seed Stage* project at the Whitney Museum of American Art, a work comprised of an enclosed studio room in which the artist engaged in daily activities, grew seeds, made art, and documented his goings-on, Rodenbeck calls into question the institution's static framing of the artist's studio. "Bringing these private and obsessive spaces into the museum, if anything, posits a dysfunctional collaboration with the audience: we are voyeurs rather than relational participants, and the studio, whether the artist's or that of a fictional persona, is a generative but fundamentally opaque site." While Rodenbeck considers the museum as site of production, Howard Singerman examines the role of the private studio in

MFA programs. He concludes with a wry reminder to readers that "one of the important art school lessons of the readymade is that one can make anything art by designating it as such, or better, by recontextualizing it, that is, by putting it into just the right sort of room, those 'studios,' those rooms, that are now obligatory."

In "The Studio and the City," Courtney Martin explores the program of urban renewal advanced by S.P.A.C.E. Ltd. in postwar London, and particularly the role of individual studios. The essay considers questions of what the artist's studio as an inhabited, nondomestic location, represents to the economy of a city and, to return to the individual experiences of artists, how a fluctuating studio concept shapes artists' practice.

Caroline Jones's research into the history of the romantic studio and its impact on the sacred production sites of the Abstract Expressionists is foundational. Reprinted here, from her previously mentioned book *Machine in the Studio*, is "Post-studio/Postmodern/Postmortem," in which she writes, "The studio has been our stage.... Its disappearance at the end of this book becomes less the fall of a curtain than the postmodern slippage of a signifier to another discursive plane." Annika Marie's article "Action Painting Fourfold: Harold Rosenberg and an Arena in Which To Act" inquisitively pulls open the curtain on Rosenberg's theory of the "act," asking, "But is the 'four-sided arena' the two-dimensional canvas on the easel or the three-dimensional room of the studio?"

Marjorie Welish's essay "The Studio Visit" abounds with insights and firsthand observations of the contradictions, confusion, and misunderstandings intrinsic to studio visits, particularly by critics. An artist and critic herself, Welish observes that "the critic is obliged to do more than describe the art he finds there" and "is not doing his job unless he or she works to get beyond taste or market value or the rationalization of trends and visual literacy." Nonetheless, "what happens in a studio may be hard to pin down. Unstated, uncodified, and subject to on-site improvisation, the exact nature and purpose of the studio visit may always remain elusive." Barry Schwabsky's essay "The Symbolic Studio" is based on his studio visit with the artist Tehching Hsieh in Brooklyn in 2009. Hsieh gave up making art on January 1, 2000, prompting Schwabsky to wonder, "Why does such an artist keep a studio, and what does the word 'studio' mean in such a case"?

Robert Storr's "A Room of One's Own, a Mind of One's Own," demythologizes the "mysterious precincts of creativity." Underscoring the contingency of the studio space, Storr, in the tradition of artists who "mounted every imaginable challenge to the fetishization of art," takes on the residual and attendant festishization of the studio space as a "place where lightning supposedly strikes." "Because there is a considerable constituency within the art

world," Storr writes, "that fetishizes not only what artists have traditionally done but where they have traditionally done it. Hence the romanticizing photographs of artists in their lairs that grace—and sometimes disgrace—so many contemporary catalogs from those that record Alberto Giacometti's primordial, plaster-splattered Bohemian den or Pollock's cramped shack, to those of Francis Bacon's hole-in-the-wall at 7 Reece Mews in London."

In "Analogue Practice," Glenn Adamson defines craft as a practice of approximation, not of replication. "This asymptotic model of production has important ramifications for the consideration of the studio, which I want to interpret here as defined by analogue (rather than serial) production. Unlike a bricklayer, a practitioner in a studio need not face new ground at every step. The terrain is constant. But the studio nonetheless has its limits, and a distinct character engendered by considerations of space, resources, infrastructure, and the skill that can be marshaled within its confines." The limits Adamson lays out are the same as those rejected by Daniel Buren in his provocative essay from 1971 "The Function of the Studio" (published in English in 1979). In 2007 Buren was invited by Jens Hoffmann and Christina Kennedy, curators of "The Studio," an exhibition complementing the previously noted re-creation of Francis Bacon's studio at Hugh Lane Gallery in Dublin, to expound on his theory. Buren, who in 1978 had "decided to quit the studio," writes, "To not have a studio, as well as to have a studio, automatically implies a production of a certain type of work. I can see that the day when I cannot move or travel anymore, as I have a done for over the past forty years, I will either stop working or my work will be different. The only thing that I can imagine helping to keep it going in its present form might be my long experience of moving and looking at different places."

The work of artist Walead Beshty is informed by the polyvalent space of provisional sites: flying coach on a Star Alliance airline, a visiting artist stint at a small liberal arts college, an extended stay at the Bonaventure Hotel in downtown Los Angeles. In "Studio Narratives," he offers a witty but matter-of-fact exposé of the realities of his practice. Conversely, the collective Art & Language, in its parodic contribution, "Art & Language Paints a Picture," appropriates the principles underlying *Art News*' long-running series "*X* Paints a Picture." Between 1949 and 1968, authors such as Frank O'Hara, Irving Sandler, and Lawrence Alloway eulogized the individual studio, penning detailed accounts of the working processes of Joseph Albers, Willem de Kooning, Joan Mitchell, Fairfield Porter, and others. The often mawkish tone of the articles was underscored with romanticized photographs by the likes of Hans Namuth and Rudy Burckhardt. Art & Language here offer a series of directions—"(1) and (2) begin to coat the canvas with a buff-colored acrylic emulsion using a roller"—interspersed with satirical dialogue: "The canvas

Josef Albers in his studio, ca. 1950. Photograph by Rudy Burckhardt.

Peter Fischli/David Weiss, *In the Studio II*, 2008.

will now have a skin. We are committed now to 'painting,' rather than to drawing: committed to be anally expulsive."

The final two essays focus on the ramifications of cultural politics and the forces of social networking, work habits, real estate conditions, and economic forces that configure today's studio. As Katy Siegel observes, "To succeed in a world of flexibility and impermanence, where one must constantly sell oneself to the next employer, appear poised for the next opportunity, we feel compelled to use our spare moments to think of new strategies and ways to 'shine.' This means erasing the line between work and life, not just temporally and spatially but psychologically." And Lane Relyea's research into the realpolitik underscoring the integrative and decentralized systems of networks generates insights that promise to reshape post-studio theory. "The studio … places the artist as a like item within an integrative inventory or database, gives the artist a mailing address and a doorstep, thus providing the means for one to show up within the network."

Artists' contributions to *The Studio Reader* reveal a multiplicity of traditional, post-studio, and networked approaches to studio practice: from

Amanda Ross-Ho studio, summer 2008.

OVERLEAF
Amanda Ross-Ho, *Frauds for an Inside Job* (detail), 2008.

Rodney Graham's painting studio, where he can "while away the hours while works are being fabricated and photographs printed by other people," to Karl Haendel's dimly lit space populated with projectors and studio assistants and marked by a "meditative and self-controlled feeling," to Rochelle Feinstein's childhood bed topped with a collection of stuffed animals arranged according to size, color, and species.

The dispersion of contemporary studio approaches, "braided within channels of connection, distribution and circulation,"[9] is cogently demonstrated in the work of the Swiss team Fischli and Weiss and that of Amanda Ross-Ho. Both privilege and present the studio, its grand mythos and its material trivialities. Yet they also surmount a range of positions and attitudes with a vocabulary comprised primarily of verisimilitude, magnification, and proliferation. Critical, ironic, sentimental, and practical, the practiced place of the studio is no longer the fixed space of inspiration that Poussin laid eyes on four hundred years ago.

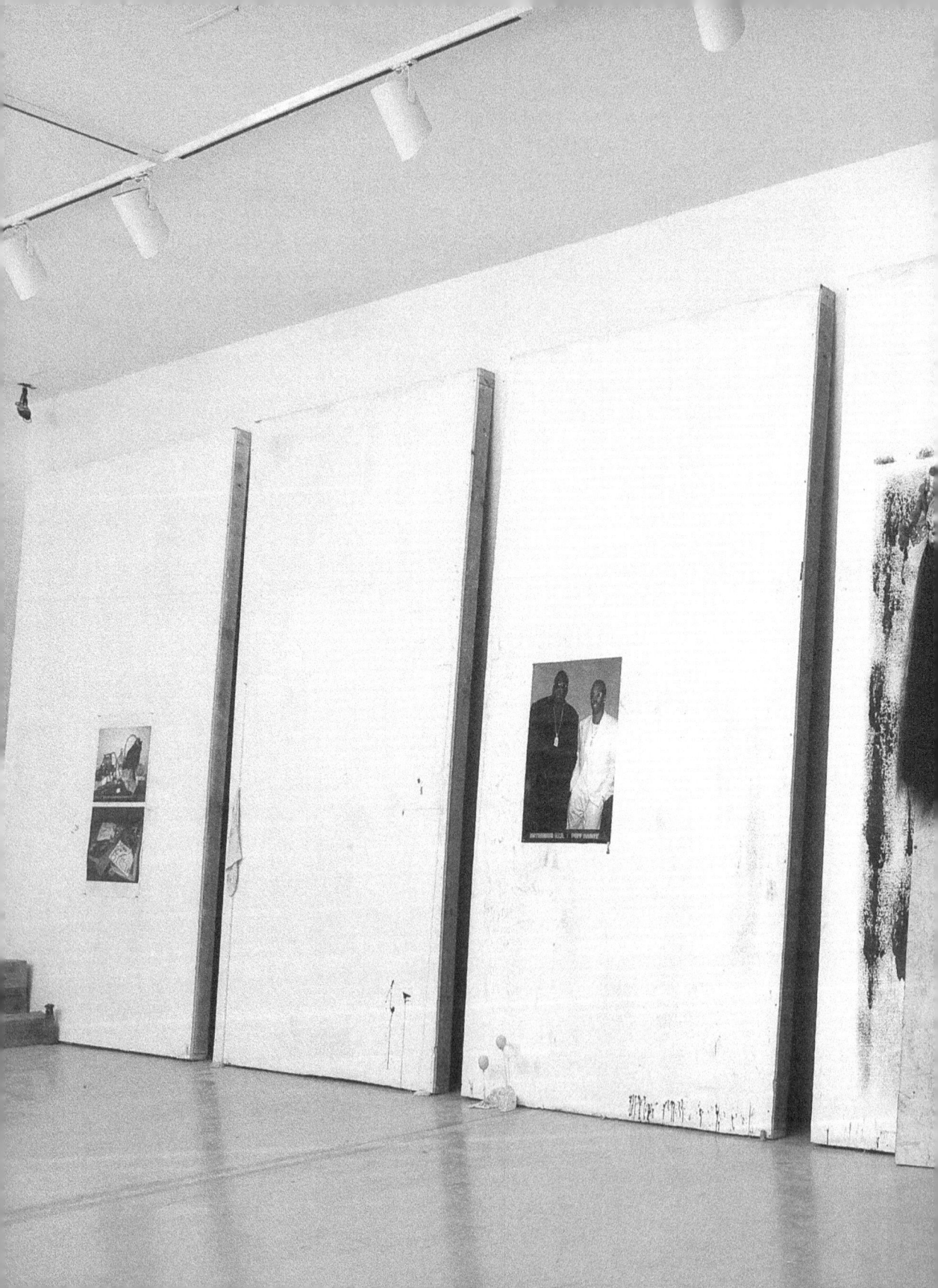

1 Ronnie L. Zakon, *The Artist and the Studio in the Eighteenth and Nineteenth Centuries* (Cleveland: Cleveland Museum of Art, 1978), 13.

2 Svetlana Alpers, *The Vexations of Art: Velázquez and Others* (New Haven: Yale University Press, 2005), i.

3 Michel de Certeau, *The Practice of Everyday Life*, trans. Steven Rendall (Berkeley: University of California Press, 1984), 114.

4 Caroline Jones, *Machine in the Studio: Constructing the Postwar American Artist* (Chicago: University of Chicago Press, 1996), 363.

5 John Dewey, "Does Reality Possess Practical Character?" in *The Essential Dewey*, vol. 1, *Pragmatism, Education, Democracy*, ed. Larry Hickman and Thomas M. Alexander (Bloomington: Indiana University Press, 1998), 130.

6 Nicholas Paley, *Finding Art's Place: Experiments in Contemporary Education and Culture* (New York: Routledge, 1995), 9.

7 Certeau, *Practice of Everyday Life*, 114.

8 Ibid., 117.

9 See Lane Relyea's essay, "Studio Unbound," in the last section of this volume.

The Studio as Resource

Buzz Spector

I have worked, or lived and worked, in fourteen studios over the thirty-seven years since I made the first artwork that could be construed as the product of my consciousness of self as an artist. These spaces have ranged in size from a corner in a bedroom to approximately 1,900 square feet. What they've all had in common are drawing tables, at least one chair, and shelves for books. It hasn't been mere restlessness that has led me to such an itinerary of places. New jobs (teaching and otherwise), graduation, sales of buildings in which I'd rented space, and changing circumstances in my private life have each resulted in a move from one studio to another.

In recent years the site of much of my artistic production has not been my personal studio but workshop or rental spaces that have the equipment I need to make photographs or works of handmade paper. Still, what happens in those sites is preceded by reveries, choices, and designs executed in spaces I call my own. I hold to the memory of some of my previous studios more than others, not so much because of their size, accoutrements, or location, but because of the small epiphanies that took place there. Such revelations move both forward and back in time. Let me share a story:

In 1982, soon after I began tearing pages out of books to make art, my parents visited my live/work space in Chicago. They were nonplussed by the array of torn books I'd set out for display on the main studio tablo. In a family of readers, the respectful treatment of books was a requirement, not an assumption, and for my mother in particular it was hard to look at those fields of torn pages as works of art. After some strained conversation about found objects and creative destruction, my mother became silent, regarding one particular altered book, which held rows of freshwater snail shells on one side of its excised text block and rows of small beach pebbles on the other. "You know, Buzz," she murmured, "you used to line up rows of shells and pebbles on the sand when I'd take you to the Morse Avenue beach." As she recalled this pleasure of my early childhood, even before my sister and brother were

born, I was myself seized by an extraordinarily vivid recollection: of sand on my fingers, the smell of suntan lotion on my back, the cries of gulls, my mother in her black, one-piece bathing suit, and the lines of shells, stones, and beach glass beneath me as I lay on my stomach making order.

Not every day, or for every artist, but on some days for most artists, a vital thought happens at/in their work, and from the interior space of inspiration the artist can begin its embodiment in the exterior space to which conceptualization is connected, the cognitive spatial armature of the studio.

Every studio I have had since graduating from college

1. Second bedroom in an apartment. Drawings made at small thrift shop table and stored beneath bed. One bookshelf, made from boards and concrete blocks, and a four-door file cabinet. Two years.

2. Second bedroom in a rental house. Drawings pinned to Celotex sheet mounted on one wall. Two file cabinets and two metal-frame shelving units: one for books, one for art supplies. Two years.

3. Graduate school studio in converted reception room of a former carriage house. Brick fireplace and small kitchen. Easel for drawings made from a four-by-eight-foot sheet of plywood. One wooden bookshelf, metal-frame shelving unit for art supplies, and same file cabinets as before. Two years.

4. Shared studio space on fifth floor of manufacturing/warehouse building. Easel from previous studio converted into worktable. One file cabinet, two wooden bookshelves, and two metal storage cabinets: one for art supplies, the other for potential collage materials and finished work. One year.

5. Second bedroom in rental apartment. Thrift shop table for drawing, completed work kept beneath bed. Same file cabinet, storage units, and bookshelves as before. One year.

6. Live/work space in commercial building. Second floor with large windows along east and south walls, sixteen-foot ceiling. Worktable made from found room-divider unit on metal frame with casters. Second worktable/desk made from hardcore door mounted on Ikea table legs, with computer and electric typewriter. Over time accumulated six wooden bookshelves, one ten-drawer wooden flat file, three file cabinets, plus same storage cabinets as before. Artwork stored beneath artist-built loft at one end of the room. Eight years.

7. Studio space in artist-run cooperative. Same worktable/desk with computer. Same bookshelves, storage cabinets, flat file, and file cabinets as before. Artwork piled along one wall. One year.

Buzz Spector studio, 2009.

8. Studio on second floor of commercial factory building. Same storage and file cabinets as before. Acquired second ten-drawer wooden flat file, more bookshelves (bringing total to eight), and new computer. Built two new worktables, recycling Ikea table legs, and wooden storage racks for artwork. Four years.

9. Small rented cottage across the street from the family home. One bedroom used for storing artwork, living/dining area used for studio. Same worktables, bookshelves, storage cabinets, file cabinets, and flat files as before. Futon in one corner converted into a bed when guests visited.

10. Second-floor faculty studio space in departmental adjunct studio building. Worktable, computer, storage racks for artwork. Four years (concurrent with following studio).

11. Two-room studio on second floor of retail/office building. Front room with same worktables, computer, bookshelves, and storage cabinets as before, and one of the flat files. Small closet for storing art and cleaning supplies. Second flat file in second room, plus hand-built storage racks for artwork. Second room later emptied, cleaned, painted, and converted into a project room for invited artists. Seven years.

12. Faculty studio space in art department studio building. Room equipped with loft storage plus built-in shelving, drafting table, and smaller worktable. Same bookshelves, storage cabinets, file cabinets, and flat files as before. New computer and printer. Six years.

13. Office in multiuse campus building. One table for computer and drawing. Storage units and university-provided laptop and printer along one wall, eight metal bookshelves along remaining three walls. Storage room across hall for finished work. Two years (concurrent with following studio).

14. Studio/office space constructed in basement of the family home. Two walls lined with bookshelves, one wall, lit by track lighting, for pinning up work. New worktable, supported by same flat files as before. Same storage cabinets, file cabinets, computer, and printer. Two years (current).

Rochelle Feinstein

My MFA thesis, in 1978, was titled "The Artist's Studio/Inside Out." In hindsight, I was clueless. I didn't ask anything compelling: What is art? Why, and where, does it art happen? Where art is made now seems as irrelevant as much *art* often is. Writing about the studio in 2009 is a revisitation of the subject. Artists today may locate their work, not on the basis of where it was made, but in relation to expanded fields of interest, geographies, and technologies. This wide-ranging artistic license operates, for better or worse, in the context of a deadbeat global economy.

It occurs to me that a chronicle of my making of things *before* they became art could be a way to consider a studio practice. A subjective conceit, perhaps, but it may cast light on the origins and variety of creative impulse. A studio is both gestalt and zeitgeist, place and non-place, whether one is a painter or a post-studio artist.

Ages 4–7 My bed, three by six feet, located in my parents' bedroom. The surface supported a menagerie of stuffed animals, systematically arranged by color, size, and species or as imagined peaceable kingdoms. I slept on this plush until my father threw out the lot.

Ages 7–10 A desk in my parents' bedroom. Rewrote and illustrated *Little Women*: Jo kept her hair, Laurie and Amy were deleted, Father was home, Mother was who knows where. Detailed drawings in turquoise ink (I still have the fountain pen), black lettering. Generated three or four volumes—greasy loose-leaf sheets, gum-reinforced, yarn-bound—which later "went missing."

Age 11 Undertook research. Paperbacks and movies were locationless studios. Most inspirational books: *I'll Cry Tomorrow*, Lillian Roth's autobiography, and Nelson Algren's *The Man with the Golden Arm*—the stories of a drunk and a junkie. Saturdays, took the bus to the Utopia Theater on Utopia Parkway, blocks from Joseph Cornell's home. I didn't know his name then, later fantasized we might have shared the same movie at the same time—possible with me sitting through three shows a day.

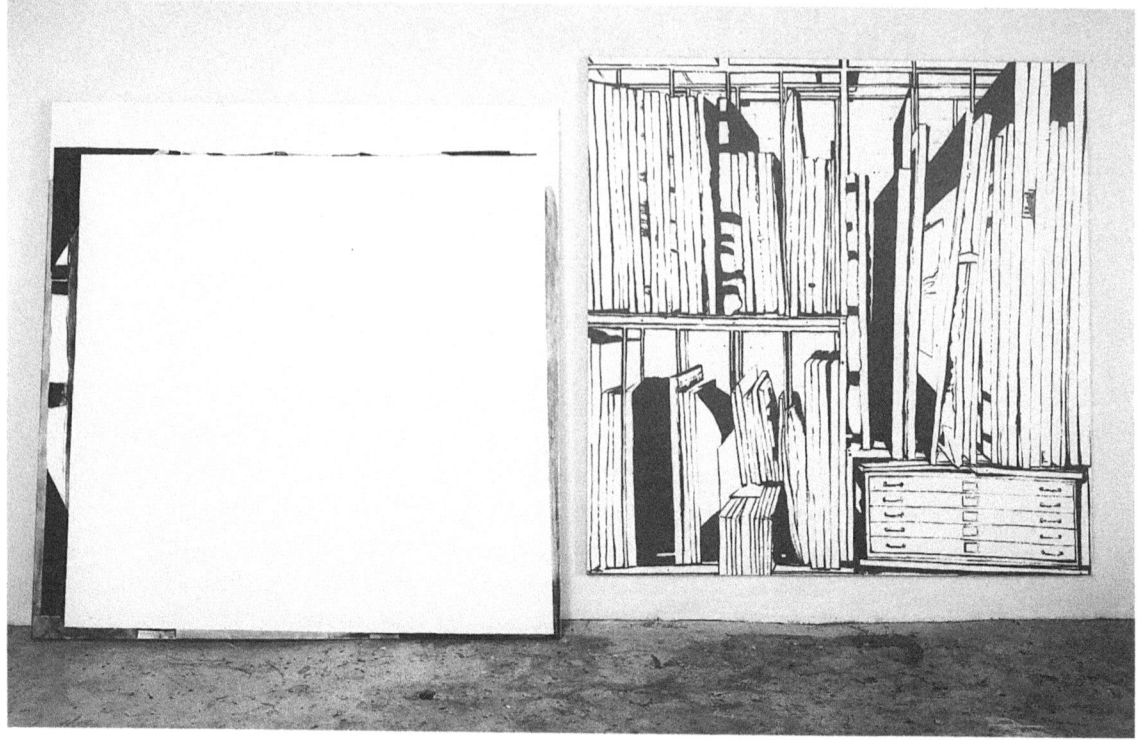

Rochelle Feinstein, *Before and After* (detail), 1997–1998.

Age 12 Books thrown out and my bus pass forfeited because I had "too many fantasies" and had grown anemic from "lack of sunshine."

Age 13 I was given art materials. Took them to Alley Pond Park. Drew and painted every day after school, my first daily practice of art. When finished, wrapped everything in a plastic bag and hid it under a flat rock—protection against weather and discovery. I smelled like mulch for five years.

Since age 18 Studios include a kitchen table in Fort Greene, a dead storage space used by my graduate faculty, spare rooms in rent-controlled apartments in New York City, spaces in East Village, Chinatown, Soho, Williamsburg, Tribeca, and Dumbo. These studios map an urban pattern in which artists colonize barren, undesirable industrial neighborhoods, which then historically become gentrified.

An artist's studio might be a thought-made material, or not. I started on a bed and write this on a MacBook OS X 10.5.8.

Shana Lutker
Index: Dream Studio, 2003–2006

My studio is full of things—things found, things made, things that may help make more things. I have all of the *New York Times* from 2003 to the present, currently stored in seventy-six white file boxes lining the walls. I also have about fourteen hundred pink straws in blue boxes, dozens of lampshades, beach balls with different kinds of stripes, over four hundred pig figurines, a few brass scales, a box of empty water bottles, thousands of gold doilies, at least six gallons of Elmer's glue, an eighty-foot wide stage curtain that once belonged to the magician Doug Henning, hundreds of books presenting points of view that have since been proven wrong, and a file drawer filled with printouts from the Internet of images of or related to Freud. The following is a collection culled from my dreams, an index of appearances of the word *studio* from the years 2003 to 2006. In these abstracts, the studio emerges as a place of anxiety, where work happens (or doesn't happen). Also revealed are some surprising insights into the dream studio's organization, location, and inhabitants.

Studio, Working In

April 27, 2003 I was saying that it seemed like I spent all of my time at the studio, as if the guards were conspiring to keep me there. I told them that there were two guards in particular, specific guards who may have been planning to keep me at the studio until 1:00 every night.

January 13, 2006 I kept losing my water glass and going to refill it. The room was cluttered and had very orange lighting. It was an art studio or something.

August 3, 2006 I had a new studio (it used to be Skylar and Erlea's). It was a white, L-shaped room, bigger than I needed though smaller than my studio now, and it was completely empty. I had to do some work for a show but I was having a hard time figuring it out. There were some drawings I wanted to make with text in them and some other things.

September 2, 2006 I think she supported my leaving my jobs to spend more time in the studio. But I also kept getting the impression that she was implying she thought I should have a baby, which seemed out of character.

November 6, 2006 I was setting up this studio, a big room with this lofted part. I was sitting next to a penholder that had all of these strange things in it, sticks with perfectly curled tops that had been wrapped with string, and nearby were these pieces of fabric, all rolled up and stacked, that were really, really beautiful. One piece was on top of this box of scissors or feathers. I started drawing on this sheet of 8½ × 11 paper as I was unpacking, and somehow I could translate the alphabet of those things in the penholder; they were stand-ins for the Serbian alphabet, or some other alphabet that belonged to some rarely spoken language. I knew what the letters were and I was making this drawing of pictures that were somehow related, all of these images sort of collaged together. It was a good drawing, black pen, and I had almost filled the page when I got distracted.

Studio, Underground

May 16, 2003 The studios were cramped and dark; it might have been the space that Lauren and I looked at in West LA. I was trying to explain that I used to make videos, but no one really listened to me.

January 13, 2004 A lot of people were working in this house that was sort of underground, it was a domestic space that had been turned into studios.

Studio, and the Outdoors

April 6, 2004 For some reason Elliott took the engine of my car and hurled it onto the roof of the studio while it was running. The roof of the studio was huge and there was a lot of junk on it, and a forest. We went up there and were looking for the engine, but there was no hope of finding it.

April 28, 2005 At the end of the complex there were all of these art studios, and there was a lake in the back of the house. The house had a pool, but it was so close to all of these other pools, they looked like wading pools for the lake.

Studio, and Visitors

July 21, 2003 I went into my studio to find it, and someone had been in there and had taken out my typewriters and left them all out and broken.

Shana Lutker studio, 2009.

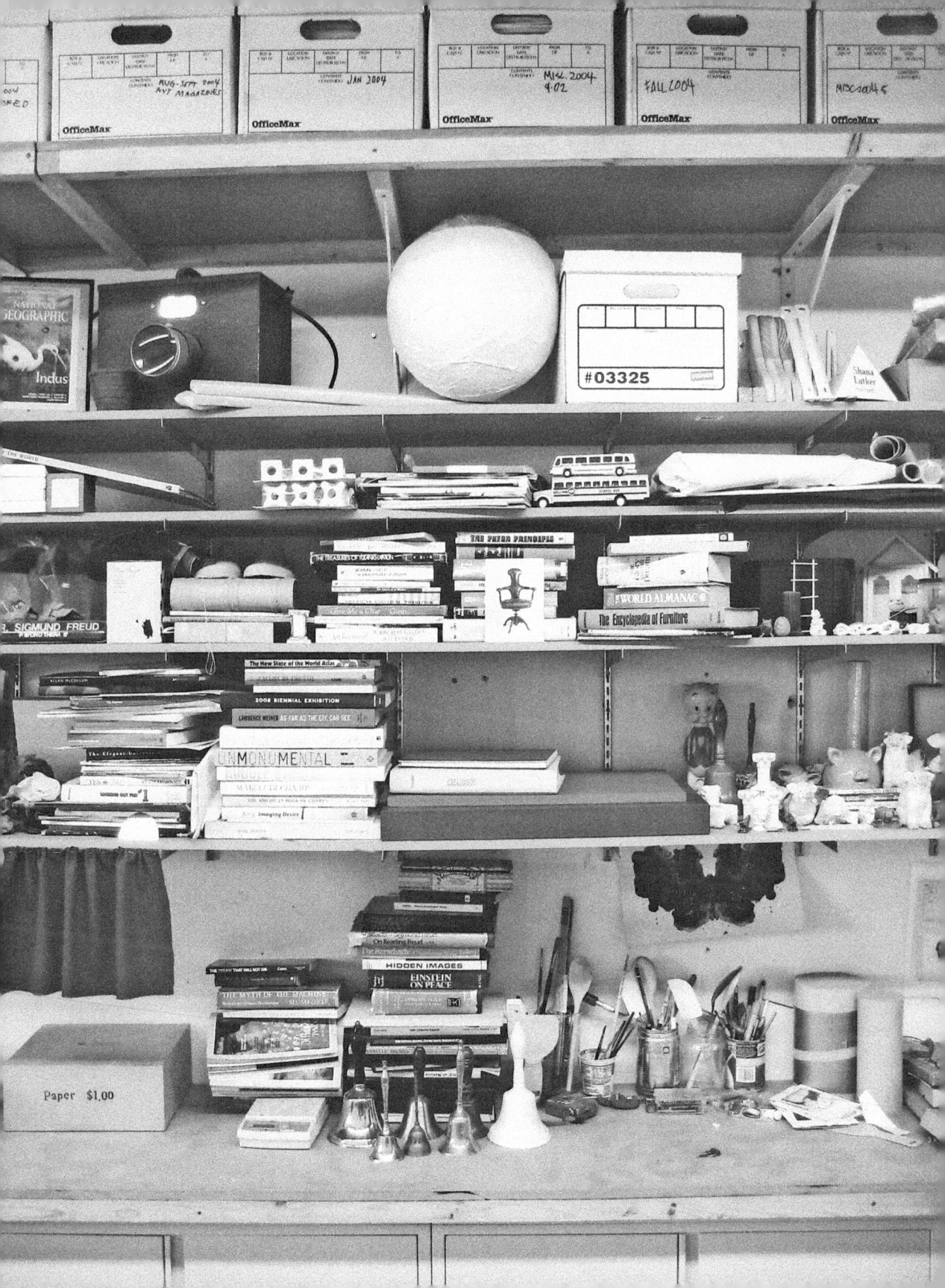

December 6, 2003 I had just cleaned my studio and had a meeting with some people when Elliott walked in. He said, "Well, you have a Jason drawing here." It was a drawing of a boy's face in black pencil, or maybe it was a litho. It was kind of cartoonish and sitting low on the page, with a black cloud around it.

December 16, 2003 I was working in the studio. Skylar was there showing me a book that he had made, and I was sitting at the computer. It was kind of an empty studio, and there was a refrigerator in it; it might have been an extra one. Then we were sitting around a table with a bunch of the other kids talking.

January 30, 2005 I was in my studio and this lady came in. She was a curator or something. She came in and I could not open my eyes, no matter what I did. She came back later and I was able to get up. My studio was clean, and the walls were covered by these dark paintings, painted panels, around three sides. The background was black, and there was a design in red and yellow, and these heads, sort of like Max Headroom or something. One was George W. looking really green. I explained to the lady that I had painted his face that way because he was so disturbing, he made me sick.

Studio, and Sharing

August 26, 2003 I was assigned a huge studio that I had to share with one person. I walked into the studio and the girl, named Alex, had painted the whole thing this very strong pink-brown color. The room was about forty by twenty-five feet, with windows and nooks—the walls were not straight or clean. I walked into the room and I was super angry. I walked out, then went back in and really yelled at this woman, saying that it was completely rude and irresponsible of her to paint the whole room to exhibit her own work the day of open studios. She was kind of haughty and unreceptive. There was another woman who had worked with her, also named Alex, who was equally snotty about it. I looked at the walls that were left and went to get some work. When I came back there were three other artists in there. It turns out that I had to share the space with four other people, and I was really freaking out. One of the people was Matt, and he came in and put up his drawings on half of the wall that I had been using. He took the good part of it and did not understand at all why I was angry about the red wall and the fact that he had taken down half of my work and put up his own without consulting me.

June 17, 2004 I was sharing a studio with these two guys in a sort of bad neighborhood. The two guys were not people I knew very well and they were kind of tough. One had longish, chin-length hair, and the other had a very short buzz cut. The guys wanted to have a show, or open studios in our space, and

started doing a lot of work to clean stuff up and install the work. For some reason, I could not get my act together to be there at the right times. I knew that I was installing my *Dream Paper* piece, but it was going to be a video that had a series of questions and then some other components. The layout of the main studio space was perfect because it was divided into three separate rooms of the sizes that I wanted.

October 19, 2004 There was a lot of stuff in my studio that wasn't really mine: a built-in closet filled with clothes, an empty rolling TV rack, a TV rack with a television, a slide projector. I kept looking at this tan sweater.

November 29, 2004 I was in this large warehouse that was my studio and also where my family worked or lived. Danny was panicking because we had no money, and we were going to move to New York and get jobs. He was excited because he had met the CEO of Amelié, a company where he was going to be a manager. He kept bragging about how he was going to be one of the only people to work at the office. Everyone else worked in the field. Then my dad told me it was a cab company and Danny was going to be a dispatcher. I am not sure Danny knew that, but he was very insistent about my mom and I packing everything up. I had a big huge piece, about sixteen by ten feet, on a piece of thin sheet metal. It was a collage, kind of like Elliott's earlier work, and I was stacking it against the wall with some other, earlier pieces. There was a painting on pink foam about three inches thick, eight feet long, and three or four feet high, and it had a bunch of children's toys or winter hats glued to it. It was something that I had made in college. It was all dirty and Jay was sweeping it with a small broom, but he did not know about the feathers, so I had to get him to stop and I leaned both pieces against the wall, facing the wall.

Michael Smith
Recipe: Perfect Studio Day

- Wash dishes
- Fresh coffee
- Window with view
- Quiet
- Plenty of ideas
- Room to pace

To this day I get nostalgic for simpler times when I waited with excitement for the muses to transport me from my studio to uncharted territory, when every upturned rock and stone led to discovery and wonder. At some point the eager anticipation dissipated, and now only the anxiety remains, as the extraordinary has devolved into the incredibly ordinary. I feel like a full-time clerk, a manager of my own lost-and-found, where old ideas get mixed in with new projects and creative flashes get mistaken for frantic searches for something I misplaced on my desk in the many piles of paper within arm's reach. I like to think I am deliberately playing bad clerk to my good clerk, providing amusement for some fly on the wall, as I transform into a real life Mr. Magoo, aimlessly groping at phantoms, climbing up and down ladders, and creating havoc with the many stacks of boxes filling my studio. Invention and delusion intertwine in my current creative process, with collating replacing automatism and filing likened to the application of a delicate glaze.

 Perhaps I was misled or wasn't listening, but I was under the impression that it was supposed to get easier, that it would be all fun and games in the studio. Fortunately, I have figured out an adjustment to my Perfect Studio recipe. The focus I once mustered to refrain from checking messages or answering calls has been channeled into a new passion: puttering. I embrace distraction. Puttering, a kind of running in place, has become a major component of my daily practice—proof to myself that I am busy, productive, and on some sort of course. The anxiety I used to experience when facing the blank page, the empty canvas, the impending deadline—the uncertain future—is temporarily held in check as I busy myself with a Post-it note, a scribbled scrap, or an old receipt. One glance over to my boxes grounds me firmly in the present, empowering me in my self-appointed role as Chief Clerk, preparing me to climb

Michael Smith,
A Typical Day, 2009.

the ladder or dig into the past: to be busy is to be creative. These searches inspire me to think beyond Mr. Magoo, to channel previously mismanaged energy into my new Little Engine That Could inner self. Reciting, "I think I can, I think I can, I think I can," I transition seamlessly from list-making to retrieving my e-mail to cleaning my desk to moving stuff all over my studio, constantly reassuring myself that everything eventually finds its place, including me. At my lost-and-found, it may get lost and it may never be found, but count on me to look busy, searching.

John Baldessari
In Conversation

Mary Jane Jacob I have read—and I don't know if this is still current—that you have four and a half studios.

John Baldessari That's more or less true.

MJJ One touchstone here is that you are famously connected to the post-studio course…. But in a way—maybe the course was post-studio, but the experience, I might say, was almost all studio. You know, when we talk about students living in their studio—the twenty-four-hour studio and the arts school as this sort of open thing.

 We're really aware of how people use the studio and the idea that, in fact, it doesn't go away. Art-making might change, but we still have a studio. So all of that said, we come to a question that is really very personal: What does a studio mean to you? Why do you have a studio? You have four and a half of them, or maybe more—you're not sure.

JB Yeah, I'm sorry—that got out of control. But starting out when I was in the National City, San Diego area, and the idea of having a place to work…. I think the first place I had was a little storage shed on my parents' property where I was brought up, and I worked there. That wasn't much in terms of space. And then I think what came next was that my father was kind of a slumlord, and he had this building that was—I don't know what was there—but he was approached by some Las Vegas gambler, and I guess there was a city ordinance where in National City gambling might be legal. And so he made a deal with my father to put up a building for a low-rent casino…. Then, I guess, a lot changed … and part of the deal was that the building reverted to my father.

 Then he rented it out as a laundromat—I remember that—in front. And in back, it was first a furniture company, and then the furniture company went belly-up and it was vacant for some time. So I asked him, "Until you rent it, might I use that space?" And he said, "Okay." And so that became my first, I guess, real studio.

MJJ A casino–laundromat–furniture company.

JB Yeah. [*Laughs.*] And what came after that was an Earl Scheib body-painting company moved in, which I kinda liked. Two different kinds of painting. And what I remember about that space—it had no windows, so I was totally encased in my own little world. And basically, that's where, every time I had any free time, I worked. I remember having one wall of just shelving made of 1-by-12 planks of wood on cinder blocks.

And when I got hired at UCSD [University of California, San Diego], I remember Paul Brach—he looked at all the books and magazines and said, "Oh, I get it. You import your culture"—which is true, you know. I got ahold of every art magazine and then every art book I could find—because, you know, I was living in National City, so I had to do that.

Anyway, that was the first studio. And then what happened next—I guess my father sold the building to this Earl Scheib guy, so I had to get out. But then he had another vacant building, which was a movie theater. This was right when television came out and people were staying away from movies in droves, so he had that vacant. Again it had no windows, but this time it had a sloping floor, so I had to have these terraced worktables, you know, where I worked. That was my painting period.

MJJ Oh, really?

JB Yeah. And then I got the offer to teach at UCSD and I was offered a studio there, which were all Quonset huts. So I moved up there. Then later, I took a job at CalArts [California Institute of the Arts] and came up to Los Angeles and—

MJJ Did you have a studio at CalArts?

JB Well, I was offered that. The deal was that they would give you a studio space, but I didn't want to be available to students dropping in. So I said, "No, I'll pass on that." And by that time, I was a full-fledged conceptual artist. You know, they don't need studios. God forbid that it leaked out that I had a studio. [*Laughs.*]

So anyway, I was just sort of working in my living room over at this old house we had in Santa Monica. My neighbor [William Wegman] who lived down the street, he had a studio, and Ilena [Sonnabend] had this loft on—I think it was on Crosby Street. She said that one of us could have it if we wanted to come to New York. I had to pass on it because my wife didn't want to go to New York. We had two children at the time, and she didn't want to raise them in New York, for which my daughter never forgave her. [*Laughs.*]

Anyway, I said, "Bill, you take it," so he went to New York. And he asked me do I want his studio, and I said, "No, what am I going to do with it? It's just

too big for me." And he said, "Well, you can maybe split it up and sublet it." I thought, well, it was pretty modest, so I said, "Okay, I'll take it." And I remember just working in one corner of the studio, and slowly spreading out.

MJJ That was a generous swap—him going to New York, you going down the street.

JB Yeah, yeah. So, then, yes, from 1970 up until—I still have it.

MJJ Wegman's studio?

JB Yeah, exactly. I still have that. But it was always on a monthly lease—not even lease, monthly rental—and it still is. I started looking around for a new studio but couldn't find one. I remember my realtor said, "Every time I find you and try to find a space for you, you don't like it." He said, "You *have* the only studio in Santa Monica." [*Laughs.*] Everybody in the neighborhood had been forced out because of gentrification.

So I was getting more and more nervous. I couldn't find anything. And then my assistant—I don't know if you met her—Kim—she's good at sniffing around real estate, that sort of thing. She found a place in Venice, and I said, "Well, this time, I've got to buy. I don't want to always be moving." But at that time, my finances were unsure, and I was concerned about supporting my kids, trying to set up some sort of foundation that could support them.

So she said, "Well, maybe this is not a good time," and the place she found got sold. Then about half a year later, it was on sale again.... I remember it was $4,000 more by that time and I bought it because I knew it was just going to keep going higher.

MJJ Yeah, those were the days.

JB Yeah. So then I moved in, getting ready to get evicted from the other space. Then the real estate market began to tank. I still have the space, although, you know, it could happen at any moment. They have plans.

And the great thing about it—oh, this is a great story. In front—you probably don't even remember—but there was a surf shop. And when the landlord, the property owners, wanted to develop condominiums, somehow word leaked out around the world, because this surf shop is where skateboarding was born. So anyway, Santa Monica is getting letters from all around the world saying you can't destroy this; this is a shrine, a landmark. And I thought, "Well, maybe I can get in on this." So I had all these directors in LA write letters, and that had some affect. They said, "Yes, you can be landmarked, but you have to be dead." And I said, "Well, I'll pass on that one." [*Laughs.*]

So that's the state of it right now; nothing's been done. What they're plan-

ning is not going to happen until the economy gets better, so I have it until then. But in the meantime, I moved into this other space.

MJJ The Venice space.

JB Yeah. And then, I bought a building up on the next block, just for income. It was one of those faux artist blocks that doctors and lawyers inhabit. And I thought, "In the meantime, it can carry itself financially." So I bought that. And then—

MJJ You're kind of like your dad.

JB Yeah, really, I guess so. And then I got thinking. I was getting more assistants, and I said, "I just want to be by myself." So I said, "Okay, I'm going to turn that into an office so I can be by myself." So that's now an office for all the employees I have working, and I can just be by myself in this Venice studio.

MJJ So it's a studio to get away from the studio?

JB Well, it's really an office, not a studio. And I can just be by myself, working. And then I used to farm out my work to this company to print all my work. The evolution of this Epson printer—I got one of those, and then got another one. And finally, I rented a small space down the street to house them, so that accounted for another studio. So that's where it comes in.

MJJ Okay. So that's your print studio?

JB But again, I don't really inhabit that. I just have this one woman who is very good at doing all that stuff, and that's where she works. And that's it!

MJJ So would you say that the making/thinking space is the Venice studio?

JB Yeah, that's pretty much it. And again, I sort of replicate myself. It's books everywhere, and magazines and—people always want to come to my studio. They always say, "I want to come and see what you're working on." Well, one, I don't want anybody visiting me and, two, you know, I'm not physically working on anything.

MJJ Well, this space does have some windows; I think, sort of high windows.

JB Yes, it does.

MJJ It was interesting when you were talking about the Earl Scheib space, and even the theater—with no windows, being encased in your own world, and then you filling that world.

JB Exactly.

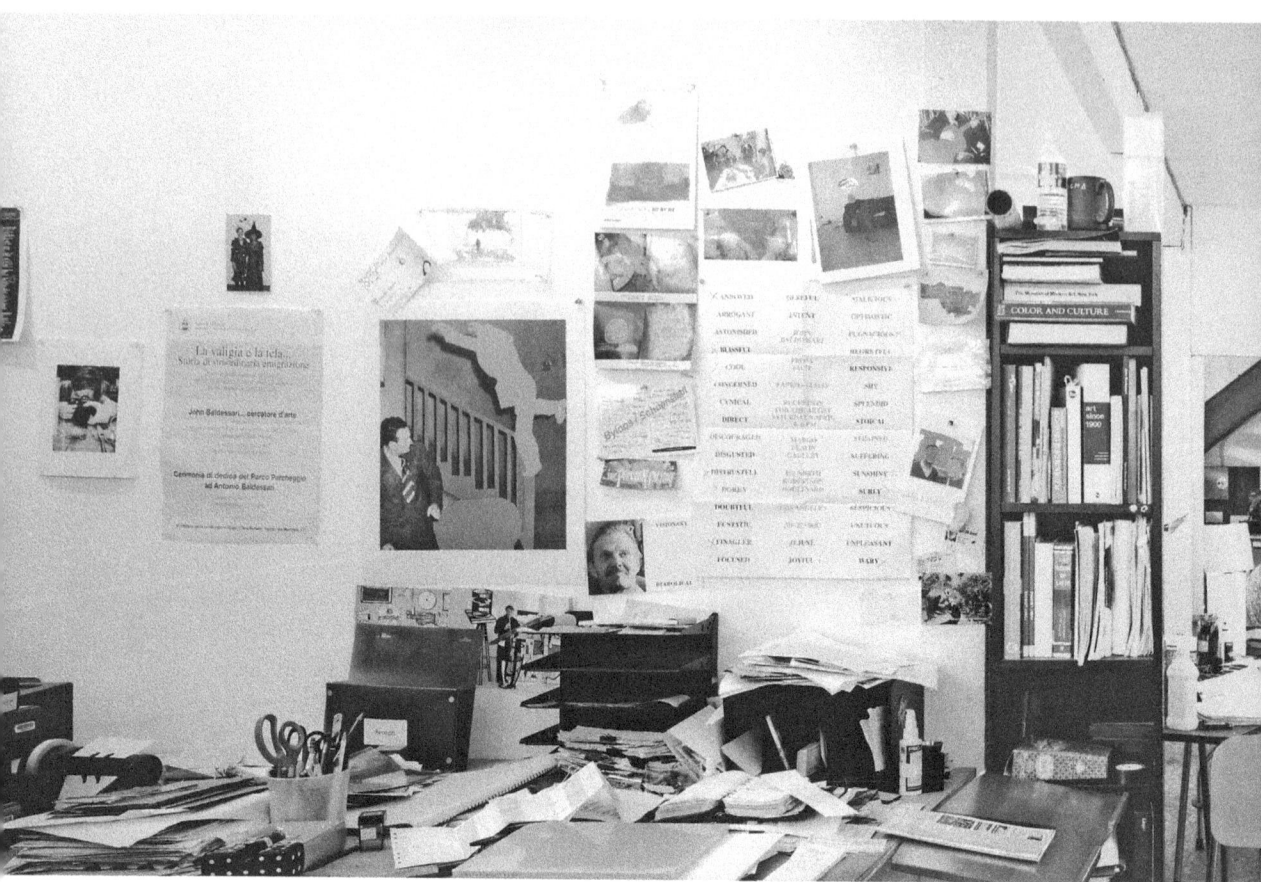

John Baldessari studio, 2009.

MJJ It has a curious kind of irony. To some people—maybe not to us in the art world—it might sound like being in prison, but it is about this desire to be confined.

JB It is, yeah. I think there is something psychological there. For me, I'm increasingly on the road. And when I get back, I just don't want to see anybody, and I just totally isolate myself.

MJJ And that's the studio.

JB Yes.

MJJ Or the office, depending on which place you land.

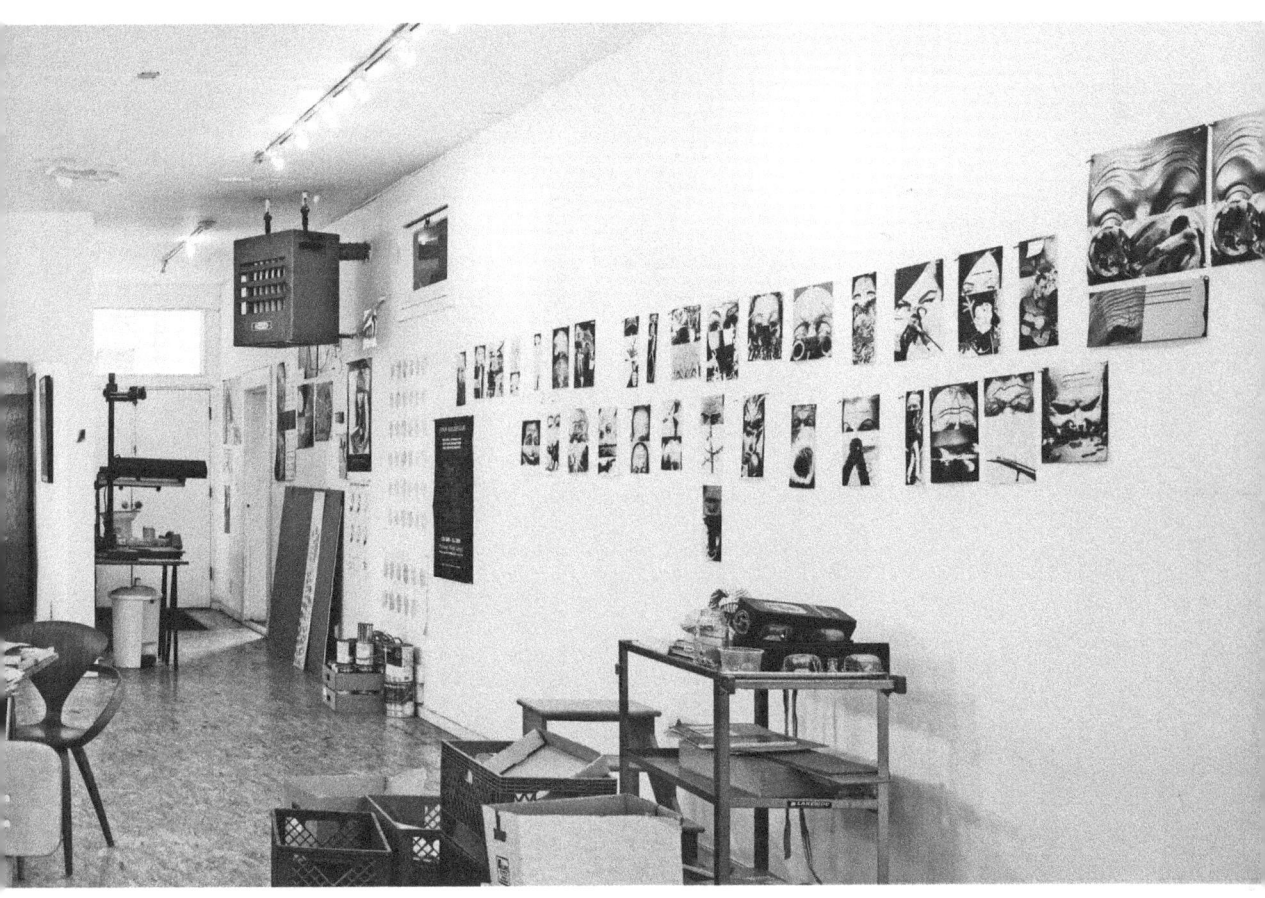

JB Well, I stay away from the office space. Actually, I need one hour a day with one of my assistants. We go over e-mail and phone calls, and then she leaves me here in my studio, and that's it.

MJJ In the end, that confined quiet and being away from people is, as I can see, a pretty full space, full of stuff. So this isn't the Zen meditation room.

JB Yeah, it is, and in my house, I've replicated the same thing. It's just—take everything that's available and pile up magazines. I remember that Vito Acconci once said—and it stuck in my mind—he said, "I just like to have stuff around to pick up and look at." And I have the same thing. I like to just look at a magazine, whatever, so that's how I fill my time.

MJJ Right—and that leads to the next thing, of course.

JB Yeah.

MJJ It's not always so linear or one-to-one. It's that fullness.

JB Yeah. Well, it's also a place for, well, meditation. In that sense, it works. You know, I do little sketches for works that I'm going to do. And some of them survive; not many of them do. And then I put them up on the wall, and—you know, I'm a cigar smoker—I sit there in my chair with the cigar and just stare at them.

The Studio as Set and Setting

Howard Singerman
A Possible Contradiction

I had planned to begin this essay with a brief recollection by Bruce Nauman, but since I am writing this from Tuscany (on my way, as it happens, to see Nauman in the American pavilion in Venice), let me begin instead with Leonardo. In one of the various manuscripts assembled, copied, and circulated over the century after his death in 1519 (and published by 1651 as "The Treatise on Painting"), Leonardo wrote of "the life of the painter in his studio." That, he seems to say, is where a painter belongs, but over the course of three cobbled-together paragraphs—which painters and academicians read ardently through the nineteenth century—his advice gives rise to what the eminent art historian Martin Kemp terms "a possible contradiction."[1] Leonardo begins by insisting that "the painter or draughtsman should be solitary." "If you are alone," he writes approvingly, "you belong entirely to yourself." And yet he warns that the artist who withdraws completely courts madness; thus, when necessary, the artist should keep company, but the "company he keeps should be like-minded" toward the study of art and mathematics. Finally there is the admonition that Kemp finds contradictory: "To draw in company is much better than to do so on one's own for many reasons."[2] Among those reasons are the effectiveness of shame and envy as teaching tools, tools discernable even now in most graduate art programs in the form of the critique and visiting artist's talk.

I raise Leonardo's now five-hundred-year-old comments because I find them echoed, albeit without citation and in very different language, in the College Art Association's guidelines for MFA programs in "studio art," published in 1977 and revised in 1991 and 2008: "For the majority of students, private studios are necessities. They should not be so private or segregated as to prevent healthy contact and interchange. Independent studios should be supplemented by readily available access to all shops, labs, and general studios."[3] Like Leonardo, the CAA is concerned both with the problem of isolation and the problematic nature of interchange. "Healthy" is an inter-

esting word here; like Leonardo's invocations of madness, envy, and shame (terms the CAA cannot quite acknowledge), it suggests that the studio is at least in part a psychological construction, tied to the individual artist as part of the formation of artistic identity. Which is, as it happens, the way the British painter Patrick Heron first saw the private studios that by 1970 had come to fill the earlier spaces described in the CAA document as "general studios":

For those who do not frequent our art schools, let me describe the scene that is most typical: enormous working studios are invariably fragmented by small temporary partitions which define small semi-private individual work spaces, varying in size from a cubicle or cubby-hole to a decently spacious private studio. These always dissimilar working spaces have grown up in every instance around an individual student: he creates the space he needs in the style he needs it; in fact these cubicles or alcoves have the highly developed personal and idiosyncratic character of a private dwelling.[4]

Heron's recollection is useful for at least a couple of reasons: first, it helps us date the emergence of the private studio in the modern art school. In the years between Leonardo and Heron, art students learned to draw as Leonardo had suggested, in academies devoted to the teaching of drawing and, always, in the company of others; the same was true for painting or sculpture. Indeed, what Kemp saw as a contradiction within Leonardo's text might simply have reflected the obvious difference between the studio in which the art student belong and that in which a mature artist works. The distinction is more explicit in Heron's and the CAA's statements: that one word, *studio*, names both the private space that belongs to (and in Heron's description, characterizes) the individual artist and the shared, "general" working spaces that belong to the school and to the métiers imparted in them: the painting studio, the printmaking studio. The fragmenting of these medium-specific spaces and their articulation into the architectural equivalents of particular artistic personalities (if I may exaggerate Heron's reading) is then a relatively recent development, one that Heron can see taking place, and it has gone hand in hand with the fragmenting and decentering of the craft skills that once structured them. In a nice twist, then, the nearly obligatory private studio arrives at about the same moment as the term *post-studio*. That label was probably first used in 1972 by Lawrence Alloway, who characterized Robert Smithson's practice as "a 'post-studio' system of operation,"[5] but by the end of the decade it had come to name the broadly influential program headed by John Baldessari, Douglas Huebler, and Michael Asher at the California Institute of the Arts, a program that continued to offer its students individual studios—perhaps because the studio it sought to put into question, or

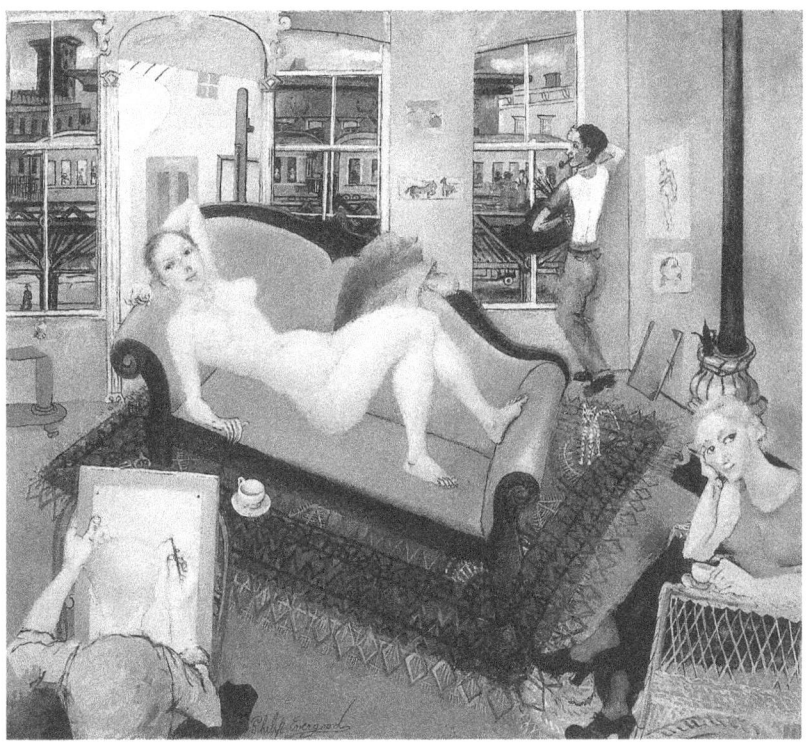

Philip Evergood, *Nude by the El*, 1933.

to surpass, was not so much the private one as the general one, and a certain conjunction of space, artistic identity, and "studio" practice.

Implicit in Heron's description is a matching of identity to the space of the studio—one interior rhymes the other. Post-studio's critique adds a third: the work of art, taken as the emblem of artistic autonomy. Daniel Buren's 1971 essay "The Function of the Studio" makes at least part of this isomorphism clear: before all of the other "frames, envelopes, and limits ... which enclose and constitute the work of art"—the pedestal, the gallery, the museum—the studio, he writes, "is the first frame, the first limit, upon which all subsequent frames/limits will depend." Like Leonardo's studio, or Kemp's reading of it, Buren's studio is marked by contradiction: "the unspeakable compromise of the portable work."[6] In order to be seen, a work made in a specific, even idiosyncratic place—one marked, perhaps, by a specific light or a particular and peculiar privacy—must leave the enclosure of the studio, and thus displace it into other, more explicitly architectural frames. "It is in the studio, and only in the studio, that [the work] is closest to its reality.... The work is thus totally foreign to the world into which it is welcomed (museum, gallery, collection)."[7]

The work goes out precisely because the artist doesn't, and the foreignness of a work to its reframing and to the world is a measure of its, and the artist's, autonomy—what Buren, from a different perspective, calls its "mortal paradox." Buren is far from the first to point to the isolating function of the studio, and, it's worth noting, his essay leaves aside any question of the artist's "healthful" social relations. The Russian-doll figures of the isolated, inner-looking artist, the autonomous painting, and the private studio were on the table together much earlier; take, for example, Meyer Schapiro's 1936 address to the American Artists Congress against War and Fascism, "On the Social Basis of Art." It is the historical particularity of the modern artist, Schapiro asserts, that he works alone in the privacy of the studio, on his own inventions, pictures whose subject matter only repeats (as though site-specifically, one might say now) the studio's isolation. He paints only "himself and the individuals associated with him; his studio and its inanimate objects, his model posing, the fruit and flowers on his table, his window and the view from it; … all objects of manipulation, referring to an exclusive, private world in which the individual is immobile, but free to enjoy his own moods and self-stimulation."[8]

Artists "who are concerned with the world around them in its action and conflict," Schapiro concludes, "cannot permanently devote themselves to a painting committed to the aesthetic moments of life … or to an art of the studio."[9] As it happens, and perhaps unexpectedly, the CAA statement on standards speaks to these concerns as well. The committee's concerns for healthy interaction were part of the oldest draft, from 1977; the document's more recent revisions suggest, if not Schapiro's Marxism, then at least some attention to developments in art and its discourse, to "new genre public art," say, or, even more current, to "relational aesthetics." "The visual arts and creative practices have changed dramatically over the past several years. Increasingly, the artist's studio functions as a dynamic and vital space for learning, exploring, and negotiating the complex relationships that individuals and communities have with the larger social, cultural, political, and natural environments in which we live." This seems right and appropriate, but these terms too suggest a "possible contradiction"—not just in their abstractness, but in the odd way they occlude or exclude the moment of making: "learning, exploring," one could say, take place before that moment, "negotiation" necessarily after. Indeed one of the strongest criticisms of the permeable, relational studio—at least as it emerged in art schools and departments in the last decades—is that it is too open to negotiation and to the art market as the field in which value (in all its senses) is produced. I will leave the critique of that studio problem to others (except to note that in

Italy, where I am now writing, the word *studio* is used most often to designate a professional office: *studio legale* or *studio dentista*).[10]

Here I want to follow the CAA's discussion of the new studio just a little bit further. The association "recognizes that many of today's students enter graduate programs with intentions to work outside traditional studios or labs and will seek links to spaces (virtual or real), interdisciplinary curricula, and/or local and global opportunities on campus and in communities. In effect, studio and equipment needs are self-defined, according to the type of research and creative activity involved and how the student wants to communicate about it or disseminate it." Which again seems right, except that it at once imagines the incoming student as already formed and knowing and leaves the individual artist, like Heron's painter, to produce his or her own space—only now outside the homologies and demands of a métier.

Or perhaps this too is an isomorphism, an updated version of the analogy between the artist and his or her architectural surroundings: no longer the painter framed but the post-studio artist networked and negotiating—interested, as one might say after Donald Judd, and not unlike Roland Barthes's reader, who became, two decades or so ago, the emblem of postmodernism. In contrast to Leonardo's studio artist, who belonged "entirely" to himself, Barthes's reader is "without history, biography, psychology; he is simply that *someone* who holds together in a single field all the traces by which the written text is constituted,"[11] woven with and through by an interdisciplinary curriculum, perhaps, or by local and global opportunities.

But what does one make of or, indeed, *in* a studio that is not in some way synonymous with and absorbed by a métier? And is the space the incoming artist is given—which is in most schools no longer self-fashioned (and, in Heron's description, "self-fashioning") but inherited from previous classes and artists, or even, and increasingly, readymade and professionally designed—still in any familiar sense a studio? Perhaps it is only a room, an architectural space without qualities—"without history, biography, psychology"—other than its enclosure, and rather precisely empty. This is also, of course, the sort of space in which the university schedules classes or assigns offices. There is, as Michael Fried noted early on, something quite literal about a room, something tied to the threat that he imagined minimal art posed to the category "painting," to a specific discipline that one might learn as skill and as history. What characterizes minimal art, and a great deal of the work that comes after, is the "concept of a *room*[, which] is, mostly clandestinely, important to literalist art and theory. In fact, it can often be substituted for the word 'space' in the latter: something is said to be in my space if it is in the same *room* with me."[12]

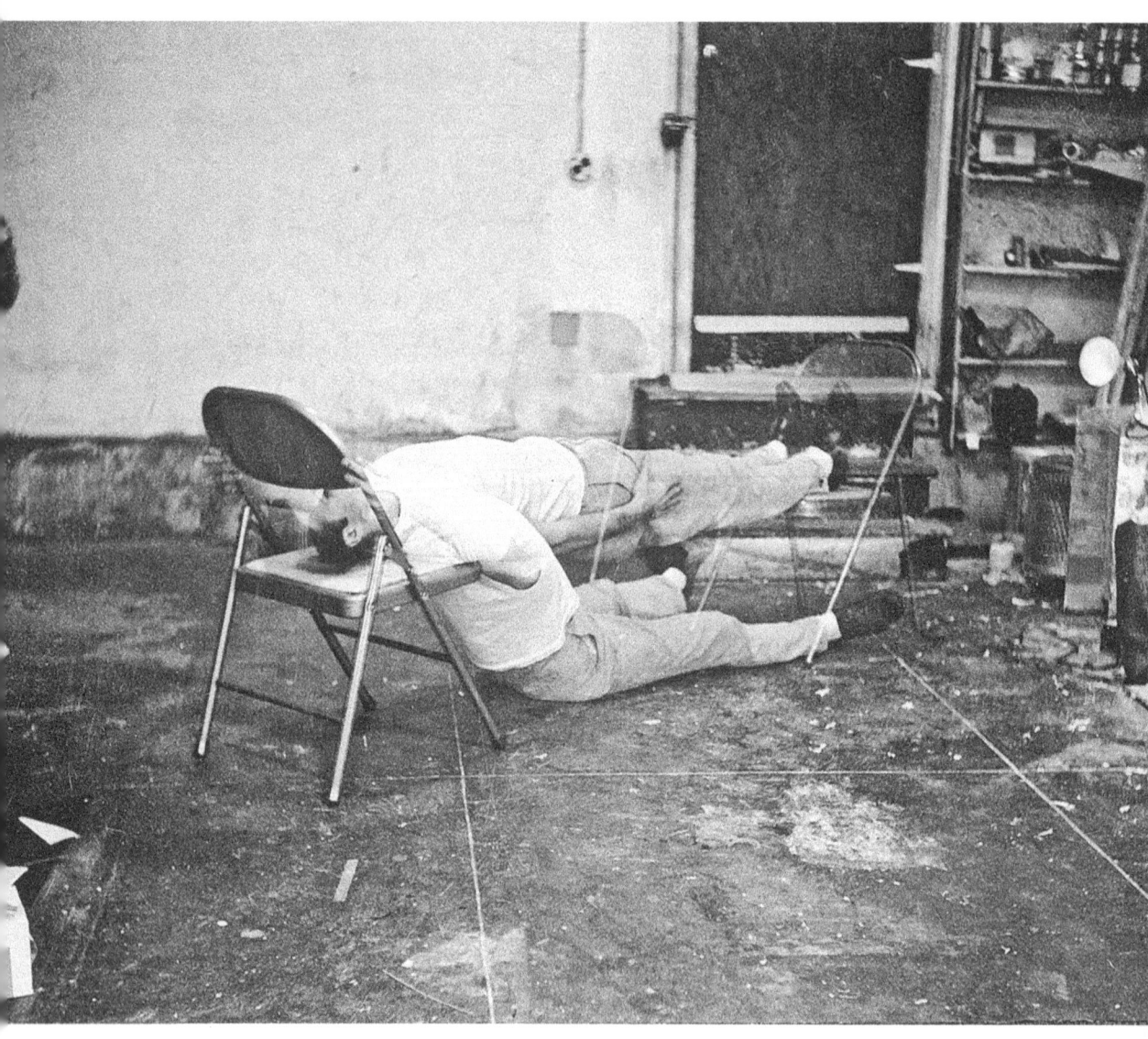

Bruce Nauman, *Failing to Levitate in My Studio*, 1966.

Which brings me finally to the quote I intended to start with. In the late 1980s Bruce Nauman recalled to an interviewer how he came to think about art-making after receiving his MFA from the University of California, Davis, in 1966: "If you see yourself as an artist and you function in a studio and you're not a painter … if you don't start out with some canvas, you do all kinds of things—you sit in a chair or pace around. And then the question goes back to what is art? And art is what an artist does, just sitting around the studio."[13] Nauman's assessment is not wrong. One can see in his work, from the early private performance films and videotapes to his 2002 instal-

lation *Mapping the Studio*, that he has made the studio central to his art practice.[14] But it is a curious studio, a studio understood precisely as a "space" in which things happen—bouncing a ball, masturbating, walking exaggeratedly along the room's perimeters—or fail to, as in his 1966 *Failure to Levitate in the Studio*. It is, to cite the title of yet another Nauman work, from 1984, a "room with my soul left out / room that does not care." Nauman's practice, one could say, inverts the traditional function of the studio; it is no longer the space in which the artist produces art, however compromised, but the space in which the artist him- or herself is created, produced, perhaps, as art, however literalist. This is what I take to be the lesson of his 1966 photograph *Portrait of the Artist as Fountain*, in which Nauman becomes the work, but the work he becomes comes, after Duchamp, readymade. One of the important art school lessons of the readymade is that one can make anything art by designating it as such, or better, by recontextualizing it, that is, by putting it into just the right sort of room—those "studios," those rooms, that are now obligatory.

1 Martin Kemp, ed., *Leonardo on Painting*, trans. Martin Kemp and Margaret Walker (New Haven: Yale University Press, 1989), 289.

2 Ibid., 205.

3 MFA standards, adopted by the CAA board of directors, April 16, 1977; revised October 12, 1991, and October 26, 2008. http://www.collegeart.org/guidelines/mfa.html.

4 Patrick Heron in the *Guardian*, October 12, 1971, cited in Charles Madge and Barbara Weinberger, *Art Students Observed* (London: Faber and Faber, 1973), 268.

5 Lawrence Alloway, "Robert Smithson's Development," *Artforum* 11 (November 1972): 52–61, cited in Caroline A. Jones, *The Machine in the Studio: Constructing the Postwar American Artist* (Chicago: University of Chicago Press, 1996), 271.

6 Daniel Buren, "The Function of the Studio," trans. Thomas Repensek, *October* 10 (Autumn 1979): 51, 54.

7 Ibid., 53.

8 Meyer Schapiro, "The Social Bases of Art," in *First American Artists' Congress* (New York: American Artists' Congress against War and Fascism, 1936), 33.

9 Ibid., 37.

10 The idea of "artists in offices" was strange enough that the sociologist Judith Adler could use it as a title for her ethnography of the nascent California Institute of the Arts in 1979; it was understood that artists belong in studios. But studios have always been mixed objects, as Leonardo suggests and as a "new art history" has continually rediscovered. See, for example, Svetlana Alpers's 1988 *Rembrandt's Enterprise: The Studio and the Market* (Chicago: University of Chicago Press, 1988), or Sarah Burns's discussion of William Merritt Chase's studio in her "The Price of Beauty: Art, Commerce, and the Nineteenth-Century American Studio Interior" (in *American Iconology*, ed. David C. Miller [New Haven: Yale University Press, 1995], 209–38). Chase outfitted his turn of the twentieth-century New York studio

as a showroom—quite consciously, and in ways not dissimilar from the then new art of department store display.

11 Roland Barthes, "The Death of the Author," in *Image, Music, Text,* trans. Stephen Heath (New York: Hill and Wang, 1977), 148.

12 Michael Fried, "Art and Objecthood," in *Minimal Art: A Critical Anthology*, ed. Gregory Battcock (New York: E. P. Dutton, 1968), 134n14.

13 Quoted in Coosje van Bruggen, *Bruce Nauman* (New York: Rizzoli, 1988), 13–14.

14 In Venice 2009, opening in conjunction with the Biennale, was an exhibition at the Palazzo Grassi curated by Alison Gingeras and Francesco Bonami, entitled "Mapping the Studio: Artists from the Francois Pinault Collection." According to the press release, the curators adopted "the title of an important video-installation by Bruce Nauman in which the artist records the nocturnal microactivity present in his studio and offers an unedited vision of the symbolic space in which the creative process emerges … in order to underline the a profound analogy between the intimacy of the artist's studio and the passion of the collector's personal vision." This is a kind of negotiation, of course, but I would question whether the space of *Mapping the Studio* ever becomes symbolic space, or whether, indeed, it was ever intended to.

Frances Stark

Recently I was asked, by someone who was somewhat familiar with my studio, if I would let a museum group visit. I warned him that I had just finished a show, so there probably wouldn't be much work around. "Let's schedule it for a different time," he said. "We wouldn't want them to think Frances Stark is a bad artist because there's nothing in her studio."

Frances Stark in her studio, 2009.

This reaffirms for me the idea that a studio is often expected to be a site of display, offering, at the very least, some captivating evidence of a process. There is nothing photogenic or charming about the way I do what I do, and there's no special atmosphere created by doing it. I tried to take some pictures of it to see what my so-called studio is like, but achieving a representative image proved difficult. I am starting to think that, for me, being an artist *in the studio* is a complete fantasy.

Actually, I have two "studios." I needed to expand, and the only practical solution was to rent the space one door down from my current unit. Now every time I shuttle between the officelike place with the calendar and the couch and the messy place with all the paper scraps and mismanaged shelves, I pass by an architect's office. In the past I have been critical of artists' studios modeled after architects' offices, but there are days when I pass by, look in at my neighbor, and envy the focus that seems so apparent in that one functional room. There the architect produces real houses with actual flushing toilets that people are happily crapping into. Don't get me wrong, I believe in what I do, and I even love what eventually goes out my door, but my methods have yet to form a place that feels like home. Sometimes I think my studio says as little about my work as a basketful of my dirty clothes conveys of what I look like.

Robert Storr
A Room of One's Own, a Mind of One's Own

The bottom line is that artists work where they can and how they can. Accordingly the announcement "I am going to the studio" can mean the going to: the living room, a bedroom, the basement, the attic, an attached or freestanding garage, a coach house in the back of grand old house, a storefront downstairs or down the block from your apartment, the floor of a warehouse, the sublet corner of a floor of a warehouse, the sublet corner of a sublet corner of a floor of a warehouse, the classroom of a vacant school that has been turned over to artists by enlightened city officials, a room in an office building on its way to becoming a residential building, a cubicle within a subdivided factory in a neighborhood that light industry has left for good, a cubicle in a subdivided factory so toxic as a result of the previous manufacturing of goods or storage of materials that no one has figured out how to clean it up even if the site were razed, which no one is going to pay for unless enlightened city officials force them to or a very rich or a very gullible client shows up with a plan to gentrify the whole area with or without telling future tenants that they will forever after be inhaling noxious fumes and drinking water infused with carcinogens.

Naturally, there are other possibilities. However, many of them are exotic from the vantage point of artists who make their living as artists or make their living some other way so that they can spend the remainder of their lives "in the studio." These, in the main, are the purpose-built studios of the kind featured in shelter magazines and deluxe catalogs and monographs. Naturally, as well, the range of them is as various as the fantasy life, taste, and means of artists in a position to design and build them. We know from his own paintings how opera stage–like the studio of William Merritt Chase was. The practice of combining work room with show room in the nineteenth century exemplified by his vast and ornate interior comes down to us through the twentieth into the twenty-first essentially unchanged, such that many studios are conceived of in anticipation of the theatrical rituals of barring and then granting entrance to the mysterious precincts of creativity,

while assuring that the domestic layout glimpsed along the way does one of two key things as the client arrives at the inner sanctum: one, either it informs that client that the artist they have come to meet lives just as comfortably as they do—albeit with an intriguingly different style—understands money and manners much as they do—although the artist takes liberties in both regards that they would not—and thus reassures the client that whatever price is asked for the work and eventually agreed upon—after some pro forma bargaining—is a fair one for someone who, despite these engaging particularities, nonetheless belongs to their own social milieu or its periphery; or two, it demonstrably sets the artist apart from the client, economically, socially, and stylistically, in such a fashion as to add a premium to the price of the work on sale that is the extra increment that all people living in the gated communities and doorman buildings of their imagination are willing to pay for a walk on the wild side.

Poor artists create the second type of ambiance effortlessly; rich ones re-create it by design. Thus, when he moved to Greenwich, Connecticut, to reign as the Grand Old Master of the New York School in intimate proximity with his patrons, Robert Motherwell commissioned a studio the exact size and proportion of his downtown Manhattan loft so as not to lose his bearings, though it is hard to see how the change of scene outside his window could have failed to tell him that he was no longer on the front lines of cultural struggle. If there is anything good about the contradictions and conflicts of interest that artists carving out space in disenfranchised urban sectors must face, it is the daily reminder that they are, as Jasper Johns dryly said, the elite of the servant class. Motherwell represents the type of artist who longs to move out of the servants' quarters into the mansion—and does. He also represents the type of artist whose standard party patter is soaked in *nostalgie de la boue*.

Of the Abstract Expressionist generation, de Kooning exemplified a contrary dynamic. Unlike Motherwell, who was born to privilege, de Kooning was the son of a barkeeper and never made any serious money until he was well into his fifties. Wealth made him uneasy. At one level—and his studio-house on Long island has several levels, each essentially open to the other—erecting the workspace of his dreams was a wholly practical matter. But for a man as subtly visual and as innovative in his craft as de Kooning, practicality was subject to almost infinite refinements once the basic orientation and configuration of the primary structure were decided. For starters, that structure looked nothing like his often tenebrous New York lofts, but was overtly modern and light-filled. One key element was the placement of his small bedroom above the wide-open work area so that when he awoke in the middle of the night, anxious about what he had done during the day or eager

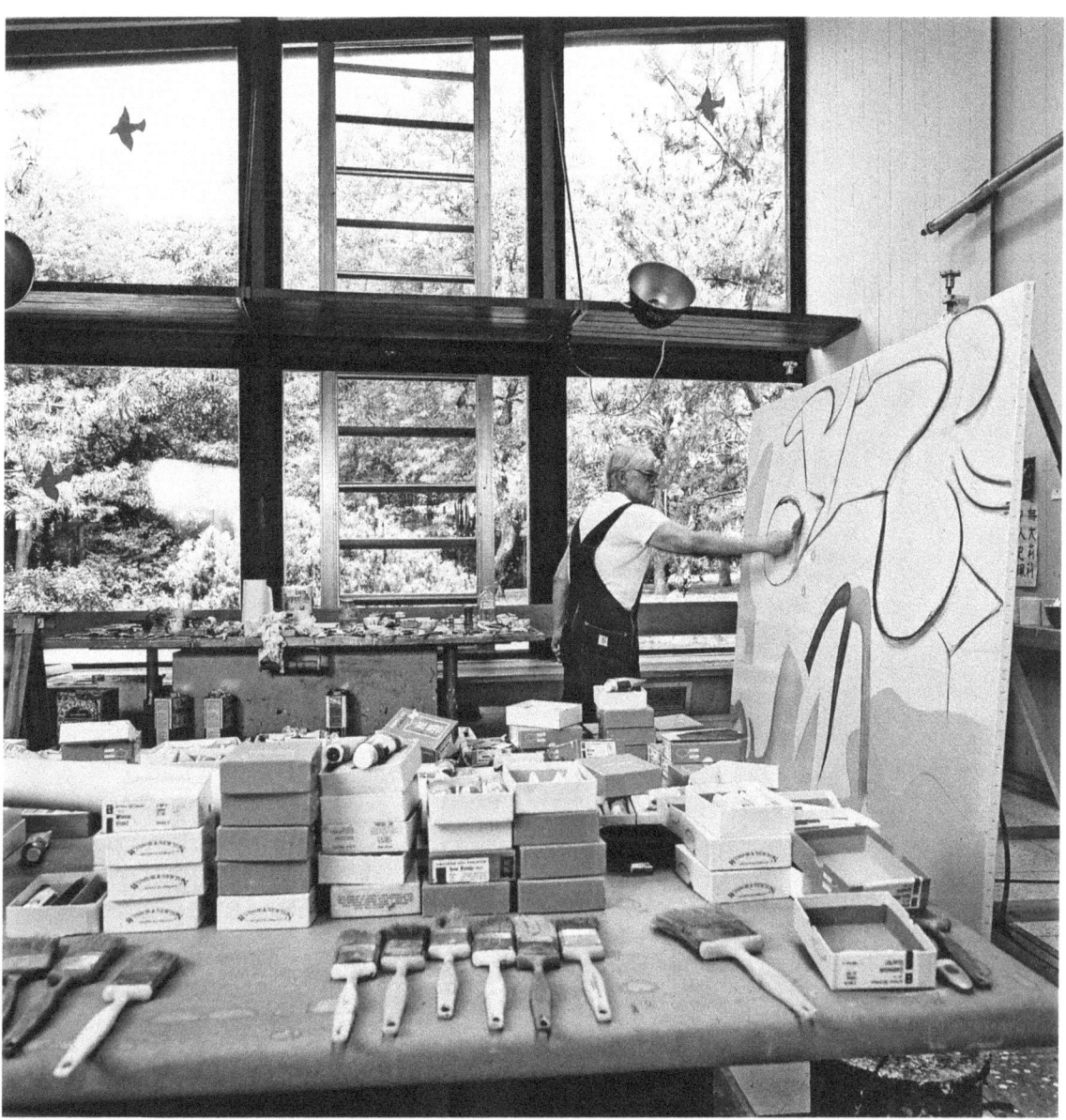

Willem de Kooning in his East Hampton studio, 1983. Photograph by Hans Namuth.

to project a fresh thought onto the painterly field he had been laboring over, all he needed to do was look out the interior glass window of the bedroom and down to the floor below. Desiring a better vantage point, de Kooning subsequently added a cantilevered, railed promontory much like the platform bowsprit of a deep-sea fishing boat. Walking out on this narrow overhang, de Kooning could scan the entire floor beneath him, and look straight at drawings and painted scraps of newspaper laid on it, just as he would look

at a distance at the same kinds of materials tacked to the wall, that is to say, at a ninety-degree angle.

As he aged and became less able move his canvases, de Kooning's assistants came to the rescue by inventing an easel that at the push of a foot pedal would raise, lower, and, most importantly, given his habits and techniques, rotate them at any height, with a trough in the floor swallowing the bottom edge when he needed to work on the top from the same standing position in front of his picture. A virtually identical system is currently in use by Chuck Close. Thanks to it he can paint large format paintings from his wheelchair, though in other respects, Close's studio is just a converted storefront of a kind rented by countless artists in countless nondescript commercial zones. Such ordinary façades are perfect camouflage for the extraordinary things found inside, for insofar as some artists may seek the limelight, others are on the look out for a place where they can go to ground and, no more conspicuously than the shopkeeper or the plumber across the street, go to work unmolested by the idly curious.

With all of this in mind, de Kooning who could dazzle when he wanted to but generally preferred to dress down and blend into his surroundings, nevertheless spent lavishly on a large idiosyncratically modernist studio sited in a small Long Island town dominated by farmhouses, fishermen's dwellings, and early twentieth-century vacation homes for the unpretentiously well-heeled, though the sprawl of the Hamptons and its ostentatious estates has so altered the landscape that de Kooning's folly looks modest by comparison. Why folly? Because it would seem that one of the principle objects of the extensive remodeling of de Kooning's studio was to use up the fortune he had made and that made him so uncomfortable. In contrast to the conspicuous expenditure that boastfully advertises unlimited wealth, de Kooning almost seemed determined to rid himself of what he had by spending like a sailor.

Or so some who were close to him have said. Irving Sandler recalls meeting a dejected de Kooning on the street in New York during his first years of prosperity. When Sandler asked what was bothering him, de Kooning replied, "Didn't paint today," ruefully adding, "Cost me ten thousand bucks." Previously, bad days in the studio had had no price tag because his work had almost no market. Now "losing money" by not working just made matters worse, though in de Kooning's case having money was its own form of torture. Whether or not it is true that de Kooning wanted to divest himself of millions by pouring it into his studio, it is certainly true for others who from one season to the next have been catapulted from the lower economic ranks of American society to the upper ones that creating "house" or "studio" beautiful is less a matter of keeping up with collectors or showing off to peers—who promptly begin to envy such visible success, resulting in misery

on both sides of the yawning dollar differential—than of preoccupied people who have learned how to live without money just not knowing how to live with it. Open the pages of an article in the lifestyle press that displays an artist's perfect spread—and tremble.

For artists there are, to be sure, other forms of luxury than customized or unlimited space. Unlimited materials are, if anything, the most desirable one. Next comes storage. Consider, for example, the deep lockers running around the base of the windows in de Kooning's studio. In the late 1970s, when it seemed that he was drowning in a tide of alcohol that washed through his seaside retreat because enabling and equally hell-bent assistants had left the doors open to it—never take refuge in the country if your first guests come with a six pack and your next one is a lost soul with a bottle—his estranged wife Elaine took matters in hand. A reformed alcoholic herself, she drove out the beer buddies and then went about tempting the dried out but still largely inactive old master back to work by laying out before him a treasure trove—or drunkard's dream—of paints that played on his greater addiction to oil pigments. Thus some $10,000 worth of the highest grade Winsor & Newton pigments in orange boxes was deposited in the bench/bins nearby his dining room table–size glass palettes, like a deposit on the next decade of work. When the supplies were depleted Elaine topped them up again with a quick call to New York Central Art Supplies in the East Village or some other outlet in Manhattan.

This abundance of materials recalls that of Arshile Gorky, whose studio de Kooning first visited in the mid-1930s. There, in the depths of the Great Depression, Gorky horded precious tubes of paint, canvas, paper, brushes of every description, and all the other tools of his trade. It is a safe bet that the studio on Union Square was a cold-water walk-up—how many artists with their eye on the ads in *Artforum* know what that is, much less remember living in one?—but de Kooning and others remember the studio as a kind of paradise in contrast to their greater poverty. A variation on de Kooning's cornucopia of oil colors can be found in the garage/hangar in Sarasota, Florida, that John Chamberlain has used to store car parts and scrap metal. Visiting this studio almost twenty years ago I found its owner/occupant holed up in rooms off to one side that had in all likelihood been the offices of the mechanics who had built the place. When I called out Chamberlain's name there was much hung-over growling in that cave, as if a bear had been roused from its hibernation, although it was late morning on a sunny day. After deciding that it was unwise to provoke him further, I set out on my own self-directed tour of the mammoth shed. On the concrete floor were distributed groups of fenders, doors, sections of roof, hoods, and other more or less "prime cuts" of chop-shopped automobiles carefully sorted by finish and hue,

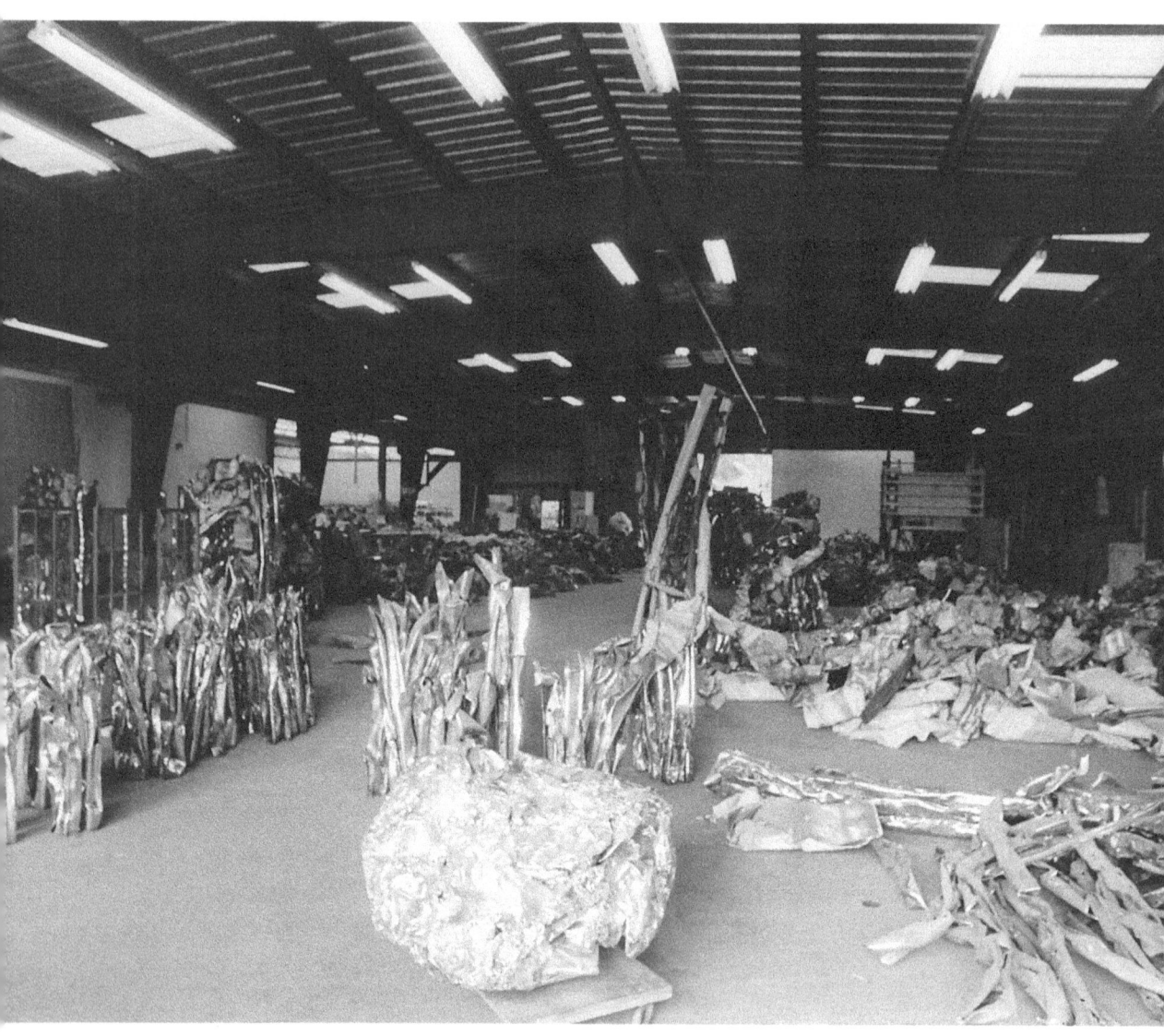

John Chamberlain studio, Sarasota, Florida, 1991.

much as de Kooning—to whose work Chamberlain's looked as admiringly as de Kooning's had looked to Gorky's—had laid out blobs of cerulean blue, cobalt green, cadmium orange and red, alizarin crimson, *jaune brillante*, and various exotic tints and shades, plus tangles of shiny chrome that could have been squeezed from gigantic lead tubes by a titanic hand. Perhaps only those familiar with scrap yards can fully appreciate how elegant and epicurean the whole ensemble was, but if the image the general public has of "junk sculpture" hinges on crudeness and visual chaos, in this reservoir of semi-raw

materials aestheticism and order reigned supreme in the fading years of the Machine Age.

At the other extreme was the rural studio of the wood carver Raoul Hague. The Armenian Hague was a "primitivist" of modernism in the same way that the Romanian sophisticate Constantin Brancusi was "a Parisian peasant." (I owe that phrase to the Surrealist/Stalinist dandy Louis Aragon, who improbably and inexcusably managed to love Matisse and Socialist Realism equally.) After having made his reputation in Manhattan during the heyday of the first-generation New York School, Hague removed himself to a small house on the property next to the one Philip Guston had bought near Woodstock, New York, around the same time. This was roughly the same period during which de Kooning, Larry Rivers, and others made their exodus from the increasingly busy, distracting, and ever more youthful downtown Manhattan scene of the late 1950s and early 1960s. Perhaps it was the habit of cold-water walk-ups or nostalgia for ancient homesteads in the old country that convinced him to go radically green half a century before it was fashionable, but Hague's house had no central heating—only an antique stove and a bed piled high with warm blankets. And even when the air was crisp, as it was the day I paid him a call, the windows were wide open. As one approached the house—I crawled over a crumbling fence from Guston's land to get there—one saw an almost Tim Burton–like American Gothic dwelling standing alone in a cleared field. There was a tall, solitary tree close to it, and the outer wall was covered with mirrors that caught and reflected the sun. I believe the glare they created was intended to frighten away birds, but Hague was also good with a gun, and one of the presents he gave to visitors were the torn-off wings of blue jays that he kept in a carved wooden bowl by the door.

Hague populated this splendid isolation with his own sculptures, which he kept in an arc of specially designed barns that partially encircled the house, like battlements around a medieval keep. His work was for the most part tailored from massive tree trunks he had preserved after clearing the terrain, and from those that highway crews cutting new roads in upstate New York dropped off. I have not been there since the mid-1980s—Hague died at eighty-nine in 1993—but I imagine much of the compound he created remains, along with much of the work, since in the era of industrially fabricated collectibles by the likes of Damian Hirst and Takashi Murakami, the demand for "naturalist" sculpture is pretty slow. But slowness becomes such an aesthetic, and to the extent that Hague's sculptures can be seen against a background of the living forests from which he extracted their primary elements, that setting is also the perfect place to begin to understand

the art Hague added to nature. In this way, the Hague studio has a chance of morphing into a Hague museum. It would be the perfect solution for work that could never have flourished in the city and does not need it now.

That said, the studio-as-factory that David Smith established for himself in the rolling hills of northern New York State at Bolton Landing is a reminder that the "Machine in the Garden," as cultural historian Leo Marx termed the dialectic between the pastoral and the technological, has been one of the major tropes of American art since early in the nineteenth century. And as Marxist historian F. D. Klingender noted in his study *Art and the Industrial Revolution*, the earliest factories built in England tended to crop up in locations close to the raw materials they used, hence William Blake's image of natural paradise despoiled by "dark satanic mills." But just as the organic connection between nature and art lends something special to both in Hague's studio/storage facility, the stark contrast between verdure and metal, natural greens and enamel yellows, growth forms and fabricated ones at Bolton Landing, accents both nature and art just as strikingly if not more so.

In varying degrees other ex-urban studios, like that of Henry Moore in Much Hadham, Hertfordshire, or that of the late Senegalese sculptor Mustapha Dime on Gorée Island off the coast of Dakar, result from more than a decision to leave behind the big city, but also represent a positive choice in favor of a congenial work site that affords the artist a chance to see his art in the context of specifically compatible or contrasting ways that is utterly distinct from the conditions typical of the "White Cube" modernist gallery. In short, artists don't necessarily head for the hills to "get away from it all" or, in the current Hamptons style that now extends to other deluxe retreats like the Hudson Valley, rural Connecticut, Aspen, and Santa Fe, to get closer to their actual or potential collector base. In many cases they leave town because the city has given them and their art all it can give, whereas other working locations offer a new "background" for what they do and so a new understanding of it, or suggest new courses of action and new audiences. Some artists who have gone to a previously unfamiliar city or area to work on a biennial or site-specific show end up changing fundamental things about their work and moving to the place where that change first occurred.

It's not all about New York and Los Angeles. And never was. For decades, Siah Armajani has carried on a major international career from Minneapolis. After making a name for herself in New York in the 1950s and 1960s, the Canadian-born Agnes Martin abruptly quit New York in the 1970s and, in terms of her slow but steady conquest of the mainstream gallery and museum system, went AWOL for several years, during which time she built with her own hands a small house and studio in Cuba, New Mexico, besting

Agnes Martin, New Mexico, 1992.

even Georgia O'Keeffe for off-the-grid monasticism. Later Martin moved to another bare-bones studio in Galisteo, New Mexico. That place too had a quasi-hermetic aura to it, according to those who visited there. I never did. However, toward the end of her life I made the trek to Taos, where she created another home for herself until her death at ninety-two, a death she frequently predicted and even longed for, even as she continued to stare mortality down by working on an almost daily basis.

At this final stop the unity of her living and working space broke down, or rather, Martin decided to separate the two functions in an utterly pragmatic way. Her domestic quarters consisted of a tiny two-room apartment with bath in an adobe-style Taos motel that had been converted into a retirement residence. There was nothing in it that reflected the wealth she had acquired through the sale of her works, which by then commanded whopping prices. Nor, with an O'Keeffe reproduction and a small Aboriginal bark painting on the blue walls of her sitting room, was there anything that suggested she was other than the sort of art-lover that a retired schoolmistress

might be. (In fact she had studied at Columbia University Teacher's College, as did a number of other prominent artists of the period, since in the 1930s and 1940s the Teacher's College was one of relatively few academic institutions in New York that offered studio classes.) Across the dusty parking lot outside her unit and down the street was a restaurant where she took some of her meals, and facing it was a small building where she rented space to paint. There, when I saw her, Martin had a group of large canvases in various states of completion propped up so that she could work on them. To simplify her manual control over the drawing and tinting of the horizontal lines that provided the canvases' flickering pastel yellow, blue, and pink imagery, the artist had arranged them so that those lines descended vertically, the better to "pull" the freehand strokes with a steady gesture. I received this explanation after reconnoitering the studio on my own; Martin bid me go alone and let myself in by turning the handle of the unlocked door. When I found her again at her usual table at the restaurant she remarked that the paintings I'd seen were a commission and that she was going to get a million dollars for them. This reminded me that, like that of many other artists whose quotidian circumstances are little enhanced by riches, Martin's "purity" did not preclude a kind of abstract avarice. No less than in the upper echelons of the business world, where people make fortunes greater than they can possibly spend, in the upper reaches of the art world artists bank money they will never lavish on themselves. Yet they do it and carefully monitor it for a host of reasons. Among the incentives to count one's cash as Martin did are to ease the anxieties about returning to former poverty, to make sure that collectors who express interest in one's work want it badly enough that it hurts, or to keep score with the posted prices of one's contemporaries. Martin's indulgences were confined to charming the waiter of the unlicensed eatery she frequented into repeatedly filling our coffee cups with cheap red wine from a bottle he hid in the kitchen especially for her. Thus her studio-space-to-living-space routine was set, and she followed it like those Zen masters whose bright smiling faces have the unapologetic glow of gentle inebriation.

The studios of Susan Rothenberg and Bruce Nauman are likewise far from metropolitan hurly-burly, though it is hard to think of two artists who are more a part of cosmopolitan modern culture. Until she moved to Galisteo, New Mexico, with Nauman in the 1990s, Rothenberg was a quintessentially urban artist, raised in Buffalo, New York, and seasoned in the gritty lower Manhattan scene of the 1970s. Among other things, she painted horses, but she didn't keep them. Nauman kept them, but didn't much use them as imagery until they settled together on their ranch which sits on high, fenced scrubland with ancient Native American ruins above a generally dry arroyo

at one corner of their expansive acreage. The house is spacious but very plain. A small early Rothenberg painting hangs near the door to a patio in the middle of which sits a bronze fountain composed of rampant écorché dogs by Nauman. There is virtually no other art in sight.

At either side of the back of the patio are simple freestanding buildings. One is Rothenberg's painting space, one is Nauman's all-purpose workspace. Hers is open and relatively uncluttered except for old drawings and keepsake images pinned to the wall and unstretched canvases of various sizes and in various states of development stapled to the walls, or large sheets of paper laid flat. But for the Southwestern light, it could be almost anywhere. Nauman's working space is, as a rule, full to overflowing with remnants from projects that may or may not find their way into new work. For example, several fiberglass casts of heads made in the 1990s kicked around for years until drawing them in different orientations became an all-consuming preoccupation. Here and there are more or less comfortable reading chairs, with stacks of books on a wide array of subjects within easy reach, a reminder, if anyone needed it, that "conceptual" artists tend to be curious as well as cerebral, anxious to know about the world as well as clever in their ability to formulate challenging ideas about it. At any rate, Nauman is. And after all, for some the studio is, without any academic dust, a study. In addition to these research nests, computer equipment for editing video takes up a fair amount of space, as do other types of equipment suitable to other purposes.

But the overwhelming impression left by both studios is that they are the place two quite different artists go every day to rethink the very different kinds of art they make as if it were their first day "on the job." I recall the second-generation Abstract Expressionist painter Joan Mitchell once telling me that she went to the studio religiously, every day, for a consistent period of time each day. Whether she sat for hours in front of what she had done the previous session looking for the point of reentry, or sat for days in front of an empty canvas trying to fix her starting point, or painted furiously with unwavering intuitive purpose until the sun set, it was all, she said, work. Something of the kind seems to be true for Rothenberg and Nauman, though I cannot say from firsthand experience, because for as long as I have known them both I have never watched them work. That, it seems, is a solitary activity, except in cases where the nature of Nauman's art—be it preparing installations, making molds, or staging and taping performances involving others—requires another person.

In that connection, there is, of course, the famous remark John Cage made to Philip Guston when the latter was struggling with self-consciousness while making his late 1950s gestural paintings. "You know," Cage reportedly said, "when you enter your studio, everyone is there, the people

in your life, other artists, the old masters, everyone. And as you work they leave, one by one. And if it is a really good working day, well, you leave too." In a sense, Nauman put that notion to the test when he shot the prototype of his multiform video installation piece, *Mapping the Studio (Fat Chance John Cage)* (2002). In it, synchronized video footage records several views of his studio by night vision, time-lapse surveillance cameras—with the first few images recording his departure from the space. What one then sees is an emptiness animated by insects, rodents, and a prowling cat. It is the life of the studio after the life of art has been suspended. It is the artist's environment absent the artist and his transformative presence. It is the physical literalization of Cage's parable, and in a sly way it pointedly poses and begs the question of whether the creative individual who leaves has indeed cleared the decks of his ego and his obsessions, or whether he has taken them with him into whatever space he then occupies, which, given the household layout, in this case means taking the "studio" into domestic areas because the "studio" is the mind and the space being photomechanically mapped is a quasi void inhabited by creatures for which "art" and its material manifestation is an obstacle course they navigate in feral pursuit of each other or of invisible prey, in short, a Hobbesian state of nature with Nauman's tools and unfinished projects as its landmarks. "Fat chance, John Cage," says the man whose 1968 sound piece rants, "Get out of my mind! Get out of this room!"

On that note, let me draw this brief studio tour to a close with one related example and one important precedent from the same period as that early Nauman installation. The precedent is a term coined by Nauman's fellow California conceptualist John Baldessari, who in 1970 burned all the work he had done as a painter to clear the way to embark on a new artistic direction predicated on making work from ideas hatched without recourse to traditional means and realized according to whichever forms and processes best contained and presented a given idea. In effect, Baldessari came up with a notion and then chose his medium—video, photography, photomontage, and so on—as he saw fit. Taking the lessons he had learned from this methodological leap into the classroom where he made his living as a teacher at California Institute of the Arts (CalArts) Baldessari instituted a course called "Post-Studio Art" and initiated a quiet revolution in the way many artists make things and much of the public thinks about "art production," that very phrase signaling the shift as definitively and as succinctly as anything else that could be said about it.

Parenthetically, at seventy-five Baldessari still teaches, though he no longer needs the income, as does the eighty-nine-year-old Wayne Thiebaud—the West Coast Pop painter in whose drawing classes Nauman served as

a teaching assistant—disproving the canard that "those who can do and those who can't teach." As an aside I would also note that the late-blooming seventy-nine-year-old painter Raoul de Keyser, who was in some respects a role model for the much younger and very quick-off-the-mark Luc Tuymans, worked most of his life as a public school administrator in a small town in Belgium. His studio is an open attic atop a simple suburban house in the middle of which de Keyser has two birdcages because, he says, the birds inside provide him with an constant reminder of movement and color.

But back to the "related example" of studioless practice I promised, namely that of the multifarious Felix Gonzalez-Torres. To my way of thinking, Gonzalez-Torres is as paradigmatic a figure in his generation as Eva Hesse was in hers, insofar as during a very short career, truncated like hers by a fatal illness, Gonzalez-Torres not only established formal, conceptual, and social precedents that are pivotal for the paths taken by many artists who have arrived on the scene since he was active, but because he also succeeded in realizing a complete and complex statement of his primary themes before his untimely death. Gonzalez-Torres's actual works range from interactive, often self-depleting installation sculptures that use readymade modules like candies, cookies, and printed images and texts to public billboards with seeming private messages, jig-saw puzzles, conventionally framed photographs, photographic and typographic multiples, and more. None of this work was made in a special workplace, unless you consider a small apartment filled with Mickey Mouse collectibles and a Paul Nelson sofa a workplace.

Yet like Nauman's, and Baldessari's, and that of many others, Gonzalez-Torres's production was intensely visual and very specifically material, a series of post-Duchampian "thought objects" whose sensory qualities were intrinsic to their meaning rather than merely illustrative of it: in sum, quintessential demonstrations of the yin/yang of the conceptual and the perceptual. Exceptionally well read in critical theory, Gonzalez-Torres belonged to a circle of artists of the 1980s and 1990s that mounted every imaginable challenge to the fetishization of art and yet still made utterly distinctive things whose content was inaccessible unless one experienced them firsthand as things.

Why insist on this point at the concluding stage of a long meandering piece on studios? Because there is a considerable constituency within the art world that fetishizes not only what artists have traditionally done but where they have traditionally done it. Hence the romanticizing photographs of artists in their lairs that grace—and sometimes disgrace—so many contemporary catalogs, from those that record Alberto Giacometti's primordial, plaster-spattered Bohemian den or Pollock's cramped shack, to those

of Francis Bacon's hole-in-the-wall at 7 Reece Mews in London (although reportedly Bacon didn't actually make his generally fastidious expressionist paintings in the much documented mare's nest, which was posthumously relocated in the Hugh Lane Gallery, Dublin as a shrine to his Saturnine genius), to the incomparably campy tableaux of Julian Schnabel facing down the muses in his palatial studio-as-stage-set. That a tome published to celebrate an exhibition of works drawn from the collection of French tycoon François Pinnault, misnamed "Mapping the Studio," opens with some fifty photo spreads of artists' studios—Gonzalez-Torres's Mickey Mouse shelf appears, as does Nauman's vacant redoubt—just shows how firmly this cult retains its hold on the collective imagination.

Little can be done to preempt that fascination with the place where lightning supposedly strikes, but let me end where I began: the bottom line is that artists work where they can, and how they can. There is nothing mysterious about this, since artists must be pragmatic even when they pretend not to be or do the best they can to disguise themselves and conceal their process. The mystery and the marvel is in the work. The rest is contingent reality and real estate.

Bruce Nauman
Setting a Good Corner

When I was making that piece [*The Artist Is an Amazing Luminous Fountain*, 1967] originally and then thinking about it later, people, a lot of people, were thinking about how to structure time. John Cage was making different kinds of ways of making music and Merce [Cunningham] was structuring dance in different kinds of ways. And then Warhol was making films that went on for a long period of time. And Steve Reich and La Monte Young were making music that was structured in a very different way. So it was interesting for me to have a lot of ways to think about things. And one of the things I liked about some of those people was that they thought of their works as just ongoing. And so you

Bruce Nauman, stills from *Setting a Good Corner (Allegory and Metaphor)*, 1999.

could come and go and the work was there. There wasn't a specific duration. This thing can just repeat and repeat and repeat, and you don't have to sit and watch the whole thing. You can watch for a while, leave and go have lunch or come back in a week, and it's just going on. I really liked that idea of the thing just being there. The idea being there so that it became almost like an object that was there, that you could go back and visit whenever you wanted to.

In *Setting a Good Corner*, we're building a corner to stretch a fence and hang a gate. It had a real purpose in the ranch here. I needed to do this. But at the same time, it made a beautiful structure.... My partner—Bill Riggins at the end of the tape—I showed him the tape, and he said, "Boy, you're going to get a lot of criticism on that because people have a lot of different ways of doing those things." So I put down some of the things that he said, about keeping your tools sharpened and not letting them lie on the ground where they get hurt or get abused and dirty and you can't find them. And some thoughts about how his father used to do things. How these things—if you grow up with them—you learn them in one way.

I wasn't sure when I finished it if anybody would take it seriously. It turned out to be kind of interesting to watch. I gave a certain amount of thought to how I set up the shot and then after that.... That's not an uncommon way for artists to proceed. What makes the work interesting is if you choose the right questions. Then, as you proceed, the answers are what's interesting. If you choose

the wrong questions, you still get a result, but it's not interesting. So that's in there. I think I learned some of that from Sol LeWitt, who does a lot of that. He builds a structure that you have to work with, and the work could come out different every time. But if you follow the structure, it's interesting, sometimes beautiful and sometimes just interesting.

Well, that's the art part and that's what you don't know. That's the hard part. Sometimes the question that you pose or the project that you start turns into something else, you know, but at least it gets you started. And sometimes you finish and you look at it and say, "I got a bad result; I don't like what came out here." And so you have to start over or change it somehow.

I mean if the fence is going to last it has to be done well. And so you want to do a good job. Other cowboys and ranchers are going to come around and they'll see it and they'll say, "Well, that—that's a good one." Or, "That's not a good one." It's when you go to work at somebody else's place and the gates all work, or you have to get out of the truck, or off your horse, and drag them around and make a lot of extra work for yourself because nobody wants to spend the time to fix them up and make them work better. I have a lot of other things to do, so if I'm going to do it, I'd like to get it right so that when I have to use it, it's just there and it's useful and usable and I'm not wasting time with a lot of extra baling wire and stuff, patching it every once in a while.

You have to adjust yourself to it because it's hard work. And so you adjust

yourself to the task and if you go out there and say, "Boy, I just hate doing this and I got to get it done," you're probably not going to do a good job. Or you might just forget, not even bother. But if you can find that spot—I suppose it's like running—I used to be a swimmer and swim laps, and you just have to be there with what you're doing. Your mind could actually go a lot of other places, but your body has to be there with what you're doing. It's a good discipline. In the studio, I don't do a lot of work that requires repetitive activity. I spend a lot of time looking and thinking and then try to find the most efficient way to get what I want, whether it's making a drawing or a sculpture, or casting plaster, or whatever. But part of the enjoyment I take in it is finding the most efficient way to do it, which doesn't mean that corrections aren't made. I like to have a feeling of the whole task before I start, even if it changes.

If you're an amateur artist, you can get it sometimes and not other times, and you can't tell and you can't always do it over again. And the part about being a professional artist is that you can tell and you can do it over again, even if you can't say how you got there exactly. You've done it enough and you know how to get there. I don't have any specific steps to take because I don't start the same way every time. But there is a knowing when it's enough and you can leave it alone. You could go on and maybe make some changes, but they could ruin it and they aren't going to necessarily make it better. They're just going to be different. And so that's what keeps me in the studio, the not knowing part and always being surprised.

From an interview with Bruce Nauman conducted for the documentary series Art:21—Art in the Twenty-first Century *(2001), originally published in the companion volume of the same title (vol. 1, 2001). © Art21, Inc. 2001–2009. All rights reserved.*

Michael Peppiatt and Alice Bellony-Rewald
Studios of America

It appears self-evident today that a distinctly American studio exists. No sooner are the words said than one sees a very large, plain, whitewashed space in a building that once functioned as a factory or a warehouse, frequently in a dilapidated part of town. There might be a chair or two, a couple of photos or images tacked to the wall, but the emphasis is entirely on the work under way. Nothing connects it to the plush, well-filled ateliers our grandfathers and great-grandfathers admired. Not only is there no attempt at a reassuring comfort and ostentation (quite the reverse!), but virtually every established studio practice and every piece of equipment has changed. In this bare modern room, palette and easel, punch and mallet would look like heirlooms. The canvas is spread directly on floor or wall, and a person dressed not in velvet but in workman's dungarees goes at it with house-painter's tools and huge pots of industrial paint, or operates trip-hammer and acetylene torch in an acrid, machine-shop atmosphere. Yet this freedom from the past was achieved only after many generations of American artists had absorbed centuries of tradition.

Up until the 1930s, when the loftlike atelier made its tentative debut, the leading American studios closely resembled their European counterparts. When Frederic Edwin Church built his painter's castle above the Hudson River, he was not unmindful of the hybrid splendor in which his peers were lodged in London, Paris, and Vienna. Similarly, William Merritt Chase vowed he would make his Manhattan studio as exotically impressive as anything he had seen during his six years of study and travel in Europe. Yet even the most slavish imitations of the way prominent artists were established abroad ended, naturally enough, by acquiring an irreducibly American note. And for every Church and Chase, there were scores of more humble artists who lived by painting anything from shop signs to portraits, setting up their "studios" wherever commissions were to be had, and then moving on like the itinerant artists of Europe during the Middle Ages.

Church's master, the highly gifted Thomas Cole, began his career in just

this way. English-born, but having arrived in Philadelphia as a young man in 1818, Cole was keenly aware of the new nation's untapped visual wealth. "All nature here is new to art," he noted, and with no further apprenticeship than having watched another painter at work, he set off across the country with a knapsack full of canvas, raw pigments, and the other tools of the trade. Naturally, the untutored young artist accepted all requests, however inglorious, such as touching up unflattering portraits left behind by other itinerant painters. The odd success nevertheless occurred, as when he was asked to paint "the visage of a military officer"; this turned out to be his "best likeness" since, he said, "I could hardly miss it. "'Twas all nose, and in the background a red battle." Cole did not come into his own, however, until he journeyed up the Hudson River in 1825. With the fervor of one who had suddenly discovered his true calling as an artist, he sketched the magnificent spectacle before him, then carried the result back to his garret in New York City, where, "perpetually fighting with a kind of twilight ... elbowed and pushed by mean partitions," he worked up on canvas the vast yet detailed and luminous vision of nature that was to be variously interpreted by a whole school of American landscapists.

By the time he was twenty-eight, Cole was established as America's leading painter. Like most successful American artists throughout the century, he went on an extended tour of Europe; yet he was in no way awed by the old continent's great centers of artistic tradition. Indeed, he openly criticized the later landscapes of Turner (whose previous work he much admired) and left London convinced that he had "done more than all the English painters." Shortly before his death in 1848, Cole was to return to Europe and lock himself in a Roman studio so as to work out of sight of the Italian old masters who, unlike the English, gave him a crippling sense of artistic inadequacy. But his work as a great initiator had been accomplished, and passion for landscape on the grandest American scale had been sparked in his most successful pupil, Frederic Church. Schooled for three years by Cole in the latter's Catskill studio, Church lost no time in establishing the pattern of his painting life. Having spent the whole summer traveling and sketching out of doors, he would return, fit and bronzed as a sportsman, in October, and disappear into his New York City studio—to emerge a pallid wraith, used up by too much work, in the spring. Until he retired to his dream castle, "Olana," built on a bluff overlooking the Hudson, Church worked in the famous West Tenth Street Studio Building, a hub of America's "society favorites." A prodigious amount of energy went into each of Church's huge, meticulously accurate compositions. They were researched during voyages that took the intrepid artist as far afield as Ecuador, Greece, the Near East, and (to gain a firsthand familiarity with icebergs) Labrador. Hundreds of oil sketches were

made in situ and brought back to New York, where they were transformed through the artist's dexterity and prodigious visual memory into landscapes so full of natural fact that for one of them an essay-length guide was produced to direct the spectator's eye to various salient points.

The canvas in question was *Heart of the Andes,* finished in 1859. It was eagerly awaited, and when the moment came to reveal the painting to the public, Church shut out all natural light from his studio and spotlit the work by means of clustered gas jets set in silver reflectors. Exotic plants and sumptuous hangings heightened the impression of a magical event: a distant land brought in all its real-life splendor to the heart of New York! The exhibition became a roaring success, netting nearly $600 a day in entrance fees, and the picture later drew crowds in a dozen major European cities. Like his counterparts in France and England—the Gérômes and Alma-Tademas—Church aimed at absolute fidelity to measurable fact in everything he painted, and like them he worked regularly from photographs and stereographs. In the West Tenth Street studio, likened by one enthusiast to a "great alchemist's laboratory," whole portfolios of documents were assembled to assure the accuracy of each composition. *Jerusalem* was not begun until a photographer had provided special panoramic views of the city. Collections of tropical birds' eggs and butterflies, backed up by a comprehensive natural history library, formed part of the archives of this remarkable atelier in Greenwich Village. Yet however impressive, it was dwarfed by Church's subsequent extravaganza.

"About an hour this side of Albany is the Center of the World," the artist wrote to a friend. "I own it." By 1872, Church had moved into what must be the most ambitious studio-palace ever built. Called Olana (from the Arabic meaning "our place on high"), this lofty mansion was a grand architectural fantasy in the "Victorian-Persian" style, designed by the artist and incorporating polychrome towers, brick "minarets," and Oriental interiors. The studio wing—part Mexican, part Oriental in inspiration—contained a gallery and a rooftop observatory that provided an unparalleled view over the Hudson to the Catskill and Berkshire mountains. Here Church planned to make astounding new studies of the storms and sunsets that had always fascinated him. But a chronically rheumatic wrist prevented him from working, and the splendid studio—with its Tiffany silver, its Shaker rocking chair and pictures by Cole and Murillo—remained essentially a showplace of the artist's eclectic tastes.

Olana was only one of a considerable number of studios to have sprung up "like a picket line" along the Hudson River. Albert Bierstadt, German-trained and immensely successful as a limner of the grandiose West, commanded such high prices from the international élite that he was able to

build a painter's castle overlooking the Tappan Zee. Called Malkasten (and since destroyed by fire), it contained thirty-five rooms, including a seventy-five-foot-long studio, which the vigorous artist had enlivened with Indian artifacts, wapiti heads, and other shotgun trophies. Several painters had studios specially constructed to contain live animals; George Inness, for instance, created a "zoological glasshouse" in which he was able to depict the animals of his choice against a variety of backgrounds without ever leaving his comfortable interior. The Long Island genre painter, William Sidney Mount, made the contrary arrangement. Following his belief that "the painter should have no home—but wander in search of scenery and character," Mount devised a horse-drawn studio that allowed him to amble down country lanes and execute "portraits, pictures and landscapes—free from much dust, heat and cold—during windy and stormy weather." Several rustic scenes later, Mount sang the praises of this atelier on wheels as the "extract of the very best studios in the world."

With true American practicality, artists set up their studios in the most unexpected places whenever commissions seemed to be forthcoming. After specializing for a time in huge, rapidly painted political banners, George Caleb Bingham established himself in a hut at the foot of Capitol Hill and waited for famous statesmen to come and sit for their portraits; none did, and Bingham turned, more rewardingly, to depicting life on the Missouri. Other eager portraitists opened their easels in the New York Stock Exchange and dashed off an investor's likeness before a change of fortune could intervene. Many of those fortunate enough to have some kind of a painting room had no other accommodation and were obliged, as one contemporary noted, to "bivouac at night in their studios or offices amid ... plaster casts, boxing-gloves, easels, squares of canvas, skulls, fencing-foils, portfolios, pipes, armor, weapons and sketches."

Such makeshift arrangements would not have been tolerated, naturally, by the grandees of American art, many of whom at some point in their careers kept a studio in the prestigious West Tenth Street building. Church and Chase were long resident there, and other noted inhabitants included Bierstadt, Sanford Gifford, Emmanuel Leutze, Martin Heade, and Winslow Homer. Thus the building, which continued as an artists' community until it was pulled down in 1955, provided the focal point of New York's artistic life for several decades. Most of the studios opened into one another; and although, like less fortunate artists' rooms, they harbored "all sorts of odds and ends of old drapery and knick-knacks thrown about in tangled, picturesque confusion," they lent themselves admirably to showing off new work to a select public of potential collectors and proven cognoscenti. These visits gradually grew into full-scale "artists' receptions," outstanding social events

to which invitations were coveted. Every trace of toil was removed from the studio and the most salable paintings hoisted to best advantage amid artistically scattered potted plants and curios. The artists, for their part, trimmed their beards, donned their Sunday best, and stood by their studio doors to greet visitors. Music and a buffet were often provided, particularly in Chase's studio, which had once been the communal exhibition area and so was by far the largest space in the building. As prodigal as he was successful, Chase entertained like a rajah, giving studio parties that were described as the "sensation of the 1880s." The fabled Carmencita, invited by John Singer Sargent, danced there with such éclat that some of the ladies present tore off their jewels and cast them at her feet. Chase's Russian greyhounds, macaws, and cockatoos never failed to make an impression, while for the single-minded art enthusiast there were, as one visitor records, "faded tapestries that might tell strange stories, quaint decorated stools, damascened blades and grotesque flintlocks."

One might leave these busy interiors and follow similarly well established artists to their summer haunts, to the sketching parties or relaxed painting schools they set up in prosperous villages along the eastern seaboard, take further note of their eccentricities and extravagances, and conclude that it was a golden age of popularity and ease for artists. That would, of course, be a false impression. America might take to her bosom a painter who skillfully conveyed the image of her prosperity and grandeur. But anyone less successful than the handful of society favorites tended to suffer, if not materially, then at least from a crippling sense of isolation. In Munich or Düsseldorf, Vienna or Rome, artists either obscure or in stylistic rebellion could count on a certain understanding and even a sense of community. America was still too new and too vast to afford this, and when they could, many American artists took extended refuge in Europe, where, according to Nathaniel Hawthorne, they continued to "shiver at the remembrance of their lonely studios in the unsympathizing cities of their native land."

An independently American art, and hence an independently American studio, was still far off. Throughout the late nineteenth century, American artists who had opted to live in Europe were, as Church dryly observed, "as plentiful as ants in an anthill," and there was not a single academy or open atelier from London to Rome that could not boast a transatlantic pupil. Thus the latest European attitudes in art were regularly shipped back to America. Before returning to his native Philadelphia, where he taught at the Pennsylvania Academy of the Fine Arts, Thomas Eakins studied under Gérôme—whose atelier at the Ecole des Beaux-Arts in Paris also included Frederic A. Bridgman, Abbott Thayer, and J. Alden Weir. The situation did not change greatly in the early years of this century. At the time of the Cubists, depen-

dence on Europe was still sufficiently absolute for one of the most percipient connoisseurs of the period, Gertrude Stein, to declare, "Painting in the nineteenth century was only done in France and by Frenchmen, apart from that painting did not exist, in the twentieth century it was done in France but by Spaniards." Before such massive oversimplification could be definitively rejected, American artists had to take a long, lonely leap into the dark.

The most dramatic of the figures through whom the transition to a more specifically American art took place was undoubtedly Arshile Gorky. Born and brought up in Armenia, before emigrating to the United States in 1920, Gorky remained keenly aware of the importance of first assimilating the great achievements of the modern European artists. "I was *with* Cézanne for a long time," he told his future dealer, Julien Levy, "and now naturally I am *with* Picasso." Each apprenticeship was undertaken with such fervor that this latter attachment earned Gorky the nickname "Picasso of Washington Square." During a Picasso exhibition in New York in 1937, some fellow artists chaffed Gorky about the fact that Picasso had begun to allow his paint to drip. "Just when you've gotten Picasso's clean edge," one of them lamented sarcastically, "he starts to run over." "If he drips," Gorky replied, undeterred, "I drip."

Gorky's studios in New York announced a new degree of desolation in American art. Even the most criticized and controversial of his immediate forebears, the members of the so-called Ash Can School, would have been alarmed to find an artist reduced to such poverty and isolation. Robert Henri, for instance, the leader of these "apostles of ugliness," lived in reasonable comfort in his studio on Walnut Street in Philadelphia; it became a regular artists' club where aesthetic discussion was frequently interrupted by all kinds of games and generous servings of Welsh rabbit and beer. Similarly, William Glackens and the Prendergast brothers organized a tranquil life, despite fierce criticism, in the house they had split up into studios at 50 Washington Square in New York City. Gorky lived in obscurity on the same square for a while, then found another room for his studio on Union Square. The barren walls of this atelier were relieved to some extent by fading reproductions of some of the artists he most admired, notably Uccello, Piero della Francesca, and Mantegna. Admiration for the "purity" of Ingres's line was also apparent in the photostat of his *Self-Portrait at the Age of Twenty-Four*, which Gorky kept beside him while he worked. The only other prominent feature in this unaccommodating room was the cast of a Hellenistic female head from which Gorky drew the large, greatly simplified eyes that he used in the early portraits of himself and his family.

This atmosphere of want and loneliness was heavily underlined by Gorky's

own appearance. He was a tall, gaunt man, and his leanness was dramatically emphasized by the ragged, outsize overcoat he wore like an emblem of his artistic status, a being beyond ordinary society. The air of arrogant poverty reflected not only Gorky's precarious material situation but his despair at the task looming before him each day. How could the American artist come out of the shadow of the European heritage and forge a language of his own? In his melodramatic fashion, Gorky summoned a number of New York artists to his Union Square studio and announced his conclusion: "Let's face it," he told the assembled company, "we're bankrupt." He went on to suggest that the only satisfactory work they might do would be collective—with one artist providing the overall project, another drawing it, a third selecting the colors, and so on.

By the time Gorky had evolved a distinctly personal style of painting, misfortune overclouded any sense he might have had of his achievement. In his last years he had begun to paint in a barn in Sherman, Connecticut; in January 1946, this rough and ready studio burned down. "Paintings, drawings, sketches, and books, all were burned to ashes, not a thing was salvaged," he wrote in despair. At least twenty-seven paintings were lost. The following month, Gorky underwent an operation for cancer. Physically undermined, he decided to settle in Sherman. But his health was once again seriously affected by a bad automobile accident. Shortly thereafter, in July 1948, he hanged himself.

Similarly tragic ends cut short the lives of many of the other artists, major and minor, of that self-assertive and painfully isolated generation. Jackson Pollock's headlong career and sudden death have now, like Gorky's, become woven into the larger myth of the *artiste maudit,* the Promethean seeker punished by the gods. Pollock's studio-barn in East Hampton, Long Island, has acquired a corresponding aura as one of the high places of contemporary creation: an ordinary space rendered magical because an excitingly original approach to painting was evolved within its walls. Pollock had begun working there in the mid-1940s, leaving the Greenwich Village area for the summer (like so many other "loft rats," as soon as they had the chance). In winter, the bitter Atlantic winds whistled through the loose planking of the barn, making it virtually unusable. Pollock had it properly insulated in the last years to enable him to work all year round, but not before he had broken a two-year abstinence by downing a glass of whisky to help him thaw out after an icy session in the studio—thus going back for good to his addiction to alcohol.

The East Hampton barn's large, plain space clearly had its effect on the development of Pollock's new style, which he began to practice from 1947 onward. Here was a "studio" that had nothing to do with any traditional con-

cept of what the artist's working space should be. Centuries of precept and method fell away: a structure normally used to house cattle or a plow made no claims on art history. Neither did the artist. Before him there were nothing but huge, virgin canvases and quantities of industrial paint. A medieval painter would have supposed the space to belong to an artisan of the crudest kind, and it is unlikely that many contemporaries would have linked it to any notion of creativity. But Pollock wanted instinctively to begin at the beginning. The strange war dance he performed went back to the most primitive ritual; beside it, the cave paintings of Altamira or Lascaux are incomparably sophisticated. Yet this primitivism was in no way faked. It sprang from a real need, an almost physical need to come at painting as if no one had ever painted before.

Pollock nevertheless proved quite articulate about the elemental methods he used. "I hardly ever stretch my canvas before painting," he explained. "I prefer to tack the unstretched canvas to the hard wall or floor. I need the resistance of a hard surface. On the floor I am more at ease. I feel nearer, more part of the painting, since this way I can walk round it, work from the four sides and literally be in the painting." Several theories have been advanced to suggest how Pollock might have been led to his revolutionary dripping technique. The time he spent in 1936 at the experimental workshop opened in New York by the Mexican painter David Alfaro Siqueiros would—at the very least—have opened his eyes to a wider range of technical possibilities. Situated on West Fourteenth Street, the workshop promoted the use of spray guns and airbrushes, as well as the latest synthetic paints and lacquers; discussion between the artists there frequently turned to "spontaneous" or "gestural" ways of painting, and such seductive notions as "controlled accident" were also bandied about. Pollock himself referred to his interest in the ritual and techniques of Indian sand painting, but once he had established the bases of his own method, his dominant concern was to take the experiment as far away from conventional practice as possible. "I continue to go further from the usual painter's tools such as easel, palette, brushes, etc.," he said. "I prefer sticks, trowels, knives and dripping paint or a heavy impasto with sand, broken glass and other foreign matter added."

For a decade, the Long Island barn—much photographed and even filmed—remained the scene of Pollock's efforts to achieve a dynamically new pictorial statement. With finished works and others in progress tacked to its walls and a floor heavy with the interlacings of countless paint drippings, the studio came to look like a vast three-dimensional Pollock picture—an archive of past "accident," but also a matrix suggestive of new beginnings. Cut off from tradition as well as contact with the contemporary world, it became a world unto itself, a universe of pure paint.

Outside the private universe of the studio, there were few enough places for New York artists of that postwar generation to go to find the sort of stimulus that their Parisian counterparts expected in café discussion groups or that London artists looked forward to in certain restaurants, pubs, and clubs. "I don't see why the problems of modern painting can't be solved as well here as elsewhere," Pollock had stated defiantly, but he was keenly aware of the greater isolation in which American painters and sculptors did their work. The main places where artists met outside their studios were the Waldorf Cafeteria, at Eighth Street and Sixth Avenue, and the Cedar Tavern, on University Place, both in Greenwich Village. After a disagreement with the Waldorf management about their right to keep a table all evening for the price of a cup of coffee, a number of artists decided to rent space on Eighth Street, thus founding the Eighth Street Club, which became the focal point of the New York School's extrastudio activities until the end of the 1950s. The club proved a boon above all to artists who had moved out of Manhattan and who, like the sculptor David Smith, made regular trips into the city to visit the galleries and "run into late-up artists chewing the fat."

Smith, whose life, like Pollock's, was cut short by a driving accident, set up his studio in the mountains above Lake George, in Bolton Landing, New York, in 1940. Called the "Terminal Iron Works" after the waterfront welding shop in Brooklyn where Smith first welded sculpture, the studio resembled a personalized foundry more than an "artistic" place of work. After a visit there for *Art News* magazine, Elaine de Kooning gave this highly evocative summary of its contents: "The huge cylinders, tanks and boxes of metal scrap; the racks filled with bars of iron and steel-plate; the motor-driven tools with rubber hoses, discs and meters; the large negatively charged steel table on which he executes much of his work; the forging bed nearby; and the big Ford engine that supplies the current for welding." Added to this were the mountains of materials that Smith required. "Sheets of stainless steel, cold and hot rolled steel, bronze, copper and aluminum are stacked outside; lengths of strips, shapes and bar stock are racked in the basement of the house or interlaced in the joists of the roof; and stocks of bolts, nuts, taps, dies, paints, solvents, acids, protective coatings, oils, grinding wheels, polishing discs, dry pigments and waxes are stored on steel shelving in his shop."

Smith modeled in wax and carved in wood and marble, but steel was what he called his most "fluent" medium. "Possibly steel is so beautiful," the sculptor suggested, "because of all the movement associated with it, its strength and functions.... Yet it is also brutal: the rapist, the murderer and death-dealing giants are also its offspring." Smith's creative fluency stemmed in part from the apparent ease with which he transformed discarded bits of metal and machinery into arresting sculptural concepts. Perpetually on the

David Smith at work on *Canopic Head*, 1951, Bolton Landing.

lookout for promising elements, Smith amassed mountains of rusted scrap, then reflected at leisure on the new role he might give them. Thus he salvaged four discarded turnbuckles and had them hanging in the studio for a couple of months before, suddenly, he "recognized them as the bodies of soldiers with the hooks for heads." Out of that flash of recognition came a sculpture representing four soldiers at the charge.

"The studio of a sculptor," Nathaniel Hawthorne observed in *The Marble Faun*, "is generally but a rough and dreary-looking place.... Bare floors of brick or plank, and plastered walls; an old chair or two, or perhaps only a block of marble ... to sit down upon; some hastily scrawled sketches of nude figures on the whitewash of the wall." He would have been astounded by Smith's profusion of metals and machines or by the equally forgelike atmosphere of Alexander Calder's workshops, with their forests of mobile and static form. This description, however, closely evokes the desolate air of the places where the New York School's most illustrious survivor, Willem de Kooning, began working. The material difficulties that dogged de Kooning for many years are sufficiently well known to have merged into the broad romantic myth of the artist struggling to establish a new vision amid poverty and neglect. The hardships were nonetheless real, and de Kooning's gift for survival may well be related to his taste, while at work, for unfavorable odds, setbacks, and repeated risks—"because," as he says, "when I'm falling, I'm doing all right; when I'm slipping, I say, hey, this is interesting. It's when I'm standing straight that bothers me."

This instinct at least made him one of the first artists to realize that former button or toy or hat factories in downtown Manhattan could provide large, cheap working spaces. Once inside, all the indigent artist had to do was to remove partitions and slap on a lot of white paint, thus creating (to quote de Kooning's biographer Thomas Hess) "a room as serene as the nave of a Cistercian chapel." So the "artist's loft" was born, furtively enough, since such spaces were limited by law to commercial use only and required careful vetting of any unexpected knocks at the door, as well as a bed that could be folded instantly out of sight. De Kooning's loft on Tenth Street had nothing "homely" about it; apart from a small gallery, a circular table, and a few chairs, the whole area was given over to work. A glass table top served as a palette, and the walls were easily transformed into easels by tacking the canvas directly onto them; thus de Kooning could also dispense with stretchers until he felt a painting was complete. Among the shelves stacked with materials, the portfolios of drawings and the paintings in progress, the one vaguely extracurricular note was a bulletin board on which, beside drawings and art-book reproductions, the artist kept sports photos, the odd pinup, letters, and telephone numbers.

Later de Kooning took over the top floor of another building on Broadway, transforming it into a more elegant affair with sanded and waxed floors. New York's crystal light—compared by Matisse after his first glimpse of Manhattan to "the light in the skies of the Italian primitives"—and the unbroken, unfussy spaciousness of the loft helped to free the artist in his search for an expressivity untrammeled by preconceived notions as to what a painting should be. Unlike his friend Mark Rothko, who kept the skylight of his converted carriage house on New York's Upper East Side shrouded with a parachute, de Kooning has always favored direct natural light. The unusual luminosity of Springs on Long Island was one of the factors that decided the artist to build his new studio there, and since 1963, de Kooning has been able to paint (and, latterly, to sculpt) in an environment entirely of his own choosing. Throughout that time, his preoccupation with questions of pure technique has continued to be as intense as ever. "We all have our tricks," he remarked a few years ago; but his own "tricks" possess a near-medieval complexity. To his oil paint, for instance, de Kooning has at one time or another added kerosene, safflower oil, and even mayonnaise—less to taste than to achieve a particular consistency. Another account of his experiments, worthy of Cennino Cennini, mentions generous dashes of turpentine, stand oil, and dammar varnish. Housepainter's brushes came naturally to this resilient iconoclast at a time when such a choice seemed an act of deliberate derision. But the iconoclasm was seconded by a painstaking application that leads de Kooning to rework certain passages of his canvas over and over again to achieve the greatest illusion of "spontaneity" possible.

As with the chicken and the egg, it would be hard to say which came first: a "typically American" painting and sculpture, or a "typically American" studio. The truth is, no doubt, that they have always been inseparable, the one shaping and defining the other. The loft type of studio, with its unpretentious, unvarnished appearance and its emphasis on a freer, more artisanlike approach to the task in hand, was created in the image of the new American artists' needs. Since then, it has been adopted, with its fresh set of attitudes and techniques, all over the world. It now constitutes the contemporary studio par excellence, and its basic formula is sufficiently flexible to allow of any number of future variations. But however representative and protean, the loft remains—as we shall see in the final chapter—only one of a range of artists' studios as astonishingly diverse as the spectrum of contemporary art itself.

...

From Imagination's Chamber: Artists and Their Studios *(Boston: Little Brown, 1982), chap. 9, pp. 173–200.*

Annika Marie
Action Painting Fourfold: Harold Rosenberg and an Arena in Which to Act

Throw some blue love
It's like action painting
Dash yourself against the canvas
It's very action painting

"Action Painting," sung by the Pizzicato Five (1998)[1]

I see this essay as a small contribution to the growing, though sporadic, body of scholarship of the last three decades that attempts to reconsider the American cultural critic Harold Rosenberg. As my predecessors have pointed out, the primary obstacle in this undertaking has been the very prominence and tenacity of the popular imagery of "Action Painting" and its seemingly unlimited susceptibility to gaglike reenactments. In 2009 the undergraduate art student Nicholas Steindorf staged a video performance of ridiculously frenetic activity in a mocked-up studio, advertised via rock concert–style posters, and the *Boston Globe* reported on BMW-sponsored artist Robin Rhode's football field–scale action painting made using a Z4 roadster outfitted with paint nozzles. The problem is that we know the Action Painter's scene and script too well: "At a certain moment the canvas began to appear to one American painter after another as an arena in which to act," and thereafter the painter "approached the canvas head-on, in direct, unpremeditated confrontation, and left it strewn with drips and splatters, accidental gestures and studio debris."[2]

In visiting and revisiting this simulacral Action Painter's studio (a "site" devised and sustained by a slew of fragments—quotations, photographs, films, advertisements), I myself begin to slide into the stock role of the stubborn detective who continues working a hopeless closed case. What is the crime? one might ask: the Action Painter's studio was supposed to be the very locus of authenticity, a sanctum where expression and action formed a single inviolate gesture, but we find instead the stage set and props for

easy pop clichés, like those in the Pizzicato Five's song. A pragmatic superior would have taken me off the assignment long ago, admonishing me not to waste the taxpayers' money, assuring me that there was nothing more to be done.

The first question at the crime scene is always Where's the body? But in the case of the Action Painting studio, even this is more complicated, and already my detective alter ego is fumbling badly: Where *and what* is the body/figure, and on what ground? Where did the action take place? We know from "The American Action Painters"—Rosenberg's seminal 1952 *Art News* essay that introduced the term "Action Painting"—that the "interest lies in the kind of act taking place in the four-sided arena, a dramatic interest." And we are familiar with arenas as framed spaces for staging, for focusing attention on dramatic, often conflictual, encounters, recalling perhaps that the pragmatic Romans covered their arenas with sand to soak up the blood.[3] But is the "four-sided arena" the two-dimensional canvas on the easel or the three-dimensional room of the studio? Is the "act" a dramatic dialogue among strokes of paint on the canvas or the staged encounter between the painter with material in his hand and that other piece of material in front of him? It's a question of orientation: should the detective be looking up and out toward what hangs vertically on the walls, or down and around at things on the horizontal grounds?

Rosenberg's detractors could write off this unexplained disjuncture to his incapacity as an art critic, compounded by his signature rhetorical extravagance. Rosenberg was a "lousy" and "blind" art critic, Paul Goodman chided in a 1959 *Dissent* review of *Tradition of the New*, who had failed to "concentrate his intelligence on the object before him," one whose critical writing, Sidney Tillim allowed in 1970, never "proved to me that he was capable of understanding a picture in visual terms."[4] John Russell states, even more harshly, in an obituary for Rosenberg, "He did not so much fail to meet as flatly ignore the fundamental test of an art critic: his ability to analyze a given work of art in depth and at length.... He was not a critic. He was not, that is to say, a man who could focus on a single canvas."[5] Instead he got caught up in the situation—in history, social relationships, "philosophical schemes," and ideological stances. "Rhetorical dough," Hilton Kramer called him.[6]

What was Rosenberg doing, then? Why was he there, so frequently, in the artist's studio? What was he seeing if not paint and canvas? What, in fact, was he writing about? The primary change in recent Rosenberg scholarship has been toward questioning the set expectations by which Rosenberg's criticism fails and asking instead where it succeeds. What scholars such as Fred Orton, Elaine O'Brien, Brian Winkenweder, and Hee-Young Kim all have

Nicholas Steindorf,
In Action, 2009.

stressed is Rosenberg's complex, extensive, and career-long engagement with the "act," in theorizations of action that are damagingly condensed by that spotlighted moment in 1952 when Rosenberg got pegged as the slick "Action Critic."[7] In part, it has been by taking Rosenberg's act out of the studio, by unlinking the terms *action* and *painter*, by acknowledging that the first of those terms invokes the actor, not the artist, that some distance has been created between the Action Painting clichés and Rosenberg's theory of the act. From these investigations interesting questions arise: What kind of theory of the act is it? Is Rosenberg a Deweyan pragmatist, a Sartrean existentialist, a historical materialist? a Marxian dialectician? a Schlesingerian liberal? What are the philosophical, political, and aesthetic implications of each?

I would like to sidestep those questions for the moment by staying with the "American Action Painters" and all the difficulties and embarrassments that compound term spawns. What I want to suggest is that the ambiguity in orientation, dimensionality, and framing discovered here in the primal scene of the Action Painter's studio should not be shrugged off but rather considered as a signal rupture that orients us to Rosenberg's own critical arena and object. What the confusion of the two frames or arenas—that of the canvas and that of the studio—stages or draws attention to is the activity of framing and orientation, of figuring and grounding, and to what it is that generates or sets the stage such that acts and actors are framed and become "visible" entities. What would happen if we took those four-sided arenas of the Action Painter—the studio and the canvas—and considered them as ancestors of those fourfold arenas to which Martin Heidegger brought such attention through his etymology of the word *thing*. Heidegger noted that in a number of languages the word referred to the ancient discursive sites of representative assembly—both a "clearing" and a "gathering"— where issues were played out, matters tended to, judgments rendered. These were the frames (the gathering and the clearing in which it occurred) and processes (dialogue, questions, and decisions) by which stuff achieved visibility, becoming a thing. What if we took the Action Painter's act as a locus for the "thinging of the thing"?[8]

With this image in mind, I'd like to propose a rough suggestion for continuing to unearth and piece together Rosenberg's theory of the act. What I am struck by are the similarities between Rosenberg's methodological and critical use of the act and the concerns of actor-network theory (ANT), a critical social theory that emerged in the 1980s, associated with the theorists Michel Callon, Bruno Latour, and John Law, among others, and that set out a new methodology for picturing the social as gatherings and movements within an actor-network.

It may seem perverse to suggest such an alignment, especially if one has precast Rosenberg's Action Painter as unhinged from the social network, acting in an autonomous space and mode as the pure creator. But contrary to this prevalent misreading, Rosenberg's act was situated—situated within external determinations—as he made clear when he stated, "Regardless of what he thinks, anyone who speaks or acts is an agent of someone or something else."[9] The act that Rosenberg spent his life grappling with was the "great riddle of the twentieth century," a "hybrid, transitory and fragmentary" nexus that he was able to represent only roughly using the inadequate dualisms of subject-object, syntagmatic structure–diachronic history, ideality-materiality, individual-collective, repetition-difference. As

he laments in 1952, toward the end of "The American Action Painters," "Language has not accustomed itself to a situation in which the act itself is the 'object.'"[10]

Despite what Rosenberg perceived as the absence of language for figuring the act as object, he repeatedly tried to describe this elusive yet concrete process-thing, this noun-verb. "The human act, if it exists at all," he wrote, "is suspended at the intersection of numerous impersonal processes, some still unlabeled. To act is to locate oneself in a middle."[11] Bruno Latour has similarly characterized the ANT understanding of action as "not done under the full control of consciousness; action should rather be felt as a node, a knot, and a conglomerate of many surprising sets of agencies that have to be slowly disentangled." What also seems key is the attention paid, in both cases, to the roles played by objects, things, and materials in these intersections, nodes, and knots. ANT has been described as bringing objects back into action, as insisting that objects too play a role, that they "are actors, or more precisely *participants*, in the course of action waiting to be given figuration."[12] Similarly, in Rosenberg's famous description the canvas itself is the "'mind' through which the painter thinks," it "'talk[s] back' to the artist ... to provoke him into a dramatic dialogue."[13] I wonder what the formulators of ANT would make of Rosenberg's description of Action Painting, which seems to locate its specialness in the semiotic-material union:

The innovation of Action Painting was to dispense with the *representation* of the state [the artist's psychic state or tension] in favor of *enacting* it in physical movement. The action on the canvas became its own representation. This was possible because an action, being made of both the psychic and the material, is by its nature a sign—it is the trace of a movement whose beginning and character it does not in itself ever altogether reveal ... yet the action also exists as a "thing" in that it touches other things and affects them.[14]

My guess is that they would neither have minded Rosenberg's "blindness" nor taken him as so much rhetorical dough.

To end, a closing shot of the Action Painter. What I believe Rosenberg's 1952 essay offers is the representation of the artist's studio as an actor-network. By playing with scale and orientation through the ambiguity of the term *arena*, what is stressed, even aggravated, are our frames for seeing things, our own processes of "thinging," challenging us to pose the questions of what stage needs to be set for which actors to appear, and vice versa. There is still a performance going on, but it is one having less to do with mythology and more to do with methodology.

1 From the album *Pizzacatomania*, translated from the Japanese by Andrei Cunha, http://new.music.yahoo.com/pizzicato-five/albums/pizzicatomania--189146199;_ylt=AlfB1ZIWJSahsOM.SwVffX8OxCUv, accessed June 1, 2009.

2 Harold Rosenberg, "The American Action Painters" (1952), in *The Tradition of the New* (New York: Horizon Press, 1959), 25.

3 Ibid., 29.

4 Paul Goodman, "Essays by Rosenberg" (review of Harold Rosenberg's *The Tradition of the New*), *Dissent* 6, no. 3 (summer 1959): 305, quoted in Bruce Glaser, "Modern Art and the Critics: A Panel Discussion," *Art Journal* 30, no. 2 (Winter 1970–71): 155.

5 John Russell, "The Action Critic," *New York Times*, April 22, 1979, 3.

6 Hilton Kramer, "Month in Review," *Arts Magazine* 33, no. 10 (September 1959): 56–59.

7 See Fred Orton, "Action Revolution Painting," *Oxford Art Journal* 14, no. 2 (1991): 3–17; Elaine Owens O'Brien, "The Art Criticism of Harold Rosenberg: Theaters of Love and Combat," PhD dissertation, City University of New York, 1997; Brian Winkenweder, "Art History, Sartre and Identity in Rosenberg's America," *Art Criticism* 13, no. 2 (1998): 83–102; and Hee-Young Kim, "The Tragic Hero: Harold Rosenberg's Reading of Marx's Drama of History," *Art Criticism* 20, no. 1 (2005): 7–21.

8 See Martin Heidegger, "The Thing" (1951), in *Poetry, Language, Thought*, translated by Albert Hofstadter, (New York and London: Harper Colophon Books, 1975), pp. 174–75.

9 Harold Rosenberg, "Themes," in *Discovering the Present: Three Decades in Art, Culture, & Politics* (Chicago: University of Chicago Press, 1973), 208.

10 Bruno Latour, *Reassembling the Social: An Introduction to Actor-Network-Theory* (Oxford: Oxford University Press, 2005), 71.

11 Harold Rosenberg, "The Diminished Act," in *Act and the Actor: Making the Self* (New York: World Publishing Company, 1970), 6.

12 Latour, *Reassembling the Social*, p. 71.

13 Rosenberg, "American Action Painters," 26.

14 Rosenberg, "American Action Painters," 27. This is a footnote added to the essay in the 1959 Horizon reprint.

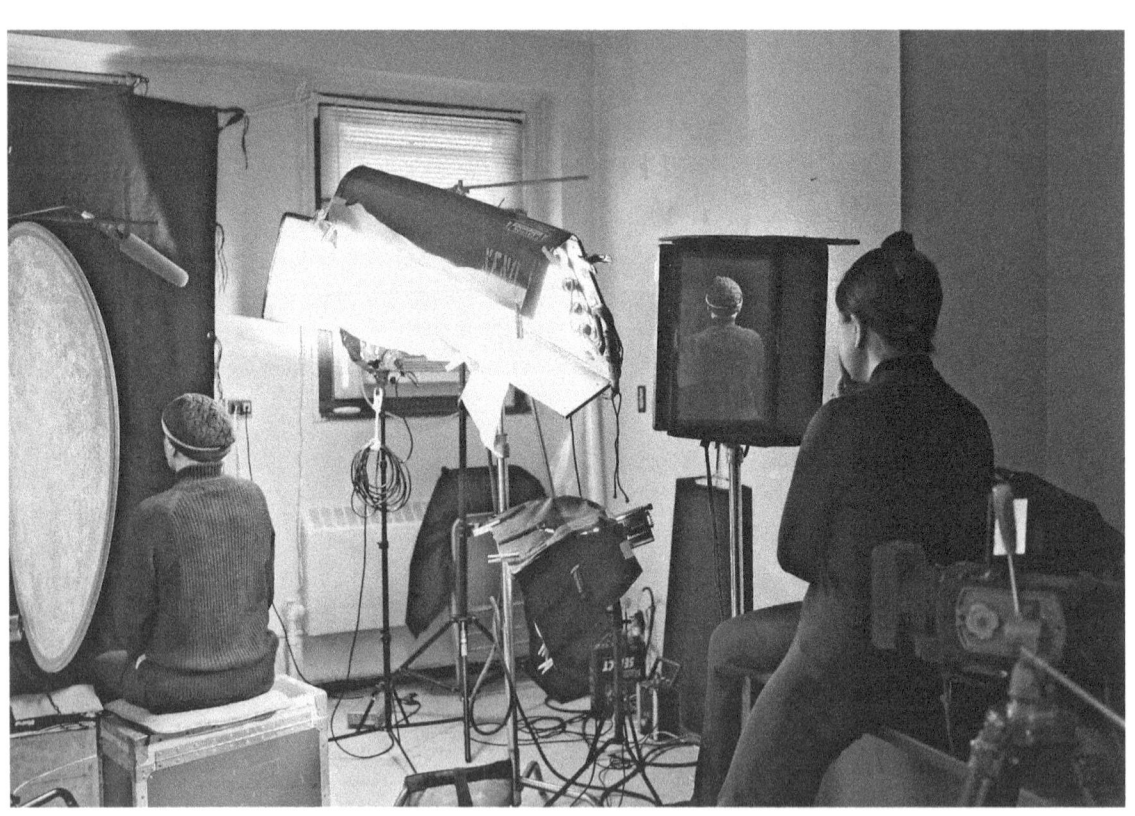

Kimsooja, *An Album: Hudson Guild*, work in process, 2009.

Kimsooja

There are projects which were not possible because of economic, time, space, and technical problems. Some forgotten project will come back to mind when it is needed. I contain my projects in my body, which I find as my studio, and I don't try to remember or describe them all.

My working process is intuitive and I believe its own logic. Being nothing/nothingness and making nothing/nothingness is my goal. It is a long process.

Barry Schwabsky
The Symbolic Studio

Recently the idea came to me to interview Tehching Hsieh. Hsieh is an artist whose work affected me deeply even before I began coming into contact with the art world or writing for art magazines. And it's not surprising that his art reached me—through no other medium than word of mouth—before I had any connection to the institutions of art, because his art had very little connection with those institutions (galleries, museums, magazines, etc.) and in fact as little connection as possible with any institution whatsoever, since during the time most of his work was made he was living in New York as an illegal immigrant. Begun in 1978, his work was essentially over by 1986, during which time he performed five year-long works: living in a cage, punching a time clock every hour on the hour, living outside, being tied to another person, and no art.[1] In 1986 he declared that for the next thirteen years, until the end of the millennium, he would make art but not make it public; on January 1, 2000, he reported that during this period he had stayed alive. Since then, he has not made any art, and his work was accorded little recognition.[2]

Suddenly all that changed. In 2009 documentation of his work was exhibited at the Guggenheim (as part of the exhibition "The Third Mind: American Artists Contemplate Asia") and MoMA ("Performance 1: Tehching Hsieh"); the MIT Press published a big monograph on his work;[3] and Marina Abramović invited him to be present as a "master" in a performance festival she organized in Manchester, England. I was curious to see what my old hero thought of his belated success, how he had been occupying himself, and how the work of his youth now seemed to him.

I didn't know Hsieh personally, but through an intermediary I made contact. He agreed to the interview and I was asked to meet him in his Brooklyn studio. Already I was fascinated: What did it mean, *studio*? If ever an artist embodied a post-studio practice, I'd have thought, it must surely be Hsieh. And on top of that, he hadn't made any art of any kind for a decade. Why

does such an artist keep a studio, and what does the word *studio* mean in such a case?

To some extent I found an answer when I made my visit for the interview. In Hsieh's case, a studio is a clean white space with a table, chairs, and a computer, its walls pretty much bare except for the posters tracking his performances of the 1970s and 1980s. If this was a studio, then a studio meant, not necessarily a place for making things, but for thinking—a refuge from distraction. But that seems like something almost anyone would want to have if they thought they could. Why call it a studio if what was going on there was not art?

In retrospect, I understand why. Hsieh does not say, exactly, that he will not make any more art, but only that he has not been making art. And he does not say that he is no longer an artist. He makes a very clear distinction, too, between his 1985–86 performance—which was to "not do ART, not talk ART, not see ART, not read ART, not go to ART gallery and ART museum for one year. I just go in life"—in which he was making art by abstaining from art, and what he is doing in the present, which is simply not making art.

Hsieh has said that during his thirteen-year program, the work that he attempted to do—but failed—was to disappear. "I went to a totally strange place to start a new life." But he gave it up. "I didn't finish this plan, but at least it can show the direction in which I practiced art."[4] I can't help thinking of the greatest disappearing act in the history of modernism, that of Arthur Rimbaud and his decades of silence in Abyssinia. But Hsieh was no Rimbaud—more like Duchamp, who practiced silence without disappearing, maintaining an enigmatic presence.

To understand what a studio is for such an artist, consider this passage, which might at first seem to be purely humorous or satirical: Elaine de Kooning's account of Adolf M. Pure, an imaginary painter (transparently based on Ad Reinhardt) who makes only white paintings. Pure's rejective method "necessitates having a great many materials in his studio which he must not use. 'A painting must have no color,' explains Pure; therefore his shelves are lined with tubes of color that he never touches. (Permanent green light and alizarin crimson are the pigments he most prefers to reject.)"[5] While de Kooning's portrait as the artist as purist is very funny, it wouldn't be half as amusing if it weren't based on a profound grasp of aesthetics, including the aesthetics she is lampooning. Every aesthetic choice is a rejection of whatever else could have been chosen but was passed over; if Mr. Pure finds it necessary to keep at hand all the colors he has no intention of using, this is to demonstrate (above all but not only to himself) that his disregard for them is not simply a matter of habit but of a choice constantly renewed. It demon-

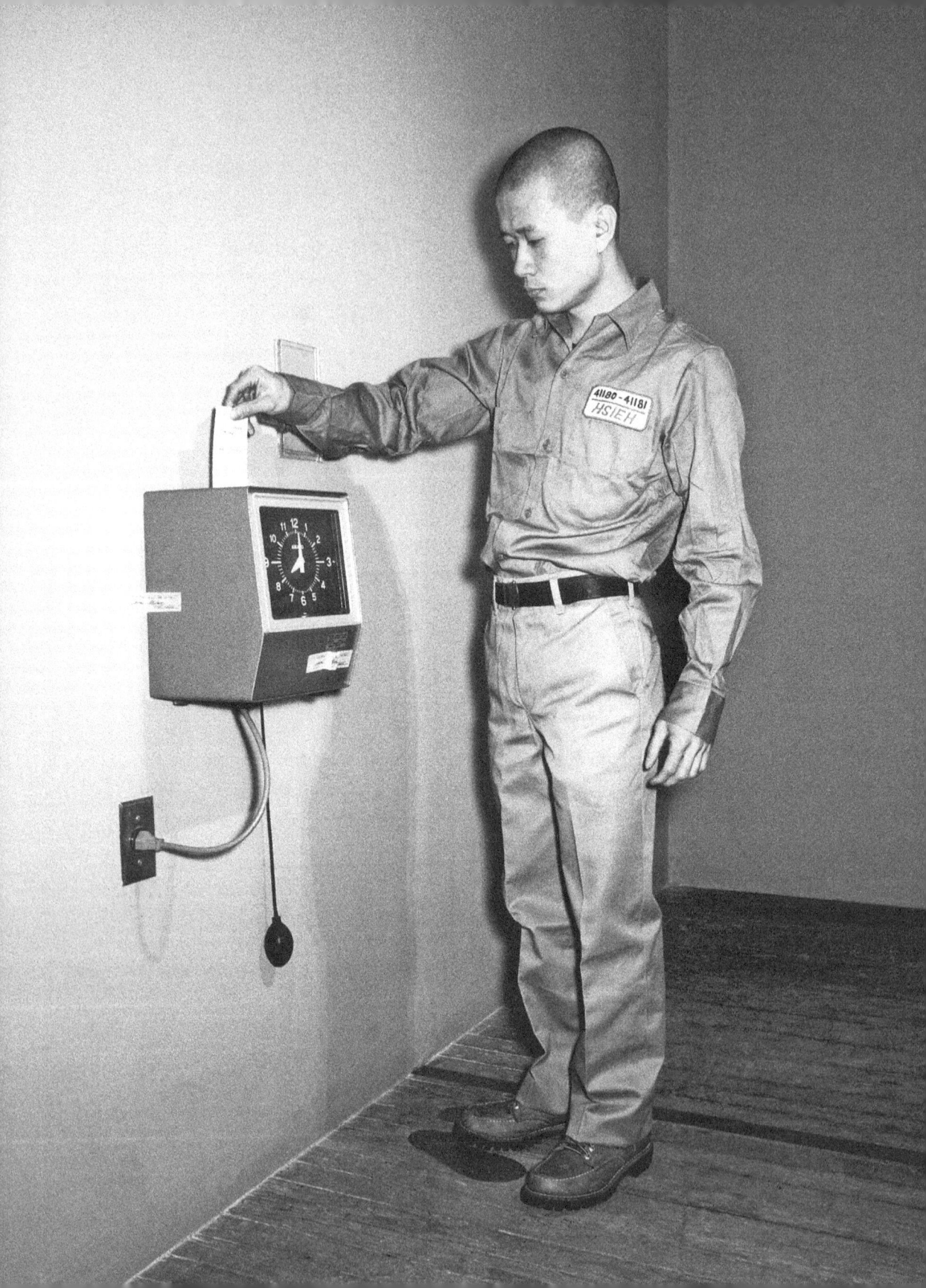

strates that as a painter, he has every color available for his use, and that his decision not to use them is a decision made within the realm of painting—its history and conventions, including those of its materials.

"Making something," as Duchamp famously put it, speaking just two years after the publication of de Kooning's tale, "is choosing a tube of blue, a tube of red, putting some of it on the palette, and the artist always choosing the quality of the blue, the quality of the red, and always choosing the place to put it on the canvas, it's always choosing."[6] Duchamp was reframing the practice of painting in terms of his idea of the readymade through the ubiquitous role of choice in art, but it was already becoming possible to imagine choosing *not* to choose those tubes as a way to make something, too: art as what the Hegelians would call a *determinate negation*.

I wonder if for Hsieh—an artist whose practice could also be described as one based on a multitude of rejections, and to an extent that would have been unimaginable to de Kooning, though she was writing just twenty-one years before Hsieh began his first one-year performance—the decision to maintain a studio might not have a similar basis. He uses his studio, I think, in order to be clear about, and to choose anew every day, his decision not to make art. He uses his studio, in other words, in order not to make art *as an artist* rather than, as others do, not making art because one is not an artist. Artists use all kinds of equipment to make their work: brushes, cameras, computers, and innumerable others. Each tool is specific to particular kinds of art but irrelevant to others. There is only one that comes close to being an all-purpose tool for art-making in general, and that is the one that we take so much for granted that we barely even recognize, most of the time, that it is something like a tool, and that is the studio. Hsieh uses the studio to enable his determinate negation of art in general.

My purpose here is not to analyze the work of a great artist, but simply to point how he—almost by the by but through the same severe process of reduction that he has imposed on everything to do with his art, especially what is most basic to it—made more perspicuous to me the symbolic importance of the artist's studio, an importance that is inseparable from its use value. Of course the studio as symbol is an old story. Everyone knows Courbet's "real allegory" of 1855, that vast work in which the idea of the studio is seen to encompass, not simply the place in which the artist works, but also "all the people who serve my cause, sustain me in my ideal and support my activity," either through their material or moral support of his art or through making up his subject matter: "the masses, wretchedness, poverty, wealth, the exploited and the exploiters."[7] And yet the painting that we see him synthesizing out of all this, the picture within the picture, depicts none of it; on his easel is a landscape—not the Paris of the studio but the artist's home

Tehching Hsieh, *One Year Performance*, New York, 1980–1981.

turf, his beloved Franche-Comté. Courbet's rich and enigmatic painting undoubtedly represents the beginning of the modern myth of the studio, but since then every artist who has made the studio an undisguised part of his or her imagery has been producing "real allegories" of the artistic enterprise, right up through contemporary realist painters like Lucien Freud and Philip Pearlstein, for whom the studio is the only setting for an encounter with the model, whether this encounter is conceived of in anxiously existential terms or coolly phenomenological ones. In either case, the painting is never so much about the model as it is about what happens in the studio when the painter tries to account for the model's presence.

For most contemporary artists, of course, the live model is no longer a necessary part of what studio work entails. Yet for a writer, used to working alone, it is impressive how little the studio is typically a place of solitude, and how open most artists are about allowing others to glimpse the work in progress going on there. Only one artist that I can think of ever flat-out refused to let me in because he didn't want his unfinished paintings to be seen. That was Chris Ofili, when he was preparing for the Venice Biennale in 2003, and I sympathize with him; the idea that someone would see a piece of my writing before I'd finished it—I mean before I had a clean draft fit to show

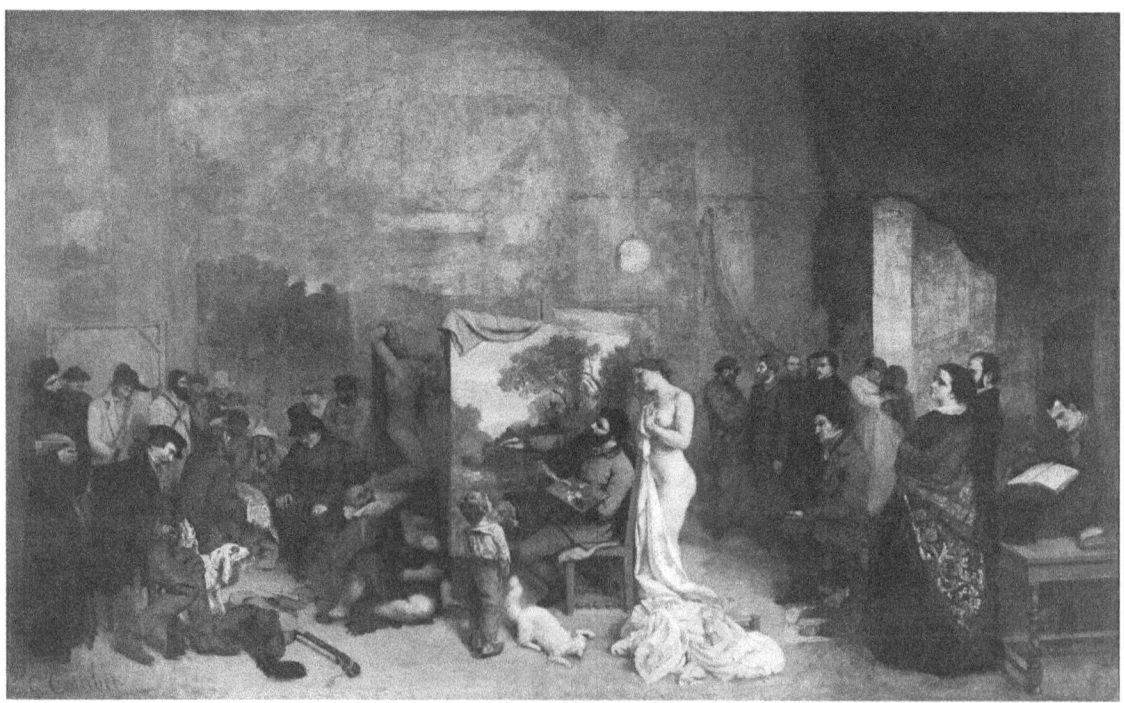

Gustave Courbet, *The Artist's Studio: A Real Allegory*, 1854/1855.

Philip Pearlstein, *Two Models in a Window with Cast Iron Toys*, 1987.

my editor—is horrifying. Yet while painting-as-performance can be said to have emerged at the time of Georges Mathieu and Yves Klein in the 1950s, Courbet's *Studio*—even taking into account its blatant fictitiousness—suggests that the studio activity of the painter has never been seen as essentially private but always somehow performative. Of course its origins in the variously constituted workshops of the Middle Ages, Renaissance, and Baroque era—all copiously peopled—only supports that observation.

In any case, the studio is not only a meeting point for people but also for things. Speaking of the artists of the nineteenth century, Jacques Lethève remarked that "even if they almost always needed to refer to models (whether living models or objects) in carrying out their works, yet in the last resort they used them in order to transform them. They might turn a poor girl hired for five francs an hour into a Queen of the East or immortalize a basket of apples or a pewter jug."[8] Perhaps sometimes, if the narrator of *In Search of*

Lost Time is to be believed, the metamorphosis could go in the reverse direction: "In this connection, a cousin of the Princess of Luxembourg, a woman of great beauty and arrogance, having taken a fancy to a form of art that was new at the time, commissioned a portrait of herself from the most prominent of the painters of the naturalist school. The artist's eye had instantly detected what it sought everywhere: on the completed canvas, instead of the grand lady, there was the dressmaker's errand girl."[9]

In the present, when one thinks of a post-studio tendency, it may implicitly be this aspect of the studio that is most pointedly thought of as having been abandoned: the studio as a place where illusion or even a sort of transubstantiation is practiced. For in the meantime it has become possible to think of art as a purely indexical activity. "Conceptual art is just pointing at things"—this remark by the artist Al Held is supposed to have been the origin of a famous group of paintings by John Baldessari, the *Commissioned Paintings* of 1969, executed by amateur realist painters from snapshots taken by Baldessari of a friend (said to be William Wegman) "pointing to things that were interesting to him."[10] A sign painter was then hired to add an inscription to each painting, giving the painter's name, for example, "A Painting by Pat Purdue."[11] The phrasing is important: the painting is by Pat Purdue but the art is by Baldessari. That Held's intended dismissal could be reconfigured as the starting point for a work—both conceptual *and* painting, but significantly not a product of the artist's own studio, having been made in those of painters conceived of (by Baldessari and perhaps by themselves) as mere hired hands—shows that Baldessari had recognized and been pleased by its essential truth. Putting to one side the label "conceptual," about which one could dispute endlessly and probably futilely, one can say that the paradigm of the readymade means nothing other than this: that the artist need not transform anything but merely point to something already there, indicate something within the realm of the real.

At worst, this notion could lead to that veritable mania for designating realia as art, and the grander the better, which was characteristic of what some critics refer to as the "neo-avant-gardes" of the postwar era. Such practices certainly seem to make the studio a dispensable piece of equipment, if only because a studio could never contain enough of the world to make a difference in the game. More to the point, though, and even or especially with respect to more subtle and sophisticated interpretations of the Duchampian model, the studio could be seen as no longer necessary, and perhaps as a hindrance, insofar as the very idea of the studio seemed to imply a need on the artist's part to transform something. And the transformations that had been rendered unnecessary or even regressive were not only those of the

models of whom Lethève speaks—the working girl turned into a queen—but also and especially of the artist's very materials.

Let's go back to what Duchamp said: "The word 'art,' etymologically speaking, means to make, simply to make. Now what is making? Making something is choosing a tube of blue, a tube of red, putting some of it on the palette, and the artist always choosing the quality of the blue, the quality of the red, and always choosing the place to put it on the canvas, it's always choosing." In saying this, like every modernist artist who wanted to understand his practice as having touched the essence of art, or at least the essence of *an* art, Duchamp shows that the readymade can be seen as the underlying model for painting. And yet he is silent about what every painter before him had understood as the reason for the choices he or she might make: to transform this red, this blue, and so on into a painting, to transform raw material into a vehicle of thought, to transform effort into success. How many times have I walked into a studio filled with unfinished paintings and shuddered for the artist who would have to present these unpromising exertions in a show already scheduled to take place in just a few short months, only to find at the end of that period that what finally met my gaze in the gallery were the beautiful developments of the malformed ugly ducklings I'd glimpsed not very long before. That's transformation for you.

I'm still thinking about Hsieh and his empty studio. Unlike Duchamp's imaginary painter, he feels no need to choose a tube of red or a tube of blue, nor even a need, unlike Elaine de Kooning's, to reject them. Secretly, I might have hoped to find that he was, for instance, occupying himself by painting, say, little still lifes—another way of making art by not making art, perhaps, but certainly a way of "passing time," which is how Hsieh defines his activity[12]—but, of course, this was not the case. Yet the studio was still there, and this is perhaps because the demand for transformation has, despite all appearances, never been absent from Hsieh's art: "An artist, he should have the ability to transform basic living conditions into art works to ponder life, art and being."[13] Even the artist who works solely with the real (rather than with illusion, imagination, or metaphor) must transform it—no longer changing paint into a painting but life into art. Hsieh's empty studio stands as a reminder of the unexhausted potential for this transformation to recur.

..........

1 These were: *One Year Performance*, 1978–79 and 1980–81, both at 111 Hudson Street, New York; *One Year Performance*, 1981–82, at various locations in New York City; *Art/Life One Year Performance*, 1983–84, during which he was tied to artist Linda Montano; and *One Year Performance*, 1985–86.

2 Marcia Tucker, founding director of New York's New Museum of Contemporary Art, was an early supporter of Tehching Hsieh. See her essay "No Title" in *Buddha Mind in Contemporary Art*, ed. Jacquelynn Baas and Mary Jane Jacob (Berkeley: University of California Press, 2004), 75–85.

3 *Out of Now: The Lifeworks of Tehching Hsieh* (London: Live Art Development Agency/Cambridge, MA: MIT Press, 2009).

4 Adrian Heathfield, "I Just Go in Life: An Exchange with Tehching Hsieh," in *Out of Now*, 338.

5 Elaine de Kooning, "Pure Paints a Picture" (1957), in *The Spirit of Abstract Expressionism: Selected Writings* (New York: George Braziller, 1994), 159.

6 "Marcel Duchamp Speaks," interview by George Heard Hamilton and Richard Hamilton, London, BBC, 1959; published in *Audio Arts Magazine* 2, no. 4 (1976), quoted in Thierry de Duve, *Kant after Duchamp* (Cambridge, MA: MIT Press, 1996), 161.

7 Gustave Courbet, letter to Champfleury, autumn 1854, collection Musée du Louvre, inventory no. 89083; quoted in Hélène Toussaint, "The Dossier on 'The Studio' by Courbet," in *Gustave Courbet 1819–1877*, exhibition catalog (London: Royal Academy of Arts, 1978), 254.

8 Jacques Lethève, *Daily Life of French Artists in the Nineteenth Century*, trans. Hilary E. Paddon (New York: Praeger: 1972), 57.

9 Marcel Proust, *In the Shadow of Young Girls in Flower*, trans. James Grieve (New York: Penguin Books, 2004), 441.

10 John Baldessari, in *John Baldessari: Paintings* (Eindhoven: Stedelijk Van Abbesmuseum, 1981), quoted in Peter Osborne, *Conceptual Art* (London: Phaidon Press, 2002), 89.

11 In 1922, for his "Telephone Paintings," Moholy-Nagy hired a sign painter to execute his designs.

12 Heathfield, "I Just Go in Life," 338.

13 Ibid., 326.

The Studio
as Stage

David J. Getsy
The Reconstruction of the Francis Bacon Studio in Dublin

Dublin has become the posthumous home of Francis Bacon. Some seventy-five years after he left Ireland at the age of sixteen, he has been welcomed back as a local art hero. In addition to important exhibitions and collections, the centerpiece of Dublin's embrace of Bacon is undoubtedly the re-creation of his London studio. Originally located at 7 Reece Mews in South Kensington, the studio and its contents have been moved to the Hugh Lane Gallery, one of Ireland's foremost museums of modern and contemporary art. Donated by John Edwards and the Bacon Estate in 1998, the studio opened in May 2001 in a new wing built specially to house it, as a permanent annex to the HLG, which has undertaken the Herculean task of cataloging and reconstructing Bacon's famously chaotic workplace. A team of archaeologists and art historians sifted through the mass of material, ephemera, and rubbish contained in the studio at the time of the artist's death in 1992. The outcome of this "dig" is a vast, computerized database of over seven thousand records, which viewers can peruse in an interactive gallery. But while this painstaking effort of preservation and reconstruction has yielded spectacular results, its underlying assumptions and motivations appear to have gone unexamined.

Within the history of modern art in Britain and Ireland, Bacon has an iconic status analogous to Jackson Pollock's in the United States. Although retaining figurative representation, he transformed it through an emphasis on the expressive gesture, and the absorption and synthesis of a wide range of visual source material. Bacon used the piles of photographs and newspaper clippings scattered throughout his studio as an ever-evolving image bank. Perilously cluttered, 7 Reece Mews seemed to bear the visual traces of his impulsive working process. (Comments by the artist, such as "chaos for me breeds images," further support this assumption.) The small, dark building also contained a tiny living area with the single bed where Bacon slept. Although collectors and museums were willing to pay extremely high prices for his paintings, he lived and worked in these cramped quarters for over thirty years. Throughout the literature on Bacon, photographs of the studio have

regularly been used to bracket discussions of his art. Through these photographs and written descriptions of the space, the studio itself has become Bacon's most recognizable image. A popular, recently published coffee-table book by photographer Perry Ogden, *7 Reece Mews: Francis Bacon's Studio*, provides another example of the long-standing obsession with the studio as a spectacle distinct from Bacon's art.

Preserved in a Plexiglas box in one room of the HLG's new wing, the studio is buffered by two information galleries. Viewers first encounter a continuously running video of Melvyn Bragg's interview with Bacon in his studio from the *South Bank Show*, shot in 1985. The exit gallery contains computer terminals giving visitors access to the database of the studio's contents. The gallery containing the studio itself is lined with vitrines, displaying a selection of significant objects extracted from the artist's workplace (most notably, Bacon's cast of the death mask of William Blake), as well as photographs of Bacon and his companions.

There are only three limited vantage points from which to see the interior of Bacon's workplace. First, a doorway opens onto the reconstructed atelier. The spectator, however, is given only enough room to step inside the threshold, as a Plexiglas box prevents further entry (a situation that also allows room for only one person to view the space at a time). The two adjacent windows located on the far end of the studio, which were kept blocked by Bacon with the back of his canvases in progress, are opened up to provide a second site from which to peer into the room. Perhaps the strangest treatment of the studio is the third avenue of visual access. When not standing in the doorway or at the window, visitors to the HLG installation are confronted mostly with blank, gray walls. In order to add another vantage point to see inside the studio space, the far corner of one of these solid walls has been pierced with two eyeholes. Two steel cylinders have been attached to the holes and protrude out from the otherwise blank exterior wall. Around twenty centimeters in length and ten in diameter each, these protrusions contain fish-eye lenses, which allow the viewer to see parts of the studio not visible from the door or through the windows. Bacon often used the walls and ceilings of the studio as his palette. The lenses are focused on sections of wall on which Bacon had tested out paints and colors, framing them as if they were paintings in their own right. (Here, the installation builds on an offhand comment by Bacon that these walls were his only "abstract" works.) Whether peeking in the windows, looking through the Plexiglas-encased vestibule, or peering through these eyeholes, the visual experience of Bacon's studio becomes like a solitary peepshow, a voyeuristic quest for the apprehension of some titillating detail.

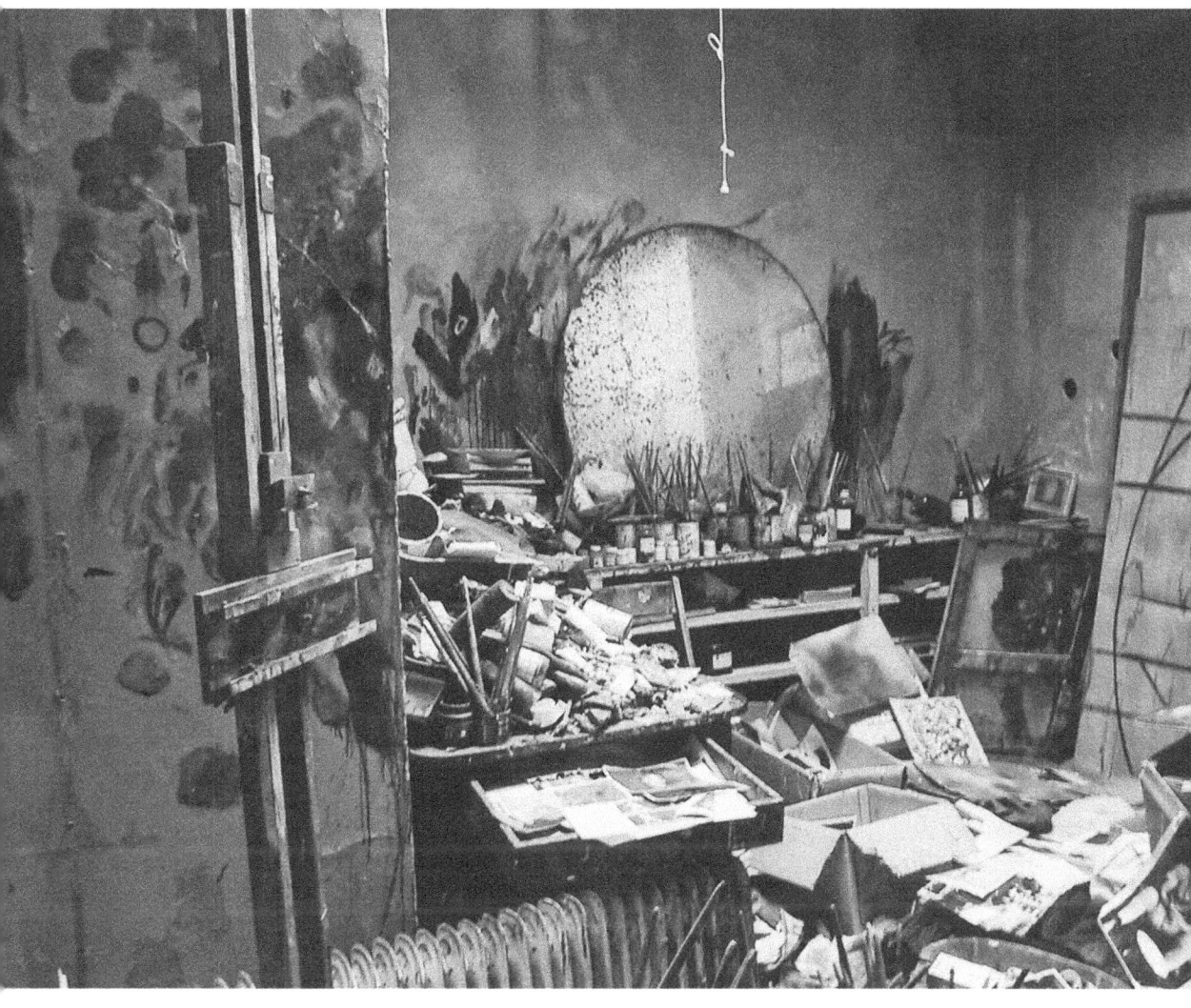

Reconstruction of the Francis Bacon studio, Hugh Lane Gallery, Dublin, 2001.

The limited and restricted vantage points guarantee that one cannot easily see another person looking into the studio, no matter how busy the gallery is. The installation keeps the viewer outside the studio but stages access to a fictitious interiority. Because the studio's main contents are tools and debris, the viewer searches for clues and personalia in and amongst the rubbish. Reading the headlines on discarded newspapers or looking at the photographs strewn across the floor, spectators can easily be fooled into thinking that they are gaining privileged access into Bacon's private space. The initial shock of the chaos of the studio fades, however, as one begins

to recognize how its contents have been subtly arranged. Too many of the photos and books are legible from the doorway, forming lines of sight emanating from the main vantage point inside the threshold. Despite its overwhelming mess and disarray, the space is a carefully orchestrated artifice—one designed to convince us that we are seeing into the inner workings of Bacon's workplace and, by extension, his creative process.

Bacon himself never allowed others to watch him paint, but he did allow people to visit the studio. It came to function, as in the *South Bank* interview, as a means of deflecting attention rather than inviting examination. The studio was less a window into Bacon's private self (as the HLG installation implies) than a shield behind which he could hide when others were present. The literal sedimentation of images and materials was, indeed, a fundamental part of his process, but the studio's spectacular disarray also functioned as a form of camouflage. Despite his undisguised homosexuality and dark subject matter, Bacon achieved a legendary status during his lifetime and was frequently considered one of Britain's greatest living painters. Just as much as his powerful works, his "mad genius" behavior fueled these legends. Bacon hid behind the mythology of the modern artist, and his workplace played a key role in aligning his public persona with that stereotype. Consequently, it was perceived by many as a transparent reflection of the inner workings of the mind that could produce such disturbing paintings—concrete proof of Bacon's "disturbed" eccentricity. Stories of Bacon's dealers wading through the mess to find slashed canvases and recover buried paintings help to confirm the image of Bacon as the contemporary heir to the popular myth of the artist as mad, creative genius. Unfortunately, it is this stereotype, rather than Bacon or his work, that the Hugh Lane Gallery ultimately capitalizes on and enshrines.

The HLG project does little to illuminate the technical, conceptual, and visual sophistication of Bacon's art, nor does it critically engage with the construction of Bacon's artistic persona (by himself and others) through the studio. For all the assiduous reconstruction of the space, the studio is presented less as a workspace than as a social space. Photographs of Bacon's friends and companions (many taken in the studio) have been installed in the display cases, yet there is little attempt in the installation to discuss how Bacon actually used his studio and what it allowed him to do in painting. The focus is largely on Bacon the individual rather than on Bacon the painter. Fittingly, there is no art inside the studio. Unlike other reconstructions, such as the Atelier Brancusi in Paris, the Bacon studio has had its art extracted. An important group of over seventy drawings (Bacon repeatedly and famously denied that he created drawings for his paintings) have been transferred to the HLG collections. Some of the canvases, which remained incomplete

upon Bacon's death, have been installed in a separate gallery in the studio wing, presented like finished works. Preserved as it is in its Plexiglas shell, the Bacon studio resembles an empty stage set, or an old-style natural history museum display. As such, it lacks only its taxidermied protagonist.

Undoubtedly, the cataloging of the disparate contents of the studio and the archaeological and photographic recording of their placement will be of use to Bacon scholars seeking to uncover his employment of visual sources, new techniques, and materials. This computerized visual catalog is the real benefit of the HLG's efforts. It is marked, however, by the same problem as the physical reconstruction of the studio space: the problem of attempting to freeze one final moment in the history of an ever-changing environment. During his life, Bacon's studio could change dramatically and traumatically from hour to hour. The database, much like the installation and the many photographs taken of the studio before it was moved to Dublin from London, can only provide episodic glimpses. Lost is the experience of the constantly shifting mass of materials and images that made the studio so useful to Bacon. Nevertheless, the database provides significant insight into the depth and range of sources at the studio's last incarnation. Beyond this valid justification for the enormous expense of the project, the reason for preserving Bacon's studio in a museum is singular: to capitalize on the mythology of the modern artist by providing visually stunning but ultimately voyeuristic and somewhat exploitative entertainment. The Hugh Lane Gallery may well have gained a successful tourist attraction, but it has lost out on the chance to make a useful critical contribution to the understanding of Bacon—or of modern art.

From Documents *22 (Fall 2002): 65–69.*

Art & Language
Art & Language Paints a Picture

Direction:

Art & Language paints a picture in a studio at 3 Wesley Place, Chacombe. Chacombe is a village on the border of Oxfordshire and Northamptonshire, England. The studio is small (approximately 6 × 3.55 meters) with a single window facing south. It has a small washbasin in one corner. There is an impromptu table near the door. A roll of paper rests across the entire width of the room. It rests on an internal tube which is fixed to the top of the skirting board on either side. There are drums of acrylic emulsion standing among the junk underneath the table, and packets of pigment are piled in a small recess cupboard. Two artists, (1) and (2), are unwrapping a brown paper parcel containing white cotton-duck canvas. A large pencil drawing is pinned to one long wall; a smaller halftone sketch is pinned to the other. The pencil drawing is divided into 6-centimeter squares with green ink.

(1) "A fresh canvas. What it is to start the day with a fresh canvas of almost the best quality."

(2) I want to say, but it is by no means going far enough... I want to enjoin, "Do paintings addressed to the expression of emotion and do it reconstructably—in the pattern of causality." This might be the route to nothing. You might say the paradigmatic route.

(1) What would a Studio said to express, e.g., anger be like? And how would this question be affected by our "presence" or "absence" as figures in the picture?

(2) If we were excluded, how? That we are in the dark does not mean we are not there. There are other questions of lighting, of representational order and so forth.

(1) The possibility of spiritual penitence doesn't seem to be a possibility of expression. Is this why we want to make expression claims? We can only hang our heads in silence by not seeming to do that at all.

(2) The Studio genre is hardly penitent. It goes to platitudes of autonomy.

(1) We make a hiatus of these.

(2) "But it is our hiatus."

(1) Does that mean it was made for us?

(2) We talk of penitence or perhaps of revenge. We used to speak of "subversion." Revenge implies upholding the cause but also exacting retribution. It's hot and nasty—you can have a career in superstructural subversion. We are taking the work out of that virtuoso debate and into ... what?

We adopt various personae. We are artists acting "artist." The works, paintings we produce, are like masks which are invitations to look behind them, where meaning and signification is perpetually fugitive. If you talk of fugitive significance ...

(1) Eh?

(2) ... you could perhaps talk of a kind of criminality. A criminal goes in for various kinds of fugitive activities—robs, murders, embezzles, etc. A criminal doesn't usually make a display of his criminal activities. Unless you go in for a kind of fashionable terrorism, which is a kind of revenge, I suppose, flaunting criminality rather than concealing it.

Direction:

(1) and (2) unfold the canvas and attach one short edge to the paper roll with white tape. They then roll the canvas around the tube until what remains unrolled lays flat and covers most of the floor.

(1) "The freshness of fresh cotton duck."

(2) "Such prospects of our own incompetence."

(1) To keep one's "head hung" is the problem.

(2) What is "hanging one's head" in what Christian Schlatter calls "occidental culture"?

(1) It can hardly amount to "being depressed."

(2) It might be "seeming depressed."

(1) Is it perhaps making your work in a circumstance of some more or less adequate "genetic'" knowledge? And to make nothing, nothing "aesthetic" of this?

(2) This seems just like "refusing."

(1) What I'm trying to grope for is the idea that our work is made of antecedent aesthetic materials and other genetic conditions. It presents these materials, these genres, these finesses, these symbols "without resolution" in a rather special way: as hiatus. This is a penitence in *our* emotivist aesthetic culture. You cannot be penitent *sub specie aeterni*.

(2) So there is some sort of contingency.

(1) The work must be open to investigation. Reconstructable, adequately retrodictable. And this goes to a morality of moral strenuousness.

Direction:

(1) and (2) tack strips of wood to the long edges of the canvas with the aid of a hardboard straight edge. The hardboard is then used as a square and strips are tacked across the canvas so as to form a rectangle approximately 3.5×4 meters.

(2) "Perfection: the absorbent surface. I can hardly contain my desire, my need, to mark it."

(1) The world of modern art has become a world of hysterical malingering.

(2) We are producers of representations, not only in the sense that we are involved genetically, with retrodiction to various cultural conditions, but we also seem to be involved paranoiacally.

(1) Demolition of the emotivist instrumentalities of the manager's culture entails systematic demolition of the agent of demolition.

(2) Our culture is not so much a ruin as a few trivial remnants.

(1) Our high culture, however, is a fraud.

(2) But it is mostly out of this, out of art, Kant, and emotivism that we make our work.

(1) There's more to it than that.

(2) That's not important: its decadent fraudulence is not much in doubt. What is required of us is that our desire to reproduce (in whatever apparently emergent form) the form of life which gives us our materials…

(1) First-order materials…

(2) … be matched by our desire to refrain and hang our heads in shame. These conditions of culture are not coercive.

(1) We need a critique of the Baudelairian flâneur.

Direction:

(1) and (2) begin to coat the canvas with a buff-colored acrylic emulsion using a roller. The paint is in a shallow grill pan.

(2) "The canvas will now have a skin. We are committed now to 'painting,' rather than to drawing: committed to being anally expulsive."

(3) Modern art is hysterical. Yet there are no masks. Only managerial instrumentalities. We sit among the products of an almost entirely transparent hysteria. Transparent, yet powerful enough to be instrumental, to produce and sustain "aesthetics" and art.

(1) It may be that our concern with undisclosed causal conditions (and undisclosed causal assumptions), our concern with (hysterical etc.) closures, goes to a sort of imprisonment. What we may need to know is not how to find better explanations but how to get out of (by requiring, making a necessity of) the "language" of causes altogether. How to get ourselves and others to make do with nothing (or less) built upon an obsession with genealogy. By this I am suggesting that to have nothing is better than to have cheek pouches. I mean that a nothing necessitated by adequate genealogical inquiry is a sort of penitent liberty. Liberation from "the pale Königsbergian light" may seem to be its extinction.

(2) But its extinction *materially* implying its use?

(1) Perhaps it is true that liberation from the *misuse* of Kant's illuminations is tantamount to their extinction. It is our emotivist culture and our Weberian sociology that has "liberated" us from Kant. But that liberation has been an inadmissible enslavement to aesthetics—to unreflective management—wearing clean Kantian clothes. The main aesthetic categories are the vestiges of a dead language whose meanings have been transformed into instrumentalities.

Direction:

(1) and (2) now draw the nails and remove the strips of wood. The paint dries. Fresh canvas is pulled from the large roll as the painted stuff is rolled onto a

smaller paper tube. The canvas now has the appearance of a scroll. The fresh canvas is tacked down and painted with primer.

(1) "Another ocean of beauty."

(2) But when it's painted it looks more expensive. Our last two paintings are a conscious production of the appearance of sickness. They are not mistakes. They are in the margin of lies. They are that margin of lies which goes to half-realized acts of spiritual penitence, to images (or self-images) of silence and head hanging.

(1) The "Studio" series began in one world and it will end, if it ends, in another. Indeed, it is already in another.

(2) Isn't it rather that it began at *the margins* of one world and it is now at the margins of another? The series began in a world discursively connected with contemporary art (or with various identifiable models of contemporary art).

(1) Out of this world we selected symbols. These numbered among our explicit materials.

(2) The discursive connection was mediated by a sense of grotesque fraudulence, of genealogical absurdity.

(1) We are now in a world dislocated from this. Yet we must presuppose, continue to make a necessary condition of, our genealogical critique, which goes in part to contemporary art.

(2) And then make nothing of what emerges.

(1) Recognize that what emerges will be next to nothing. The "new" world is pretty frail.

(2) "My talent is waiting to explode on the canvas."

(1) The managerial barbarism of contemporary aesthetic discourse is no indication that things will always be like this.

(2) No. But a possible future aesthetics will not necessarily be not to get nothing out of the exposure of the rottenness of the previous position. This is possible even if that exposure is intrinsic to the later one.

(1) Our "discursive" connection with contemporary art, *soi disant*, in its various worlds and manifestations frequently acted to limit our didactic aims.

(2) Misrepresented them.

(1) And worse. Independently perhaps of this discursive relation, we were tending to imagine some emergence, some constructive significance in the generation of "second-order discourses," causal critique, and so forth. And this notwithstanding a dressing of "hiatus" and "hiatus for us."

(2) We haven't examined the significance of or the mechanism of our hiatus very fully. The possibility that we do "mean" that which has had its meaning canceled by us, that which is genetically dependent upon a second-order (or nth-order) demolition of the mechanism of its meaning, is a very delicate thing indeed.

(1) However, we must not be satisfied with an emotivist *aesthetic* of hiatus.

(2) "The scherzos, the veritable fugues on themes of resurrection in our last two paintings, are undeniable."

(1) "Could it be argued that their failure to signify is redeemed by their hapticity?"

(2) We do *want* to be popular with the bourgeoisie, don't we? A kiss is a kiss. The sensitive are sensitive. But reflect on a kiss that has been identified antecedently as a contraction of herpes.

(1) A Studio in the dark seems to deny the possibility of detail. And this is the possibility of vividness perhaps.

(2) This lack of vividness in respect of first-order representational detail will have to be recouped in some way.

(1) In some other index of detail.

(2) We are not painting by mouth.

(1) And we are not claiming that this painting is painted by mouth.

(2) We are not denying it though.

(1) Its graphical form or, rather, our basic chart or drawing is produced by mouth.

(2) When we were painting *Index ... I* and *II* we pondered the question "What are the consequences of an asserted 'painted by mouth' claim's not being in fact true?"

(1) The falsehood of such a claim goes to a gentlemanly (or arty) distance from hiatus. The claim would be the claim of genealogical puppeteers.

(2) We would have made masks never to wear them.

(1) There are some Dali paintings that show visages in clouds. There are other paintings of clouds without physiognomies. People "saw" faces in them.

(2) Of *Index: The Studio at 3 Wesley Place III (in the Dark)* we make no "painted by mouth" claim. There is the possibility that some onlooker will suffer the Dali effect, viz, "reading" the painting as painted by mouth.

(1) And that would be projecting the (slight or large) hiatus experienced in respect of those Studio pictures of which painted by mouth is a significant retrodiction.

(2) "Reading-in" and "seeing-in": are these real hermeneutical mistakes? Is "reading-in" or "seeing-in," in the sense of "projection onto" or "transference," the "not yet" of a hermeneutical "no longer" or the "no longer" of a hermeneutical "not yet"?

Direction:

The priming continues.

(1) This will be a tedious week.

(2) "Yet having primed this canvas we have signaled our intention to engage with material."

(1) "With a material tradition."

(2) "Though less materialist than sculpture."

(Child) "Hello, Fatty and Skinny."

Direction:

The priming is complete. The last section to be pinned (the left-hand quarter of the painting) is divided into 10-centimeter squares in pencil. The line-drawing (by mouth) is taken from the wall and two strips, corresponding to the left-hand quarter of the painting, are cut off.

(2) Some of our "materials" are to be found in the possible world (or worlds) or fragments or remainders hiding in or between the relations of hiatus. This world (etc.) is very likely to be, among other things, a world of foolishness and moral disquiet.

(1) A very nothing-like possible world.

(2) It may be indeed that our aims (even our quotidian aesthetic in some guise) goes to what to do "in" the nothing left behind by hiatus. The motes hovering above the gap.

(1) And the gap is made of real possibilities. The conditions of hiatus are, in some sense, demonstrable.

(Clement Greenberg's voice off) Braque's tack suggests deep space in a token way and destroys the surface in a token way.

(1) If we "add" this possibility of hiatus to the other possibilities, we get a different sense of hiatus. A different cardinality. But a cardinality which does not reflect the ordinality of "one more hiatus."

(2) Imagine *Index: The Studio at 3 Wesley Place IV (Illuminated by an Exploding Car)*.

(1) "I wish we did drawings the same size as the painting. A cartoon is a German professor's map."

(2) "I wonder what James Lee Byars is doing now. I wonder what Cindy Sherman, Jörg Immendorf, Terry Atkinson, Mrs. Braggins, and the Green Party are doing now."

(1) "Tim Clark is constantly on the lookout for people wondering what other people are doing."

(2) Someone might say that we have "lost" the art world because today's fatuities are worse than yesterday's. But that isn't the reason. Neither do I think the real reason is that "contemporary art" suddenly overburdened us with anger and humiliation.

(1) Or by using various masks or simulacra we generate hiatus. In spite of second-order (etc.) discourse, tiny shards of "real" anger, real expression seemed to remain. Catless grins?

(2) Are you sure "in spite of" is correct? You could say that these "fragments" exist in virtue of second-order-ish critique, that they are a philosophically possible population only after such a critique is accomplished.

(1) Perhaps these shards are left behind by the masks and not by the hiatus.

(2) The masks are connected to hiatus by necessity.

(1) I do not think that these next-to-nothings emerged as a consequence of the necessity that our causal critique remains incomplete. The fact that our

investigation of the mechanism of closure—of misrepresentation—merely serves to dramatize the power of the aesthetic management is no indication that that investigation is indecisive.

(2) At the same time, I think that the next-to-nothings emerge from a redoubling of the sense of hiatus. This redoubling is born of an inkling that the ground of "our" second-order (etc.) discourse is vain.

(1) "Penitence" is a very technical term.

Direction:

(1) and (2) transcribe the drawing by mouth onto the canvas in pencil. One of them works faster than the other. So as to have some work to do, he/she keeps cutting strips off the section being transcribed by his/her colleague.

(1) "A blunt pencil is truly alienated. A short one is not."

(2) "What's it like to have the sureness of touch of a Picasso in his sexual prime?"

(1) "What's it like to have the intensity of several Goyas?"

(2) A critique of causal-type analysis or, rather, a sense of its vanity does not, however, lead us to blather about sensitive alternatives to the modern world. These alternatives are the fullest dramatizations and the dullest reflections of emotivism.

(1) Operatic brutalism is one of the most powerful instruments of this managerial co-option of aesthetics.

(2) The confusion of taste with mechanism—or rather the inflation of taste to the status of mechanism—is symptomatic of emotivism.

(1) The shards remain possible as products of this mess.

Direction:

The transcription is complete. (1) and (2) are now looking at the right-hand quarter of the canvas.

(1) "We should roll back. It is methodologically important, even a transcendental necessity, even a Reich des Sollens to start in the top left-hand corner."

Direction:

They roll back in a manner reconstructable from the descriptions above. Paint is mixed; dry powder is mixed in a food processor with acrylic emulsion. The pigments are lamp black, heavy French black, mars black, graphite powder, oriental blue, oriental green, mars violet. There are other colors in tubes. The food processor explodes. They continue to mix the paint by hand. (1) decants some paint into baby-food jars (lamp black, mars black, and a graphite–lamp black mixture). He starts painting at the far top left. (2) takes the larger container and starts to work on his right. There is a reproduction of a Goya on the wall. The halftone drawing has been taken down and lies propped up in front and between the two artists.

(1) We make causal, genetic-type enquiries. We also try to make necessities of these. But these enquiries are not some kind of "no longer."

(2) The "formula" is made too little of by Nietzsche's literary interpreters. It is just a consumer's insight that art resides somewhere between the "rationalistic" "no longer" and the (what?) "irrationalistic" "not yet." The contents of a "not yet" will always include a maximally closed form of a "no longer," and the contents of a "no longer" will always be, in part, a "not yet."

(1) Indeed, it could be argued that a "no longer" is always a "not yet" from some point of view.

(2) But that isn't interesting. What is interesting is the idea that they are functionally connected, isomorphous. More interesting than that is the idea that they are genetically and logically interdependent.

(1) Anger in the mask of "rationality"; "rationality" in the mask of anger ...

(2) Marxism's failure to include itself in its "no longer" is one of the conditions of its emptiness.

(1) We are not prepared to consider a work of art as independent "of the character of its creator." And in this sense we are not prepared to consider the aesthetic as independent of the moral.

(2) To this extent we are little different from the shrill disimbricators of power-sex ideology and other polytechnic-lecturer's themes.

(1) Where we differ is the mechanism of our penitence.

(2) They are "not yetting" with their "no longer," and yet misrepresenting this as "no longer" tout court.

(1) They assume a *managerial* mode.

(3) I've written a bit more lecture. Can you stand to hear it?

(1), (2), (3) … The expressive range of Pollock's art rests on very limited resources. In that sense it is both classical and pessimistic. As painting goes it is also very easy to reconstruct technically. The substantial lesson of Pollock's art lies not in its "optical qualities," its "reduction of pictorial depth," its "freeing of line from the functions of description and definition," its invocation of the "cosmos of hope," or in any of the other available forms of valediction. It lies rather in the requirement of assiduousness: in the demand that one recognize how little is left to work with. …

(1) We can make only the minimum assumption that we will succeed in reproducing this drawing.

(2) Let's hope it is a minimum. Enlarged as a painting, this thing goes to the canons of clever and *slightly* paradoxical *modernist* painting.

(1) The sort of stuff that only operates if you accept the *theoretical* strictures on its production. Bureaucratic modernism with iterated complexity … one idea and a lot of intracanonical variations.

(2) "By contrast, I view the section of the painting upon which I'm working as uncoerced, as a paysage of passion."

(1) Unfortunately, I've just made an incompetent Augustus John.

(3) Can you stand a bit more?

(1), (2), (3) … The point I wish to make is that all those whose work I have been discussing can be seen as attempting to cope—albeit in different ways—with the consequences and implications of Abstract Expressionism. They were determined by nothing so much as its *negative* implications, by the closing off of possibilities and by the difficulty of confronting that requirement of assiduousness for which Pollock's work stands as an example. The line of development through the 1950s and 1960s is branching and incoherent, and there are a plethora of dead ends and little failures. There are no clear lines of succession. For example, Johns does not initiate Minimal Art. Rather Johns, Stella, Judd, and Morris each articulate in different ways—often unconsciously—an intuition of the historical and cultural conditions which determined the production of art from the mid-1950s until the 1970s. An identifying characteristic of these conditions was that claims for psychological or metaphysical content in art seemed not to be sustainable without bathos. …

Direction:

(1) and (2) continue. They complete an apparent stage in the representation of *Burial at Ornans, Donnez Votre Travail,* etc. About one-quarter of the painting has been covered in lamp black, graphite black and oriental blue.

(2) "The blue is hideous but necessary. We have to be able to navigate."

(1) "It's vital we avoid volunteering. We must be committed to the possibility that we make decisions and not to the illusion that our smoldering talent will out."

(2) I think this depends on our working in describable stages. We are left to do what we can almost not bear. We can't stop and make emotivistic choices. It is these we must avoid systematically.

(1) We are bound to make them anyway.

(2) It seems partly to be a problem of keeping the sense of the describability of a given stage or process.

(1) It is no doubt true that the concepts of aesthetics may be understood as a ragbag of fragmented survivals from an older past than our own. This can be a dangerous insight, a chance for those deepest entrenched in emotivist culture to (mis)represent themselves as having transcended it. The identification of deep-laid "residues" and so forth in certain favored art works is no more than the echo of the critic's own (emotivist) voice.

Direction:

(1) and (2) survey what they have done.

(1) This is so demoralizing, so incompetent.

(2) This is a bad case of Robespierre.

(1) Worse. This is materially incompetent, witless, and humiliating.

(2) What is it like? Is it worse than *Lenin at the Rostrum*?

(1) Worse.

(2) "Courage is not required."

(1) It's got to come off. This is a month's work. "What crystalline rigor!"

Direction:

Starting from the top left-hand corner, (1) and (2) spread Nitromors, an ethylene chloride–based paint stripper, on the painting. They scrape it off, exposing bare canvas.

(1) An erased, incompetent Augustus John. Somehow it doesn't have the frisson of *Erased de Kooning*.

Direction:

(1) and (2) redraw large areas of this section of the painting. The paint is mixed to a watery consistency and the image is filled in in the manner of "painting by numbers." The lightest areas are painted oriental blue. This color is applied casually so as to overlap contiguous gray and black areas. The black so covered looks cooler and darker as a consequence; the grays approach black.

(1) The paradigm is *Guernica*.

(2) It was necessary to generate some arbitrary pattern. Otherwise we will return to floundering with the "geometric" boundaries of things. The sense in which the thing is modern must not depend entirely on the obscurity of things. It must "mention" modernity not solely in virtue of a kind of optical exhaustion in shadow. This must remain a possibility though.

(1) "I think the fundamental sense in which my enjoyment of the breast is to be matched in my enjoyment of the painting, creating the painting, will depend on this."

Direction:

(1) and (2) scrape and strip a section for a second time.

(1) "It is outrageous that I've had to scrape off the 'witches-sabbath-of-dooms-day-aspect' to replace it with the paltriness of consistency. Removing the traces of my passion."

(1), (2), (3) What grounds contemporary aesthetics is catastrophically empty. Our emotivist culture is the final occidental act. It is the ground of a groundless aesthetics. The aesthete's grounds are instrumental and managerial. The power of the aesthetic manager hides his emptiness. Misrepresentation of the mechanism of his aesthetics imposes necessity on that mechanism; the mechanism makes necessity of the misrepresentation.

Those who long for a nondecadent aesthetics, a nondecadent art, do their longing in images of their arbitrary power. The longings are themselves decadent. This gives us something to do. But we are bound to use these resources as their products and to make *nothing* of them. Those resources of which we do not, perhaps, make nothing are little better than nothing themselves. There is no angst in this remark. Only a sense of necessity and scarcity.

Appendix

The following items are depicted in *Index: the Studio at 3 Wesley Place III (In the Dark)* in monochrome. They are some of our most lamentable failures. They have been suppressed or hidden from the public domain. They are sources of embarrassment.

From top left to bottom right:

Portrait of V. I. Lenin at the Rostrum in the Style of Jackson Pollock, 1979
Born in Flames II, 1978
East Window of All Saint's Church, Middleton Cheney, 1979
It's Still Privileged Art, 1976, poster by Carol Condé and Karl Beveridge
A Miner Drilling the Hole for Shotfiring in the Style of Jackson Pollock, 1980
Our Progress Lies in Hard Work, 1978
Riot at Night, Painted by Mouth, 1981
Index 04, 1973, microfilm reader
Ten Postcards, 1977
Singing Man II, 1975
Commemorative Portrait of Robespierre, 1980
Oak Tree near Middleton Cheney, 1978
Puzzle, 1977
Nobody, 1977
Ways of Seeing?, 1978
Monument Commemorating Pavel Pestel and Other Heroes, 1980
Poster, 1976, by Michael Corris and Andrew Menard
Pure Painting (Closed to Open Forms), 1965, painting by J. Kosuth

..

From Art & Language. *Exhibition catalog (Ikon Gallery, Birmingham, May 1983), 54–59.*

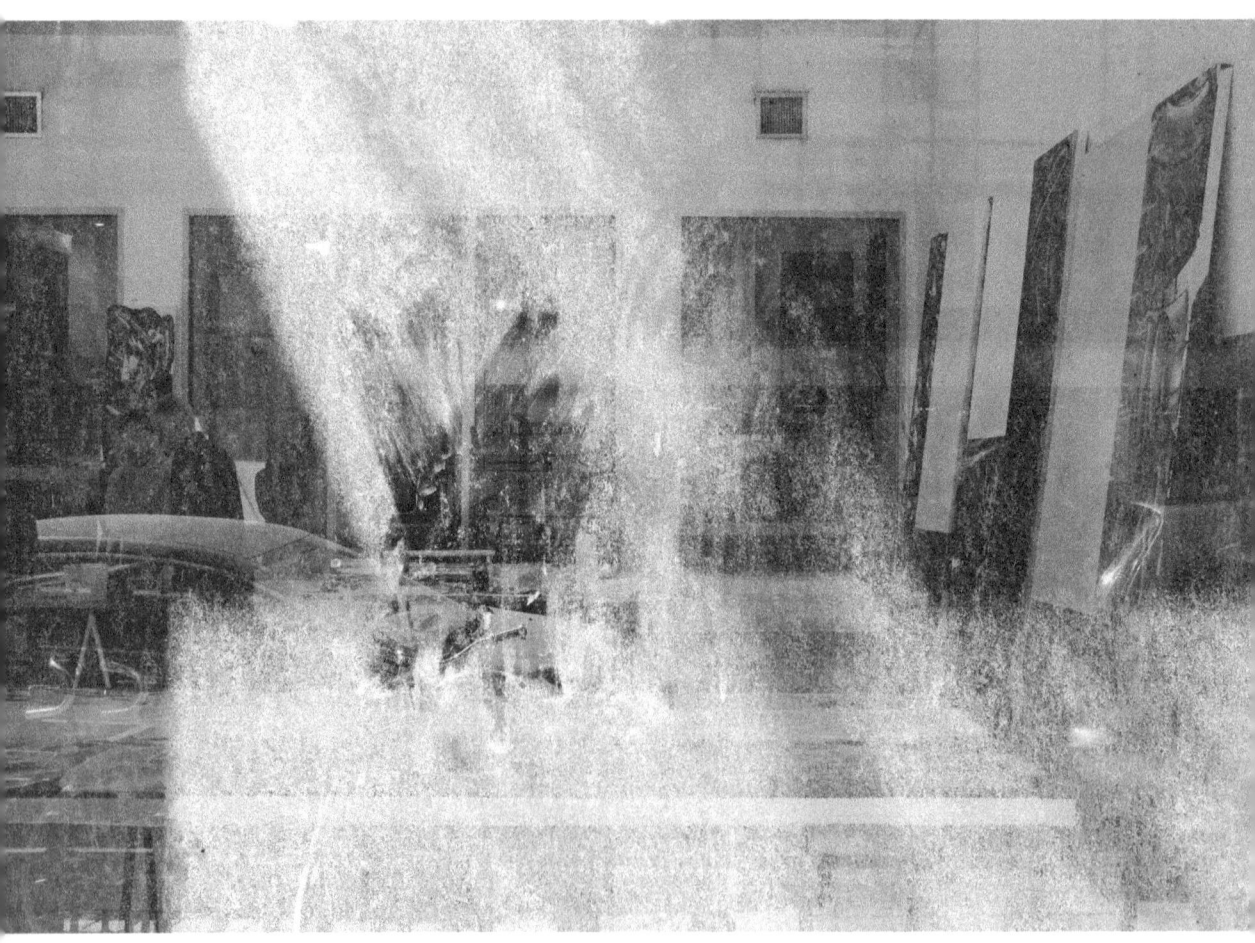

David Reed studio, external view, 2009.

David Reed

I first saw the work of Felix Gonzalez-Torres in a group show at Artists Space in 1987 in New York. Impressed by his work, I asked to visit his studio. Felix hung his head and said, "Oh, David. I'm sorry. I don't have a studio. I'm just a kitchen-table artist." I loved his phrase, but since I had a mistaken concept of what a studio could be, I didn't ask to visit. Now, of course, I wish I had. We could have had a studio visit sitting at his kitchen table. John Baldessari called his legendary class at CalArts "Post-Studio Art." I think there can be meaningful post–post-studio art, but I don't want to go back to the misguided idea of the studio that I had when I spoke with Felix.

I've heard artists on panels say that they like painting because in the studio they feel free. I sometimes share this feeling, but I've learned to distrust it. I've found that while painting, I'm in a conflicted emotional and perceptual state. On one hand, I want to be in the painting, right there inside of what I'm doing. But on the other hand, I want to be aware of the whole of the painting, and this requires me to be outside looking in. I find the experience of this split consciousness to be painful. At first I tried to paint as quickly as possible to avoid it. Now I've learned to try to sustain the experience, to grit my teeth and live with it. Perhaps the studio I want is a place in which one can have a similar experience of being both inside and outside at the same time—a studio without walls. Can I make this kind of a place for myself?

When I think realistically about my life, I realize that the problem is not that I need a studio that is a special place, even one conceptualized in a new way. What I really need is more time, say, an extra six hours each day. Then I could paint as well as have a life. Perhaps I could give myself just three hours each day and call that gift to myself a studio. But I would still feel selfish and self-centered and be back again to that old studio problem: How can I justify making art that I hope is connected to the world if it requires a strategic, temporary disconnection from the world? I could argue that what I need is not really a disconnection; it might seem to be a disconnection but it's really a way to

connect to the world. But that's not really honest, or at least it doesn't remove my guilt. I could argue that the world, for some reason, hates art. But what is the use of disagreeing with the world? A friend, Guy Goodwin, says that while working in the studio he feels both completely alone and in the company of others. Perhaps for those three hours each day, while I paint, I can pretend that I am talking with Felix across his kitchen table.

Thomas Lawson

I have a straightforward relationship with my studio; it is the place where I make my work. I have two skylit rooms, the larger and brighter of which is where I work on the paintings. This room is minimally furnished, with a worktable, a rolling cart for paint and brushes, and a couple of chairs. At any given time there will be one or two works in progress, and a number of recently finished pieces stacked against the walls. This is a resolutely practical space. When I am there I am either sitting down, looking closely at a surface, considering a next move, or I am standing in front of the work, making that move. On occasion I invite someone over to take a look at what I've done. The other room is more intimate; if the larger space is dedicated to the act, this is a space of memory and consideration, the central nervous system mapping and guiding decisions over a span of thirty-plus years. This archive is dynamic—information is added and rearranged all the time. Older ideas resurface to enrich new ones, which grow in the shelter of experience.

These rooms are in a building on a busy thoroughfare in a complex and thriving city. Art is made of the noise and distraction of the street, the passing signs, multiple voices, the endless cacophony of the city. But it can only be brought to fruition at some remove from all that, and my workspace is in the back of the building, withdrawn from the hurly-burly. Back there I reflect, make notes, begin to order my thoughts, and in time bring things into shape, give them form and color.

I stress the everyday quality of this space because the idea of the studio is too easily inflated past recognition. Gustave Courbet painted a version of this mythic space, a grand theater for the display of his talent, his model, and his fans and collectors; that the model stands naked while all the rest wear coats and hats only underscores the cruelty of the fantasy. But why shouldn't artists celebrate their hard-won successes? Thus, the gaudy trophies of financial success, the castles and palaces collected and built by artists as various as Frederic Church and Pablo Picasso, find an ascetic counterweight in the strict modesties of Mondrian's room or Pollock's shack. The great stand-off between

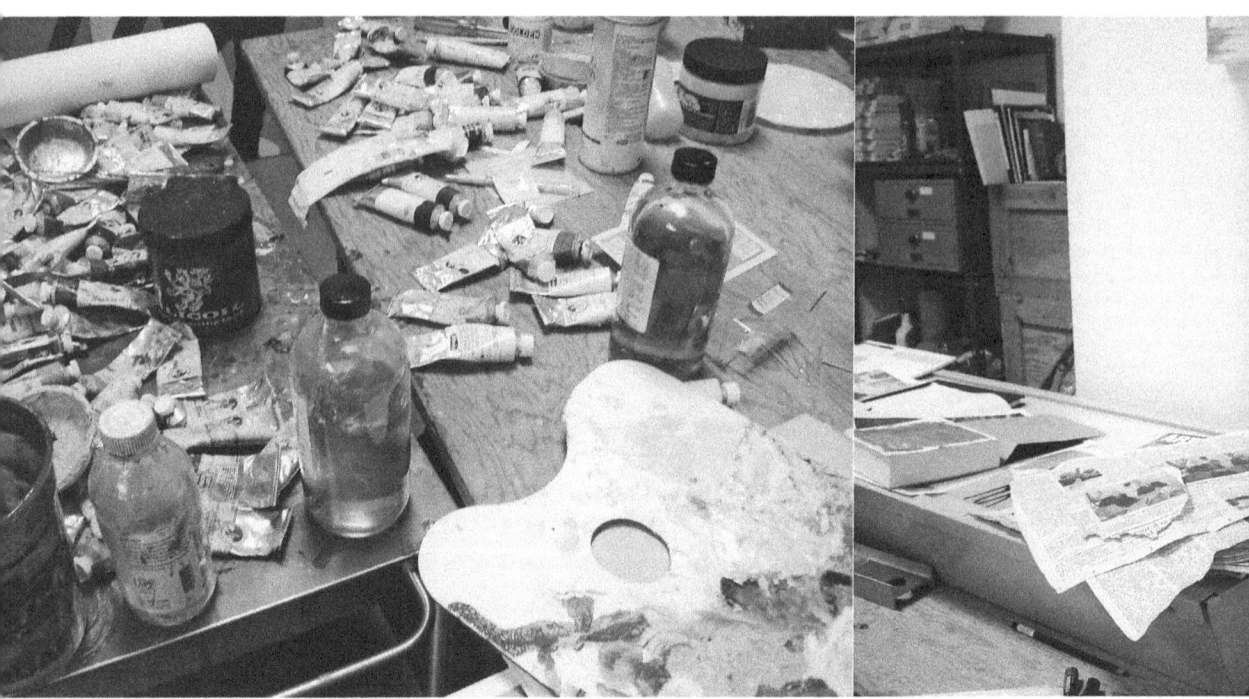

Thomas Lawson studio, 2009.

ostentation and authenticity blinds an avid public eager to visit (through on-site restoration, re-creation within a museum, or the vicarious snooping made possible by real estate websites and blogs), to the daily reality that artists find in the spaces they feel most comfortable in—and need to produce art. In some cases, the appearance of such places, the elements of design consciously brought forth, may throw some light on what they make, but for most artists the best studio is neutral and practical, no more and no less than a place to get away and work.

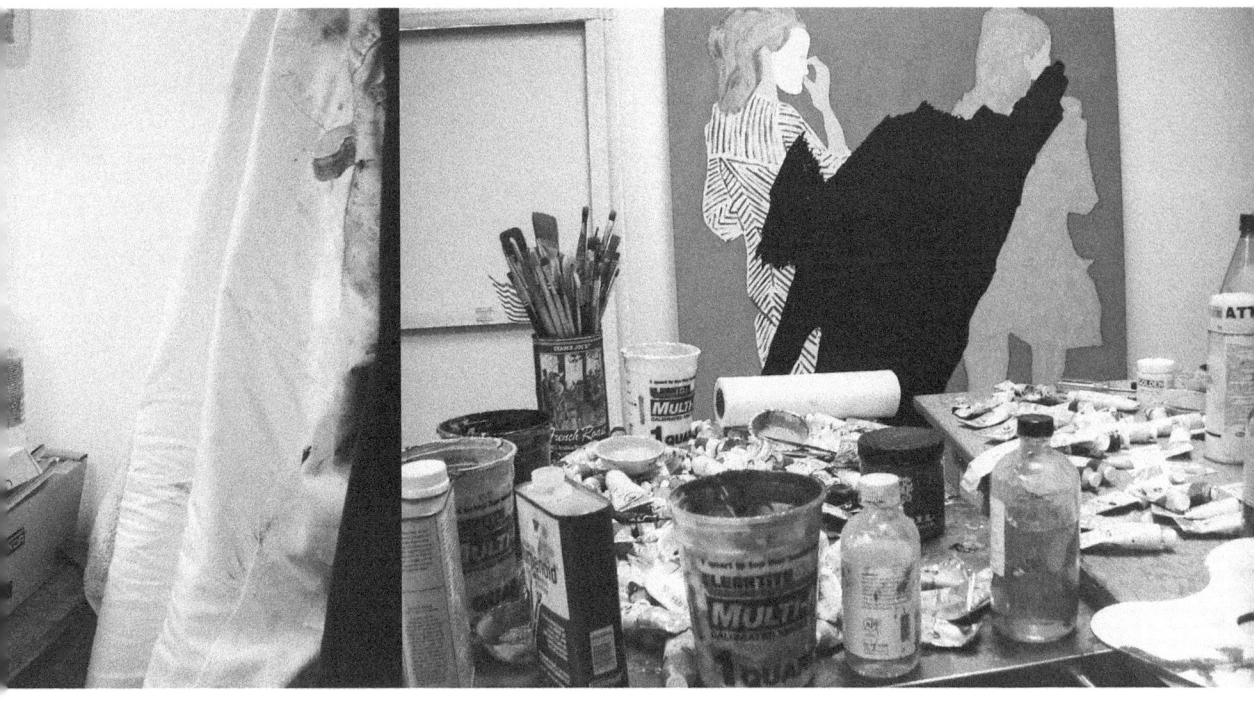

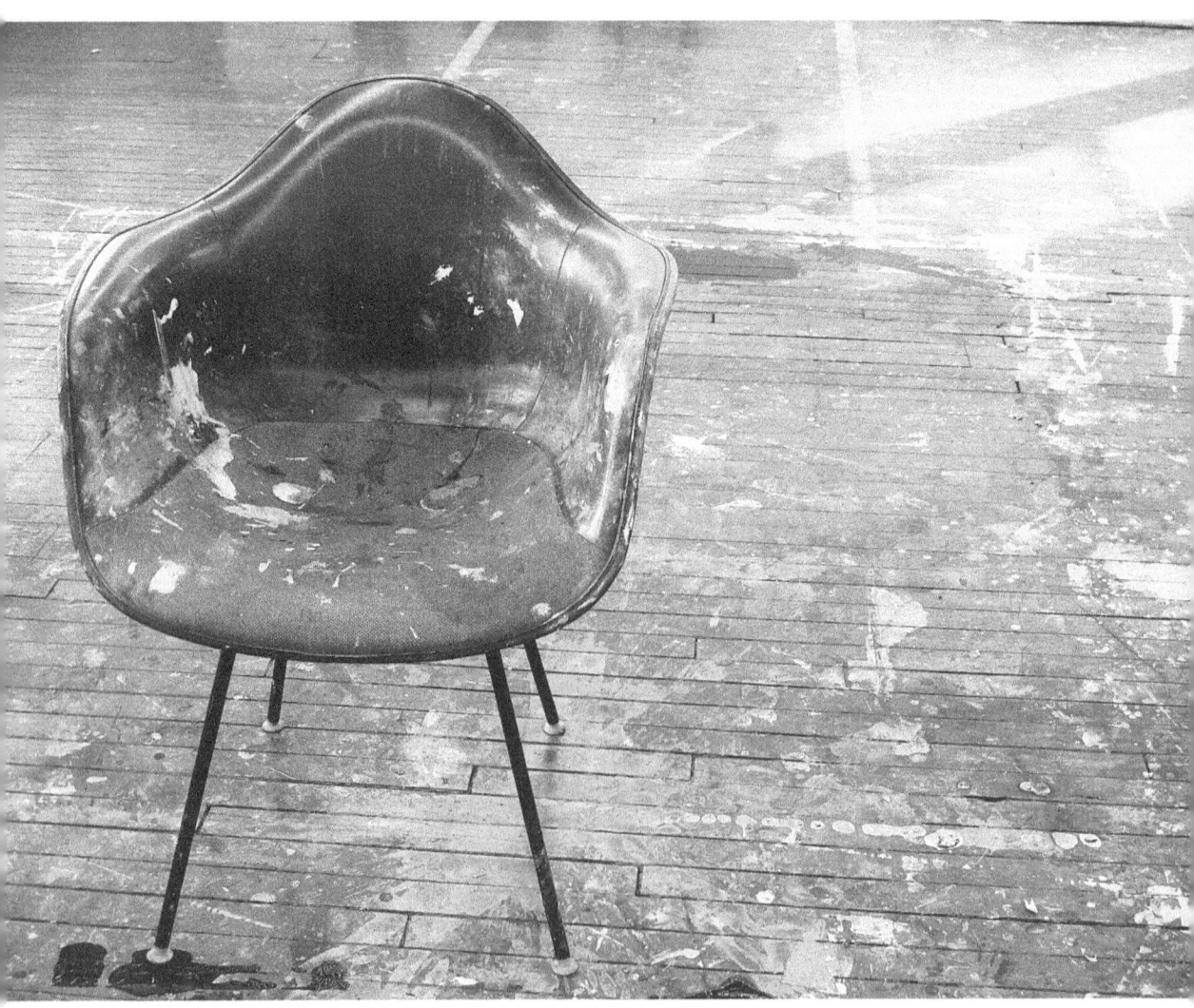
Charline von Heyl studio, 2009.

Charline von Heyl

The idea of the "studio" is as much a fantasy as the idea of the "artist" is a fantasy.
Both cease to exist when the work begins.
If there is work, there is no studio, there is no artist.

The stage of the studio is necessary, though, to enjoy the tortures of procrastination,
for the enactment of the melodrama of solitude,
for the playing out of visual monologues.

It is an anachronistic luxury to have studio-time and studio-space for the celebration of perpetual creative crisis,
for the charging and discharging of moods, and for the invention of feelings.
Being aware of this probably accounts for always feeling slightly guilty while in there as well.

The studio is the claustrophobic vault of the self-feeding vampire.
It is the stew-dio … an alchemic laboratory for inspiration, stagnation, confrontation, resignation, procrastination, contamination, inflation, reflection, intoxication, regression, invention.

The "studio," with its excess of presence, invents the "artist,"
feeds pictures and movies to the hungry eye.
The raw silence at night. Poussin called it *silence panique*,
the empty canvases.

But the studio full of new paintings: hall of mirrors, royal pleasure, Versailles.

The studio initiates work as finally the only way out of the swamp of self.
The jump to action from the pull of the sofa is an act of survival,
a leap to freedom, the jump into the abyss, the fall into the sky.
It is breaking out of the prison of the studio into the freedom of the work.

Svetlana Alpers
The View from the Studio

By looking at paintings made both in and of the studio in and after the seventeenth century, my aim will be to offer a reasoned account of some studio realities. The topic is not the studio as such (a theme that goes back at least to a subject such as St. Luke painting the Virgin), or studio motifs or models directly represented (though motifs and models both play a part), but rather the situation in which the two overlap: that is, when the relation of the artist to reality is seen or represented in the frame of the workplace. It is a large topic and any account is bound to be selective and compressed, but the grip of studio practice and its internalization into the practice of painting are powerful. Picasso often took the artist in the studio with the model as the subject for his art-making, though the evidence is that, unlike Matisse, it was not his practice to work "after life." As Françoise Gilot jokingly pointed out, he carried a red chair for a model around with him from place to place but no one ever actually sat in it to be painted. She illustrated the point with the *Large Nude in Red Armchair*.

But the studio appears to have lost its appeal. The figure of the painter in the studio seems of the past, even a little suspect. Art produced for or in public venues—from earthworks and public sculpture or assemblages to photography, videos, graffiti, and work produced on gallery walls—is in. Painting made by someone alone in the studio (or art that supports the fiction of being made alone in the studio) is out. Here, for example, is Caroline Jones explaining what Andy Warhol's factory was an alternative to: "The dominant topos of the American artist was that of a solitary (male) genius, alone in his studio, sole witness to the miraculous creation of art." And it certainly wasn't just an American thing. Studio painting is at the heart of the pictorial project as it came to be deployed in Europe for the four hundred years from 1600 to 2000. One way to respond to present antagonism is to show that painting in the studio had at once a narrower and a more humane basis.

The connotations of the words used for the site of the artist's work—studio, *bottega*, *atelier*—are rich: place of retreat/withdrawal (the English

studio/study); but also shop, store (the Italian *bottega*), and the combination of workplace with exhibition place and sales outlet has had a long life. The French *atelier* derives from the Old French *astelle* (modern French *attelle*), the piece of wood used to bind horses, hence a harness or more properly a yoke—different again. Rather than simply making claims about or *for* the studio, I am interested in the constraints it offers, offered, because the challenge to the studio in recent times is not Warhol's factory model but the greater world outside it. At present, either the studio is felt to be too constrained, or constraint itself is suspect.

The Experimental Model

Historians and sociologists of science have been considering the role that the workplace for experimental science plays in the nature of scientific knowledge. This is part of a change in emphasis from theory to practice, or from science considered primarily as the formation of natural laws to science as the making of experiments. When I began to think about the realities of the studio, I was encouraged for several reasons by the example of studies of laboratory work and life. It serves as a corrective. In the study of art, as in the study of science, the precepts of an assemblage called theory (as in the usage "art theory") are often privileged at the expense of artistic practice itself.

The relationship between the practice of art and the practice of science was particularly striking in the seventeenth century, when the artist's studio, in the sense in which I am considering it, came into its own. English (Baconian) experimentation and Dutch descriptive painting share a perceptual or visual metaphor of knowledge of the world. Though they both represent the world, neither is transparent to it. In one case it is represented by a technology such as that of the lens, in the other by painting itself. Experimenting and painting are comparable crafts. The comparison works in two directions: it grants a seriousness to painters that is appropriately visual in nature (treating them as skillful observers rather than as moral preachers), while it brings experimenters in natural knowledge out of their isolation.

The illustration for a chapter on diseases of the eye in a seventeenth-century Dutch medical handbook shows a camera obscura—a hole fitted with a lens that by the action of light makes an image of the world—which is the way the mechanism of the eye was understood at the time. Two gentlemen in a dark room hold out a surface on which is cast the image of the landscape outside. This eyelike bringing of the outside world inside in the form of an image is a model of painting as practiced by Dutch painters. Vermeer's *View of Delft* (Mauritshuis, The Hague) is the supreme example.

I began this enquiry about the studio intending to pursue the social

construction of the artist's workplace. The questions were to follow on studies of the seventeenth-century laboratory or house of experiment. Was the site where experiments were conducted a private space or a public one? Was the work done by individuals working alone, with assistants, or in a group? Who were witnesses to the findings? But these laboratory questions, while perhaps of interest about the actual workspace, were not so productive when directed to paintings. The problem is that painters represent the studio experience as seen and experienced by an individual.

We know, of course, that painters often were not alone when at work. There are Dutch paintings that show a painter sharing his space with students, assistants, or a serving maid. But whatever the conditions behind its production, the phenomena we shall be concerned with resist the implications of this kind of social construction: compare the drawing of Rembrandt drawing after a nude model among his students/assistants to Hendrickje posing for him as *Bathsheba*; or Poussin's drawing of an ideal studio to his *Self-Portrait*; or Mieris's studio with maid coming in the door to Vermeer's *Art of Painting*. The studio may, on occasion, have been teeming with people. But what is represented as the studio experience is a solitary's view.

There is something obvious about the point—how else *but* as an individual does one see and experience one's ambience? This is not, of course, necessarily the concern of image-making. But the fiction sustained by studio painting is that a painter works alone. This does not mean that art is cut off from the world, but that the condition under which the connection is forged is imagined to be solitary.

From its beginning in the seventeenth century, the experience of the painter/observer was part of the experiment or experience (in the seventeenth-century sense of the word) represented pictorially. The realities of the studio are not only what is observed there (how the world is put together), but the artist's visual and, often, bodily or phenomenological experience of it (how it is experienced). What the painter in his/her painting makes of the world so experienced is central to the studio as an experimental site. What I am invoking is not a personal matter. It has to do with how every individual establishes a relationship with the world. One of the vexations of art is man. In the laboratory, by contrast, the impact of the interference of the human observer in an account of natural phenomena was not registered until modern times, and then with a different effect. It is possible to argue that the practice of painting was ahead of the practice of science in regard to the observer. The truth of this might, in part, explain the studio's enduring life.

In sum: the link studio-laboratory lets one look on painting as an investigation. I shall first consider what sort of realities the painter can address in

the studio. What is the relation of the painter to reality as seen in the frame of the workplace? Then, why might painters have taken this turn and, most importantly, because it reflects back on the studio itself, what does not find a place in the studio, or what does the studio exclude and what have painters done about it? Finally, a brief consideration of the depiction of landscape, outside and inside, leads to the notion that a basic reality addressed in the studio is the nature of the studio itself as an instrument of art. The reference to an instrument returns us, in an unanticipated sense, to the analogy offered by laboratory practice.

In the Light-Box

Let us begin with the baseline case. A person is alone in an empty room or light-box. It is somewhat darker in the room than in the world outside. Light is let in through several holes in the walls. Curious though it seems, the person has withdrawn from the world for the purpose of attending better to it. In this case, since the interior is empty, he withdraws to attend to the effect of the play of light. An illustration from Athanasius Kircher, *Ars magna lucis et umbrae* (1646), depicts a camera obscura enlarged to the size of a room and set in a landscape. The light conveys some trees as images on the wall.

The painter at work in a picture by the seventeenth-century painter Pieter Ellinga Janssens had depicted himself in such a space. The artist, head silhouetted before a window, stands at an easel in the farther room. The Dutch painter usually used a room in a house as a studio. The interior is dark. Light coming through large windows reflects off the floor, flooding the far wall and a chair. In the foreground room it puts on a wild show. Sunlight angles through the bright upper part of large windows, casts shadows of the leading on the lower frame, strikes the wall and (from there?) the floor, and casts the shadow of a chair and table back onto the window wall, where reflected light glistens off the glass of the shuttered lower window. A number of pictures (nonreflectors) and a mirror with gilt frame (light reflectors both) are on the walls. A woman reads by the secondary light and a maid sweeps. Treetops make a faint pattern on the leaded glass. These are matters of optical presence, even though Janssens perhaps saw fit to enhance them with his own "impossible" imaginings.

What is it like to be in a particular light?

Pieter de Hooch is less flamboyant about this sort of matter than Janssens. Though he never depicts himself, De Hooch's best paintings are in large part lingering investigations of light seen by him as if while at work. Light enters though windows and, often, a distant door, illuminating and reflecting differently off earthen tiles and metal, fur, and gilt. Its interruption is

marked by shadows cast by window frame, chair, bed-warmer, and handle, and the dusky atmosphere of the interior of a house. One understands the recommendation, already made by Leonardo, that light in the studio be from the north. Northern light, Leonardo says, does not vary. It is never, as here in De Hooch's interior, direct sunlight. The unobtrusive figures in his interiors appear to be stilled by its activity. A woman, back-viewed, posed against the light in a shadowed hallway leading out suggests an escape to the world beyond. But De Hooch frequently depicts a child poised to receive the light that floods in through an open doorway, associating the painter's experience with that of a child. Withdrawing from the world into the studio becomes a regressive act. It rehearses how we come into an experience of the world. De Hooch's children are related to the child the artist put by his side in paintings of the studio like those by Subleyras and Courbet.

The studio serves as a place to conduct experiments with light not possible in the diffused universal light or the direct solar light of the world outside. Studio light is light constrained in various ways. And it is also the light the artist is situated in. This state of affairs is codified in the paintings of Vermeer. The painter, according to Vermeer in *The Art of Painting*, is the man alone in the room—with which we began. But his working space or ambience (a better because less limited term) is restricted to a corner. A single window, here hidden by a tapestry, lets light in. It comes, as is usual, from the left, ensuring that the painter's right hand does not cast a shadow on his painting as he works. The painter is in the light he paints. When, exceptionally, as in *The Lacemaker*, the light in a painting by Vermeer is from the right—that is, from the left of the painted figure—it is likely that Vermeer imagines himself in her place. Beside her hands is an improbable (for a lacemaker) red tangle of stuffs. Seen at the close distance that the diminutive scale of this painting proposes for the eye, the red pigment is a deposit of *his* paint as much as it is a loop of *her* thread. But it is the light striking the woman from the right (*her* left) that marks Vermeer's identification with her.

There is a wildness about light in Vermeer. It provides the drama in his pictures. Vermeer's people exist between the play of light that is the agent of visibility in the world and the erasure that threatens when, without it, they fall into shadow. Light is not assumed by Vermeer, it is studied. It is not received as in a De Hooch by a child in a domestic interior (no children appear in Vermeer's domestic interiors), but functions as the defining presence, or even as an assault on the world outside. Without light, individuals fade. Note the lost cheek of the lacemaker at the left in contrast to the clear edge defined by the light on the cheek to the right.

There are other distinctive kinds of studio light. Caravaggio notoriously represents an angled, raking light in an otherwise darkened space. It was

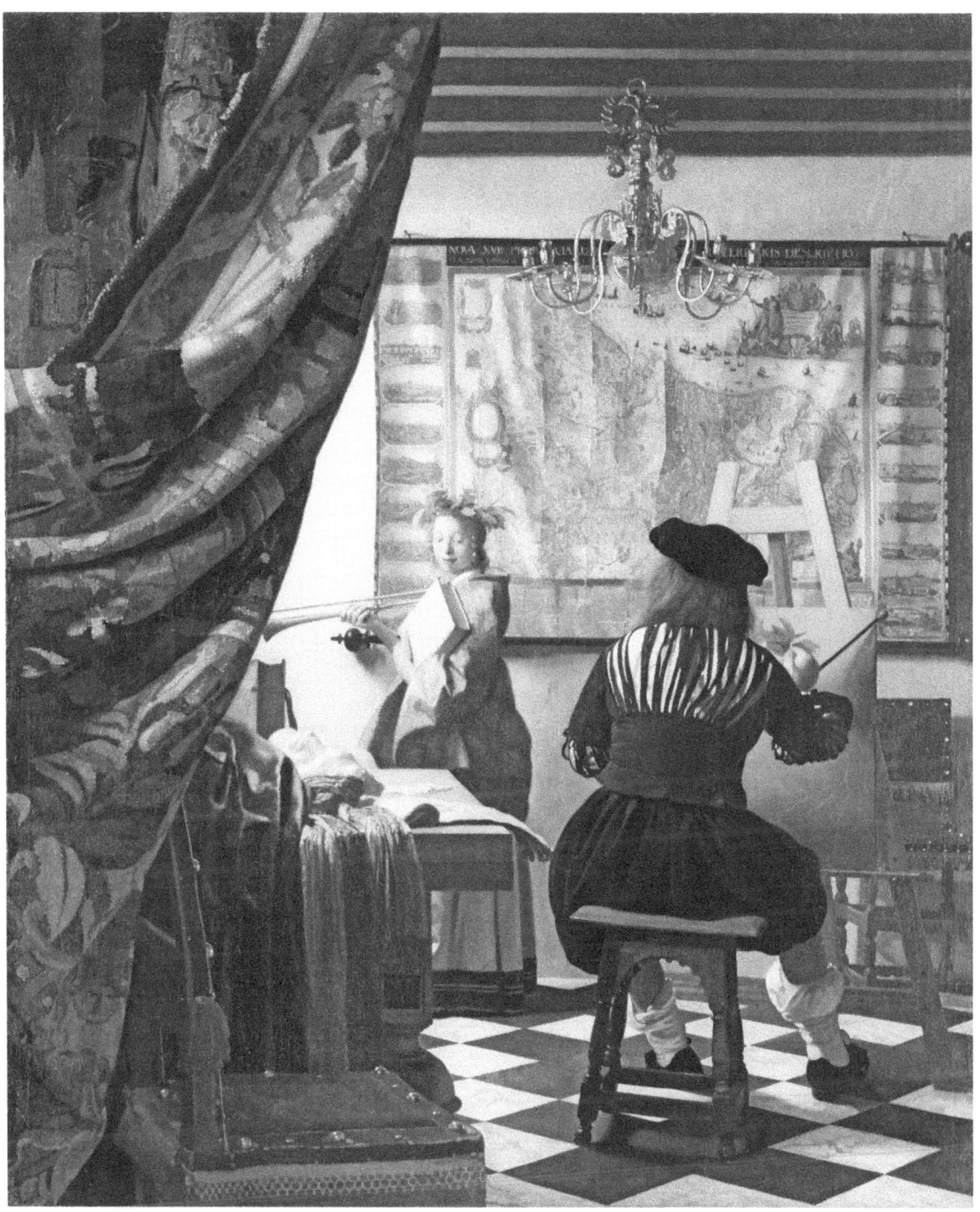

Johannes Vermeer van Delft, *The Art of Painting*, 1665/1666.

attacked at the time for being cellarlike. It is interesting that Caravaggio's flaunting of indecorum was attributed to his indecorous, cellarlike workplace. The light in his works—which, of course, depend on many other aspects of motif and handling—supports the accusation that when he worked he painted in actual light such as this. Picasso, a willing heir to all of this attention to the studio and its light, wittily leaves a light bulb suspended in the *Guernica*. It is a reminder that, for a studio painter like Picasso, the studio—as we know it from a series of prior drawings—was the imagined site even of a painting of a public and historical subject like this one.

Light is not necessarily represented as entering the studio though a window. And indeed, with time the window, when it does appear—from the drawing of his studio by Caspar David Friedrich (Kunsthistorisches Museum, Vienna) to paintings by Matisse—is not set at the side, as in Vermeer, but in the back wall. It functions not as a source of light, but as a reminder that a world lies outside it or, conversely, that the studio is withdrawn from the world that lies outside. There is a curiously impacted instance of this kind of window in Manet's *Luncheon in the Studio* (Bayerische Staatsgemäldesammlungen, Munich). The window set at the left in the back wall of the room has been rendered as opaque (as if shuttered), the glass panes reflecting some interior light. Withdrawal from the world is confirmed. Manet's studio, as his other paintings confirm, offers no way out. The lack of exit serves as a cautionary reminder of the limitations of studio light. An anecdote about Michelangelo told by Vasari puts this succinctly. When a sculptor threw open the windows of his studio the better to show his work in the "lume delle fenestre," Michelangelo is reported to have replied that only in "il lume della piazza"—or in the public light—is a work properly judged. His play on words serves to make the point that light in the studio, any light in the studio, is a private experience, not the, to him, essential public view.

What is it like when objects are introduced into the painter's lit room? The essential case in the pictorial tradition is the setup known as a "still life." See, for example, one of Willem Claesz. Heda's spare arrangements featuring a wineglass, a silver bowl, an olive, and a nut. We are so accustomed to painted tables with objects on them that the oddity of the format is not often noted. Objects, even objects on tabletops, had been depicted before this. There are displays of collectibles on a table in the still-life painting of flowers and shells within the painting of an encyclopedic collection by Frans Francken. But it is in Dutch painting of the seventeenth century that the still life is first situated in the studio. Attention to light is an indication of this transformation. The objects on the tables, generally domestic in nature, are lit by light from the painter's left. Objects are related to each other by reflections off neighboring things on the table—a lemon reflected onto a

pewter dish, lit pewter back onto the lemon. The leaded panes of an unseen studio window are often reflected on and sometimes even through the surface of a goblet.

Still lifes of flowers, however, continued rather like displays of collectibles. In the seventeenth century, flowers are generally highlighted against a darkened wall. Perhaps they were not represented in studio light because the blooms of different kinds and seasons represented together in a vase would never actually have been seen together on a single studio occasion. In the nineteenth century, rarity was no longer an issue and flowers of one season are commonly depicted in a vase in studio light. It is then disconcerting to come upon a bunch of flowers that are, instead, painted as growing in a sunlit flower-bed. The diffused daylight, but also the size, our implied position (above and not close), is disorienting *because* we have become used to flowers painted in the studio.

The situation with people is different. If the studio declined looks odd in the painting of the flower-bed, so studio lighting maintained can look odd in the paintings of nudes outdoors. A person studied by studio light cannot simply be moved outside into the light of day. The nude is the most aggravated example of this studio constraint. An interest is that we can trace its history. Giorgione, with Titian following close after, is the presumed inventor of what became the genre of the nude figure in the landscape. In the Dresden *Sleeping Venus* there is no disparity between the light on the flesh and that on the terrain in which the nude woman lies. Light is diffused and universal. This is prior to the studio in the sense in which we are speaking of it here. Once a nude body is painted (as distinguished from being drawn) in studio light and at studio proximity, it is incongruent when set outside. The problem surfaced in the nineteenth century. Frédéric Bazille bares it when he inserts a nude man, studio-lit, into an outdoor setting; he appears not to be standing on, but silhouetted against, a sunlit riverbank. Some accommodation must be made. Degas recommended representing figures as if they are outside at twilight when they appear as silhouettes. Manet keeps nudes inside. For her performance in the *Déjeuner sur l'herbe*, Victorine Meurent undressed in the studio. The landscape behind her is frankly studio decor.

The windowed corner of the Vermeer room and the adjacent table with objects is an exemplary studio site. It is curious, then, that although light remains an abiding concern for still-life painters from Heda at least to Chardin, the window does not figure in the still-life genre itself. Once it was assumed, the light needed no explanation. But individual lit objects can serve as what one might call studio markers. This is less a way of fitting up a room than a way of showing that the painter worked there. Vermeer favored a particular lit white porcelain jug (though at least once, in addition, the legs of the ea-

sel are reflected in a mirror). Velázquez incongruously set a white jug similar to Vermeer's—a simple domestic object casting a remarkable shadow—where one would not expect to see it on the mantelpiece in his *Forge of Vulcan* (Prado, Madrid). The white vase depicted in a particular light is a reminder, perhaps, that the forge is a kind of studio.

The Phenomenological Experience

The still-life assemblage has been understood as a bourgeois phenomenon. This is to consider its objects as subordinate to man, for our use, manipulation, and enjoyment, conveying our sense of power over things. Paraphrasing Meyer Schapiro, still life in this interpretation is the construction of a portable possession. But, taking the empty room once more as the baseline, there is a prior sense in which the objects on the table—one can expand this to any objects or people in the studio—put pressure on or exact something from the painter who has retired there. The studio experience, then, is the addressing of motifs. They register something that the painter deals with or, perhaps better, plays with in paint. Still-life objects are depicted as if at arm's length and approximately life-size. The distance from what the artist paints is a reality of the studio. Maybe studio-size is a more accurate description than life-size. The studio is a place where things are introduced in the interest of being experienced by the painter.

The peculiarity of the relationship between the artist and the objects/models in the studio comes out in James Lord's account of sitting to Alberto Giacometti (a consummate studio artist) for a portrait. At first, Lord is astonished to be told to sit only four feet from the artist. But studio proximity proves to be more than a matter of real optical scale. It was also a matter of bodily presence and identity. Lord tells of an occasion when Giacometti accidentally kicked the easel on which the portrait rested and immediately apologized to the sitter. The artist in the studio takes the painting for the person or object being painted. A painting (or here a drawing) understood in this way is not a substitute for an absent thing (the view of images when language is taken as the model of human experience), but constitutes a newly made thing in itself.

But what kind of a thing is it?

The representation of the hand of the painter in Vermeer's *Art of Painting* poses the question more sharply. A shaded blob is where the hand of the painter painting the blue and tawny leaves on the model's wreath should be. Why such an ill-defined blob? One could say that the painter has not yet realized his hand, in the double sense of not yet having fully perceived the object before his eyes as a hand and not yet having painted it as a hand. An

experience of ambiguity is part of the process of perceiving. By pictorial ambiguity I refer to the possibility of the painter representing the perception of a thing, and representing it for viewers, in such a way as to encourage the mind to dwell on perceiving as a process: the painter's experience of an object as coming into its own, distinguishing itself from other things, taking shape. Painting a modeled blob not yet recognizable as a hand, he notes the potential of its being seen as the flesh of a painted face. He had painted a similarly ambiguous object near the bowl in the foreground of his early and, as it were, pre-studio, *Diana and Nymphs* (Mauritshuis, The Hague). Is it a bit of discarded cloth or, perhaps, a white dove having a drink?

There is a further twist: the shaded blob-about-to-be-a-hand that looks like a face also appears to be part of the painting that the artist is painting. He is working on the blue and tawny leaves on the model's wreath. If we look at his hand in combination with the leaves he is putting on the canvas, it has much the same relationship to leaves as the face of the model crowned by her wreath. Like the flesh of her face, the flesh of the hand is in shadow below, lit above, the bit of white at *his* wrist is the white collar at *her* neck, *his* dark cuff standing out below and to the right is the stiff cloth behind *her* neck.

We have caught the painter in the studio experiencing and playing with his hand in paint. The hand is *the* object that a painter always has at arm's length immediately before him while working. Velázquez in his studio in *Las Meninas* and Rembrandt in the *Self-Portrait* now at Kenwood were also interested in this: Velázquez's hand mimics the color and directionality of worked pigments, Rembrandt's hand mimics the instruments with which he paints. But the hand has particular presence in *The Art of Painting* because Vermeer—seen from the back, his hat a black hole—has disappeared into or is lost in the act of painting. On Vermeer's account the representational status of the hand is fluid, unresolved. Though it is part of his body, the hand is represented neither as entirely belonging to him, nor entirely as an object in the world, nor entirely as a painted image. In his manner of depicting it, Vermeer probes at the making of the relationship, perceptual and in that sense psychological, between himself and the world.

The painted hand serves Vermeer as an illusory experience that is psychological in another sense. Pictorial ambiguity had, of course, been entertained by painters before the seventeenth century. The difference that the studio makes is that it frames the ambiguity as originating under particular circumstances. In the studio, the individual's experience of the world can be staged as if it were at its beginning. The hand works rather like those me-not-me objects that the psychoanalyst D. W. Winnicott called transitional. Winnicott coined the term to describe the means by which an infant creates its first links with the world. Under studio conditions pictorial ambiguity is

not only a resource of the medium, it becomes a matter of artistic investigation. This gives to studio painting its probing, forward lean. It is a matter of discovery, not demonstration.

It is in connection to figuring our earliest consciousness of and relationship to the world that a certain line of studio paintings dwells on objects whose status or nature remains unresolved and hence disturbing. Beyond a huge, foregrounded paint box and palette with protruding brushes in Degas's *Portrait of an Artist and Lay Figure*, a Degas look-alike withdraws into a corner dejected after his labors, paintings to either side. To one side a painted woman lounges against a tree, to the other a painted man is stretched out on the ground. A lay figure, having served as the model from which the first was taken, but resonant with the second and with the artist as well, is slumped on the floor against a wall, discarded—discarded as a child might have done with a toy.

Cézanne's *Still Life with Plaster Cast of Amor* proposes another vertiginous experience of studio as world. There is no painter here, only his/her effects: the blue drapery and the green tops of an onion on a tabletop reach upwards and merge, puzzlingly, into a painting. A plaster Amor is backed against or bursts out from an empty canvas, its angle and pedestal resonating with the truncated flayed man right and above—a statue transformed into a painting. What Vermeer leaves covert—a discarded plaster head lying on the table beside the model in *The Art of Painting*—is openly displayed by Cézanne.

Objects can be at risk in painting: a lay figure drained of life; a plaster head cast down; a flayed man who is not all there. One senses the pressure on things (or models) bent, against their will, to be part of the painter's experience, to be his or her symbols. A certain madness is in play. For Winnicott's child, in this sense like the artist, creation is the making of illusions. Put simply, art on this account is like a child's insistent creation of interest/connections, rather than, as Melanie Klein would have it, an adult's effort at reparation. In a footnote to a paper titled "Primitive Emotional Development," Winnicott put it that "through artistic expression we can hope to keep in touch with our primitive selves whence the most intense feelings and even fearfully acute sensations derive, and we are poor indeed if we are only sane." On Winnicott's observation of children, such regressive behavior could be aggressive.

Winnicott encouraged what he called squiggles to be made collaboratively and sequentially between himself and his very young patients. There is one he made himself that is compelling in this regard. It depicts a sculpted object on a pedestal bearing the inscription "Frustrated Sculpture (wanted to be an ordinary thing)." Its relevance is pictorial—it happens to look rather like

Cézanne's flayed man—but also psychological. This squiggle does not want to go along with the game. It wants to be just an ordinary thing. It is as if the nursery-room hobby horse ridden by the child in Gombrich's famous essay resisted being used as a substitute for a real thing and, in doing so, called attention to the ambiguity of its own nature and function.

Winnicott is useful for thinking about studio-making because his focus is on a pre-oedipal and hence (like the studio painter as I see him/her) a one-to-one relationship between person-world, and because he addresses the child's prelinguistic and hence (like the painter's) nonverbal experience of the world. Possible objections to such a view—that it leaves out or cannot deal with things beyond time present or the immediate reach of the hand or eye—are instructive about how some painters have depicted the studio as the world.

Studio painting so understood is an alternative to the world as it is dealt with in language. Differentiation of "time when" is not enforced. The studio resolves experience into the present. Vermeer's *View of Delft* has been taken as a paradigmatic instance of how memory is effectively wiped out in the presence of a painting. The predicament is manifest in the dovetailing of Proust's experiences of the Vermeer in his writing and in his life, but also in his own past and his present. It is known that in 1921 he rose from his sickbed to see Vermeer's painting then on exhibit at the Jeu de Paume in Paris. In *Le temps retrouvé*, Proust writes of Bergotte's death immediately on having seen it at the exhibit. In front of the picture the reconstruction of the past that constitutes Proust's writing, until that moment, is overtaken by the present. This is an extreme case: Vermeer's *View of Delft*—as experienced by Bergotte in Proust's novel and as experienced by Proust in his life—is not only an alternative to memory and to words, but proves fatal to both.

In sum, something basic in human psychology and its representation has been confronted in the studio. The question remains, how the studio became such a site and with what changing nuances have perceptual truths been pursued there.

Studio as Retreat

The workplace had not previously been conceived of as the retreat it was to become. An Italian mural painter like Piero della Francesca can be described as setting up a temporary workplace in San Francesco in Arezzo while he was painting his fresco cycle there in the mid-fifteenth century. Climbing up on the scaffolding during a recent conservation campaign, one came into the artist's space—the choir of the church with its window and two facing

walls established the boundary within which he worked. Piero and his team painted the walls purposefully, adding to the *buon fresco* after it was dry with touches of tempera and pigments in other media. The detailed work on the surface has an unexpected immediacy. Proximity to the work, the artist's proximity and one's own, challenges the perception of the dominant motifs. The *Battle of Chosroes* appears as the accumulation of painted details—stripes of blood, gripping hands, human hair juxtaposed with a horse's tail, and a bleeding throat with a cross. But this experience was the painter's alone. Having finished, Piero left. And the deposited activity of the artist in his choir workplace was visible only to worshippers, at an angle and from below.

In time, Italian mural painting came to take the viewers more immediately into account. In the seventeenth century, artists painting murals in Italy reached for grander and more obvious effects, many of them spatial in nature. But not until G. B. Tiepolo in the eighteenth century was the old workplace sense of mural painting returned to and renewed, but with a difference. The draftsmanly Tiepolo extended his drawing up onto walls and ceilings alike, which served as a kind of giant sketch pad for his frescoes. In that sense, his working site was also his studio and his performance there was for us to share. Meanwhile, in northern Europe, the studio crystallized as a retreat in the familiar-to-us way and it took hold with a specific loss. History painting cannot be done in a domestic studio while still life can. Still life understood expansively—featuring a stationary model of some kind—became the benchmark genre.

What kind of account can be given of the *retreat* to the studio in the seventeenth century? It was celebrated at the time by some remarkable self-portraits of artists with the tools of their trade: Rembrandt's paintings at Kenwood and in the Louvre in Paris, Poussin in the Louvre, the so-called *Las Meninas* of Velázquez, and, though not openly a self-portrait, Vermeer's *Art of Painting*. Their circumstances are diverse. They were made in different places, on different occasions, for different kinds of clients. But each painter, in his own context, dealt with the newly ambiguous social function of art or the role of the artist. For each of them—whether at court (Velázquez), in the home (Vermeer), or away from either (Rembrandt, Poussin)—the working space was a way to proceed. It was a way to define ground that is the painter's own, a license to be a self or a way to take on the identity of being a painter.

Attention to studio realities marks the demise of European history painting as it had been. Painters withdrew from depicting significant, text-related actions (religious, mythological, and historical) taking place in a greater world. With the striking exception of Rubens, who might be described as an

old believer, the imaginary theater of art that existed previous to this was over. Poussin and those who followed him in France worked to reconstitute history painting in new and distinctive terms.

Two paths into the studio can be distinguished, both of which have had a long life. After his *Christ in the House of Mary and Martha* (National Gallery of Scotland, Edinburgh) and *Diana and Nymphs,* Vermeer turned to objects and people appropriate to the domestic situation of his workplace. The imaginary theater survives only in a few pictures reimagined on the wall—a painting of the *Finding of Moses* displaying a prominent naked back hangs in *Lady Writing a Letter with Her Maid* in the National Gallery, Dublin, and the Louvre *Astronomer.* Rembrandt and Caravaggio instead try to bring the themes of history painting into studios that are not domestic. They deploy models in the studio to replace the dramatic figures of history painting. Late in his career, Rembrandt repeatedly represented people who sat to him in his studio in such a way as to suggest historical personages. A favorite model poses as Aristotle, his common-law wife Hendrickje poses (or is imagined as posing) as Bathsheba. He attaches historical themes to portraiture, an essential studio genre.

Caravaggio persists in depicting dramatic enactments, which, however, he stages (or appears to stage) with models in the studio. This is signaled by a darkened interior and by the lighting, scale, and proximity of figures (in particular their flesh and accoutrements). One might describe him as configuring historical themes as a sort of still life, the other essential studio genre. His works were criticized at the time as being *senza attione* or lacking action. And Caravaggio was accused of killing off painting by following nature too closely. Behind the accusation was a notion that art is done more or less either after nature or out of the mind (the real or the ideal). But studio practice confounds these terms. It is not nature (the real) but painting in the studio—neither the real world, nor the imagining of it, but a third, new way—that posed the threat to painting as it had been.

But the studio strictly conceived presents problems for the artist—among the vexations of art. Prominent among them is the fact that it excludes so much of the world and that its condition is that of isolation. Both lead to trying to make connections. Poussin, it has been recently shown, preferred to conceive of his paintings not as being sold on the market, but as circulating among friends. He defined the market for his pictures not by an exchange of money (though that did take place) but by an exchange of friendship, which is represented by embracing arms in the Paris *Self-Portrait.* One response to the solitude of the studio is to reach out for company. Poussin read and admired Montaigne. It could be that, like Montaigne alone in his

tower library, Poussin valued friendship all the more for the solitude of the studio, depicted here by a stack of empty frames. The court visitation that Velázquez arranged to his studio, like the busy workplaces of the spinners or Vulcan's helpers, which he also devised, does not disguise the fact that the painter of *Las Meninas* is elusive. It is surprising that Velázquez painted his own portrait at all.

At one level painters have tried to deny studio limits. An exemplary case is Courbet's great painting of his studio. Why is the painting so large and crowded with so many people? Courbet himself gave a long title to it, described it at length in a letter addressed to the critic Champfleury, and the assembled company has been the subject of much interpretive analysis. Without going into the many particulars, one could say that his is a grandiose attempt to make the studio large enough (the painting measures 12 × 20 feet or 3.6 × 6 meters) to encompass the world, at least, that is, the world of his friends and models. But it is striking that the artist before his canvas, the nude model, and an attendant child (standard features of the depicted studio) are detached from or isolated from the rest. Perhaps this is not the depiction of a studio grown big enough to contain the world, but is in fact no longer a studio: a pictorial demonstration of what the studio as we have been considering it cannot do or be. Unless, that is, the studio is imagined to be a public space. Courbet seems to want to have it both ways.

Courbet's *The Painter's Studio: A Real Allegory Determining a Phase of Seven Years of my Artistic Life* (Musée d'Orsay, Paris) deals with time past and with isolation, both problematic in the studio. Studio experience is by its nature in and of the present. Like the empty, light-filled room with which we began and the perception/experience that it sustains and extends, its lean is forward, not back to the past. Courbet counters this forward lean by introducing figures and models from history, his own history, and paintings past. (Like his predecessors he includes a model, the child, and a curious figure of a naked man under pressure.) The assembly of people also saves the artist from himself, from his isolation. But about this Courbet is clearly ambivalent. Invoking the world and the past, and the nude model and the child, the artist turns his back on it all to paint a landscape instead. Is the landscape another piece of the real world he is trying to bring in to the studio? or is it a way to escape? Delacroix objected to the landscape because of its uncertain status. "La seule faute est que le tableau qu'il fait peint fait amphibologie [ambivalence]: il a l'air d'un *vrai ciel* au milieu du tableau." In the letter to Champfleury, Courbet writes that he will hang two of his own paintings on the back wall of his *Studio*. Instead he left a stretch of not quite empty wall— an extended, puzzling, faintly marked screen. Even with effort we can make little out except, perhaps, the suggestion of some trees.

Landscape and the Studio Condition

The painting of landscape puts the notion of the studio under pressure—Courbet is no exception in this. The historical account that has been given of it is complex. An accepted history of landscape painting turns on locating the moment when painters free themselves from the studio and its conventions and exit to make paintings outside in the real world. According to this account, one based on the nineteenth-century case, the real world is not inside the studio but outside—studio and world are alternatives or opposites. In the sixteenth century some artists drew outside; in the seventeenth century many carried sketchbooks about and made landscape drawings; and later Constable did oil sketches of clouds. But as a rule, until the nineteenth century artists executed their finished landscape *paintings* in the studio, removed from seeing the thing itself. Painters went out to do empirical studies and came in to compose. Despite its appearance of reality, Courbet is painting the landscape in his *Allegory* inside. But then things changed. A number of painters came to accept the inconvenience, the glare and changing light, decomposition, and the challenge to the integrity of the figure that painting in the world outside the studio entailed. The story is told of Monet digging a ditch in which to lower his large canvas when he went out to capture the "real" play of light and shadow on the dresses of women in a garden. (Though we might remember that his *Nymphéades* were painted inside a specially constructed studio.)

In recent years this account has been expanded to include Corot and other early nineteenth-century northern European artists painting small paintings outdoors in Rome and the *campagna*. A different history of landscape painting emerges, with less emphasis on Monet. It can be shown that painting landscapes outdoors was already a procedure within academic painting. This involves making a distinction between a practice (painting small studies outdoors) and the system (academic protocol that finished works were done in the studio) of which this practice was a subsidiary part. Painting small landscapes from nature in the open air was, then, a break with the conventions of the studio nurtured within the system of academic painting itself.

But there was another departure in taking up landscape in which the studio, in a new sense, remained a determining factor. Thomas Jones, an Englishman working in Italy in the 1780s, is celebrated as one of the first Europeans to work with oil paint outdoors. Living in Naples in 1782, he turned from painting panoramic views of bay and hills complete with conventional repoussoir trees to making, instead, marvelous oil sketches on paper of rooftops close by seen in a brilliant sun. But are Jones's tiny sketches really studio-free? Obviously, they are different from his other landscapes. They seem

more immediately experienced. Jones viewed what he painted from his window or roof. But the depictions he made from his rooftops can and have been described as having the pictorial immediacy of something represented in the studio. The small scale (5 × 8 to 13 inches or 14 × 21 to 35 cm), close handling, and the steady light are like those of a still life. Something about this is very odd indeed. How can one put a landscape on a table? Or to put it differently, how can one experience something with the expanse and the movement of a landscape—its mountains, hills, trees, clouds—as if it had the visual and bodily presence, the immobility of objects present before one on a table?

The answer is that one can't see landscape as if it were a still life on a table before one without changing the notion of the realities addressed in the studio. Jones's juxtaposed and lit walls are easily accommodated to the tabletop condition. He primarily depicts buildings, not the land, trees, and sky itself. What would happen if the painter proposed experiencing something that cannot be experienced in the studio as if it were? that is to say, proposed experiencing something in a studio way that lacks the presence before the eyes of a studio motif? What if Chardin, let us say, had painted a landscape resting on a tabletop instead of a bowl of plums?

It was Cézanne who experimented with experiencing a landscape as if it were a still-life motif. Despite all his excursions outside to paint particular motifs such as the Montagne Sainte-Victoire, Cézanne's landscapes share with his still lifes the studio terrain. They are distinguished by the absence of people, of seasons, of time of day. Cézanne's often-remarked sacrifice of light in the studio (light being registered in the modeling implied by individual brushstrokes themselves) is part of the move to a new kind of painting. But it is one thing to display the buildup of still-life objects with pigment and brush, quite something different to do that, as Cézanne does, when depicting a landscape. Landscape is subjected to a new kind of analysis. The difference between things—between landscape as a motif and still life, or between rocks and trees and fields before mountains and bowls or a vase on tabletops placed before the leaves woven into a tapestry—is minimized in the process of painting. If his landscapes are like still lifes, so his still lifes are landscapes. It was partly to this end that Cézanne often took up tapestried leaves—similar to ones that Vermeer had also depicted—as a backdrop. As he said to Joachim Gasquet, all during his youth he had wanted to paint a tablecloth of new snow, "cette nappe de neige fraîche" as Balzac had described it. To treat landscape as a studio motif in this manner is to alter the basis of painting. Studio representation is construed differently or pitched at a different level than it had been.

But what exactly does that mean?

I have described the turn to the studio in the seventeenth century as

a retreat. Rembrandt's historicized portraits and Caravaggio's still-life histories are studio alternatives to the painting of an imaginary world as it had been done by the old art. But, alternatively, one might speak of the studio not as a retreat but as a taking up of a condition that is differentiated from another mode of painting. The painter's choice becomes either studio or not.

When the studio condition comes to include more than is actually there before the artist's eyes and body, it can become a matter of the mind. Cézanne's landscapes are an example of this, and so are his depictions of the nude. Pre-studio painting had produced great inventions privileging groups of human bodies (often nude bodies) in action. Could this concern, a primary one of the old art, be pursued in the studio? Vermeer, for whom the studio was domestic space and whom we do not associate with an interest in the body in this sense, finds a way to do it by depicting a singularly repainted painting of a *Finding of Moses* hanging on the far wall in *Lady Writing a Letter with Her Maid* and *The Astronomer*. (Why the subject of the *Finding of Moses* should feature nude male(?) figures in addition to a naked baby remains a question.)

Cézanne, a painter of studio still lifes and studio landscapes, invented a separate genre in which to depict the human body. The works in question are referred to thematically as "the bathers." They began as many small pictures, obsessively repeated, which expand at the end to a monumental scale. They were highly appreciated—one today in the Petit Palais was owned from early on by Matisse. There was precedence in the pictorial tradition, mythological precedents specifically, for depicting nudes in a landscape. But there is good reason in Cézanne's case to consider them alongside his studio landscapes and still lifes as studio nudes. The figures (the French *corps* seems the right word) are often not distinguished sexually, appear in free-floating configurations (the small paintings are barely composed) and surrounded by greenery (they are hardly "in" a landscape or in natural light). Nude models never posed in the studio for Cézanne. Neither repression nor fantasy (both of which have been suggested) totally convince as descriptions of his bathers. But an experience of bodies in a phenomenological sense is registered. Like his landscapes, Cézanne's bathers are studio performances that present the artist's imagined experience in a way characteristic of his other studio paintings. Cézanne manifests the condition of the studio as in or of the mind.

Studio as Instrument

The studio, in the account that has been given here, begins as a light-box such as the experiment with the room-sized camera obscura of Kircher and

the domestic rooms painted by Janssens and De Hooch. When objects on tables become the focus, the condition of still-life painting obtains. So the box comes to be a site in which the artist experiences objects before him or her in the world. We have described Cézanne's studio as a change from the experience of a motif before the artist to a motif experienced as if in or of the artist's mind.

Although there is agreement that Cézanne's painting gives a new look to things, this has proved difficult to justify. Remarkably, there is a report of experimental laboratory practice that, in its form and in its content, can be of help. It concerns the transformation in the use and hence the findings of an experimental chamber devised and set up in the Cavendish laboratory in Cambridge, England, in the late 1890s. The laboratory experiment brings us back to the analogy between experimental science and experimental art with which, in reference to Francis Bacon, this enquiry began.

The story, elegantly told by the historian of science Peter Galison, is of how an instrument or chamber designed in order to reproduce clouds came to be useful instead to detect subatomic particles. Put too simply, the nature photographer and physical meteorologist C. T. R. Wilson built the cloud chamber in order to reproduce atmospheric phenomena of the real world in the laboratory: his hypothesis was that condensation nuclei were electrical ions. In its condensation of artificial clouds, his experimental apparatus imitated nature. But working beside Wilson at the Cavendish laboratory were men who were not interested in studying the world that was being imitated within the chamber—*clouds*—but rather the real things, small and never before observed, whose tracks were visible in the condensation produced there—*subatomic particles*. Galison describes the transformation of the meteorologist's cloud chamber into the physicist's bubble chamber as a change from mimetic to analytic experimentation—from experimentation that mimics nature to one that takes nature apart. Stated succinctly (and paradoxically) in terms of what was being made and observed, it was a change from artificial clouds to real particles. Though he persisted in his meteorological observations, Wilson was awarded a Nobel Prize in 1927 for his work in physics. His work highlights, by straddling, the difference between imitation and analysis.

The scientific terms can be adapted to describe Cézanne's pictorial innovations: from attending to an imitative landscape to attending to real particles of things. In conversations recorded by Gasquet, he speaks in a manner consistent with a description drawn from science or, more properly, from natural knowledge. Cézanne had, for example, been absorbed in reading Lucretius to support his own pictorial analysis of the structure of nature.

Pour bien peindre un paysage, je dois découvrir d'abord les assises géologiques. Songez que l'histoire du monde date du jour où deux atomes se sont rencontrés, où deux tourbillons, deux danses chimiques se sont combinées ... je m'en sature en lisant Lucrèce.

To paint a landscape truly, I must first uncover the geological lie of the land. Imagine that the history of the world dates from the day when there was an encounter of two atoms, where two vortices, two chemical dances combine ... I have absorbed myself in reading Lucretius.

The change from the mimetic to the analytic use of the cloud chamber is a sharper way of saying that studio representation is construed differently or pitched at a different level than it had been before. And the paradox in the scientists' changing use of the chamber from imitating clouds (what Galison refers to as a *camera nebulosa*) to tracking particles might also be said to have obtained in the studio of a painter. Having begun as a light-box making *images* of things, the studio becomes, like the mind, tracking basic connections in matter. Cézanne, like Wilson in this, straddled the two. Many attempts have been made to explain what is depicted in the array of marks in a painting by Cézanne. But it is safe to say that whatever they depict they register the activity of the mind. This is confirmed in the frequency with which words evoking it—mind, brain, spirit, thought—come to him when he talks of his painting with Gasquet.

Le paysage se reflète, s'humanise, se pense en moi. Je l'objective, le projette, le fixe sur ma toile.

The landscape reflects on itself, is humanized, thinks itself in me. I objectify it, project it, fix it on my canvas.

A new basis for the study of landscape in the studio had been invented.

The tale of experimental Cambridge has a larger interest. It emphasizes the role of experimenters in establishing the character of an instrument (the chamber) and the effects produced with it. Every instrument produces artifacts or effects that are intrinsic to its construction. But the nature of an instrument and the interpretation of the artifacts produced by it are also subject to human manipulation and interpretation. The lens or glass and the camera obscura are among the most familiar instruments that were used by experimenters in natural knowledge and artists alike. But encouraged by the evocation of the chamber in Cambridge (and admittedly charmed by the metaphoric affinity between chamber and studio), we might define the studio itself as such an experimental instrument. Perhaps it is here, in the uses of an experimental instrument, that there is a fruitful analogy between the

artist and the experimenter, between painting and experimenting. Bacon's vexations are verified.

Starting in the seventeenth century, so an account might go, European artists began to treat the studio as a basic instrument of their art. For some, it was not simply the site *where* they worked, but a condition of working. The studio as instrument is an invention that has had a long life—from Pieter Janssens's studio as a light-box to the studio as a state of mind. The art historical project, not unlike that which engages a historian of science, is to track the transformation of the studio-as-instrument while resisting the tendency to consider it, and its products, as either simply conventional (which has been the default of art) or simply transparent to the world (which has been the default of science). This essay is a prolegomenon to that.

It used to be argued that the problem-solving nature of the best Italian Renaissance art made it the model for the progress in human knowledge that later came to be associated with science. This notion of the link between art and science privileged the notion of development and progress. As Gombrich wrote, "The artist works like a scientist. His works exist not only for their own sake but also to demonstrate certain problem solutions." An immediate reference was what he and others took to be the scientific and demonstrable character of perspective. The link studio-laboratory focuses instead on the constraints under which knowledge is achieved. It is the changing conditions of pictorial knowledge rather than its progress that are tracked. But that pictorial knowledge is a value is not in doubt.

..

From The Vexations of Art: Velázquez and Others *(New Haven: Yale University Press, 2005), chap. 1, 9–45.*

Introductory section

The artist's studio is an unwieldy theme taking in dwelling, training, practice, use of models, collecting, exhibiting, and the marketing of art through the ages. The literature is vast. The subject lends itself to illustrated books, scholarly studies, and things in between.

Examples of the first include Alice Bellony-Rewald and Michael Peppiatt, *Imagination's Chamber: Artists and Their Studios* (Boston, 1982), and Alexander Liberman, *The Artist in His Studio* (New York, 1988). Not surprisingly, Paris gets prime attention: John Milner, *The Studios of Paris: The Capital of Art in the Late Nineteenth Century* (New Haven, 1988); Catherine Lawless, *Artistes et ateliers* (Paris, 1990); Jean-Claude Delorme and Anne-Marie Dubois, *Ateliers d'artistes à Paris* (Paris, 1998).

Examples of the second include W. G. Constable, *The Painter's Workshop* (London, 1954); *Children of Mercury: The Education of Artists in the Sixteenth and Seventeenth Centuries,* pub-

lished in conjunction with an exhibition by the Department of Art, Brown University (Providence, RI, 1984); Peter M. Lukehart, ed., *The Artist's Workshop* (Studies in the History of Art, Center for Advanced Studies in the Visual Arts; Hanover, 1993); Anthony Hughes, "'An Academy for Doing,'" pts. 1, "The Accademia del Disegno, the Guilds and the Principate in Sixteenth-Century Florence," and 2, "Academies, Status and Power in Early Modern Europe," *Oxford Art Journal* 9 (1986): 3–10, 50–62. Later on, Hughes, like many others at the end of the twentieth century, came to question the primacy given to individual talent: Anthony Hughes, "'The Cave and the Smith': Artists' Studios and Intellectual Property in Early Modern Europe," *Oxford Art Journal* 13 (1990): 34–48. Studies of (mostly modern) individual artists such as Degas, Picasso, and Giacometti fall somewhere in between.

Françoise Gilot's remark about the chair was made in a talk in the evening lecture series of the New York Studio School, fall 2002.

For the solitary male genius, see Caroline A. Jones, "Andy Warhol's 'Factory': The Production Site, Its Context, and Its Impact on the Work of Art," *Science in Context* 4 (1991): 101. The point is expanded in her *Machine in the Studio* (Chicago, 1996).

The Experimental Model

On the experimental model, see David Gooding, Trevor Pinch, and Simon Schaffer, eds., *The Uses of Experiment: Studies in the Natural Sciences* (Cambridge, 1989), and Brian Peppard's shrewd review of its implications in the *Times Literary Supplement,* September 29–October 5, 1989, 1057.

For an account of the relationship between painting and experimenting, see Svetlana Alpers, *The Art of Describing: Dutch Art in the Seventeenth Century* (Chicago, 1983). For the illustration of the working of the eye, see pl. 18, p. 42.

On early laboratory spaces, see Owen Hannaway, "Laboratory Design and the Aim of Science," *Isis* 77 (1986): 585–610, and Steven Shapin, "The House of Experiment in Seventeenth-Century England," *Isis* 79 (1988): 373–404.

In the Light-Box

Leonardo on studio light: *The Notebooks of Leonardo da Vinci,* ed. Jean Paul Richter, 2 vols. (New York, 1970), vol. 1, para. 515.

Bellori's remark on Caravaggio's studio lighting: "Che non faceva mai uscire all'aperto del Sole alcuna delle sue figure, ma trovò una maniera di campirle entro l'aria bruna d'una camera rinchiusa, pigliando un lume alto, che scendeva à piombo sopra la parte principale del corpo, e lasciando il rimanente in ombra à fine di recar forza con vehemenza di chiaro, e di ocscuro." Giovanni Pietro Bellori, "Michelangelo da Caravaggio," in *Le vite de' pittori, scultori et architetti moderni* (1672; Genoa, 1968), 251.

For the notion that the window refers to Nadar's photographic studio, see Larry L. Ligo, "The *Luncheon in the Studio*: Manet's Reaffirmation of the Influences of Baudelaire and Photography upon his Work," *Arts Magazine* 61 (1987): 46–51.

Michelangelo, on Vasari's account, said, "'No ti affaticare, che l'importanza sarà il lume

della piazza'; volendo inferire che, come le cose sono in pubblico fa giudizio s'elle sono buono o cattive." Giorgio Vasari, *Le Vite de' più eccellenti Pittori Scultori e Architettori,* ed. Gaerano Milanese (Florence, 1881), vii, 280.

Degas's journal entry of 1869 on working outside at twilight is quoted by Richard Kendall, *Degas Landscapes* (New Haven, 1993), 118.

The Phenomenological Experience

Meyer Schapiro on still life: "The Apples of Cézanne: An Essay on the Meaning of Still-life," in his *Selected Papers: Modern Art, 19th and 20th Centuries* (New York, 1978), 18–19.

James Lord on sitting for Giacometti in his first, shorter account: *A Giacometti Portrait* (New York, 1993), 37.

On the transitional object, see "Transitional Objects and Transitional Phenomena" (1951), in D. W. Winnicott, *Through Paediatrics to Psycho-Analysis: Collected Papers* (New York, 1992), 229–42. For the footnote on artistic expression, "Primitive Emotional Development" (1945), 150, in the same publication.

On the irrational impulse in human art-making, see Marion Milner, "The Role of Illusion in Symbol Formation," in *The Suppressed Madness of Sane Men* (London, 1988), 87, and also her brief and pungent "Vote of Thanks for Professor Gombrich's Ernest Jones Lecture," *International Journal of Psychoanalysis* 35 (1974): 411, which begins with reference to Gombrich's "Meditations on a Hobby Horse or the Roots of Artistic Form" (published in *Meditations on a Hobby Horse and Other Essays on the Theory of Art* [London, 1963], 1–11). Milner, a British psychoanalyst with a particular interest in art, speaks of symbols instead of transitional objects. Like Winnicott, she celebrates the inherent madness of merging or losing oneself in play. Freud, in withdrawing from the practice of hypnosis to analysis, turned away from this. On Winnicott's account, Freud also chose to turn away from clinical conditions in which it was logical to use hypnosis. His psychoanalysis replaced the immersion and identification of hypnosis with the analysis and transference of the talking cure, in which memory and narration have a distinctive part. This distinction was teased out in the recent dispute about trauma and its treatment. See in particular Mikkel Borch-Jacobsen, *The Emotional Tie: Psychoanalysis, Mimesis, and Affect* (Stanford, 1992), and Ruth Leys, *Trauma and a Genealogy* (Chicago, 2000), significant parts of which appeared in a different form in Leys's previous articles.

A similar point about Proust and painting is arrived at by Christiane Hertel in her study of the differing reception of Vermeer in Germany and France: "Proust thus defines death most strikingly and simply as the identity of past and present." *Vermeer: Reception and Interpretation* (Cambridge, 1996), 125. For the span of Proust, his text, life, and death, see Jean-Yves Tadié, *Marcel Proust,* trans. Euan Cameron (New York, 2000); for the viewing of the *View of Delft,* 744–46.

Studio as Retreat

"La quale historia è affatto senza attione" is what Bellori writes about Caravaggio's *Conversion of St. Paul,* in Bellori, *Vite de' pittori,* 254.

The point about Poussin and friendship is made by Elizabeth Cropper and Charles Dempsey, *Nicholas Poussin: Friendship and the Love of Painting* (Princeton, NJ, 1996), 177–215.

On Delacroix's reaction to the landscape on Courbet's easel, see Eugène Delacroix, *Journal 1822–1863* (Paris, 1981), 529. For the French text of Courbet's letter on his *L'Atelier,* Hélène Toussaint, *Le Dossier de "L'Atelier" de Courbet* (Paris, n.d.); for an English translation, *The Letters of Gustave Courbet,* ed. and trans. Petra ten-Doesschate Chu (Chicago, 1992), 131–34.

Landscape and the Studio Condition

For the appreciation of Thomas Jones, see Lawrence Gowing, *The Originality of Thomas Jones* (London, 1985), and the recent book accompanying the exhibition *Thomas Jones (1742–1803): An Artist Rediscovered,* ed. Ann Summer and Greg Smith (New Haven, 2003). It is now recognized that Jones's working out of doors was not an isolated phenomenon; see *Corot in Italy: Open-Air Painting and the Classical Landscape Tradition* (New Haven, 1991).

Cézanne read to Joachim Gasquet from Balzac's *Peau de chagrin,* "Une nappe blanche comme une couche de neige fraîchement tombée et sur laquelle s'élevaient symétriquement les couverts couronnés de petits pains blonds," and commented: "Toute ma jeunesse, j'ai voulu peindre ça, cetre nappe de neige fraiche." *Conversations avec Cézanne,* ed. P. M. Doran (Paris, 1978), 158.

Studio as Instrument

For Wilson and the cloud chamber, see Peter Galison and Alexi Assmus, "Artificial Clouds Real Particles," in Gooding, Pinch, and Schaffer, *Uses of Experiment,* 225–74, which appears recast in Peter Galison, *Image and Logic* (Chicago, 1997), 73–120.

Cézanne, landscape painting, natural knowledge, and the working of the mind, again as recorded by Gasquet, in Doran, *Conversations avec Cézanne,* 112, 110.

For art as problem-solving, see E. H. Gombrich, "The Renaissance Conception of Artistic Progress," in his *Norm and Form* (London, 1966), 7

Rodney Graham
Studio

For many years I couldn't afford a studio. Not that it mattered: I was doing conceptual work anyway. Not only lack of finances but the very adult "rigors" of my work forbade me to indulge in the infantilizing experience of a studio practice. Now I have changed my tune, pouring over those 1950s coffee-table books full of rich gravure plates of Picasso in his chateau/studio La Californie in Cannes, the ultimate artist's playpen, and after a sumptuous repast, I too dazzle my guests by making a cunning little sculpture out of an old Dover sole.

It was, in fact, the image of this playboy mansion of studios, if not the Playboy mansion itself, that inspired the first photo work I made devoted to the subject of the artist's studio. It represented the 1962 midlife crisis of a male professional with only a passing interest in art, who is galvanized by a gallery exhibition of Morris Louis paintings. He turns his quite expansive living room into a home studio to try his hand at some "pour paintings," on the premise (correct, as it turns out) that anyone can do this. This living room, outfitted with a state-of-the-art sound system modeled on that of the Playboy mansion, was considerably larger than the workspace of Morris Louis himself, who as everybody knows, made his very large paintings at home in the dining alcove of a very small Baltimore bungalow.

I am trying to make a new work on the subject of a nineteenth-century artist's studio in which I play a painter's model (posing as a fallen Zouave bugler). I am modeling my setting on the studio of Alphonse de Neuville, the ex-soldier and academic painter of military subjects who specialized in scenes of the Franco-Prussian War. De Neuville followed the fashion, started by Messonnier, of extreme meticulousness with respect to historical detail, and famously filled his studio to overflowing with guns and armor, helmets, sabers, spears, saddles, bridles, and other articles of a military nature (no mandolins on the wall here), partly as a result of his dedication to painterly realism and partly to impress the fact of his dedication upon his clientele.

I started painting recently because I now have a studio and as something to do to while away the hours, while works are being fabricated and photographs printed by other people. Of this I could say, like Picasso, that the only thing that saves me is the fact that I am getting worse, with the difference that he was very good to start with.

Rodney Graham, *The Gifted Amateur, Nov 10th, 1962*, 2007.

Donelle Woolford working in her studio, 2006.

Joe Scanlan
Post–Post Studio

Under the careful hand of the artist, the studio can be a magical place where materials, images, and even people come to life. Pygmalion's statue, Frankenstein's monster, Rrose Selavy, and the many incarnations of Cindy Sherman are but a few examples of the primordial power of the artist's lair.

Donelle Woolford is another entry in this line of avatars, an artist spawned from an admixture of postcolonialism, narrative license, craftsmanship, and branding. She was originally employed as my studio assistant. One day she stumbled onto a wooden collage that had an eerie resemblance to Cubism. Technically she was making the collage for me—it was, in parlance, a "work for hire"—but it seemed better suited to her character than mine. One collage led to another, a point of view and a personal history took shape, and in two short years she had become a full-fledged artist working in a studio of her own.

In the 1990s a generation of artists came to be known as "post-studio" artists because they did not make art by conventional means. Rather, they made work only when someone invited them to do so, usually in a faraway city. Their practice consisted of visiting the location, conceiving of an artwork, then having the logistical expenditure of producing the artwork (or some version of it) assumed by the host institution. In such an environment, the studio came to be seen as an anachronism, ill-suited for the "just-in-time" economics of the international biennial circuit. The studio was a place where paintings and sculptures got made—pejorative terms if ever there were ones.

In this decade a few artists like Pawel Althamer, Tino Sehgal, Artur Zmijewski, and myself are trying to rejuvenate the studio as a site of production by enlisting others to inhabit it for us, thereby outsourcing the labor of making art as well as the burden of authenticity—the burden of being studio artists ourselves. In what might be called a post–post studio practice, the idea of the studio artist makes a comeback, only now the artist is a paid actor performing on a set designed to look just like an artist's studio. IF the work that the artist-actor makes (or pretends to make) is just as good, it shouldn't matter whether the artist is real or not.

Carolee Schneemann
The Studio, June 22, 2009

It is emptying, it is filling. It is the constant site of permission—permission of uncertainty and the rarity of the circumstance in which I can address only my materials and the influences which may or may not bring them into a new form ... but the permission is that I can be in a solitary concentration ... the strands are pulling at research, at dream, synesthesia, at political outrage.... A beam of light through the western window reminds me to reposition a group of motorized fans.... The studio is full of nests. The nests are mechanical or perhaps organic, as in piles of straw or drawing papers or a provoking pile of printed images I have layered in the computer printer ... a digital printout being recalibrated by a slice of light shifted through a studio window.... There may be a tree at the window and as usual, the speeding, vibratory variation in the leaves is a filmic implication.... I get up and pace around in the uncertainty of the necessary implication of a very particular ultramarine streak projected onto a studio wall on which layering marks imply ...

When the studio is chaotic with materials to be organized, the very handling and shifting may lead to a concept for layered projection, a collage, a drawing. When the studio is very organized, there are ways to invite the shelves to begin spilling, small animal carcasses, paints, thumbtacks, shredded.... The studio permits shifts of scale and gravitational elements plunging across the paper, the space in which to see.

The domestic surround must be organized ... make the bed, do the dishes ... that stabilizing aesthetic, and then go into the studio and invite the unexpected, the accident, conjunctions which are still and always part of my own spatial unconscious ... out of which the conscious determination to shape, form as time in motion.... The studio has been specific as a landscape or small as a kitchen table. It had been a closet become film editing room ... it has become as high and wide as a barn, partly filled with the accumulation of what I make, have made, and am forced to caretake. I am comforted by the story that every artist of achievement sells very little work and all have a garage, a barn, a shed filled with works that the studio can no longer contain.

Carolee Schneeman studio, 2009.

Philip Guston was generous to me as a student first in New York City from the University of Illinois. He invited me to his studio in the Village. I did not, at that time, imagine that the marvelous personal history he shared was already part of his extended mythology. His studio was very bare with an oversized easel, the big gritty paintings stacked against the wall. Puffing on a fat cigar, he told me that before he could begin work in his studio, he had a daily exorcism to perform. He said, "First I have to banish my gallery dealer, then the art historians, the critics, the other painters I am close to, unknown persons, finally my family, and then, when I feel the studio is finally empty of these presences, I can occupy the space and begin to see the brushes, the paints, the canvas."

This studio is static and in motion. Grab on—wrestle it back down to earth.

Daniel Buren
The Function of the Studio

Of all the frames, envelopes, and limits—usually not perceived and certainly never questioned—which enclose and constitute the work of art (picture frame, niche, pedestal, palace, church, gallery, museum, art history, economics, power, etc.), there is one rarely even mentioned today that remains of primary importance: *the artist's studio*. Less dispensable to the artist than either the gallery or the museum, it precedes both. Moreover, as we shall see, the museum and gallery on the one hand and the studio on the other are linked to form the foundation of the same edifice and the same system. To question one while leaving the other intact accomplishes nothing. Analysis of the art system must inevitably be carried on in terms of the studio as the *unique space* of production and the museum as the *unique space* of exposition. Both must be investigated as customs, the ossifying customs of art.

What is the function of the studio?

1. It is the place where the work originates.
2. It is generally a private place, an ivory tower perhaps.
3. It is a *stationary* place where *portable* objects are produced.

The importance of the studio should by now be apparent; it is the first frame, the first limit, upon which all subsequent frames/limits will depend.

What does it look like, physically, architecturally? The studio is not just any hideaway, any room.[1] Two specific types may be distinguished:

1. The European type, modeled upon the Parisian studio of the turn of the century. This type is usually rather large and is characterized primarily by its high ceilings (a minimum of 4 meters). Sometimes there is a balcony, to increase the distance between viewer and work. The door allows large works to enter and to exit. Sculptor's studios are on the ground floor, painters' on the top floor. In the latter, the lighting is natural, usually diffused by windows oriented toward the north so as to receive the most even and subdued illumination.[2]

2. The American type,[3] of more recent origin. This type is rarely built according to specification, but, located as it is in reclaimed lofts, is generally much larger than its European counterpart, not necessarily higher, but longer and wider. Wall and floor space are abundant. Natural illumination plays a negligible role, since the studio is lit by electricity both night and day if necessary. There is thus equivalence between the products of these lofts and their placement on the walls and floors of modern museums, which are also illuminated day and night by electricity.

This second type of studio has influenced the European studio of today, whether it be in an old country barn or an abandoned urban warehouse. In both cases, the architectural relationship of studio and museum—one inspiring the other and vice versa—is apparent.[4] (We will not discuss those artists who transform part of their studios into exhibition spaces, nor those curators who conceive of the museum as a permanent studio.)

These are some of the studio's architectural characteristics; let us move on to what usually happens there. A private place, the studio is presided over by the artist-resident, since only that work which he desires and allows to leave his studio will do so. Nevertheless, other operations, indispensable to the functioning of galleries and museums, occur in this private place. For example, it is here that the art critic, the exhibition organizer, or the museum director or curator may calmly choose among the works presented by the artist those to be included in this or that exhibition, this or that collection, this or that gallery. The studio is thus a convenience for the organizer: he may compose his exhibition according to his own desire (and not that of the artist, although the artist is usually perfectly content to leave well enough alone, satisfied with the prospect of an exhibition). Thus chance is minimized, since the organizer has not only selected the artist in advance, but also selects the works he desires in the studio itself. The studio is thus also a boutique where we find ready-to-wear art.

Before a work of art is publicly exhibited in a museum or gallery, the studio is also the place to which critics and other specialists may be invited in the hope that their visits will release certain works from this, their purgatory, so that they may accede to a state of grace on public (museum/gallery) or private (collection) walls. Thus the studio is a place of multiple activities: production, storage, and finally, if all goes well, distribution. It is a kind of commercial depot.

Thus the first frame, the studio, proves to be a filter which allows the artist to select his work screened from public view, and curators and dealers to select in turn that work to be seen by others. Work produced in this way makes

its passage, in order to exist, from one refuge to another. It should therefore be portable, manipulable if possible, by whoever (except the artist himself) assumes the responsibility of removing it from its place of origin to its place of promotion. A work produced in the studio must be seen, therefore, as an object subject to infinite manipulation. In order for this to occur, from the moment of its production the work must be isolated from the real world. All the same, it is in the studio, and only in the studio, that it is closest to its own reality, a reality from which it will continue to distance itself. It may become what even its creator had not anticipated, serving instead, as is usually the case, the greater profit of financial interests and the dominant ideology. It is therefore only in the studio that the work may be said to belong.

The work thus falls victim to a mortal paradox from which it cannot escape, since its purpose implies a progressive removal from its own reality, from its origin. If the work of art remains in the studio, however, it is the artist that risks death ... from starvation.

The work is thus totally foreign to the world into which it is welcomed (museum, gallery, collection). This gives rise to the ever-widening gap between the work and its place (and not its *placement*), an abyss which, were it to become apparent, as sooner or later it must, would hurl the entire parade of art (art as we know it today and, 99 percent of the time, as it is made) into historical oblivion. This gap is tentatively bridged, however, by the system which makes acceptable to ourselves as public, artist, historian, and critic, the convention that establishes the museum and the gallery as inevitable neutral frames, the unique and definitive locales of art. Eternal realms for eternal art!

The work is made in a specific place which it cannot take into account. All the same, it is there that it was ordered, forged, and only there may it be truly said to be in place. The following contradiction becomes apparent: it is impossible by definition for a work to be seen in place; still, the place where we see it influences the work even more than the place in which it was made and from which it has been cast out. Thus when the work is in place, it does not take place (for the public), while it takes place (for the public) only when not in place, that is, in the museum.

Expelled from the ivory tower of its production, the work ends up in another, which, while foreign, only reinforces the sense of comfort the work acquires by taking shelter in a citadel which insures that it will survive its passage. The work thus passes—and it can only exist in this way, predestined as it is by the imprint of its place of origin—from one enclosed place/frame, the world of the artist, to another, even more closely confined: the world of art. The alignment of works on museum walls gives the impression of a cemetery: whatever they say, wherever they come from, whatever their

meanings may be, this is where they all arrive in the end, where they are lost. This loss is relative, however, compared to the total oblivion of the work that never emerges from the studio.

Thus, the unspeakable compromise of the portable work.

The status of the work that reaches the museum is unclear: it is at the same time in place and in *a* place which is never its own. Moreover, the place for which the work is destined is not defined by the work, nor is the work specifically intended for a place which preexists it and is, for all practical purposes, unknown.

For the work to be in place without being specially placed, it must either be identical to all other existing works, and those works in turn identical among themselves, in which case the work (and all other identical works) may travel and be placed at will; or the frame (museum/gallery) that receives the original work and all other original—that is, fundamentally heterogenous—works must be adjustable, adapting itself to each work perfectly, to the millimeter.

From these two extremes, we can only deduce such extreme, idealizing, yet interesting formulations as:

1. all works of art are absolutely the same, wherever and whenever produced, by whatever artist. This would explain their identical arrangement in thousands of museums around the world, subject to the vagaries of curatorial fashion;

2. all works of art are absolutely different, and if their differences are respected and hence both implicitly and explicitly legible, every museum, every room in every museum, every wall and every square meter of every wall, is perfectly adapted to every work.

The symmetry of these propositions is only apparent. If we cannot conclude logically that all works of art are the same, we must acknowledge at least that they are all installed in the same manner, according to the prevailing taste of a particular time. If on the other hand we accept the uniqueness of each work of art, we must also admit that no museum ever totally adapts itself to the work; pretending to defend the uniqueness of the work, the museum paradoxically acts as if this did not exist and handles the work as it pleases.

To edify ourselves with two examples among many, the administration of the Jeu de Paume in Paris has set impressionist paintings into the museum's painted walls, which thereby directly frame the paintings. Eight thousand kilometers away at the Art Institute of Chicago paintings from the same period and by the same artists are exhibited in elaborate carved frames, like onions in a row.

Does this mean that the works in question are absolutely identical, and that they acquire their specific meanings only from the intelligence of those

who present them? That the "frame" exists precisely to vary the absolute neutrality of all works of art? Or does it mean that the museum adapts itself to the specific meaning of each work? We may ask how it is that, seventy years after being painted, certain canvases by Monet, for example, should be recessed into a salmon-colored wall in a building in Paris, while others in Chicago are encased in enormous frames and juxtaposed with other impressionist works.

If we reject propositions 1 and 2 above, we are still faced with a third, more common alternative that presupposes a necessary relationship between the studio and the museum such as we know it today. Since the work which remains in the studio is a nonentity, if the work is to be made, not to mention seen in another place, in any place whatsoever, one of two conditions must apply; either

1. the definitive place of the work must be the work itself. This belief or philosophy is widely held in artistic circles, even though it dispenses with all analysis of the physical space in which the work is viewed, and consequently of the system, the dominant ideology, that controls it as much as the specific ideology of art. A reactionary theory if ever there was one: while feigning indifference to the system, it reinforces it, without even having to justify itself, since by definition (the definition advanced by this theory's proponents) the space of the museum has no relation to the space of the work; or

2. the artist, imagining the place where his work will come to grief, is led to conceive all possible situations of every work (which is quite impossible), or a typical space (this he does). The result is the predictable cubic space, uniformly lit, neutralized to the extreme, which characterizes the museum/gallery of today. This state of affairs consciously or unconsciously compels the artist to banalize his own work in order to make it conform to the banality of the space that receives it.

By producing for a stereotype, one ends up of course fabricating a stereotype, which explains the rampant academicism of contemporary work, dissimulated as it is behind apparent formal diversity.

In conclusion, I would like to substantiate my distrust of the studio and its simultaneously idealizing and ossifying function with two examples that have influenced me. The first is personal, the second, historical.

1. While still very young—I was seventeen at the time—I undertook a study of Provençal painting from Cézanne to Picasso with particular attention given to the influence of geography on works of art. To accomplish my study, I not only traveled throughout southeastern France but also visited a large number of artists, from the youngest to the oldest, from the obscure to the famous. My visits

afforded me the opportunity to view their work in the context of their studios. What struck me about all their work was first its diversity, then its quality and richness, especially the sense of reality, that is, the "truth," that it possessed, whoever the artist and whatever his reputation. This "reality/truth" existed not only in terms of the artist and his workspace but also in relation to the environment, the landscape.

It was when I later visited, one after the other, the exhibitions of these artists that my enthusiasm began to fade, and in some cases disappear, as if the works I had seen were not these, nor even produced by the same hands. Torn from their context, their "environment," they had lost their meaning and died, to be reborn as forgeries. I did not immediately understand what had happened, nor why I felt so disillusioned. One thing was clear, however: deception. More than once I revisited certain artists, and each time the gap between studio and gallery widened, finally making it impossible for me to continue my visits to either. Although the reasons were unclear, something had irrevocably come to an end for me.

I later experienced the same disillusion with friends of my own generation, whose work possessed a "reality/truth" that was clearly much closer to me. The loss of the object, the idea that the context of the work corrupts the interest that the work provokes, as if some energy essential to its existence escapes as it passes through the studio door, occupied all my thoughts. This sense that the main point of the work is lost somewhere between its place of production and place of consumption forced me to consider the problem and the significance of the work's place. What I later came to realize was that it was the reality of the work, its "truth," its relationship to its creator and place of creation, that was irretrievably lost in this transfer. In the studio we generally find finished work, work in progress, abandoned work, sketches—a collection of visible evidence viewed simultaneously that allows an understanding of process; it is this aspect of the work that is extinguished by the museum's desire to "install." Hasn't the term installation come to replace exhibition? In fact, isn't what is installed close to being established?

2. The only artist who has always seemed to me to exhibit real intelligence in his dealings with the museum system and its consequences, and who moreover sought to oppose it by not permitting his works to be fixed or even arranged according to the whim of some departmental curator, is Constantin Brancusi. By disposing of a large part of his work with the stipulation that it be preserved in the studio where it was produced, Brancusi thwarted any attempt to disperse his work, frustrated speculative ventures, and afforded every visitor the same perspective as himself at the moment of creation. He is the only artist who, in order to preserve the relationship between the work and its place of production,

dared to present his work in the very place where it first saw light, thereby short-circuiting the museum's desire to classify, to embellish, and to select. The work is seen, for better or worse, as it was conceived. Thus, Brancusi is also the only artist to preserve what the museum goes to great lengths to conceal: the banality of the work.

It might also be said—but this requires a lengthy study of its own—that the way in which the work is anchored in the studio has nothing whatsoever to do with the "anchorage" to which the museum submits every work it exhibits. Brancusi also demonstrates that the so-called purity of his works is no less beautiful or interesting when seen amid the clutter of the studio—various tools; other works, some of them incomplete, others complete—than it is in the immaculate space of the sterilized museum.[5]

The art of yesterday and today is not only marked by the studio as an essential, often unique, place of production; it proceeds from it. All my work proceeds from its extinction.

This essay, written in 1971 and first published in English (trans. Thomas Repensek) in October 10 *(Fall 1979): 51–58, is one of three texts dealing with the art system. The others were "Function of the Museum," published first by the Museum of Modern Art, Oxford, and subsequently in* Artforum *(September 1973), and "Function of an Exhibition,"* Studio International *(December 1973).*

1 I am well aware that, at least at the beginnings of and sometimes throughout their careers, all artists must be content with squalid hovels or ridiculously tiny rooms; but I am describing the studio as an archetype. Artists who maintain ramshackle workspaces despite their drawbacks are obviously artists for whom the *idea* of possessing a studio is a necessity. Thus they often dream of possessing a studio very similar to the archetype described here.
2 Thus the architect must pay more attention to the lighting, orientation, etc., of the studio than most artists ever pay to the exhibition of their works once they leave the studio!
3 We are speaking of New York, since the United States, in its desire to rival and to supplant the long lamented "School of Paris," actually reproduced all its defects, including the insane centralization which, while ridiculous on the scale of France or even Europe, is absolutely grotesque on the scale of the United States, and certainly antithetical to the development of art.
4 The American museum with its electric illumination may be contrasted with its European counterpart, usually illuminated by natural light thanks to a profusion of skylights. Some see these as opposites, when in fact they merely represent a stylistic difference between European and American production.
5 Had Brancusi's studio remained in the Impasse Ronsin, or even in the artist's house (even if removed to another location). Brancusi's argument would only have been strengthened. (This text was written in 1971 and refers to the reconstruction of Brancusi's studio in the Museum of Modern Art. Paris. Since then, the main buildings have been reconstructed in front of the Centre Baubourg, which renders the above observation obsolete—author's note.)

Daniel Buren
The Function of the Studio Revisited: Daniel Buren in Conversation

Thirty-five years ago Daniel Buren wrote a text entitled "The Function of the Studio," which remains key in the artist's career-long treatise on the "desertion of the studio and its implications" for artworks. In this early text Buren declared his rejection of the studio and a commitment to working in situ and allowing the physical context of the exhibition site to influence the artistic outcome, a modus operandi he has maintained throughout his career. In advance of the exhibition "The Studio" at the Hugh Lane Gallery in Dublin, in which he was a participating artist, Daniel Buren was invited to revisit this text.

The function of the studio is absolutely, basically, the same as it always was. The studio as I defined it in 1971 has not changed, although perhaps more artists are escaping their studios today than when I wrote "The Function of the Studio." Artists have a much looser idea of what constitutes a studio than they did in the early 1970s. However, I think it is still the main place of work for the majority of artists.

The function of the studio is the making of a work of art for an ideal place, a work which may be endlessly manipulated. If you work most of the time in a studio you produce works that are destined to be installed somewhere else. That was the key point of my text—in a studio you produce work to be shown anywhere—whether in a gallery, museum, or private collection—and you must work with a preconceived idea of what these rooms might be like, as the final destination of the work is totally unknown.

It is a different case when the artwork calls on the specifics of its location for its identity and completion and cannot be installed or seen in another place. This returns us to the idea of the site as an integral component of the work whereby it can only be understood at that site, which is in turn transformed by the artwork, forever or for the time that they are together. If the work is created thus there is a break from the idea and the idealism of the studio.

When the studio becomes a place to work on something that will be

visible only at a particular site, then the spirit of production is entirely different. But the function of the studio as I defined it a long time ago is exactly the same even if the work seems to be different. A studio obliges a certain type of work even if you are just using it to prepare a plan. Today, of course, you have many more variations of the studio, yet that which I defined in the text is still completely valid in the majority of cases. The system still prescribes the result under the same restrictions.

The studio process creates objects that complement our society of exchange and market value. The market value of an artwork that is produced in the studio is directly influenced by exchangeability and critically relies on an eternal nomadism, not of the producer but of the artwork. Needless to say, I reversed that habit. The art market barely existed in 1971. It is a hundred times more prevalent now than when I wrote the text. Then it existed for historical art rather than for any young working artist, and it would have been a dream to even survive by selling work. Today, if you start out as an artist at twenty years of age you cannot imagine that you are not going to make an adequate living from your work. If you cannot, you simply do not do it. In the 1980s, although it was a little provocative, there were artists who would say, "If I'm not commercially successful in two or three years I'll go back to the stock exchange and stop what I'm doing." The most surprising thing is that some of the people who said that succeeded with their art, such as Jeff Koons. Not that he represents the majority, as obviously it was and still is very hard to survive on artistic production. Today artists are much more aware of the market than was the case thirty-five years ago, reinforcing even more the idea of objects that are absolutely born of the studio.

In the context of the Francis Bacon studio on permanent display at the Hugh Lane there is much of interest to many people, particularly if they do not already know much about Bacon. It is informative to the curious but anecdotal, going beyond the banal but not contributing to the analysis of the studio and even less to its criticism. Nor does it make us appreciate to any greater or lesser extent the works that such a place permits to be created. On the contrary it shows the particularity of a studio that has been used by a famous artist, a particularity that always exists and each time is unique, whoever the artist. This great artist, even at the end of his life, already extremely rich, living and working in such garbage ... maybe he was a little nuts! At least somebody would dare to say so after seeing the studio. So such a studio gives us an idea of the personality of the artist and surprises us with the state of his studio, but that is all. For me, it has nothing to do with the question of the studio. The function of the studio is the same. Reconstructions of artists' studios such as those of Pollock or Mondrian made you feel a little closer to the artist, as a film might do; it's sentimental, it's curious,

it's charming, it's negative, or it's positive. But the function of the studio is as it always was and still remains for the majority.

In 1971 my standpoint was unusual because, to the best of my knowledge, Brancusi was the only one who saw the contradiction between the work and the way that the work was shown. In leaving his studio to the French state he decided to keep the very lively aspect of the artist in the studio where the work was most comprehensible. He wanted to show that it is this site where the work is most readily understood. It is where you speak with the artist and see the environment where he creates. In the case of the Brancusi studio, in its first incarnation, you had a conceptual totality as designated by the artist rather than a reconstruction that was never requested by him, as happened later when the studio was reconstructed outside the Pompidou Centre in 1977 and again and even worse in 1997. From this history two perspectives are presented that define contrasting attitudes: criticism or analysis.

For me, analysis leads to criticism and criticism leads to action. In 1968, when I decided to quit the studio, I hadn't realized all of the implications. Many familiar doors were immediately closed to me, although luckily others opened that I hadn't even been aware of. To not have a studio, as well as to have a studio, automatically implies the production of a certain type of work. I can see that the day when I cannot move or travel anymore, as I have done over the past forty years, I will either stop working or my work will be different. The only thing that I can imagine helping to keep it going in its present form might be my long experience of moving and looking at different places. Perhaps with documentation I could still work, but I would miss those little details that you can only see when you are there, when you meet people. My work would be completely different and certainly, as far as I tell from my viewpoint today, would revert to more traditional aspects. I prefer not to think about it!

...

From The Studio *(Dublin City Gallery, 2007), 104–6. Abridged from a conversation between Daniel Buren, Jens Hoffmann, Christina Kennedy, and Georgina Jackson, Dublin, September 26, 2006.*

Carrie Moyer

Color is what separates one shape from another.

I start by offering this cheeky, inscrutable one-liner often quoted by painters of a certain age. In other words: "Don't look for any explanations here." For some of us, one of the seductions of painting is how slippery it is, how spoken or written descriptions can never quite pin it down. We may talk endlessly and eloquently about and around the work. In the end, though, painting always seems to trump language. It needs to be seen in person to be really understood.

When I started on this body of work several years ago, the iconic imagery of seventies feminist art hovered around the edges of my studio. I was looking for forms that were nearly recognizable and that generated the preliterate force of the Venus of Willendorf. I trolled the Web, used bookstores, and museums looking for ritual vessels, sculptural "prosthetics" (headdresses, masks, armor, and weapons), and ethnographic oddities that could be morphed into fearsome and/or sexualized silhouettes. More recently I find myself transfixed by Oceanic, Inuit, and pre-Columbian objects similar to those collected by André Breton and the Surrealists. Is the world really such a finite place, filled with a fixed (and paltry) number of things to look at? Or am I susceptible to the same aesthetic charms that so radicalized the early modernists nearly a century ago? This thought both horrifies and delights with its insinuations of cultural myopia and art historical patrimony.

These days I enter the studio with less language than ever and start by picturing shapes already preloaded from a long-accumulated image bank. Through the interplay of abstract shapes, glitter, and transparent veils of acrylic, I gradually transform these suggestive yet "blank" forms into personal avatars. In the process, long-held politics of representation are sublimated and eclipsed by a strong urge to bring design and craft to a kind of arresting, pictorial stasis. Inventive, meticulous facture becomes the evidence of painterly expression, rather than the usual signifiers of gesture and brushy mark. However, unlike Max Ernst, whose technical innovations were generally tied to specific

Carrie Moyer studio, 2009.

pictorial content (for example, decalcomania was used to suggest plant or marine matter), I am interested in cross-wiring the sign values of how paint is put down and what is depicted.

Ironically, in my paintings color rarely does the job of separating shapes from one another. Instead the application of color is the signal event that drives each painting. Shiny, plastic slicks of paint and glitter dissolve hard edges, while stippled, iridescent glazes define the nooks and crannies of individual forms. Flat-colored grounds serve to both restrain *and* heighten the luminosity and the action of the pour. Exposed areas of raw canvas, seemingly cut out of the picture plane, allow the viewer to look in and see the "back" of the painting. Through the complex, interlaced layering of shape and color, the narrative of *how* the painting was made becomes obfuscated, imbuing the final image with a kind of timelessness and mysterious presence.

Marjorie Welish, studio installation with works from the series "Indecidability of the Sign: Frame," 2008.

Marjorie Welish

A thought experiment: Let us consider theories of the studio drawn from poetics. Theory of the studio drawn from poetics has the advantage of regarding practice through principled models and so lends our practice a theoretical perspective. What is the knowledge that the studio embodies then?

The Mimetic Studio imitates no actual studio, yet attains to the Idea of the studio, compared with which actual studios and practices are merely appearances.

The Pragmatic Studio delights as it instructs. Here, out of the encyclopedic artisanal techniques and disciplines performed through an experienced hand, the demonstrated knowledge of an art manifests itself in the object. As they render the art-in-progress palpable, the habitats constituting the studio leave traces of the progress that fascinate the visitor.

The Expressive Studio issues from the artist and her genius, and in this sense her originality becomes the measure of the art created and the test of intentions professed by the artist to a visitor on behalf of the art.

The Objectivist Studio constructs an artifact from the store of materials and techniques, and also the social forces that put pressure on realizing artworks, the workings of art. This studio-as-such, articulated through display, may suggest a rhetoric for exhibition practices, audience, and reception.

Recent developments further the postanalytic position. The Discursive Studio researches cultural presuppositions assimilated through praxis; it assumes the studio to be a knowledge inscribed in language, and so addresses the studio as a rhetorical situation rather than as a logic, a problem rather than a place.

The Reading Studio meanwhile gives warrant to postanalytic evaluations wherein differential descriptions are welcome. In this realm of interpretive indeterminacy, translation tends to enhance differentials and incommensurables from within plausible responses; comparing several interpretations of artwork also tests the difference between what is plausible and all that is possible to say.

Let the studio as knowledge be viewed through speculative lenses such as these.

Marjorie Welish
The Studio Visit

Although many of us have rejected the Romantic notion of artist as creative genius, we critics still cling to the related notion that the studio is an arena where an artist grapples with creative process. An artist's invitation to visit the studio, then, would seem like a gesture of uncommon intimacy. Affording the critic the privilege and responsibility of helping the artist to articulate the issues giving rise to his or her art, the studio visit further allows judgment of what has been going on in this creative sanctuary.

Contrast this practice with an eighteenth-century instance of opening the studio to the public. It was a big step in the prehistory of alternative spaces when in 1785 Jacques Louis David, in opposition to the official salon, opened the doors to his Roman studio to allow the public to view *The Oath of the Horatii*. An immediate clamor registered as reviews in foreign newspapers, in response to this subversive political image. The privacy of the studio had allowed the artist to utilize impeccable neoclassicism for expressing a revolutionary sentiment so powerful that, despite its antigovernment message, David's painting was received into the annual Salon back in Paris—a practically instant conversion from private creative to shared public experience.

By contrast, opening a studio to an informed audience of one does not risk public notoriety. Glorious or abysmal, a critic's visit does not even count as a public event. Compared with the publication of David's canvas, the typical studio visit today suggests an augmented privacy, as controlled an opening as can be imagined. Extending an invitation to a critic risks only such interpretation and evaluation as the artist is bound to hear, with no repercussion of widespread recorded judgment.

However else it may be defined, a studio visit is an occasion for dialogue within the assumed context of approval. Before inviting a critic to visit, the artist has already induced through casual conversation or at least through published writing that the critic might "like the work." The implication is that an elaborated form of the same sort of rapport will follow once the

critic and artist are alone together. Twenty years of making and receiving studio visits tell me that, fearing denunciation, most artists will tolerate some probing questions if plenty of encouragement cushions the tough engagement. Some artists extract a different arrangement, however, and seek to gratify a need for dialogue or approval. Both extremes, contention and admiration, are populated. Of the two, the more common situation is of course the one in which the critic is invited only to admire, and one way or another the artist will manipulate the critic into that stance. Rare, but frequent enough to note, is the situation in which broad-based intellectual rapport between artist and critic suffices to establish trust; then the artist will invite dialogue and a fair degree of contention because he has faith that a common aesthetics or ideology will at last harmonize all differences of belief. A view from both these margins is instructive. Where the artist manages to extract critical approval at all costs, grooming is not merely the preferred contact, it is mandated. Under these circumstances, the critic has no choice but to think that the artist standing before him may not be reconciled to tha fact that the work of genius is rare. Harboring the dream he is this rare bird, he asks: what do you think of my paintings? To reverence the forgivable delusion, but also to establish initial courteous contact, my answer to this question will take the form of either a brief description or a one-sentence analysis of what I take to be the art's central concern. If I persist in my description of the painting, it is by way of signaling that matching hospitality with hospitality is all I deem he really wants from me.

At the moment I have in mind one person who, including me among weekend guests, was proud, insecure, and sensitive to all manner of latent content expressed visually and verbally, so there was no question he "picked up on" my intention to stay within the decorum framing our encounter. But as it happened, he pressed further, "Yes, but what do you think?" The artist was evidently pressing for positive evaluation, but despite my being his guest, I deflected his question, signaling that if he pressed further he would indeed get a serious evaluation of his work, but one probably not entirely to his liking. This person—code name Mansfield Park—tends to indulge in certain kinds of outflanking maneuvers. "I know, you hate my work," he cried out. Such a declaration coerces the critic into a position of conciliation, if not retreat ("No, I do not hate your work"). He claimed to be doing paintings of "passion," but at no point during this or subsequent visits could I adequately sidestep his psychological manipulation. I was thus unable to respond candidly and say that his considerable manual facility and complicated mental contrivance presented obstructions to his hoped-for passion but could be turned to advantage if he were willing to forge a style from a gestural chinoiserie tantalized by Abstract Expressionism's passion. Another

studio visit inspired the outcry, "But an artist doesn't want to hear the truth; he wants lies!"—a statement which I take to mean both that an artist lives by delusion and that an artist may himself articulate his faults although a critic may not.

A lesson learned here concerns the perils of hospitality. Many artists carefully refrain from impressing the critic or at least from wearing down his resistance to their art through extra-artistic means: the exploitation of hospitality, including the ubiquitous seduction-by-cuisine, and appeals through name-dropping, if not the actual presence of celebrities, to sway the critic's impartiality. Indeed critics are impressed by social milieu. One *New York Times* critic has given special dispensation to artistic scions of the well-connected famous, even arguing in one lead article that we can scarcely doubt Juan Gris's artistic ability: why, look whom he knew ... This critic is not alone in assuming that social circle valorizes art. The forms an artist's manipulation takes may even entail adjusting the personality or enhancing the pathos of his life story to appeal to the "human" side of the critic and soften the critic toward the art.

Critical manipulation often entails an artist's presenting his art as exemplary of his beloved ideas. This campaign may start with an explanation of "what my work is doing," then proceed as a not-so-harmless orientation that presupposes aesthetic intention to be sufficient and, of course, sufficiently fulfilled by the art. But more often than not, the in-house conscience a critic represents uncovers a discrepancy between intention and realization. If the critic says so, what follows is a moment of tension, perhaps even of defensiveness. Mature artists and critics, sensitized to the vulnerability of the situation, can convert this impasse to constructive dialogue. But whenever the artist insists that his intellectual agenda is perfectly realized, or is so defensive that his ideology remains impervious to all questioning, he is in effect demanding worship by foreclosing all other discussion.

Ms. Prision, as I will call her, is a conceptual artist working in mixed mediums, whose topic in the past has been gender politics. But she betrays more aptitude for craftiness than for troping ideas. Her most promising batch of work succeeded where most artists fail, evincing a masterly structure. Creating a fresh metaphor for rote female iconography, however, did not lead her far enough, and subsequent work brandished a shrill visual punch to compensate for an attenuated and confused content. After listening to her rap during a studio visit, I expressed skepticism as to whether her art in fact embodied the content she professed it did; I dared not say more. Highly articulate, the artist was also alarmingly fierce in presentation of intention, and hostile when I made a verbal misstep. I dared not say that the discrepancy between her deconstructive rap and her art proved rather her infatu-

ation with the intellect and, in this case at least, an unconfessed careerism. Nor did I say that the art itself betrayed, despite her alleged intellectual authority, a limited capacity for self-critique. Given her recent artistic direction, she seemed surprisingly oblivious to her collaboration with the culture industry—her art remaining fashionable because superficial or sporadic in assimilation of major ideas. Intellectual affection, not thoroughgoing style, was her accomplishment. Previous gallery press releases told me what I saw confirmed in the studio: the artist's interpretation of the work had begun to shift seasonally to accommodate the latest intellectual trend. When I expressed doubt that the work can so effortlessly shift content at a moment's notice, she replied that, as I wrote in my piece on Yves Klein, every new shift in cultural context alters the reading of art, and so changes its meaning. Not proven by her appeal to reception theory was whether her artifacts enact any one cultural shift adequately, let alone manage the infinite regress of historicism she desires.

The most taxing encounter in the studio occurs with the ideologue precisely because, if he has mastery over the concepts and arguments supporting his belief system, he can effectively "control the board." Also, his art may fulfill the obligations of his theory to perfection. But if that perfection is academic or labored, the artist will be reluctant to see it, for he has become so expert in visualizing the theory that critical perspective is indeed difficult. Moreover, a lifetime of devotion to the transcendence conveyed by the sensitive facture of Symbolism, or to the materialist implications of modernism, or to the idea of functionalism as democratic, is not apt to be susceptible to the well-intentioned exegesis of a nonbeliever or a relativist. The critic who expects to be able to overturn the very validity of the ideology itself is unrealistic. To be effective as a critic in this situation, one must demonstrate respect for the intellectual paradigm and work with the artist's assumption that art is normative if the artist is to see how he can transcend his obligations while fulfilling them. Then the artist might concede that something like a pictorial analogue of doctrine would indeed be unworthy of him. All critics must have encountered highly intelligent, totally rigid artists of this type. It is so obvious to such an artist that there is only one way of creating art—his. Yet his fanaticism may also be the sort that appreciates genuinely radical art, knowledge profoundly and rigorously addressed. These are potentially the great artists, or at least the great historians. Their intellectual passion is so highly developed that they would rather sacrifice their art than the style they are defending to the death.

Explanations for this defensive behavior conventionally invoke the psychology of the artist. If one accepts the psychoanalytic paradigm wherein love and death are axiomatic, then it follows that art may emerge from the

activities of pleasure as they assume a kind of paradise of self-expression. The artist identifying with such pleasure is a narcissist, at least to the extent that he is devoted to making a world that "loves him" as he loves it. The palpable suspicion radiating from an artist throughout a studio visit may originate in apprehension of the critic, who after all symbolizes the possible agent of wounding and harm. Indeed, when threatened by the questions a critic poses, all the artist's self-protective alarms go off. The Stranger Is the Enemy might well be the motto of the most defensive artists, despite the fact that the professional art critic trained in art history and conversant with modern art and its ideological implications, including postmodernism, should be much more likely than a dealer or collector to give relevant responses, complex pertinent analyses, and generally to work at full intellectual extension in evaluating the art.

The narcissistic type may readily affiliate with an art that is patently libidinous in form and content, and where, compounding the situation, the artist poses not so much a defense of doctrine as a defense of sensibility. Let's call this person Louis XV. An abstract expressionist whose stylistic omnivorousness forages among rococo and surreal idioms, all put in the service of a brilliant sense of decor—this painter (and a particular one does come to mind) is gifted in the extreme, capable of genuinely imaginative applications of his inherited visual languages. At his best, he proves that decoration is a profound mind-set.

Familiar with this artist's work and decidedly predisposed to it, I was unprepared for the disastrous course of events that occurred in the studio. No doubt about it, this artist's sense of entitlement was monstrous enough to extend even to dictating the terms of my praise. The vocabulary—the very words—characterizing and esteeming the art were adjusted if they deviated from the artist's preferred image of himself. Not surprising then, though I was unprepared for it, was his massive denial of critical—that is to say, analytical and discriminating—comment, and, when reservations were expressed, his conversion of negative to positive value. To the suggestion that a work of his was "breezy," for instance, came the correction that it was a work of "virtuosity." Subsequently, whenever a studio visit came about, he made sure to tell me how long he had worked on his paintings, having filed away in his mind that I esteemed art that took time to hatch—or rather, this was the interpretation he gave to my remarks. Soon after, when I confessed my shock to a writer whose highly developed visual faculty surpasses that of many professional critics, she told me, "I always tell him, 'Wonderful, just wonderful!', because he throws a tantrum if you tell him anything else."

Editors, biographers, and historians have been known to express themselves narcissistically. Artists have no exclusive rights to this. Positively

speaking, narcissism as theory of creativity extends well beyond art and permeates cultural artifacts ceaselessly. In arriving at original solutions the minds of genius mathematicians and physicists are impregnated by imagination, as, for instance, the achievement of the late Richard Feynman would attest.

Furthermore, narcissism constitutes a Romantic theory of creativity that, as fruitful as it is, does not exhaustively comprehend the aesthetic impulse. The normal vulnerability of the artist to criticism of an artifact built of his overflowing libido may, in an artist who values ideas or issues more than his pleasure, drive the creative process well beyond self-commemoration. He may elect an aesthetic that he deems the most culturally progressive not because he likes it, even less because it likes him. To paraphrase the composer Arnold Schoenberg: I didn't want to be Arnold Schoenberg, but no one else volunteered. An aesthetic commitment often originates despite the artist's desires, despite the wish for dilettantism which glides past unwanted, troubling thoughts.

If the studio visit offers an opportunity for dialogue predicated on approval, the situation is by no means always a matter of adoration. An invitation to visit often comes about despite no promise of flattery, no demonstrable liking of the artist's work. A prelude to the visit, then, is trust posited on common philosophical ground. Artists of this kind, who require only intellectual rapport, not psychological obeisance, are eager to engage in a dialogue with the critic.

I remember writing a mixed review of surrealizing pictures of deer portraying omniscient animal intelligence, aware of the likelihood that, as so often happens, my acquaintance with the artist would sour once the review appeared. Months later, he approached me to say that mine was "an interesting review—let's talk about it." For once, a negative review inspired not boycott but an invitation to further discussion. Nor was this artist coy in his intention, for in the studio, sitting on kitchen chairs and sipping tea, he asked me to explain what I had meant when I wrote that his visual sophistication was far in advance of his literary ability. Remarkable to me, as I learned while visiting him, was this artist's deep appreciation of that which is problematic. Less concerned with gossip than many artists, he was much more concerned with tracking intellectual nuance than in psychological backbiting. Moreover, during subsequent studio visits he followed through the implications of our literary dialogue. How to get past literal and naive portrayal of mythopoetic content became the springboard of many discussions leading far beyond his own immediate interests. Allegory versus myth, a topic of central concern to this artist, became a much more inclusive issue as time went on. The problematic nature of mannerism, so threatening to Ms. Prision,

was endlessly fascinating to Sky Watcher, as were such matters of taste as whether certain painterly approaches to subject matter are too "ingratiating." Time and time again, this painter, not the visiting critic, raised critical issues that were troubling him, testing his articulation of the problem by restating it, as if holding it up to the light for examination. However involved in his own art, Sky Watcher consistently demonstrated greater commitment to the connoissership of aesthetic issues than to any particular cathected object. The philosophical matter that brought us together initially, namely, the nature of metamorphosis in art, was instrumental in transforming the studio visit itself from a simple-minded reflection of the artist's worldview to a situation animated by mutual respect for the independence of thought on a variety of topics.

Positive attraction to the Other, to the viewpoint that complements one's own, provides the stimulus for inviting dialogue. To gauge whether a conversation is a genuine dialogue (or only parallel monologues, or even a single monologue by virtue of the speaker's vetoing the words of his companion) one need only listen for "the creative process" in verbal exchange. In this regard, artists are often not engaged in a creative process at all; all the more noteworthy, then, when in the studio they encourage a give-and-take of ideas.

Rare though it may be, this need by the artist for intellectual engagement and growth has been underestimated. With one young artist, intellectual rapport grew casually and sporadically several years before a studio visit transpired. Our rapport developed undiminished even as it became obvious that our aesthetic "positions" often markedly divergent. Notably, a mismatch climaxed in his disavowal of De Stijl: "It's not natural to love Mondrian," he said. Whereupon I confessed to a strong bias ever since seeing his art in reproduction as a child; Mondrian was indeed the first art I "loved." Meanwhile, his funky sculptural reliefs hanging in a loft he shared had elicited no response from me; to his recent talented, if belated, Symbolist painting, I had remained noncommittal until he initiated a studio visit. Then, this artist, whose name should be the Emerging City for always exercising his sense of inquiry, his strong analytical bent, and his contempt for "bullshit" in himself as well as in others, presented his cargo of several years' canvases. As our studio visit wound down, he confessed his impatience and disappointment with the "mere" praise given him by other visiting critics and artists, for, lacking concreteness, "it gave me nothing to go by."

Here, then, was an artist who was frustrated by the truth of praise. He complimented me for giving a "useful," specifically, discriminating, analysis and evaluation of several paintings. I in turn was delighted he had responded to a tactic I had hoped would be helpful. Given his analytic mind, I let him

in on my interior monologue while scanning the paintings: I thought aloud. "Considering such-and-such to be his art's aim, then it might by strengthened by so-and-so," my response went, presenting him with a series of contingencies. Extremely unusual was this artist's insatiable appetite for more and more specifically directed challenges from the critic.

When dialogue, not praise, becomes privileged, the success of a studio visit would appear to rest less on agreement than on evidence that the integrity of the critic's response matches the integrity of the artist's own: weak work must be unmasked, strong work must be discerned for what it genuinely achieves. The artist will require explanations in support of aesthetic judgments, and will be on the lookout for reasons that "click" with him. Not that artists eager for discourse accept challenge on all fronts. An artist seeking dialogue may be inarticulate or else touchy about being compared to his or her peers yet may nonetheless be content if only the studio visit becomes therapeutic. Like the student testing a substitute teacher, this artist will distrust, if not disrespect, the pushover who cannot track his situation accurately. Getting away with murder is not the goal; being found out is.

Historically, an exemplar is Eugene Delacroix. We know from his journals that Delacroix's self-esteem depended on his own highly developed self-critical acumen. So when Alexandre Dumas visited his studio, avidly taking notes, the artist confided his distaste and embarrassment at such vulgar worship of genius that would make of him "a hero in a novel." Delacroix evidently found this form of worship repugnant. Here is an example of a genuine Romantic genius who did not subscribe to an uncritical application of the Romantic notion of genius, who was unwilling to turn genius into a rank stereotype.

Delacroix's journal also reflects his cool attitude toward Baudelaire, who adored his art. Though he found Baudelaire "modern and Progressive," the painter remained uneasy about being attached to an aesthetic of "obscurity and confusion" that linked him with Poe's verses. One may add that Baudelaire's subjective identification with Delacroix exposed the limits of his effectiveness as a critic. Calling Manet the best of a bad lot, he failed to grasp Manet's meaning, much less appreciate it, precisely because that painter's excellence was posited on aesthetic principles radically at odds with his. Nevertheless, thanks to his own honed critical faculty, Delacroix could note in his journal that the poet/critic had given him something to think about.

A psychological explanation for artists' ability to take risks in dialogue is that they have assimilated the critical principle and made it their own, embracing it as a source of the enrichment of pleasure, not a threat of pleasure's extinction. Perhaps a supreme confidence in their ability to realize

anything they set out to do inspires in some artists this sense of adventure. Yet one continually witnesses less gifted artists who, even so, have remained friendly with the superego, posing questions during a studio visit that the critic has neglected to pose, inviting intense critical engagement even though this may undermine their own control of the situation. And though, paradoxically, as the existential writer Arturo Fallico says, "the art work does not come into being to be criticized," criticism is not extrinsic to art. It is as integral to art as it is to existence.

Where artists initiate or sustain dialogue, we must credit them with something more than narcissism, or at least with a gratification that is so culturally ambitious it seeks conceptual horizons far beyond pleasure. Art as enactment, according to Richard Kuhns's psychoanalytical critique of Freud, frees the artist from the stigma of stunted maturity and enables him or her to join the more comprehensive creative process of culture at large. Citing Anna Freud, Kuhns redefines creative process to include conceptual growth by which "instinctual processes connected by ideas can be brought into consciousness." Just this process of intellectualization, Kuhns says, we see expressed in style. Art as enactment is also Kuhns's reconciliation of psychoanalytic with existential values, of tradition individually constituted, of tradition in which each human is answerable for his assertions.

In that case, dialogue in the studio can be an invitation extended to the critic to move beyond description to interpretation that exposes the philosophical underpinnings of the art on view. During the last few decades we have seen the creative critic on the rise, though he is often unlikely to be welcomed by the artist unless his interpretation affectionately confirms the artist's propaganda. Deconstruction offers the most freewheeling sort of speculation moving independently of the art, but it is only the most extreme instance of critique that investigates face-value description. Realigning criticism from objectivity to subjectivity and from production to reception allows the critic intimacy with the creative process formerly guarded so securely by the artist. Curiously, the rise of creative criticism and the theories of reception have coincided with the lessening power of the art critic to stem the tendency of fashion to supplant art history.

The myth is that the artist is the one victimized by the critic. But the critic can be rendered helpless too. Aesthetic coercion by the artist is not confined to an occasional bully. More prevalent than believed, the artist's manipulation of the critic in the guise of informing him is a source of pressure that the critic can always brace himself to expect. For this reason, the notion of the studio as site of creative struggle is so often compromised. This myth should at least be questioned. In *The Trial*, "K" discovers that the painter's garret, though it may be entered only by way of a torturous route, actually adjoins

the corridors of the courts of law where he is being prosecuted; indeed, the painter is in league with the "system." Kafka knew that under certain circumstances the artist is perfectly capable of being an intellectual thug.

The temptation is to draw some causal relation between the diminishing role of the art critic today and the artist's increasingly vigorous manipulation of the critic. It is tempting to speculate that even as the role of literary theory increases, the tole of art criticism is all but anachronistic in our time, his role vestigial now that the dealer and collector establish the validity of art, enabling the artist to bypass the critic for the "advocate"—today's euphemism for publicist—to write about his art. If the critic finds the art problematic, wishing to exercise his right to test the art against the artist's intentions, he can be dumped for someone more cooperative in promoting the artist's reputation. An art writer who writes impressionistically, in a way that doesn't rub, can be found to fill the bill.

Now that celebrity determines who can write himself into history, the critic is all too often seen as useful to the artist only insofar as he contributes to the artist's endorsements. An invitation to critique the art of a superstar insulted by fame and canonical status is improbable except for the longtime crony who can level with the artist in confidence. Certainly with an established artist whose gallery bio weighs heavily with pages of bibliography, the dissenting critic has no sway. Chances are, under such peer pressure to reinforce the artist's "classic" stature, a critic will at best pull his punches—perhaps speaking favorably of selected works while implying only by indirection that those left unaddressed are ineffective, or perhaps by addressing problematic paintings through abstract discourse. Today, moreover, the veteran critic cannot compete even with younger, recent fame. One superstar whose cynicism is well-developed stands nowadays at parties wearing a deliberately ambiguous expression—a slightly open mouth interpretable as either a smile, acknowledging a critic's presence, or not a smile, signaling non-acknowledgment—lest he seem to be friendly to the "wrong" person. Symptomatic, too, of the power play indicating a shifting authority is an occasion when, not so long ago, I was introduced by name to a current "hot" artist, and seeing him draw a blank, I added the identifying tag of art critic. He retorted quickly, "When you're important, *we'll* know who you are." Stunning here is the presumption that the world and anything valuable in it begins and ends with what the artist happens to know. History prior to his birthdate doesn't exist.

But if engagement, not adulation, is what the artist seeks in his studio, he is likely to view criticism as an exciting and necessary enrichment of the creative process. His goals are not so materialistic as the artist mandating worship, for though he too may be ambitious, he views the critic as more than an

agent for supplying favorable reviews and elegiac catalog essays to advance his career. He seeks in the studio visit an occasion for work. Whereas public exhibition is greeted, by and large, by silence, with scattershot comments by way of the grapevine, private conversation with a critic in the studio offers an opportunity to present his art to an informed public of one. At best, it may inspire sustained interpretation of the art interrogation of its aesthetic premises, and also a chance, thereby, for the artist to realize the art's potential by listening to a point of view other than his own.

Invited to the studio, the critic is obliged to do more than describe the art he finds there, but any discussion that ensues can take place only in a context of mutual trust. On the one hand, some personal defensiveness is integral to the process of being reviewed in studio, and within limits it must be respected. On the other, the critic is not doing his job unless he or she works to get beyond taste or market value or the rationalization of trends and visual illiteracy—the public socioeconomics practically swamping the art. There is no need to supply that public perspective, and the critic who does not distance the discourse in the studio from that is misrepresenting himself professionally.

..

Art Criticism 5, no. 1 (1988): 1–10.

Marjorie Welish
The Studio Revisited

The daylight was in mint condition. The sun entering the window of the artist's Brooklyn apartment and settling on spare furnishings and art was of the sort we call transparent.

The artist and I had already passed some time discussing her art when the telephone rang. Unlike most of the calls that infrequently yet typically stall such visits, this one was not benign, for it conveyed the message that her father had undergone triple bypass surgery. In shock, she repeated the signal phrase "triple bypass" several times, her own mortification mounting during the quarter-hour or so she remained on the phone.

Amazingly, the artist apologized for the delay. Though distraught, she managed to contain her feelings and proceed courteously with our business. Yet her news only added to my own small distress, which had been growing meanwhile, for what the emergency call had interrupted was that I was about to decline writing a catalog essay on her art for a forthcoming museum show. Her immediate family crisis rendered what I was about to say pitiless, and I must say that for the sake of human kindness I was tempted to go against my personal code and write the essay anyway. I postponed coming to a decision.

After a few minutes, when the artist put the question directly, I answered as temperately as I knew how, "I believe that you would be unhappy with what I would write for your catalog." My words clearly disturbed her. "But I thought that when you agreed to come to my studio you had known my work and were consenting to write on it," she said.

Among the lessons here is that the mere fact of stepping over the threshold of the studio represents in some artist's eyes a kind of critical guarantee. A comely and accurate stylistic description or an ardent art-historical discussion is assumed to imply a supportive stance, an approval that can be enlisted for positive reviews in the future. The misunderstanding may be justified. To the extent that the studio visit resembles the social call, the artist

may elide the distinction between socially mandated politeness and critical support. The more hospitality frames the encounter, the more the decorum in the studio suggests further promises. Which is not to say that honorable conduct is remiss. To her complete credit, it was the artist in the above story, not the critic, who then saved both from embarrassing silence. It was she who segued with grace and dignity to address another topic: "Have you ever read Shattuck's *The Banquet Years*?" she asked. "I'm reading it now, and what is so interesting about it is ..."

This artist is not necessarily the only one for whom a studio visit is tantamount to a kind of endorsement. Misunderstandings arise all the time, as questions of ends and means during studio visits may also rattle critics themselves. Not a survey of the art world, and with no pretense to sociological exhaustiveness, what follows does consider the phenomenon of the critic's studio visit (though from a viewpoint broadened by some experience on the receiving end, as artist). The collective experience of battle-worthy (and battle-scarred) historian/critics and artist/critics tells us that while the studio visit is a phenomenon the value of which is taken for granted, its nature and meaning remain in dispute.

A working definition of the studio visit might be that it presents an occasion for the artist to show his or her art to a critic and to engage in a dialogue with this informed audience of one. One benefit of this attention, if the artist chooses to take advantage of it, is an independent, sustained, and possibly deep response to art from which to learn—less to "take" suggestions than to absorb the critic's thought into the artist's own creative processes. Another benefit is that, unlike the response to an advertised exhibition, the rendezvous in the studio takes place without public repercussion. The studio visit, then, provides an opportunity for an augmented privacy.

But what actually happens in a studio may be hard to pin down. Unstated, uncodified, and subject to on-site improvisation, the exact nature and purpose of the studio visit may always remain elusive.

Jeremy Gilbert-Rolfe, painter and critic, says, "The artist Mary Boochever believes that the studio visit should last at least forty minutes because 'nothing much happens in the first twenty minutes,' and I pretty much go along with that." In other words, even if a critic is conversant with the art in advance, easing into the situation may require a few pleasantries to replenish the trust and rapport that brought the artist and critic together in the first place.

Gilbert-Rolfe compares studio visits exchanged between artists with those paid by critics. "It depends on who visits whom. When an older art-

ist visits younger, the younger wants both approval and critique. Stay long enough for this to happen. When younger artist visits older, the expectation is not so much critique as questions, although the examination is not so specific as at an architectural critique. When of the same age, the studio visit is based on rapport of ideas *in some sense*. It may also offer ideas to rip off from one another—a situation in which both are defensive and competitive.

"The people who get the most out of studio visits from me as a critic don't expect any one thing out of a studio visit. Also they are so secure in their art they can discuss it almost as if it were done by someone else. Visiting critics expect a 'line' from artists, a line on their work, yet the worst visits are those in which the artists have some sort of line they dictate to people. The more clearly worked out the line, the dumber the art is. This is an art rule. Or they will protest that art cannot be put into language. This is perfectly true but irrelevant since we are in studio to put whatever can be put into language."

"Rapport *in some sense*" is the operative phrase. Although Gilbert-Rolfe does not say so, rapport is, as with artists, also a prerequisite for critics, though perhaps not the same degree or kind. Liking the artist is not an issue, and even liking the art is construed to mean something other than a love match. At least in theory his profession demands that a critic's cultural tolerance be wide—wider, at any rate, than his personal taste—while an artist is not held accountable in this way.

There is an amusing poignancy in what art historian and critic Joseph Masheck says: "Anticipating a studio visit is like going on a blind date. A critic hopes that he and the art will take to each other. Mostly, though, studio visits come about after I've seen work, maybe in slides, and liked it. Occasionally, they occur on being introduced to the artist and, in the presence of the artist, I'm urged to make a visit. But I dislike being pressured in this way.

"Once in the studio, I like to look at the art without being coerced into thinking one thing or another. Annoyance sets in when I hear that prerecorded spiel some artists give and feel treated as if ignorant, as if I cannot see painting for myself. I hate to be brain-fucked. I hate the situation where one is expected to keep saying, 'Yes, yes, yes.'

"The critic, who by definition is arriving with something to learn, is distressed to encounter an artist who has no interest in learning. The give-and-take of learning within the studio is crucial to me. Beyond this, it makes so much difference to the effectiveness of the studio visit if the artist happens to be well-read, because then you know, in '60s parlance, what the 'head' is like—how the person thinks."

Some artists send out an all-points alert for critical response. Without

taking responsibility either for schooling (Gilbert-Rolfe: "Artists brought up in the 1960s lack ideas; in the 1970s they lack skill") or for the specific ideas and values propounded by the invited critic, artists nevertheless expect the critic's response to their own art to be error-free. This is especially irritating when, as sometimes happens, acting out a kind of desperate entitlement, they become presumptive about a critic's mind.

"It's nice if the artist has actually read something by the critic and knows where he's coming from," Masheck explains. "Occasionally this happens, but more often than not, when the artist does profess to know something about your ideas, he gets them ass-backwards. By failing to distinguish Suprematism and Constructivism, for instance. Or [having the idea] that, having written my iconicity essays ten years ago, I'll like anything 'spiritual.' But my interest with the ikon was as an antetype for the abstract painting, and was at least as structural as it was religious."

Dore Ashton, historian of the New York School and art critic, spots another source of irresponsibility. "Someone's making big money tutoring kids in how to solicit studio visits from critics," she reports. "The letters I've received go like this: 'Dear Ms. Ashton: I have long admired your writing. I'm sure you would love my work. After you look at slides, would you come to my studio for a visit? Yours truly, ...' It's embarrassing." Suggested here is the view that today's art education may be responsible for breeding not artists but petty self-promoters. "Getting it all together" no longer necessarily means commitment to art and to thinking things through. Now it can mean indulging in such ploys as direct mail, through which a young artist blankets every writer indiscriminately, so that if one percent respond he's had a good result.

If the comments of these critics are any indication of consensus, bona fide critics—those educated in the discipline of art history—resent being treated like art tourists to be herded through studios. By profession they come armed with knowledge of cultural paradigms and styles expressed or referenced by art. Until solicited, the artist's "line" on the art registers as mere static. Or, more importantly, since the artist's explanation of his art seldom explains the art but only some imperfect fit of intention and realization, the critic may want to cope with this other, wrought, verbal icon separately, in due course.

Complicating the issue, however, is the influx of studio visits by writers trained in disciplines other than art. They may make their presence known either by addressing the art world and its sociology, or by making naïve comments about the art's subject matter, or by riffing on the art with creative, free-form remarks, seductive but beside the point. Essentially nonvisual and out of their depth, these art writers, however quick-witted in other respects,

do require shoring up. Perhaps that is why artists are so quick to jump into the fray with their orientation speech of the afternoon.

Unlike Masheck and Gilbert-Rolfe, who are inclined to agitate for lively verbal exchange, both Ashton and artist/critic Robert Storr characterize their studio visits as given to silence. Ashton favors silence because on first acquaintance with an artist's work, or even at second sight, she may have nothing to say. She firmly believes discussion is appropriate only after diligently tracking the artist's work for some time.

For his part, *as critic*, Storr tends to be outwardly passive in the studio—processing what he sees yet keeping his own counsel. *As artist*, he is resistant to the situation in which visitors expect to see the mind they have witnessed performing in critical essays perform similarly in the studio; he resents being put in the position of having to explicate his painting or hand the visitor exhaustive ideological or stylistic analyses.

"Somebody came over and wanted a production, wanted me to come on like gangbusters. And I didn't," Storr recalls. "He really wanted me to do the work for him. That pissed me off, because you're then being asked to be your own studio visitor, so to speak.

"I tend to pay studio visits only to those whose work I'm curious about—and in that sense, it is me who is getting the benefit of the visit. Or I do it for work I support or for people I support even though the work goes up and down, but for whom I think that attention is due.

"I look around the space and see the paintings as part of a situation," Storr says. "I am curious. And my interests are not just in painting, but in artists as people. Often I just look at the painting, with nothing to say. Then I say, 'It's not my way to talk about paintings, so if I don't say anything, don't take it that I disapprove.' Sometimes, having said that, I do talk a lot. But I always try to make it clear to people that silence is not necessarily awkwardness."

Silent response raises a question about my initial working definition of the studio visit. Predicated on dialogue, it assumes two-way communication, yet the behavior of some critics would suggest otherwise. The basic situation would then seem to be that a studio visit is the occasion for sharing the art with a critic. Response may be forthcoming or not, verbal or not.

Exceptional, yet part of the practice, is the sort of studio visit that happens as a by-product of shared political or literary interests; rapport, in other words, inspired through concern for matters other than art. Dore Ashton says about herself, "I was an art student before writing on art, and when young, I married a painter and lived in a studio. So a studio visit for me is like going home.

"The nature of such visits always depends on whom you're visiting. What their mores are, where they grew up, the *politesse*. The reason I went to visit

an artist in his studio was based on an affinity for what he did. And some artists—important artists—with whom I felt no rapport were those whose studios I never visited.

"Perhaps the most peculiar artist I used to visit was Joseph Cornell. Joseph and I used to talk about literature. Sometimes he would telephone me and in his funereal voice ask me if I'd read something or other, and sometimes I would suggest that he read something. So we had several visits about Coleridge; Samuel Taylor Coleridge was a great favorite of mine, and of his. He was also interested in Mallarmé, whom I was also interested in. We never talked about the art world or his works of art. But anytime I visited him, he would show me his work and very often it would have some relationship to what we had been discussing. Now those were my peculiar interests, and I am sure other people who saw him talked about other things.

"In the case of Philip Guston, I was so much younger than he, and as I look back on that experience it is amazing how easily he accepted me as a peer, intellectually. We talked about anything that had to do with our formation in Western culture. We'd talk about Isaac Babel. Or we'd talk about how mysterious painting is—that conversation went on for years."

To hear her tell it, it would seem that Ashton never paid these celebrated artists formal studio visits, but only social calls conducted with a decided intellectual urgency. Her conduct was the conduct of the existential 1950s, when it was feared that if the cultural fuel was allowed to die, the artistic self would perish also. At that time, the ground rules for this sort of studio conversation entailed values expressed with intensity, yet, curiously enough, values not specifically directed to the art at hand. Invited by artists to be a peer in a realm other than art, Ashton was asked less to monitor their art than to participate in the active enhancement of their imaginations. To visit the studio of older or established artists, then, as both Gilbert-Rolfe and Ashton imply, is not likely to disturb the status quo of the artist's celebrated self-image—except maybe by intellectual infiltration.

What do we mean by critique, and is criticism appropriate during a studio visit? Invited to shamble around the studio, to pick through works in the racks, or, more likely, to become the fixed point around whom artifacts are placed for comment, the critic begins to form his response to the art. It soon grows complicated. Cultural rapport drew critic and artist together; now, however, the regard a critic feels for the cultural ideas to which the art pays homage may register as pressure to see the artist's intentions entirely realized. Although the critic likes to resist that design on him, he is not always willing to risk hostility brought on by dissent. Will the critic risk differing interpretation and evaluation? Not all critics look upon the practice of criti-

cism as intrinsic to a visit, and there are those who find my assumption of the appropriateness of criticism appalling.

Given that reaction, I could not help wondering whether we critics agree on the very meaning of criticism. On this point I discovered that, however they may disavow it, more critics practice criticism on the artist's premises—or at least some version of it—than own up to doing so. For some critics, criticism is that which addresses problematic works of art. For some, criticism speaks to those issues in art identified as crucial. For others, criticism is a descriptive, interpretative, and evaluative bundle applied to art. Still others believe that criticism shows itself in an active defense of art argued according to given ideological guidelines. And I mistakenly thought that only "laypeople" confuse criticism with severe disapproval, yet this is not the case.

Giving thought to the question, Gilbert-Rolfe says, "If it's the first studio visit to someone, you're likely to be taking in a lot of 'information'—the nature of the art, the studio environment—and so not be prepared to critique the art; more energy is expended in looking than in building an argument. Initially, get some sort of sense of what both people in the room are talking about, defining and finding common ground. So first is discussion, not critique—a discussion of art and how it relates to ideas and to art history. If discussion is directed to the work itself at the level of the art object, then it is to learn how the artist theorizes about the art. Otherwise, this first studio visit is tentative. What the work really is about takes place silently. Alone."

Yet as his earlier comparison of visits by artists and by critics reveals, Gilbert-Rolfe presupposes some measure of criticism weaving through the process. He especially values those studio visits in which artists are objective enough to give self-criticism. "The best artists are those in their late twenties who work productively, intensely, and who haven't sorted everything out yet. These are the artists from whom a critic is likely to learn something as well as give something. I have a problem with older artists who are not human enough because they are not tough enough on themselves. I resent the implication by them that they ought to be rewarded for their sheer stubbornness and persistence. Nothing in the world takes place without that stubbornness and persistence. The question is: what else is there?"

In contrast with Gilbert-Rolfe's assumption of aesthetic rigor expressed through debate, Masheck's approach to studio criticism allows for gently probing inquiry, skepticism voiced with permission. "The first step for the critic is getting to know the metaphoric systems people have for talking about art. And when yours meshes with theirs, then the subsequent give-and-take is the most interesting part of the studio visit. Included here is discussion of the technical, but by this I have in mind what Heidegger means by

what Aristotle really means by *technê*. It never means the merely material or the merely manual; it always implies knowledge, in the sense of mental penetration. Just knowing how to do scumbling is not knowledge.

"As soon as I have some clue that the artist wants me to be negative as well, then I feel free to point out in a simple, uncharged way things that are problematic. How do you talk about a body of art you don't like? Find something good in it, and, restricting yourself to that, it should be clear to the artist that the art is limited. How to endure the rest of the hour is the problem."

Masheck and Gilbert-Rolfe are initially very different in their approaches. Masheck concedes a lot to art by assuming that the phenomenal richness of the given facture (for instance) is intentionally tracking a certain circuitous art-historical path. In contrast, Gilbert-Rolfe, whom artists have called "intimidating," is perfectly capable of interrogating an artist to test the intentionality of key issues of which the art boasts—the meaning of representation or the bogus distinction between American and European art, for instance. But lenient or severe, their criticism has to do with articulating the meaning the art hauled out for them to see. Evaluation is implicit, tending to remain secreted within their respective interpretive strategies.

Ashton resists the notion of critique altogether. "I realize 'critique' has a long dignified history," she says, "as in *The Critique of Pure Reason*, but in contemporary art it has no place. I have told acquaintances who are artists that because I am a writer I don't really like to walk into a studio and talk from the top of my head. I first respond emotionally—and that is not a reasoned response or a thoughtful response. So there's a lot of silence when I'm in the studio. Still, the artist might say, 'Okay, tell me really what did you feel when you first looked at this painting?' I might say, 'Well, it disturbs me.' If the artist presses and asks why, I might say, 'I don't understand why you did that impasto on the left, which jumps out.' So if pressed to explain my response, I'll engage in technical studio talk, the kind of verbal shorthand that art students and professionals engage in. I never say, 'It doesn't work,' because that's vulgar. And who am I to say it doesn't work; I do say, 'I don't understand why you do this.' Then the artist might say, 'I hope to do XYZ.' But meanwhile I've been following the work and know the artist's oeuvre. So at this point in the conversation I can say, 'Well, remember your show of five years ago … remember that painting of such-and-such, well, I see now you're picking up so-and-so.'"

For Masheck, the idea of criticism is linked both to ramified interpretation of artworks and to the diagnosis of problematic pictures. Gilbert-Rolfe and Ashton both equate criticism with reasoned response, an argument in which intellectual positions are given to explanation and defense. Yet for Ashton the reasoned response of criticism is deferred until she is secure that

what she will say accords with the long-term intention of the artist. Even though the intentional frame of reference may require years to emerge, possessing this historical dossier on the artist is reassuring when it comes time to grapple with the worth of paintings immediately at hand.

When I asked Storr, "Is criticism appropriate in the studio?" he revealed that, like Ashton, his mode is to stay close to particulars. Of all these critics, he is the most reluctant to give voice to his response, whatever he may really think. "I myself don't give criticism that much, but yes, it is appropriate. It has a lot to do with whether there's an invitation. For my part, I feel ill at ease marching in and telling the artist what I think even though the artist has invited me into the space to do just that. I am not always inclined to give a reaction—it's work! Also, in some cases, it means giving away information—good information—to people who are only mildly interested in it.

"I'm not interested in saying, 'That's the right red, the wrong blue.' I am interested in why people do what they do. I'm interested in their motivation, of which one would hope their ideological stuff is an extension. But I'm not just interested in talking to people about style or the next movement in painting, because who knows that anyway, and who cares... My bias is to consider the look of paintings and work to the theory from there."

Even if viewing political art, Storr will not initiate questions about its nature or how the artist sees it in a political context. "Because that assumes that there's an objective agenda or something going on in the world that they ought to be thinking about. They're adults, they are on their own recognizance. I might say, 'I don't get it; this is vague to me.' But I never look at art in terms of issues other than those addressed directly by the work; at least, I try not to. I accept that artists have elected to work in a particular way; beyond that, the question that comes to mind is: Is it challenging, convincing, and complicated enough?"

To take their testimony at face value, these critics argue against outright evaluation in the studio, but, although reluctant to pass judgment on the art they have been invited to visit, they do exercise their critical options in other ways. How they do it, by scrutinizing form or by disputing ideas and issues, seems to depend on each one's personal bias as a critic in the world.

My own assumption is that, unlike a social call, the private professional consultation known as the studio visit, by virtue of engaging the art and leaving the artist with matters to think about, nudges the artist further along in the creative process. So for an artist to extract mere praise from a critic is a form of self-congratulation that does worse than negate the critic's presence: it forecloses on process altogether.

I disagree with Storr in that I believe that once a critic accepts an invita-

tion to stop by the studio, he accepts responsibility to "do work." It's true that a thoroughgoing analysis of style and context is exhausting. And work done for free doesn't wash in any other walk of life (perhaps fees tied to dental services are appropriate: $75 for cleaning, $125 for deep cleaning, and up. Root canal?). However sticky the situation, some expressed response that goes beyond praise and neutral description is, I believe, part of the professional contract to which a critic commits himself upon entering a studio; criticism is both appropriate and mandated by the situation. Yet, however critique is warranted, it does not mean banging a shoe on the table in displeasure. Criticism is something a little more dialectical than that.

Some reject the practice of criticism in the studio altogether. All artists relate "horror stories" of studio visits conducted for sheer abuse. Stalking the land is a critic who, on entering the studio of an artist to whom he had been friendly, said to him, "You just don't have it." Understandably, artists' fears that the studio visit will result in this sort of extermination also lead to the belief that "criticism" *means* "abuse." The sadistic critic may have just cause in trying to deal with art that is misconceived, or in coping with both would-be and celebrated artists with no gift; addressing these very real concerns is indeed a critic's responsibility. Yet I would prefer to say that a judgment forged of sheer power is not art criticism but cultural terrorism, and that the person uttering this curse is not a critic but a terrorist.

Wherever it travels, on the page or in conversation, criticism is properly an analytic, interpretive, and evaluative instrument. Yet the choice of the particular matter to be scrutinized also depends on the critic's sense of the artist's most pressing need. Perhaps amid a welter of hits and misses, one minimalist artifact stands out; it's up to the critic to help the artist articulate why this is so. If intellectual opportunism lessens the supposed nerve of, say, a batch of feminist photographs, one way or another the critic should lead to a discussion of that defect. How the critic and artist arrive there, and what artistic episodes surface meanwhile, may well be improvised en route, with these matters falling as they may, some attended to with vigilance, others dropped. Unavoidable, however, is the responsibility to deal with at least one crucial stylistic, cultural, or intellectual issue the art suggests with a complex criticality. If the studio visit does offer the occasion for providing the artist with a kind of augmented privacy, it should provide an enhanced consciousness as well.

"The purpose of the studio visit is to acquaint the critic with the artist's work," says Masheck, citing the most basic reason for entering an artist's quarters. First forays especially, as all four critics attest, will be research-intensive. How a given critic will go about acquainting him- or herself with the art reveals a lot about his or her particular style of knowing. Masheck

might sniff out an artist's background. ("I am interested in the artists' academic geneology; where they went to school, where their background phases in to their intellectual formation. If an artist went to Reed or Bowdoin, Antioch or Yale, I like to see how the attitude peculiar to the school applies.") Yet emphasizing more than other critics that it is the art, not the artist, he is visiting, Masheck will expend much creative, nonconfrontational energy in his give-and-take approach to interpreting canvases. He will actually donate meaning to art if that is what it evokes in his mind, the aim being to elevate the discourse even if this ultimately causes the art to seem more interesting than it is. The unstated hermeneutical aim: to extrapolate the art's potential.

At least in some instances, Ashton's purpose for visiting studios is to continue an ongoing dialogue with artists she supports. "If you've already established a friendship, as I had with one or two artists over many, many years, to come and see them in their studio was to engage in the continual conversation that goes on for years. Whether they were visiting me or I them, we would pursue certain ideas that impassioned us mutually." Paradoxically, the social calls she describes, including dinners over which friends slog out issues, seem more intellectually demanding of the artist than other critics' studio visits. Once in the studio, however, Ashton forgives the artist all, or, at least, puts herself in the self-abnegating service of the artist. The function of the critic in the studio, as Ashton sees it, is that of sympathetic witness, nurturing the artist to whom she is predisposed.

Beyond the occasion to see the art and pass on it, Gilbert-Rolfe's purpose in paying a studio visit seems to involve testing the limits of the artist's understanding of issues crucial to the art on view. Unlike Storr, Gilbert-Rolfe proceeds from ideas and ideology to the properties of the artwork, with the sort of dismantling intellect inspired by poststructuralism being a criterion for value. Admittedly competitive within his own generation ("I'm a middle-aged abstract painter, and so have most difficulty with middle-aged abstract painters"), Gilbert-Rolfe means, through such sparring, to get an artist to defend his art—his assumption being that the critic is properly abrasive if the artist is not tough enough on himself to provide this form of self-purifying negativity.

To satisfy curiosity about the art is only a part of Storr's anthropological interest in visiting the studio. Seeing "however the artist chooses to present himself" in his habitat interests him as well. Because studying the artist's motivation to do art is Storr's special concern, any explanation the artist delivers is useful, for it reveals the unconfessed and involuntary agendas he sustains. Storr's theory of no theory—the viewpoint of comprehensive empiricism—sets his apart from the other critics' approaches.

Beyond acquainting themselves with the art, giving some form of critical response, sustaining a cultural dialogue over time, or disciplining an undisciplined mind, the purpose in the critic's crossing the threshold of the studio may also be to give practical advice or connections to further the artist's career. "The artist," says Storr, "wants information and advice, which the critic has the option of giving or withholding, and I think that that's a legitimate function. It's fair enough to ask critics for connections, as it is fair for these critics to say no. The critic can be forthright: 'I do or do not know somebody; I do or do not want to give my name as a reference; I do or do not want to help you; I do want to help somebody, but you don't happen to be that one.' The more visible critics become, the more artists want them to come to their studios to validate them in certain ways: to do them a favor, to give them career advice, to schmooze."

The intentionality of the critic is itself worth studying in that it reveals certain personal styles of these wandering interlocutors. In his book *The Interpretation of Cubism,* Mark Roskill speculates briefly on artists' strategies of response, yet we might note the strategies of critics as well. The laconic Robert Storr, the combative Jeremy Gilbert-Rolfe, the respectful Joseph Masheck, and the apologetic Dore Ashton—each adaptive trait ensures a degree of self-protection as the critic entering the studio makes an effort to maintain intellectual autonomy.

To meet the intentionality of the artist with one's own is just one more layer complicating the transaction known as the studio visit. However the artist's intention may be sidestepped or dismissed as a fallacy in written art criticism, in person the critic must meet it head-on. Out of Goethe's threefold formula for art criticism, *What is the artist trying to do?* is not the only ingredient that critics find themselves engaging afresh in the artist's presence: *Did he succeed in doing it? Was it worth doing?* are also questions of some urgency when the artist is standing right there.

..

Arts Magazine *64 (September 1989): 55–60.*

The Studio

as Lived-In Space

Mary Bergstein
The Artist in His Studio: Photography, Art, and the Masculine Mystique

The Artist in His Studio/The Artists of My Life

Critics have long observed that as the twentieth century unfolded the idea of art-making as a male prerogative was expounded in representation. The more that masculinity came to be identified as a generative force in artistic creation, the more necessary it seemed for women to assume the foil of alterity—to be cast as natural, passive beings whose role was opposite and complementary to the artistic pursuit.[1] This essay addresses representations of artists by Alexander Liberman and Brassaï. The photographs under discussion were produced from about 1930 through the 1960s and have circulated in publication to vast audiences from the time of their making to the present.[2] I will argue that in the photographic images and accompanying texts, Liberman and Brassaï advanced specific ideas about the mystique of the artist's studio, about women and art, and about masculinity as the *primo mobile* of artistic transcendence.

Around midcentury there were several "cultic" photography books whose production and sale flourished in the United States. Alexander Liberman's *The Artist in His Studio* (1960) seems to have been ubiquitous, especially in its inexpensive paperback edition of 1968.[3] *The Artist in His Studio* can be classified as high modernist reportage. Liberman's rationale for the book was patently modernist: "I tried to reveal [the] core of the creative act, to show the creative process itself, and thereby to relate painting and sculpture with the mainstream of man's search for truth." In a foreword to the book, James Thrall Soby asserted that Liberman had "brought to the work ... a rare capacity for psychological insight." Until recently the editorial director of Condé Nast, Liberman worked for many years as a *Vogue* photographer and art director; his collected photographs of artists at work represent a project of several decades in which his stated aim was documentary accuracy.[4]

The mystique of the artist's atelier was disseminated in mainstream American magazines such as *Life*, *Vogue*, and *Harper's Bazaar*, where Alexander Liberman and Brassaï, among others, represented artists' lives for public consumption. One of Liberman's early missions had been to bring modern-

ist art to the pages of *Vogue*; his pictures, interspersed among features and advertisements conveying fine points of etiquette and fashion, set the legend of the modernist artist to women within the realm of fashion-magazine fantasy. In this context, it seemed "natural" for North American women to study a photograph of a model wearing a Dior dress within seconds of having contemplated a photo essay of Picasso in his studio. Fashion and art were glamorous consumer products—out of reach for most readers, but presented as eminently desirable. Liberman is said to have stated that *haute couture*, with its basis in feminine seduction, had a place within the tradition of Western art "from Titian and Velázquez to Matisse."[5] Likewise the tradition of masculine domination and feminine objectification in Western avant-garde art was granted a privileged place in fashion. A persistent interleaving of male artists with women's fashions in magazines like *Vogue* served to reinforce the historical association of masculinity with production and femininity with passivity and consumption.

Liberman's photo essays of artists seemed more intimate and accessible than some of the ideas expressed in actual works of painting or sculpture. Illustrated publications were far more widely replicated and circulated, and thus better known, than the art objects themselves. The experience of poring over books like *The Artist in His Studio* provided people (including photographers, students, and art historians) with a common cultural system. In Liberman's book the artists' biographical sketches consisted of photographic vignettes accompanied by verbal anecdotes. He constructed an avant-garde modernism of personal legend, inviting the viewer to inspect each image for "clues" regarding the actuality of the artist's creative experience. This material was packaged in the language of "documentary" photography.

Many points of connection link the oeuvre of Alexander Liberman with that of the more celebrated photographer Brassaï. Brassaï photographed the "artists of his life" in a thirty-year project. Some of his photographs first appeared in literary magazines such as *Verve* and *Minotaure*, and much of the work was done under the auspices of *Life* and the American fashion monthly *Harper's Bazaar*. His *Conversations avec Picasso* (1964) was translated from the French by Francis Price as *Picasso and Company*, with a preface by Henry Miller and an introduction by Roland Penrose (1966). Finally, an art book entitled *Brassaï: The Artists of My Life* (1982) reproduced many of these images of artists, with a memoir written by Brassaï to accompany the essentially photographic text.[6] Brassaï's work, like Liberman's, promulgated the legend of masculine domination through representations of studio life.

The artist's studio was an established theme in early twentieth-century painting and would become a prime subject for the documentary photographer. The atelier was perceived as a place of enchantment where the artist's

life (real and imaginary) unfolded, as well as being a workshop for the production of art objects. As these aspects of the studio merged in representation, the process of creativity became fused with the artist's personal wishes and gratifications. Picasso is perhaps the artist best known for his claim to make art through the imperious, instantaneous gesture of his own wishes: "I deal with painting as I deal with things, I paint a window just as I look out of a window. If an open window looks wrong in a picture, I draw the curtain and shut it, just as I would in my own room."[7] Brassaï remembered Picasso existing in the private refuge of his studio:

There were four or five rooms—each with a marble fireplace surmounted by a mirror—entirely emptied of any customary furniture and littered with stacks of paintings, cartons, wrapped packages, pails of all sizes ... piles of books, reams of paper, odds and ends of everything, placed wherever there was an inch of space.... The doors between all the rooms were open—they might even have been taken off ... floors were dull and lusterless, long since deprived of any polish, coated here and there with splotches of paint, and strewn with a carpet of cigarette butts.... Madame Picasso never came to this apartment.... With the exception of a few friends, Picasso admitted no one to it. So the dust could fall where it would and remain there undisturbed, with no fear of the feather dusters of cleaning women.[8]

Here as elsewhere the studio was framed as the artist's inner sanctum, a twilight zone between life and art, where domestic norms were suspended or reversed in favor of independence and self-expression.

Liberman and Brassaï evidently took pleasure in steeping themselves in the environment of artists' studios. And the material of legend was constructed through an exchange between artist and art photographer. In a documentary mode Brassaï remembered a conversation of a winter afternoon with the elderly Aristide Maillol in his studio. The photographer's written memoir of Maillol at work is almost entirely devoted to the sculptor's desire for his female models:

After my arrival, the selection process continues, punctuated by remarks. Each drawing reminds him [Maillol] of a moment out of his life, the living body of some servant, some girl, some woman. And Lucien, standing behind his father, contributes his own memories:

"That one was a solid creature! That one had splendid thighs! Yes, that's Margot, her breasts drove me crazy ..."

"Do you remember this red-headed one?" Lucien asks. "She was very beautiful. I was the one who found her, who brought her along to you ..."

"Yes, and you're the one who went to bed with her, too ..."[9]

Brassaï recorded these *delizie* with apparent satisfaction, as well as supposed verbatim accuracy. (After all, his own metier—photography—was famous for capturing moments of truth.) Throughout his writings Brassaï openly subscribed to the notion that a passive, objectified feminine presence in the painter's home or studio could stimulate artistic production.[10] The Maillol episode is conspicuously framed in the familiar terms of "having been there," and Brassaï's self-documented inclusion in the studio session serves to endorse his own position as an artist among artists. For just as Maillol was in the studio with his brushes and chisels, Brassaï was present with his visual imagination, his camera, and his (prodigiously "photographic") memory.

Reading the Photographic Material

Lawrence Durrell has suggested that Brassaï's work, whether it deals with relatively inanimate aspects of the city or with sentient human beings, has an animated, biographical character.[11] Brassaï's graffiti photographs (undated works shown together at the Museum of Modern Art in New York in 1956) communicate—as do many of his café, brothel, and street scenes—a high emotional temperature. His "language of walls" is meant to reveal psychological insights "discovered" in urban palimpsests in the *bas-fonds* of Paris. In a retrospective catalog entitled *Brassaï*, produced by MoMA under the auspices of John Szarkowski in 1968, portrayals of human beings, such as a girl at a café (1933), Jean Genet (1955), Salvador Dali (1933), Henry Miller (1932), Alberto Giacometti (1934), and of course Pablo Picasso (1932), are paired with discretely framed fragments of walls similarly excerpted from the fabric of the city.

André Malraux (whom Brassaï knew in Paris) had observed that strategic arrangements of fragments and details of art in photographic publications could suggest universal, cross-cultural truths about the creative process.[12] The physical proximity, or impingement, of dissonant or complementary images was a typically modernist tactic in the design of art books, provoking what Malraux considered a metamorphosis of vision. The strategy adopted in MoMA's *Brassaï* corresponds to Malraux's system of visual algebra. Here, portrait likenesses are paired with suggestively aggravated fragments of wall surfaces presumed to expose the psychological state of the photographed subject (painter, poet, prostitute, or *clochard*) and to exhibit an intense degree of psychological inquiry and insight on the part of the photographer. The whole setup, in which Brassaï appears to read into the mind's eye of the portrait subject, validates the modernist premiums placed upon the unconscious mind, expression, and abstract forms. *Brassaï* therefore articulates the overarching program of modernism that was particularly endorsed

by MoMA.[13] At the same time it legitimizes the photographer's status as an artist in the Malrauvian "museum without walls."

Consider Brassaï's portrait of his friend Henry Miller (1932), where Miller is seen pausing in the doorway of Brassaï's room at the Hotel des Terrasses in rue de la Glacière. The picture was made during the time Brassaï was working on the "Paris de nuit" project. Miller occasionally accompanied him on his nocturnal wanderings, naming the photographer "L'Œil de Paris."[14] In this photograph Miller's gaze is obscured by the shadow of his fedora, and his face betrays little emotional affect. An anonymous woman is both present and absent, her ear and neck *mis en abyme* in a photograph within a photograph at the upper right.[15] What is on Miller's mind? The semiabstract *sgraffito*, at once "primitive," tactile, and symbolic, that is Miller's facing-page counterpart in *Brassaï*, suggests reservoirs of heterosexual libido. Brassaï's undated *sgraffito* depicts a phallic trajectory at the center of a double-valentine form, a composition presumably taken from an anonymous wall somewhere in Paris. This particular pairing of photographs has an explicit historical reference, because in the course of his association with Brassaï, Miller had undertaken a study of the graffiti of Paris and its suburbs. Miller wrote in *Tropic of Cancer*, "Inside the toilet you could take an inventory of their [Frenchmen's] idle thoughts. The walls were crowded with sketches and epithets, all of them jocosely obscene, easy to understand, and on the whole rather jolly and sympathetic."[16] Brassaï's juxtaposition serves as a document of his relation with Miller and a manifesto of their shared mission.

But in more general terms the MoMA layout implies that such primordial scratchings were analogous to Miller's own art, in content and form. Indeed, the facing-page photo conforms to the way Miller described the awakening of artistic inspiration in *The World of Sex*: "It's when I'm alone, walking the streets [of Paris] that I get the feel of things: past, present, future, birth, rebirth, evolution, revolution, dissolution. And sex in all its pathological pathos.... In some places it permeates the air like thin vaporous sperm; in others it is caked into the walls of dwellings, even houses of worship."[17] Photographic ensembles like this one functioned as modernist rhetoric. The syntactical formation in *Brassaï* predicted the words of critics such as Norman Mailer, who later wrote of Miller in *Genius and Lust*, "Never has literature and sex lived in such a symbiotic relationship before—it is as though every stroke of his phallus is laying a future paragraph of phrases on his brain.... He may be the only artist in existence about whom we might as well suppose that without his prodigies of sex, he might have been able to produce no prodigies of literature. And without the successful practice of his literature we can wonder if his sexual vitality would have remained so long undiminished."[18] In the Henry Miller represented by Brassaï and published by

MoMA, it is stated with an eloquent economy that masculine sexuality was a vehicle to artistic (literary) expression.

The theme of the 1968 MoMA catalog is the "reflection" of the depicted artist's thoughts in the eye of the photographer. Brassaï's attitude toward his own photographic work is expressed through the format of this book, which presents visual material as though the camera were an aid to hyperperception, an instrument for seeing beyond the physical surface of things. Intuitive perception about the individuals portrayed is frequently indexed (captioned) through the representation of fragments of the urban underbelly. As we have seen in the pages dedicated to Henry Miller, portrait and wall language are involved in a relay of signals, through which, for example, Brassaï suggests that he and Miller shared a fascination for the streets, which contained a universe of fragments, "sordide, morbide, hallucinant."[19] Both Miller and Brassaï maintained that they loved the streets and locales of Paris "commes des maîtresses," and throughout Brassaï's oeuvre the Parisian landscape is frequently represented as female, whether in macrocosmic views of the streets, brothels, and theaters or in the microcosmic realm of graffiti. In *Brassaï* there are many instances (including *Bal Tabarin*, *'Père la Flute' in the Metro*, and *Salvador Dali*) in which the character of the urban environment is coded as feminine, through a variety of obvious visual signs. These signs consist of photographic representations of graffiti, photographs, posters, and other fragmented images of women's bodies that are perceived as embedded in the fabric of the city.[20]

In *Brassaï* each sitter appears to be "second-guessed" by the photographer and publisher rather than being complicit, or even aware, of the message that will be communicated to the reader. The effect is one of transparent windows to an absolutely candid psychological truth. Nevertheless, the facing-page arrangement presupposes an underlying cultural collusion among portrait subjects, photographer, and curators. Clearly it was Brassaï in his role as graphic designer—together with John Szarkowski and the MoMA establishment—who constructed this ostensibly documentary record of the environment as an intuited manifestation of the portrait subjects' deepest insights. Furthermore, the use of this "mirror" strategy reiterates the long-standing cultural expectation of photography as *speculum mundi*.

Another of the dramatic juxtapositions in *Brassaï* is devoted to Alberto Giacometti (1934). Giacometti, viewed against a cluttered mattress and the heavily worked wall surface of his studio, holds up a sculpture of a reaching arm. The hand of this arm points as if by chance to the facing page, on which appears an "accidental" or unconsciously fabricated figure of Giacomettian nervous energy ... pointing back."[21] (Does this second image depict a Leonardesque palimpsest worked up from accidental cracks and stains in the

wall by an artist's unconscious scratching or is it a crude *sgraffito* made by Giacometti himself in the studio? Are we looking at the photography of art or art photography? As these categories dissolve, the reader is deliberately confounded, and invited to speculate and search.) Again, the facing-page syntax allows for an interaction of signs in which the photographer is seen not only to illustrate but implicitly to parallel and divine the creative impulses of the sculptor. Photographic images and publication strategies (particularly those with the MoMA imprimatur) involved a tacit alliance between artist and photographer.

The collection entitled *Brassaï: The Artists of My Life* (1982) reproduces selected photographs of artists made throughout the photographer's career, together with a written text. In this assembled series of photographs, each artist's life-work and individual creative stance is defined by his relation to his personal environment.[22] Bonnard, Dali, Maillol, Kokoschka, Giacometti, Matisse, and Picasso are among the personalities represented. In Brassaï's system of representation, the artist's studio (presented as his "natural" environment) has a one-to-one relationship with his art. And to a far greater extent than in Courbet's depicted atelier of 1855, women (be they be made of clay, paint, or living flesh) are perceived as belonging to this extraordinary everyday environment. Brassaï represents the artist's studio (which is sometimes contiguous with his home) as a sort of interior arena that comprises simultaneous activities of looking, creative work, and fulfillment of desires. Women are represented—absent or present in body—on almost every page. And women, as they occur, are objectified as belonging to the artist's orbit of personal creations and possessions.

Brassaï's verbal musings corroborate his photographic material on the subject of the artist's autonomy and the place of women in an artist's life. For instance, Bonnard's model, Marthe, who was also his wife of forty-nine years, is described in Brassaï's memoir in terms of sexual comfort and availability:

With her slender, graceful body, her luxuriant mass of hair, her periwinkle-blue eyes, her high firm breasts, and her long legs, she had been his favorite model all his life. This febrile woman, with her delicate health, who spent her time indoors, who was fond of water and the warmth of the bathroom and bed sheets, was the embodiment of the sensual women in Bonnard's paintings who dream, do their hair, dress, or gaze at themselves in their mirrors, who lie back on their unmade beds, sew by lamplight, and lay or clear the table.[23]

Brassaï's text is a composite of rather distant recollections and wishes. This elegiac tenor corresponds to the fact that the photo essay was made in 1946,

after Marthe's death, when Bonnard had stopped painting nudes. Despite the fact that Bonnard himself made a whole corpus of paintings and a considerable number of experimental nude photographs of his wife, she appears neither directly nor *en abyme* in any of Brassaï's images. Instead, Marthe Bonnard is perceived in the lambent light of memory, an absent presence.[24] It is the reader, prompted by Brassaï's description and the memory of Bonnard's paintings, who is called upon to envisage the figure of Marthe, who stands for all of Bonnard's representations of women. Brassaï asks us to remember that "all those nudes in their golden nakedness like mother-of-pearl, with pink thighs, blond arms, and backs reflecting the play of every shade of rose, mauve, and orange, had Marthe's body."[25] The verbalized colors of Marthe's naked body are all the more striking in contrast to Brassaï's black-and-white photographs of Bonnard's dining room, studio, and latest paintings (still lives and landscapes), in which the female nude is conspicuous in her absence.

In Brassaï's biographical scheme, each woman is custom-suited to the physical, psychological, and intellectual needs of the artist. Gala Dali (who according to Brassaï cured her husband's impotence) is exalted by Brassaï as the "Surrealist's Muse"—having been with Max Ernst and Paul Eluard before Dali. "At once Dali's inspiration and mentor," we are told, "Gala disciplined him, soothed him, protected him; she managed to relieve his anxieties and fears." Brassaï's *Gala in the Studio in the Villa Seurat* (ca. 1932–33) portrays her leaning back into the cushions of a day bed, partly *en deshabille*, partly covered by a blanket, with light dappling her face from the upper left, her person framed as seductive and passive.[26]

In *The Artists of My Life* Alberto Giacometti is again presented as a major protagonist. And the role of the photographed artist as author looms large: "Photograph me like this, Brassaï...," says Giacometti a few months before his death in 1966.[27] Giacometti's persona and his works in the studio had provided photogenic material since the 1930s. Time and again, Giacometti not only posed but actually performed for various photographers: the resulting images convey an undercurrent of anxious, antagonistic masculinity. Giacometti's stance is articulated in Brassaï's compositions, even those such as *L'objet invisible* (1947) where the artist's physical presence is omitted. Here Giacometti's studio is presented as a work of art unto itself. The scribbled walls, inanimate female nude, woodstove, and crumpled newspapers are all of a piece, touched by the artist's hand with the indiscriminate spattering of plaster, and unified through the camera's lens, given equal value as pictorial components. The medium of black-and-white photography serves to drain away local color and suppress incidental extranea. Brassaï compresses Giacometti's studio into a "pure" Giacometti. The studio is framed as an en-

Brassaï, *L'objet invisible*, splashed plaster in Giacometti's studio, 1947.

chanted place, physically inseparable from Giacometti's work process and his ego.²⁸

The sense of frenzied angst that pervaded Giacometti's studio is replaced in Matisse's home by air, flowers, and light. Nevertheless, the two artists' photo-biographies display certain common themes in Brassaï's *Artists*. Before describing the light- and flower-filled ambience of Matisse's home, Brassaï introduces the women who are proper to the artist's physical environment, not only the painter's self-sacrificing wife Amélie, but "Antoinette, his very pretty model and his favorite." In June 1939 Brassaï was visited by a young woman carrying a message from Matisse. The painter apparently wanted Brassaï to photograph him with this particular woman, who was then his model. It is from this project—to all effects Matisse's own idea—that the series of Brassaï photographs from summer of 1939 arose. There is no question that for Matisse himself these images, in which he is represented studying the nude model, functioned as a valuable form of self-presentation. It seems that two days after the drawing/photo session, Matisse telephoned Brassaï to ask, "How do I look in them?"²⁹

Brassaï's photographs of Matisse (1939) are quintessential examples of modernist artist's biography. Matisse's self-proclaimed attitude toward the model as one of sensual pleasure is duly expressed in Brassaï's photographs. The gaze of the painter is observed and replicated by that of the photographer, reinforcing the dominant position of the male viewer in the studio setting. This is just as it had been, for example, in Steichen's 1909 photograph *Matisse with Serpentine*, where the inanimate female form is brought to life by Matisse's hands and the process of artistic metamorphosis is viewed through the photographer's lens. Through possibilities that are peculiar to the photographic medium, Steichen created an image of "Pygmalion *en abyme*." Looking at Matisse looking, the attention of Steichen and the hypothetical spectator of the photograph at once observes and replicates that of Matisse. A Barthesian sensation of the camera operator's actually "having been there" at the private moment of artistic transformation is communicated to a large audience through publication.³⁰

Each of Brassaï's pictures of Matisse in his studio establishes a complex circuit of looking. The female body is held in the painter's gaze, and is at the same time "taken" by the (unseen) photographer. All of this in its turn is apprehended, *ex post facto*, by the (unseen) gaze of the spectator of the photograph. This visual image of the act of looking (which is then, of course, reproduced geometrically in publication) is heightened by Brassaï's persistent attention to the *abyme*. But beyond her obvious role as the demure object of the studious gaze, the nude model is also cast as a "natural" attribute of the painter. If the studio is a natural place for a creative man to be, then the

woman, silent and submissive, is fully integrated into the physical environment of that habitat.[31]

By the 1930s, painters and photographers no longer needed mythological pretexts, classical allusions, or the trappings of exotic scenery to rationalize the display of a naked woman's body. The eroticized presentation of the model's body in Brassaï's *Matisse* was justified purely by the elevated status of the artist's studio. (Brassaï's presentation of the traditional surrender of the woman's body to the male gaze without classical props was historically prefaced by the work of nineteenth-century French "art" photographers such as Nadar, Durieu, Villeneuve, and others who photographed nudes.)[32]

The fiction of Brassaï's photography is that the beholder is permitted a voyeur-photographer's view of Matisse's creative process. The model's gaze is cast down, demurely avoiding that of the painter, the photographer, and the spectator. Matisse is, as usual, positioned much closer to the model than traditional academic life-drawing requires. Roles are defined by a sharp contrast of nudity and costume that could be "naturalistic" only in the setting of an artist's studio (or, as we know from Brassaï's own contemporary photographs, in the setting of a brothel). Whereas the model is naked except for slippers and bracelet, Matisse is dressed in professional—almost clinical—attire, wearing a lab coat, necktie, *gillet*, and spectacles. We may never know the extent to which Matisse's concentrated attention to drawing the model was staged for the photographer. It hardly matters, because Brassaï's chief goal seems to have been to photograph Matisse in his environment as if to reveal the painter's artistic condition and agenda *in nuce*, as a single moment excerpted from the flux of time.[33]

In a subsequent photograph of Matisse with his model (1939), more than a third of the photograph is taken up with an almost straight-on, flat view of the first version of the painting *Liseuse au Fond Noir* on the easel. Brassaï's view of the studio is correspondingly composed (and then cropped for publication) in the manner of paintings of the studio made by Matisse. The photographed painting itself contains a representation of passive womanhood in the environment of the artist's studio. Then, another, nearly identical composition was set up and replicated by Brassaï in photography, with the same model who posed naked in the earlier drawing session. But in Brassaï's photographic "remake" of the *Liseuse*, the painter himself is present twice: Matisse is seen from the back, looking intently at the model—the painter's gaze is almost parallel to that of the photographer—and his face is seen reflected in a mirror, from which he appears to look out (in the direction of the viewer) to study the model. Brassaï's pictures within pictures prompt a series of equations: The nude study pinned to the wall is presumably of the same model who enacts the part of *Liseuse*—even the crook of

her supporting elbow creates a visual echo. The painter, who dominates the scene, is framed as in a traditional portrait, looking out at the model from the mirror. The photographer's implicit presence recapitulates the privileged gaze of the artist and expresses an overwhelming sense of "having been there." Once more, Brassaï's photographic *abyme* allows for the complex articulation of a photographic space in which the relationship of the viewer to the painter, the photographer, and the model unfolds. Again, this system of photographic practice is a two-way process, which celebrates the creative potential of masculinity in modern painting even as it validates the role of the photographer as artist. The artist's studio as a place of enchantment—a Matissian "private garden" sanctioned for voyeurism—is thus articulated by the photographer. Brassaï's photographs of Matisse from the summer of 1939 formulate these precepts with an apparently effortless finesse.

Let us turn to some of Liberman's work. Liberman's strategy in *The Artist in His Studio* (1960) also packages the artists' creative experience in an ostensibly documentary style. As in MoMA's *Brassaï* of 1968, discrete images are frequently paired on facing pages. Image gives to image in the contrived photographic equation of biographical *abyme*, whether the artist was still living or Liberman was working with the conserved material of art object and reminiscence in a reconstructed site styled for photography.

In flat high-contrast color, for example, a photographed detail of some brushstrokes in Monet's *Nymphéas* series (1920s) bleeds into a separate photograph of the water-lily pond at Giverny (1954). The page ensemble suggests timelessness and spacelessness, conflating images made over the decades as if the whole were conceived in a simultaneous, instantaneous "perfect negative" situation.[34] All horizon is obliterated into graphic flatness in this layout: Liberman demonstrates Monet's modernist (visually "photographic") orientation just as he mimics Monet's project in his own photography, so that the sense of a genius "taking" from the environment of nature is redoubled in documentation.

There are several other such examples of posthumous biographical interpretation. An intimate photographic view of Pierre Bonnard's bathroom adjoining the studio at Le Cannet (1955), which documents the bath towel *still* casually, exquisitely draped eight years after the master's death, faces (left to right) a photograph of Bonnard's *Nude with Lamp* of 1912. The placement of a color reproduction of a painted nude facing a black-and-white documentary-style photograph, allows Liberman's photographic reconstruction of Bonnard's vision to resonate with the suggestion of the absent female body. Consciously or not, Liberman's method of representation parallels Brassaï's recollections of Bonnard's studio: the stark poetry of documentary photography's black and white is redolent with the memories of "febrile"

and "sensuous" women in colored paint. Liberman states that in Bonnard's world, "Dreary everyday reality was transformed by his art into an object of admiration and beauty"—an obvious allusion to the transformative qualities of Liberman's own craft in published photography.

In the same text, Liberman creates a Vasarian literary conflation of art and the artist's personality: "[Bonnard's] art is a magnification of the modest." Likewise Bonnard's life was characterized by an essential timidity and "bourgeois prudence," saving laundry receipts and lists of petty expenses, working slowly in a tiny, cramped studio. Another important aspect of this bourgeois-bohemian personality at home and in the artistic environment was the way Bonnard looked at female bodies. Liberman rhapsodizes on the subject of Bonnard's voyeurism: "His women wash, bathe and move as if unobserved in that supreme, defenseless moment when all shame disappears because, through love, confidence and trust are born. His women know that they are loved and that the painter, like a lover, will adorn them in whatever instant he sees them with the all-embellishing magic of his crystallization."[35] Bonnard's art, then (like Liberman's photography), was predicated upon a legitimation of the voyeuristic gaze.

Liberman's investigation of the artist's interior mind was represented by photographic juxtapositions in *The Artist in His Studio*. In the case of Jean Dubuffet, for example, two portraits stand confronted: Dubuffet's *Head with a Lilac Nose* (1951) faces Liberman's *Portrait of Jean Dubuffet* (1952).[36] The similarity of the two heads, presented as though they were facets of a single personality, creates a tendentious visual equation, proof positive of the man-*as*-his-work. The grainy, speedy shot of Dubuffet is constructed in a photographic *art brut* style that appears to possess a reflexive and causal relationship with Dubuffet's own idiosyncratic language. Liberman's double-portrait tactic has an obvious counterpart in Brassaï's system of psychological revelation through the "language of walls," a notion that springs to mind here because of Dubuffet's own fascination with wall surfaces and graffiti. Alexander Liberman leads the reader to believe that he has simply "discovered" the phenomenon that the painter looked like his art, and "documented" the fact that Dubuffet's art reflected his persona.

Lucrezia del Fede and Lucie Vallore

Liberman's modernist legends of the artists were constructed to be received as candid, involuntarily revealed truths. Close readings of the photographs and texts, however, disclose that traditional narrative codes supported the modernist interpretations. In the case of Maurice Utrillo, for example, Liberman represents an artist whose virility is apparently in question. Utrillo

seems unable to meet the camera's gaze as his wife (smiling stiffly, and inadvertently pointing to herself) props him up.[37] Utrillo is represented as haunted by his nagging wife, Lucie Vallore, a "loving tyrant" who drove him to withdraw into a state of perpetual sadness through her "interminable chatter." According to Liberman, Vallore spoke incessantly and, what was *worse*, "She spoke mostly about herself, Lucie Vallore, the painter." Little surprise that Utrillo himself was ravaged by alcoholism and emotional suffering: "This man gave the impression that he did not enjoy life and wanted no part of it, that he had relinquished any control. One did not even feel his presence in his own home. Madame dominated the household."[38] Liberman's representation of Utrillo as a tragic figure rests on the idea that the masculine dominance he needed to produce art had been relinquished to a woman.

Lucie Vallore had an infamous predecessor in the personality of Lucrezia del Fede, the supposedly demanding, imperious wife of the sixteenth-century Italian painter Andrea del Sarto. Indeed, the undermining effect that an assertive wife can have on a painter's life and work is a theme at least as old as Vasari's first edition of the *Lives* (1550).[39] Like Vasari's Andrea del Sarto, whose domineering wife, Lucrezia, presumably caused a lack of "*fierezza*" in his painting, Liberman's Utrillo is represented as a "humble" painter and a humiliated man.

The theme of Sarto's domineering wife as reported by Vasari was taken up by Ernest Jones in a psychobiographical essay first published in *Imago* in 1913. Jones's essay was reprinted in 1923 and again in 1951—the same year Liberman's photographs of Utrillo appeared on the pages of *Vogue*.[40] Jones's analysis of Lucrezia was elaborated in twentieth-century, specifically modernist terms: the "mutually complementary" factors that prevented Sarto from achieving greatness, according to Jones, were the "inborn lack of that ineffable quality called genius" coupled with "the unfortunate influence of the painter's wife." The problem with Sarto, Jones surmised, was that he had an essentially passive, receptive (feminine) temperament: "One cannot help feeling the difference between a masculine, creative temperament and a feminine, receptive one." The dread of a threatening ("dangerous") female presence in the artist's domestic-workplace situation was suffocating: "How could Andrea sink himself into his art (flight into work) when there was Lucrezia in the body, with him at every moment?"[41] Liberman's Lucie Vallore and Jones's Lucrezia del Fede are, *mutatis mutandis*, products of the same assumptions. The artist, in order to put genius into action, must be sexually unbound, unfettered, and free to express his primordially masculine creativity. The artists' women, on the other hand, as idealized from 1550 to 1950, from Vasari to *Vogue*, are required to cooperate in silence.

In Giacometti's Studio

Alberto Giacometti was an important subject for Alexander Liberman, much as he had been for Brassaï. The Giacometti spread in *The Artist in His Studio* was again designed to demonstrate a special style of psychological insight as expressed by two authors: the modernist sculptor and the documentary photographer. Liberman's strategy was to validate modernist assumptions by means of photographic documentation. He wished to expose the material and emotional factors that were intrinsic to the artist's biography.

Facing pages with a dozen small photographs (labelled A–L) suggest a sequential documentation of a day in the life of Giacometti, from the throes of tormented creativity to exhausted resolution. In this photographic chart, works of art merge with the domestic fabric of the studio, and likewise the personal life and material effects of the artist are inextricable from the studio environment. The strategy of photographic presentation consists of a gridlike mosaic of equal-size, mixed-sequence fragments that appear to be excerpted from the continuum of lived reality in the artist's studio. Scanning from A to L, the reader is meant to experience a candid view of the sculptor's kinesthetic thinking as he forms a clay figure. Similarly, we are permitted to glimpse Giacometti in an apparently private moment of anguished concentration. Annette Giacometti is represented in a distant vignette, reading on a dishevelled couch among her husband's scattered works of art and sketches; she turns away from the viewer into her own private world, and her face and mind are represented as absent to the degree that those of the artist are emphatically present. Liberman's captions accompany the photographic story as follows:

A. The alley that separates Giacometti's studio, right from his casting studio, left, where his brother Diego helps him.
B. The walls of Giacometti's small studio are covered with his drawings. On a shelf are many works in progress.
C. Giacometti working on a bust of his brother Diego.
D. Concentration.
E. Finished and unfinished sculptures, mysterious hieratic forms shrouded in his studio.
F. In his tiny one-room kitchen-bedroom-living room, on a chair by his bed, books of poems by Rimbaud, Apollinaire.
G. Giacometti sculpts standing; he moves around his sculpture.
H. Annette reading in the studio, surrounded by works in progress.
I. In the bedroom, flowers and drawings on the walls.
J. While he works, a cigarette is never out of his hand.

K. When he paints he holds his thin brushes at the very tip, so that his smallest movement is amplified.

L. The artist's family, his wife Annette, brother Diego.

In addition to the captions, extravagant prose reiterates the drama expressed in this visual biography. As a kind of modern-day Vasari, Liberman thrived on the fantasized details of the artist's personal life, conflating them with his work, as if to quantify that ineffable quality of genius. Liberman describes the studio with the apparently impartial but slightly amazed voice of an anthropologist encountering the customs of a distant culture. He then goes on to describe the artist's wife:

Giacometti's wife, Annette, is about five feet four, like a slender girl of fourteen. She is not fourteen, she is much older, but her youth, her beauty, a poetic quality of mood are a contrast to Giacometti's somber brooding. She has the naive and innocent expression of a child, and laughs often with a girl's laughter. This girl-wife seems made to be the companion who does not distract the artist from his work. They met in 1949. She always says the formal *vous* to Giacometti.[42]

And about the Michelangelesque genius at home: "He is a man possessed. Time has no meaning for his daily life; he eats and sleeps as he needs to. There is no specific hour for any activity, only the time to speak, to create."[43] Alberto Giacometti is represented as a person of almost unbearable intellect and *terribilità*, whereas his female counterpart is seen as small, graceful, innocent, childlike, submissive, nondistracting, and intellectually absent.

What is "captured" in Liberman's journalistic images of Giacometti is the hyperpersonal atmosphere of the studio, the *Sturm* of activated intellect in the artist's countenance and physical presence, and the contrasting benign cooperation of his wife as passive inhabitant of the studio environment.

Modernist Artists in Yesterday's News

Fashion magazines in the United States and elsewhere continue to promote the idea of masculine creativity and corresponding feminine passivity. In honor of the 1992–93 Matisse retrospective at MoMA, *Vogue* published an article by Kennedy Fraser, entitled "Matisse and His Women."[44] The essay is introduced with a Brassaï photograph (1939) of Matisse sketching a nude model, and its theme is announced by Fraser in the headline: "Matisse's women and their world are not as cozy as they seem at first glance, but they are fundamentally benevolent." *Vogue* readers were apparently meant to be reassured by Fraser's opening assertion that "Because of his importance, most of the scholars and experts on Matisse have been men. And there are

virtually no accounts of women stepping out of the pictures Matisse made of them to get jealous of each other or mad at the Great Man."

Madame Amélie Matisse was "the wife of the Great Artist par excellence in the days of early struggle ... She gave her all to him while he gave his all to his art." But sometime around 1911 Matisse's marriage fell into crisis, possibly because of his love affair with his pupil, a young Russian blond named Olga. At this time, Fraser declares, "He asserted the right to reside at will in the sunny luxuriant pocket jungle—the earthly paradise—while his wife cheered his forays and welcomed his return." As far as the artist's environment was concerned, "he would arrange to live more and more in the contemplative place where he was untroubled by the demands of others: 'the private garden where I am alone.'" Amélie had apparently modeled selflessly in Matisse's early career. But after posing for a hundred hours for *Portrait of Madame Matisse* (1913), she "sank into depression and a mysterious invalidism that would grip her completely for the next twenty years." Meanwhile, Matisse's studio continued to be overpopulated with girls and women: "Real feminine presences were jostled by representations of females in his sculptures on tables and his canvases all over the room." American *Vogue* in 1992 simply presses on with a script that is half a century old. The usual arrangement of viewpoints and applications survives. In 1992 Alexander Liberman was still at the helm of Condé Nast, Brassaï's photographs were still invoked as documentation, and Kennedy Fraser's text clearly internalizes those of Liberman and Brassaï. The piece in *Vogue* is meant to be read preparatory to attending the MoMA exhibition; or, what is probably more likely for many American women, it is meant to be read instead of attending the MoMA exhibition.

Certain mainstream art journals further amplify and elaborate on modernist legends of masculinity in the creative process. The notoriously glossy American art magazine *Sculpture* recently (April 1994) published an interview with Alexander Liberman.[45] Here, in conversation with *Sculpture*'s editor, Suzanne Ramljak, Liberman rearticulates his stance toward the image of the artist. "My book, *The Artist in His Studio*," he states, "was an attempt to find answers to questions of how the great painters of a certain period worked.... So my pictures were not a photographer's pictures, they were journalistic documents.... I photographed what I was searching for; what was noble in existence. It is always a search for the essence of the best in the world, of man's potential for human achievement."

With regard to his magazine work for *Vogue*, Liberman asserts that his main contribution "was to bring the good and noble to American life and American women." He then posits that whereas "photography feeds on reality," art feeds on the "subconscious." He speaks of the production of art in

terms of the male erotic experience, declaring that "it [art] also has to do with some sort of penetration. Penetration is one of the key forces in the experience of art, along with eroticism. To some people it may sound pornographic or ridiculous, but penetration and eroticism is one way human beings have of leaving this life and going to some superior realm." And on his own works of large-scale sculpture: "I do believe in the vertical, the erection."

When Ramljak leads back into the question of eroticism and *The Artist in His Studio*, Liberman states that the making of (modernist) art requires extensive female suffering: "That's why I didn't totally plunge into art. I was afraid of making my wife and the women I've loved unhappy. All the lives of women partners of men artists that I have observed have been rather miserable. The real artist is practically a madman, an obsessed man."

The *Sculpture* interview recapitulates the modernist values that we have seen advanced in the work of Liberman and Brassaï. Namely that photographic images of the artist in his studio serve to demonstrate the otherwise invisible essence of masculinity in art. The mystique of artistic production is equated with virility, as in the *topoi* established by Vasari in the sixteenth century and reshaped in modernity by the Freudian psychologist Ernest Jones. Texts by Brassaï and Liberman continue to encourage a particular response from spectators, who have been culturally primed: that is to scrutinize "documentary" photographic images for traces of the creative process. These representations, which were published in the guise of candid views of the making of art, continue to shape and reinforce abiding cultural imperatives.

...

Oxford Art Journal *18, no. 2 (1995): 45–58. Some of the ideas in this essay were presented at the Colloque du Comité International d'Histoire de l'Art. Images de l'artiste, Université de Lausanne, June 1994. I am grateful to Baruch Kirschenbaum, Gary Metz, and Maureen C. O'Brien at the Rhode Island School of Design for having encouraged my interest in photographic images, and to the Editorial Group of the* Oxford Art Journal.

1 This phenomenon corresponds to the assumption that whereas the proper identity and habitat of women is found in nature, culture is produced by men; see Sherry Ortner, "Is Female to Male as Nature Is to Culture?," in Michelle A. Rosaldo and Louise Lamphere, eds., *Women, Culture, and Society* (Stanford, 1974), 67–87. Suzi Gablik, in *The Reenchantment of Art* (New York, 1992), 127, articulates the consensus that in a general way, "modern aesthetics [have] been colored, structured, and controlled by a kind of compulsive masculinity." The pioneering essay on this subject, written by Carol Duncan in 1973, represents a point of departure for my inquiry: "Virility and Domination in Early Twentieth-Century Vanguard Painting," *Artforum*, December 1973, 30–39 (reprinted in Norma Broude and Mary D. Garrard, eds., *Feminism and Art History: Questioning the Litany* [New York, 1982], 293–313).

For postwar artists see Amelia Jones, "Dis-playing the Phallus: Male Artists Perform their Masculinities," *Art History* 17, no. 4 (December 1994): 546–84.

2 These images have been dispatched into society so widely and frequently that it would be futile to try to determine the number of times each image has been published, or to identify specific instances of stylistic "influence" among the clusters of images. Major published compilations of the photographs under discussion here are Alexander Liberman, *The Artist in His Studio: Text and Photographs by Alexander Liberman* (New York, 1960), foreword by James Thrall Soby; *Brassaï* (Museum of Modern Art, New York, 1968), introductory essay by Lawrence Durrell; Brassaï, *The Artists of My Life* (New York, 1982) (also published as *Les Artistes de ma vie* [Paris: Denoël, 1982]). The original photographs were made at various earlier dates (as indicated in parentheses in the text).

3 Liberman, *The Artist in His Studio* (New York, 1968). This paperback reprint was priced at $3.50. An informal survey of artists, photographers, and art historians who came of age around 1968 confirmed my impression of the popularity enjoyed by the book at that time. Portions of the book had already appeared in *Vogue* before 1960.

4 See Dodie Kazanjian and Calvin Tompkins, "In the Right Circles," *Vogue*, August 1993, 270–311.

5 Ibid., 310.

6 Brassaï, *Artists of My Life*. Germaine Richier, whose most "masculine" qualities are visually exploited here, is the only woman included.

7 John Berger, *Success and Failure of Picasso* (Harmondsworth, 1965), 98–99 and passim.

8 Brassaï, *Picasso and Company*, trans. Francis Price, with a preface by Henry Miller and an introduction by Roland Penrose (New York: Doubleday, 1966), 4–5.

9 Brassaï, *Artists of My Life*, 102–23; memories of January 22, 1937.

10 Brassaï, *Picasso and Company*, 102–3 and passim.

11 *Brassaï* (MoMA), introductory essay by Lawrence Durrell, 9–15, 9.

12 André Malraux, *The Voices of Silence*, trans. S. Gilbert (New York, 1953). For Malraux's system of photographic representation and the modernist intellectualization of art, see Mary Bergstein, "Lonely Aphrodites: On the Documentary Photography of Sculpture," *Art Bulletin* 74, September 1992, 475–80.

13 The format of *Brassaï* was determined by Brassaï together with John Szarkowski (director of the Department of Photography at MoMA) and his staff. No catalog exists for the 1956 Brassaï exhibition at MoMA. For the general intellectual direction of photography at MoMA, see Christopher Phillips, "The Judgment Seat of Photography," in *Contests of Meaning: Critical Histories of Photography*, ed. Richard Bolton (Cambridge, MA, 1993), 14–46.

14 Brassaï, *Henry Miller Grandeur Nature* (Paris, 1975), 33, 38.

15 For the "abyss" in Brassaï's oeuvre, see Craig Owens, "Photography *en abyme*," *October*, no. 8 (Spring 1979), 73–88. The photo historical concept of *mis en abyme* is discussed by Abigail Solomon Godeau, "Reconstructing Documentary: Connie Hatch's Representational Resistance," in *Photography at the Dock: Essays on Photographic History, Institutions, and Practices* (Minneapolis, 1991), 184–217, 186.

16 Excerpted from *The Tropic of Cancer* (1934) in *The Henry Miller Reader*, ed. Lawrence Durrell (New York, 1959), 32.

17 Henry Miller, *The World of Sex* (Paris, 1959), p. 20. In *Black Spring* (1936) Miller spoke of art in terms of brutal graffiti: "I want a world where the vagina is represented by a crude, honest slit, a world that has feeling for bone and contour, for raw primary colors, a world that has fear and respect for its animal origins." *Henry Miller Reader*, 26.
18 Norman Mailer, *Genius and Lust: A Journey through the Major Writings of Henry Miller* (New York, 1976), 90.
19 Brassaï, *Henry Miller*, 38.
20 *Brassaï* (MoMA), 41, 50, 53, 58, 72, 73.
21 Roger Grenier, *Brassaï* (Paris, 1987), fig. 29, "Graffiti," dates this image to 1950.
22 Among the photographs are, for instance, views of Bonnard's garden and of his dining room table (1946); Salvador Dali and Gala posed in their living room (ca. 1932–33); a console with a Maillol sculpture and flowers in Dufy's apartment in Perpignan (1949); Giacometti in his studio (1948); Kokoschka and a woman having tea before a mirror in his studio (ca. 1931–32); the garden entrance to Maillol's studio at Marly-le-Roi (ca. 1932); Matisse in his studio with a nude model (1939); Picasso with his wife, Olga, in the Château de Boisgeloup (1932); Kazbeck, Picasso's Afghan hound, in the rue des Grands Augustins apartment, with view from the window of the rooftops of Paris (1944); and so forth.
23 Brassaï, *Artists of My Life*, 8.
24 For Bonnard's nude photographic studies of Marthe, see Francoise Heilbrun and Philippe Neagù, *Pierre Bonnard, Photographe*, preface by Antoine Terrasse (Paris, 1987).
25 Brassaï, *Artists of My Life*, 8.
26 Ibid., 28–45. For Gala Dalì see Fiona Bradley, "Doubling and Dédoublement: Gala in Dalì," *Art History* 17, no. 4 (December 1994): 612–30.
27 Brassaï, *Artists of My Life*, 54.
28 Ibid., 54–67.
29 Ibid., 124–41.
30 Roland Barthes, *Image/Music/Text* (New York, 1977), 44.
31 See Duncan, "Virility and Domination," 33.
32 For background on the nude in French photography, see Abigail Solomon-Godeau, "Reconsidering Erotic Photography: Notes for a Project of Historical Salvage," in *Photography at the Dock*, 220–37.
33 For Brassaï, the single image was intended to function like a "blood sample," from which an understanding of an artist's total creative condition could be derived—a kind of scientific documentation. The blood sample simile is used by Roland Penrose to extol Brassaï's photographs of Picasso's studio in his introduction to Brassaï, *Picasso and Company*, xvii.
34 Liberman, *Artist in His Studio*, 19–24, illus. 10–15.
35 Ibid., 25–30, illus. 16–20; as art director of *Vogue* Liberman is said to have wanted to apply Bonnard's aesthetic to fashion photography—to show women undressing in the intimacy of the bath or the bedroom, but such suggestive photography was apparently considered 'distasteful' by his colleagues of the 1950s and 1960s, Kazanjian and Tompkins, p. 310.
36 Liberman, *Artist in His Studio*, 281, illus. 134–36.
37 Ibid., illus. 105.
38 Ibid., 230–34.

39 For commentary on Vasari's characterization of Lucrezia del Fede see John Shearman, *Andrea del Sarto*, 2 vols. (Oxford, 1965), vol. 1, chapter 1, "Biography and Character," and Paul Barolsky, *Giotto's Father and the Family of Vasari's Lives* (University Park, PA, 1992), 80–88.

40 Ernest Jones, 'The Influence of Andrea del Sarto's Wife on his Art', first published in *Imago*, II, 1913; reprinted in *Essays in Applied Psycho-Analysis* (London, 1923), pp. 227–44; quoted here from *Essays in Applied Psycho-Analysis*, 2 vols. (London, 1951), vol. 1, pp. 22–38.

41 It is irresistible to speculate: did Jones perceive himself in relation to Freud as Sarto had been to Raphael?

42 Liberman, *Artist in His Studio*, 276–80, illus. 127–31.

43 Ibid., 279. For an interpretation of the modes of fiction in Vasari's *Lives*, see the recent books by Paul Barolsky: *Michel angelo's Nose: A Myth and its Maker*; *Why Mona Lisa Smiles and other Tales from Vasari*; *Giotto's Father and the Family of Vasari's Lives* (University Park, PA, 1990, 1991, 1992 respectively).

44 Kennedy Fraser, "Matisse and His Women," *Vogue*, September 1992, 544–53.

45 Suzanne Ramljak, "Interview: Alexander Liberman," *Sculpture* 13 (March–April 1994): 10–12.

Rachel Harrison, *Untitled (studio view)*, 2009.

Rachel Harrison

The best ways to waste time in the studio are those that are unproductive and not related in any ostensible way to making art. I've fallen into a new way of wasting time, and it doesn't involve the Internet. My new activity is engaging and completely useless. I can't tell you what it is; it's embarrassing to me. I find a lot of what I do in the studio pretty embarrassing, but maybe it's no more embarrassing than what I make. I've never been able to work with people around. I don't want to think about myself when I'm working. It is very hard to get into this state of un-self-consciousness, where I can get lost in the work.

So I need to create an environment where the work takes over. It can't look or be too officelike or even too professional. I can't be fooled into thinking that it's a job. I like a bit of a mess around—some signs of life—and there needs to be unfinished work to respond to. I have a hard time throwing things away, as I never know if they might inspire thought or reflection. This is especially true of failed sculptures. I can put a lot of work into something, get it nearly finished, only to give up on it. I will never show these abandoned pieces in public, but I can't throw them away (just yet) as I might actually learn from them. Or maybe the work that went into the piece leads me into something better.

I could never imagine working in such a way that you are divorced from the process of creation, including the frustration of things not working. I need to be present and with the work at every stage of the game, and I need to spend time with it before I know if it is any good. Failure is often a characteristic of good artwork, but I don't want to show pieces that *actually* fail. I am pretty tough on myself, only sending out my best work into the world, so at times the studio seems like a graveyard of unsuccessful work. Some days it can be hard to face, but it keeps me on my toes. Or maybe it keeps me honest, which is something I want the work to communicate.

Lynn Lester Hershmann, image collage, 2009.

Lynn Lester Hershman
The Studio Present

I place relics of other artists within my studio. The placement is strategic, as these images serve as a continual inspiration of courage, flexibility, spirit, bravery, and audacity. For example, on the way to my computer, which has become a main location for my practice, I pass a personally inscribed epitaph from Timothy Leary in which he carefully notates the progressive failure of his body, acknowledging through the trail of entries his quiet acquiescence toward his inevitable last breath.

Nearby, Yves Klein leaps into the void, flying into space guided only by divine trust. To the left, Ruth Bernhardt's nude edges out of boxed constructions that held her captive for far too long.

Next to my workstation, in the constant periphery of my vision, hangs a passport photograph of Lee Miller. Her inked fingerprints initiate a journey to the front lines of a war where photographs shaped the history of her memories. Later she declared that same passport photo a work of art and, in doing so, objectified her own subjectivity—an act that allowed her imprint to became indelible.

These are reminders of artists who defied self-censorship and used risk as a fundamental element in all of their compositions, despite fear, loneliness, terror, or vulnerability.

Anyone who has been touched by the violence of civil society and survived realizes that there are few things more affirming than the privilege of creating one's own relics. These are the by-products of a life and eventually, uniquely, signify the choices made during the passage of time.

Brenda Schmahmann
Cast in a Different Light: Women and the "Artist's Studio" Theme in George Segal's Sculpture

In 1963 George Segal (b. 1924) created *The Artist's Studio*, a tableau depicting a female nude made from a body cast, a stand with a small bucket of paintbrushes and a palette encrusted with congealed pigments, a chimney of actual cinder blocks, an old wooden chair, and a painted representation of a wall and window. According to Segal biographer Jan van der Marck, the work is essentially autobiographical and reconstructs Segal's original attic studio, where he painted during the 1950s before shifting his focus to sculpture: "Straight from the artist's past, *The Artist's Studio* is a three-dimensional rendering of the environment of a two-dimensional pursuit with all its fondly included, traditional trappings."[1] Yet it could be argued that, to a far greater extent, it is a representation of the subject matter of the "Artist's Studio." The nude figure operates in terms of what Segal has referred to as a "parody of the classic pose of the model ... which is a cliché of a woman [who is] self-conscious in her awareness of her attractiveness."[2] Even the chimney, while having its origins in Segal's studio, does not so much reconstruct the appearance of his working milieu as comment on the kinds of fixtures that have featured in earlier representations of the Artist's Studio, where a stove was required to heat a room where a nude model was posing. *The Artist's Studio* seems in fact to offer an engagement with previous depictions of studio settings and with the ideas that underpin them: the artist/owner, physically absent but nevertheless a presence through the paintbrushes and loaded palette, appears to be less Segal himself than a generic artist figure—one constructed through and by a history of representations.

A self-conscious reference to the Artist's Studio as a theme, as a discourse, can be detected in subsequent works by Segal. In tableaux such as *Picasso's Chair* (1973) and *Rubens's Women* (1984), there are explicit references to representations of this subject matter by other artists, but even *Self-Portrait with Head and Body* (1968)—a work that seems to offer authentic insights into Segal's own art-making process—relates to earlier depictions of studios and, more especially, representations of female models in art from the past.

George Segal, *Picasso's Chair*, 1973.

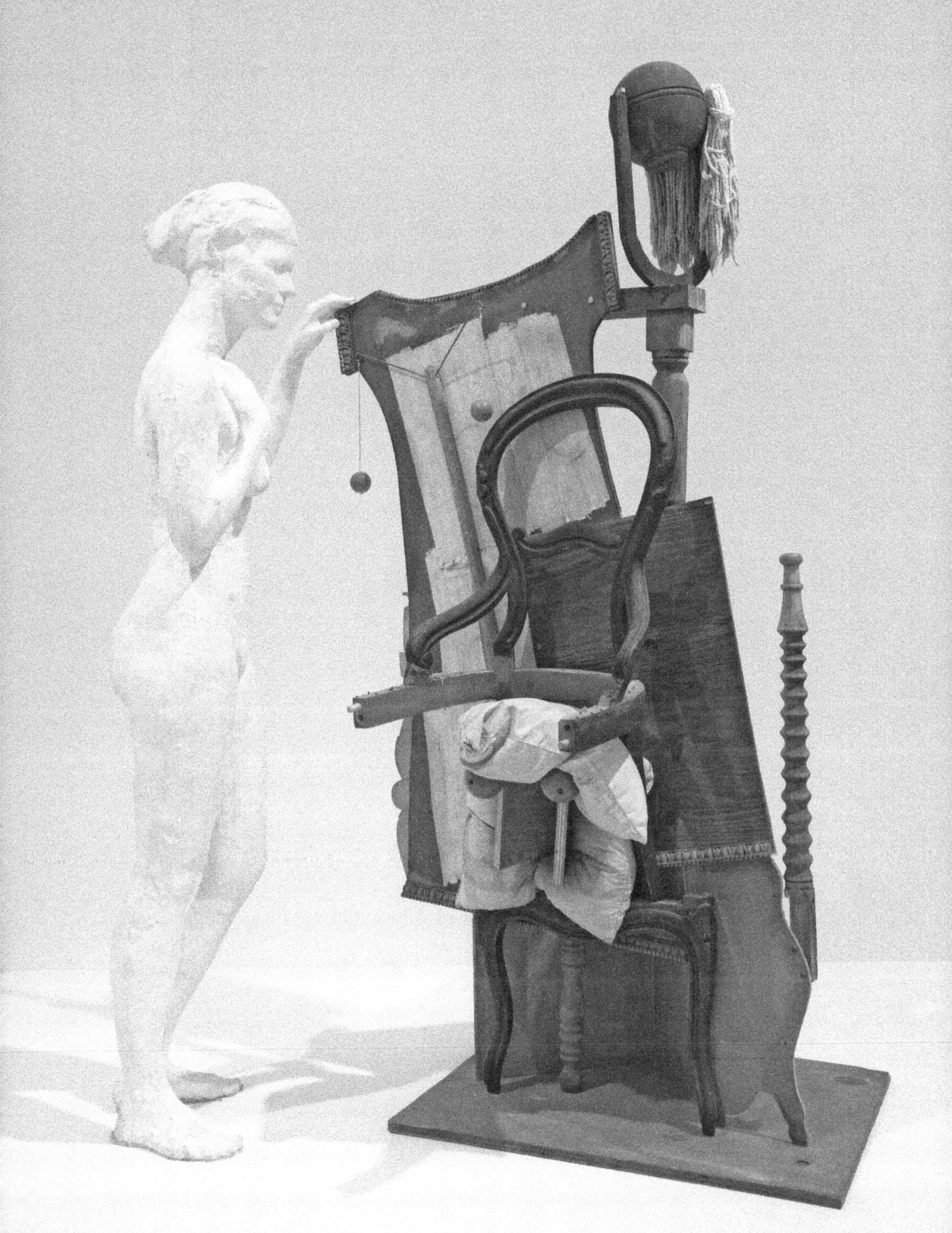

The theme of the Artist's Studio is intimately bound up with endeavors that suggest that art is the product of creative mastery and special perception, thus asserting that the artist has, or ought to have, a status beyond that of mere artisan. The theme has long afforded artists the opportunity to establish an image of themselves as visionaries and, indeed, during the Romantic period to imply that they were blessed with perceptions that separated them from society at large. According to Ronnie Zakon, this view provided a foundation for a conception of the artist as "the Bohemian who fought all conventional attitudes, especially those fostered by the Philistines of the middle class," and, by extension, of the studio as a private realm in which the artist could give form to his perceptions.[3] The nineteenth-century French painter Meissonier stated that the artist "should stay in his studio where he is king," and then asked rhetorically, "What has he to do with society which takes him over, body and soul, when he is famous and serves him up to his guests?"[4] It is the essence of these sentiments that would underpin representations of the studio by twentieth-century artists such as Picasso and Matisse—works in which the painter's (and, sometimes, the sculptor's) working environment is conceptualized as an isolated and mysterious realm in which he enjoys a supreme and seemingly God-given authority.

Meissonier's definition of the artist as "king" is revealing, and my use of the pronoun "he" to describe this creative figure is intentional: If the studio theme is informed by a characterization of the artist as a creative genius, blessed with unique powers of insight, so too is it underpinned by a conception of the painter or sculptor as male. Representations of artists' studios tend to include not only the materials used for aesthetic production—easels and canvases, for example—but also female models, and the contrast established between a male artist and a female model provides a key trope in the Artist's Studio rhetoric. On one level, the depiction of female models enables these artists to represent themselves as virile beings unconstrained by the moral restrictions of society at large—an issue Carol Duncan explored in an essay first published in 1973.[5] Even more significantly, however, it has provided a vehicle for effecting an antithesis between (female) nature and (male) culture, and for representing the model, most particularly the female nude, as what Marcia Pointon terms "a cipher for male creativity,"[6] as raw matter amenable to the transformational or creative powers of a male imagination.

Such conceptualizing of women as material awaiting shaping by a male cultural consciousness is informed by the widespread belief that women are inherently more closely linked to nature than are men. In her influential essay "Is Female to Male as Nature Is to Culture?" Sherry Ortner argues that every culture is "engaged in the process of generating and sustaining

systems of meaningful forms (symbols, artifacts, etc.) by means of which humanity transcends its purposes, controls them in its interest." Although women are recognized to be active participants in the process, they are simultaneously seen "as being more rooted in, or having more direct affinity with, nature" or at least "as being less transcendental of nature than men are."[7] Ortner accounts for this perception of women as less completely acculturated than men by focusing on three factors: conceptions of the female body and its biological functions, women's traditional social roles (which are the product of these biological functions), and, finally, the ways in which women's psychic structure (which is argued to be the product of socialization and not innate) encourages females to view themselves as somehow closer to nature than are men. Ortner notes that a woman may in practice play a role in shaping society, in forming cultural norms, but she is nevertheless simultaneously perceived as part of unregulated, unrefined nature. She is viewed, at least partly, as subject to the controlling forces of culture, as that which is implicitly acted upon rather than empowered with the capacity to initiate action.

This view of women as untamed matter in need of modification by culture would appear to underpin a vast number of images of the female nude in Western art. Lynda Nead notes how Western aesthetics, particularly classical conventions, have provided a basis for ordering the female body into an image of unity and coherence, for negotiating the threat posed by a body understood to be dangerously wayward and inchoate. She writes: "The forms, conventions and poses of art have worked metaphorically to shore up the female body—to seal orifices and to prevent marginal matter from transgressing the boundary dividing the inside of the body and the outside, the self from the space of the other." If, as Nead notes, the female body is defined as a biological entity lacking containment and issuing matter from its broken surfaces, "then the classical forms of art perform a kind of magical regulation of the female body, containing it and momentarily repairing the orifices and tears."[8] Moreover, Nead notes, the female body is understood to be in need of discipline and containment if it is to be prevented from eliciting untempered carnal desires. She shows how this concern, which has its roots in Western metaphysics, underpins Kenneth Clark's influential study of the nude. Clark contends that female bodies necessarily arouse desire and therefore "risk upsetting the unity of response from which a work of art derives its independent life."[9] For Clark, as Nead observes, the "triumph of a 'successful' representation of the nude is the control of this potential risk."[10] Viewed in these terms, classicism becomes a mechanism for managing bodies that are inherently dangerous, for harnessing unbridled lust, and for fusing erotic enjoyment with aesthetic appreciation.

Representations of studios often visualize this idea that women are in need of male creative management by establishing contrasts between the bodies of the artists and their models. Also, they sometimes include motifs that attest to a masculine scientific authority. In Dürer's woodcut *Draughtsman Drawing a Nude* (1525),[11] for example, the languid body of the female, at left, contrasts with the upright figure of the artist, at right, and an intervening grid is suggested to be a mechanism for harnessing the inert masses of the model's body into a perspectivally ordered system. An upright measuring device, placed immediately in front of the artist, reinforces suggestions that the female body is raw matter amenable to male control. Mieke Bal observes that while this object or stand is "supposedly helping him to measure distances," it has a "phallic status [which] is hard to overlook."[12] Gill Saunders summarizes the gendered message articulated in the work: "The male artist is presented as active, analytical, the female model as passive, the object of his gaze and material for his creative intelligence."[13]

Aside from including motifs that attest to male cultural authority, the studio environment has been represented in such a way that it illustrates—or invokes reference to—well-known narratives that articulate the idea that creativity is necessarily masculine, and, in the case of the story of Pygmalion, the notion that the female image is a vehicle for manifesting that creativity. Pointon notes that there are historical reasons for the popularity of the Pygmalion myth among nineteenth-century artists. Although related "to the imperatives of mimetic art forms and debates about 'Realism' in the capitalist West in that period," she observes, it is nevertheless "significant that the female body is the sign for male creativity, for that which can 'bring to life' inert material by imaginative projection."[14] Even when this myth is not explicitly represented, depictions of the Artist's Studio often invoke it. Pointon cites Gérôme's *The Artist's Model* from 1895, a painting in which "the imaging of a symbiotic physical relationship between model and work means that the flesh of the female body is valorised *only* by reference to the carved marble."[15] Equally, resonances of the Pygmalion story can be detected in a number of twentieth-century images of artists at work. If a modernist sensibility would seem to demand that the products of culture have an independent aesthetic identity, that the distinctions between "art" and "life" be made explicit, it nevertheless glorifies the artist as a figure who can breathe new (cultural) life into the raw materials of nature. The idealized image of woman that Pygmalion brings to life can readily become an image of woman transformed into an object of culture with an aesthetic life granted to her through the artist's imaginative and creative powers. In Matisse's pen-and-ink drawing *Artist and Model Reflected in the Mirror* (or *Nude with Mirror*) (1937),[16] for example, the mirror behind the model, which provides

an alternative view of her body as well as showing the artist at work, seems as if it is simultaneously an easel. The artist's materials are obfuscated in such a way that the reflected body appears to be, quite literally, the material that Matisse is forming into Art. The "real" and "reflected" female bodies are conjoined presences, manifestations of Matisse's ability to infuse the raw matter of nature with cultural life.[17]

Segal's three-dimensional images of studios and the female models who inhabit them are ironical in the sense that the method by which these works were made is antithetical to those traditionally considered suitable for producing esteemed objects of culture. Body casting necessarily counters, or challenges, a definition of art-making as a procedure that involves constructing form by working from, rather than off, the human model. Cast body parts might have a place in a representation of a studio (as, for example, in Géricault's *Portrait of an Artist in His Studio*, ca. 1818[18]), but they would not themselves traditionally be defined as Art. Likewise, the use of found objects, however ubiquitous the practice may have become in twentieth-century art-making, is antithetical to a conception of art that demands creative construction rather than relocation of objects and elements in the real world. Segal's art-making methods and treatment of materials are, then, clearly at odds with those depicted in traditional representations of the studio, and they implicitly disrupt ideas about artistic genius and creative individuality inherent in the Artist's Studio theme.

Segal's tableaux also confound and disturb the idea that the artist is a creator of culture while the model is a product of nature. If, as in Matisse's *Artist and Model Reflected in the Mirror*, for example, Segal plays with levels of reality, upsetting distinctions between the actual model and her representation, his works do not in fact create a sense that the woman's body is raw material imbued with cultural life through the hand of the artist. The key element here is what might be termed the "anticlassicism" of Segal's female nudes: although they may refer to sculptures from the ancient world or indeed to classical poses, his casts resist the principles of containment and order that would render them such esteemed products of culture.

In Segal's *The Artist's Studio*, for example, the female figure is represented in terms of uneven layers of plaster, a factured surface that is not only an index of the making process but seems also to create a sense of body that is permeable, vulnerable to both atmospheric effects and the pull of gravity. Not a clear boundary between inner and outer body, the integument of the figure seems to be overlaid with a series of ruptures, creases, and nodules that render it violable. Furthermore, while the figure adopts the semblance of a classical contrapposto stance, this pose is divested of its capacity to render the body as a self-contained, harmonious unit through a series of

balanced rhythms and movements. If contrapposto is traditionally used to create a subtle balance between an engaged and a relaxed leg, evoking stillness but with the potential for movement, here the figure's weight seems to shift between the engaged and the outstretched leg, making her appear uncomfortable rather than at ease. There is not, moreover, the kind of doubling, or mirroring, of model and artwork seen in the Matisse drawing—a twinning that might make it clear that this is a model prior to her translation into Art. The presence of the artist is suggested only through his materials, while the product of his creative transformation—the painting—is nowhere visible. If representations of female models in studios have provided artists with a means of suggesting their own capacity to transmute imperfect nature into Art, an object of culture, the figure in *The Artist's Studio* seems to be Art only by default, through the fact that the plaster shell is a simulation of her body.

If the figure in *The Artist's Studio* resists the raw matter metaphor, this may in part be due to Segal's use of body casting. Casting from life, a process riddled with ambivalences and ambiguities, unsettles the sorts of relations or enactments between artist and model that characterize (or are thought to characterize) works made through more traditional means. If life casting has been regarded as a purely mechanical form of image production, precluding the artist from assuming the role of the "creator" who transforms matter into potent and original imagery, the process nevertheless invests the artist with a type of literal control over the model even more pronounced than in traditional methods of art-making. The activity of encasing a model in plaster places her in a vulnerable situation, giving the artist control over her well-being. Furthermore, the process demands that the sitter be subject not only to scrutiny but also to touch, and the male artist's act of applying plaster, especially to a naked female body, could readily be deflected into a direct assertion of sexual domination. And yet, simultaneously, the diminishing of distance between touch and sight, the fact that the cast is an index of the subject's body, means that the model cannot help but shape her own appearance to a greater degree than can a sitter for even the most mimetic sculpture made through traditional means. It is, of course, important to acknowledge that artists' models always provide some creative input, that the idea that the model is awaiting transformation overlooks the fact that a represented figure is, as Elizabeth Hollander notes, "a deliberate creation, not only of the artist who depicts it but of the model who poses for it."[19] In life casting, however, the model's act of imprinting the work off her body ensures that her self-representation is to a large extent transmuted into the art object itself.

Scrutiny of comments by Segal and the people who have posed for him

suggests that these sorts of ambivalent power and authorial relations inform their negotiations and interactions during the casting sessions. Segal has acknowledged the ways in which he controls the sitters' well-being: "I use real models—but they had to trust me. It gets pretty scary to be wrapped in plaster."[20] Jill Johnson is more blunt and specific, albeit lighthearted, in her account of being cast for *The Girlfriends*, a 1969 tableau:

When you're sitting there with say your whole back chest arms inside yourself, inside your white plaster cast yourself, and you're dying from singing to stay alive because you're all trapped first wet soft then dry hard in this living grave of a George Segal immortal picture collection; when you're like this it's really essential that the technician the artist who's doing it to you becomes a good plumber and makes sure the excess gooey wet plaster doesn't drip down right down through the plastic sheet he's rigged up around your waist for protecting you, and into your crotch your cunt.[21]

Yet, despite the model's vulnerability, she is empowered through her ability to play an active role in constructing her representation. Segal acknowledges the degree to which his models play a vital role in creating meaning. In an interview with Henry Geldzahler in 1964, he remarked:

I usually know generally what emotional stance I'd like to have in the finished figure and I ask the model to stand or sit in a certain way. That model though is a human being with a great deal of mystery and totality locked up in the figure. In spite of my technique certain truths of bone structure are revealed and so are long time basic attitudes of response on the part of the model.[22]

Almost twenty years later Segal again indicated the extent of his dependence on his models. When Malcolm Carter asked him whether he has a clear vision of the appearance of a work before he begins, he replied:

Not all that clear. I have to start with an image in my head, yes. And I have to start with an impulse. But then I try to wipe out my own ego, compare it to a model, to allow the model to be himself or herself in the situation. Maybe I can be lucky enough to get a gesture or a turn or a collection of movements that will reveal something deep about their attitude toward: what? Toward eating an ice cream cone or toward having an orgasm in bed. If I can wipe out my opinion and give my model the lead or somehow thoroughly respect the model—there has to be a certain compassion or even approval: Here's a fellow human being just as cracked as I am—maybe it's like that.[23]

Although it is incorrect to assume that Segal takes no role in selecting a gesture or stance, his comment suggests that he gives his sitters a good deal of leeway in their poses, or at least to modify and interpret his suggestions

rather than viewing them as narrowly circumscribed instructions. Also, these remarks suggest his acknowledgment of the fact that a sitter's physiognomy and habitual gestures inform the appearance of a work, regardless of the degree and nature of his own intervention. Although sitters are vulnerable during the application of plaster to their bodies, they are empowered in the sense that Segal's representations are to a large extent framed in response to the ways in which they present, or represent, themselves.[24]

Also significant is Segal's departure from a conception that unity is something imposed on a body through the devices of Art in favor of an interest in ways in which bodies are themselves integral units. In other words, rather than operating from an assumption that female bodies are inherently formless, that they need to be ordered through the unifying conventions of an aesthetic system, Segal evokes a sense of the physiological consistency that he evidently believes is integral to all his models, whether male or female. As he remarked in 1971, "If you take a whole figure and put somebody else's finger on it, it sticks out, literally, like a sore thumb. There is an incredible consistency in each of us miserable hunks of human flesh. Our fingers have something to do with the way our ears are shaped."[25] Conceptualized in these terms, the model for a work such as *The Artist's Studio* is understood to have a physiological integrity that resists rather than invites modification by the conventions of art, and this informs her representation. The ordering system imposed on the figure—the contrapposto stance—is in fact defied by a body that responds to its own rhythms and systems of organization (rhythms and systems that are not only the product of biology but also learned or culturally inscribed habits). This defiance is of course especially ironic in the context of a work that depicts the Artist's Studio—a subject that has traditionally provided a prime vehicle for suggesting the capacity of a (male) artist to manifest his cultural control over pliant (female) nature.

While the female in *The Artist's Studio* represents a human model, ostensibly for a painting, the partial figure in *Self-Portrait with Head and Body* depicts a body cast of a woman in the process of being assembled. Yet, despite the apparent focus on Segal's art-making process, *Self-Portrait with Head and Body* is ultimately no more autobiographical than the earlier tableau; a reading of its content as, quite simply, a depiction of a technique used by Segal is undermined by the fact that the work evokes a reference to a history of representations and conveys ideas about the act of representation.

Self-Portrait with Head and Body is confounding in the sense that, apart from missing lower legs and head, the partial figure seems on initial viewing no more or less lifelike than the figure of the artist. As Christian Geelhaar notes, "The fragment of a sculpture on a chair and the Self-Portrait are both made of plaster. So with regard to the material both belong to the same cat-

egory of 'abstraction.'"²⁶ This disruption of the viewer's capacity to readily distinguish between the representation of an art object and the representation of a person is unsettling in the extreme, for it encourages the spectator to perceive the partial figure as a decapitated and dismembered body rather than as a sculpture in the stages of production. Although Segal claims that he had no such intention, he acknowledges that the work is liable to be viewed in terms of "the whole masochistic history of martyrdom."²⁷ And yet, simultaneously, the viewer is made aware of the fact that the figure is a representation of an object in that the cropped legs are clearly plaster integuments and the hollowness of the cast is visible through the opening of the neck. *Self-Portrait with Head and Body* seems, in fact, to provide a curious subversion of the Pygmalion myth: The artist is unable to invest the object of his desires with life but appears, instead, to meditate on what must necessarily remain only traces of an absent female subject.

Furthermore, while the Pygmalion story operates around an artist's desire to break down boundaries between the real and the ideal, to bring perfection into a framework in which it becomes immediately accessible, *Self-Portrait with Head and Body* bears traces of Segal's disregard for what, in 1979, he termed "a Greek idea of perfection" and "Hollywood" standards of beauty.²⁸ More recently, he reiterated:

I've always rejected the idea of "the most beautiful girl in the world," "the most handsome boy in the world," which is a Hollywood standard, which is a modern echo of Greek ideals: it goes back to Plato—the idea of a perfect leaf, the idea of perfect pectorals, sound mind and healthy body.²⁹

Although Segal has remarked that his image holding a head in *Self-Portrait with Head and Body* was a way to refer to his "admiration of classical Greece and Rome" and that "the fragment of a figure" reminded him of "Classical equilibrium,"³⁰ the depicted female body is far more particular to the model who posed for the work than are ancient prototypes. The weight of this figure's breasts and the spread of the flesh of hips and thighs belie any Greek or Roman ideals. Furthermore, those areas where one piece of plaster-infused cloth has overlapped another are highly visible, not only functioning as signs of the art-making process but alluding to flesh that is itself scarred and vulnerable. Although the female in *Self-Portrait with Head and Body* may recall antique prototypes in terms of her symmetry, the idealizations and principles for containing the body that are typical in ancient art are subverted rather than imitated.

While *The Artist's Studio* and *Self-Portrait with Head and Body* allude to the Artist's Studio theme in a generic sense, Segal's tableaux also refer to specific works that depict female models in studio settings. *Picasso's Chair*, for

example, is a three-dimensional representation of Picasso's copper etching *Model and Surrealistic Sculpture* (1933) from the Vollard Suite.[31] In this one of a sequence of prints that shows a female model with a sculpture, as Anita Costello has noted, the "differences between the two figures [the model and the sculpture] illustrate Picasso's notion that 'through art we express our conception of what nature is not.'"[32] Yet the work does not simply represent the model in her "natural" and "transformed" states, but rather two alternative renditions representing different aesthetic codes: the "live" model, who is garlanded, is associated with antique imagery, while the "sculpture," which ostensibly represents her, is structured in terms of conventions associated with Surrealism, most especially, as Costello observes, with Picasso's own drawing *An Anatomy* (1933).[33] The "sculpture" within Picasso's print is both a chair and a person, its components anthropomorphized in such a way that they retain allusions to their literal functions while simultaneously being charged with sexual symbolism. Costello explains:

The pillow ... retains its function as an object which would normally be placed upon the seat of a chair. It also serves as the lower torso of the anthropomorphized figure, a function indicated not only by its position and by the placement of the sexually suggestive shapes upon it, but also by the double curve of its upper outline. The contours suggest the curvaceous hips of a woman. Two balls are suspended in front of a patterned "cut out" resembling a woman's dress, thus assuming the role of breasts. The dress itself does not cover the upper torso indicated by the chair back but becomes confounded with the upholstered chair seat. Its flowered pattern, rather like a fleur-de-lis print, and its decorative trim, correspond exactly to the pattern and edging of the seat visible to the right of the pillow. The lower portion of the fabric thus functions jointly as both dress and chair seat.[34]

In a sense, Picasso has represented a female model whose body has been contained and molded in accordance with inherited standards of beauty, contemplating an image of herself that ostensibly reveals the dark, normally hidden aspects of her nature. In other words, the "Surrealist sculpture" in the work is less representative of the artist's ability to give form and coherence to an unconstrained female body than of his skill at exposing the untempered and dangerous desires that lurk beneath a model's apparently civilized demeanor.

In *Picasso's Chair*, Segal translates the garlanded nude into a cast figure. The literal classicism of the wreaths is dropped, as is the rather classical profile, but associations with ancient imagery are effected through the use of the contrapposto pose and the white plaster's allusions to marble. Yet, unlike those of classicized figures, the integument of the nude does not just

define and differentiate the body and surrounding environment but seems in a sense ruptured. Spatterings of plaster and creases overlay Segal's cast figure, and while these tend to allude to scarring, they also suggest bodily emissions and thus intimate that the represented flesh has become permeable and violable. Furthermore, the figure's pubis (not visible in the Picasso print, where the figure is seen in a three-quarter back view) is "impolitely" stressed. The body is, in short, deregulated in such a way that the idealizations underpinning a classicist impetus are contradicted and, indeed, challenged.

To represent a threatening and strange three-dimensional object, Picasso used a medium—etching—that does not consider sculptural issues. The forms and components of his "sculpture" need not be physically joined, with the masses and volumes structured in such a way as to be balanced and stable, and the actual medium of each component need not be specified. Much of the Picasso's capacity to disturb rests on its ambiguity, on the fact that, while appearing to be an inert art object, it could also be a monstrous double of the model, with animation and life. Segal's translation of the object into three dimensions removes this ambiguity, rendering the "sculpture" a composite of identifiable materials and objects. Rather than remain potentially threatening, the structure acquires a quality of literalness, and motifs that in the Picasso are suggestive of rampant and dangerous sexual desires operate, in the Segal work, in terms of a type of visual burlesque. The two balls on the pillow, for example, simultaneously allude to male and female genitals, whereas in the etching, they seem to function as signs of aggressive desires (or, according to Segal, as elements that make "the cool Cubist structure a bitchy metaphor of a woman with balls in her vagina"[35]). In the Segal tableau, by contrast, their redness is so artificial, so ludicrously excessive in its connotation of "hot" sexuality, that their capacity to provide a convincing statement of rampant desire is undermined. Likewise, the strands of hair, which in the Picasso have no particular origin in any kind of object, are translated in the Segal into a household mop—a workaday version of a broomstick that seems to deny the capacity of a woman to bewitch. Whereas the Picasso print offers a statement about the artist's capacity to expose a dark, hidden side of women that is normally masked, Segal's tableau seems to divest the codes, the mechanisms, used in that enterprise of their efficacy. *Picasso's Chair* is, ultimately, a work about the language of art, most especially its devices for representing women, rather that about women and their desires.

A focus on art as an inherited discourse also underpins *Rubens's Women*, although in this instance the works of another artist are referred to and evoked rather than relocated. Also, not only the "art object" (a fragment of a painting) but the three-dimensional figure refer to existent works. The

"art object" appears to be a generalized reference to paintings of women by Rubens rather than an allusion to any single identifiable work (its status as an "extract" is suggested by the frame along two of its sides, which implies that the remaining two are cropped). The standing figure, however, entails altogether more complex allusions. In it, Segal is responding not only to a particular source but to the prototype adapted in that source: the plaster figure in *Rubens's Women* is a parody of Rubens's oil painting *Hélène Fourment in a Fur Wrap* (1630s),[36] a Baroque work that is itself indebted to Hellenistic images of Aphrodite of the Venus Pudica type. (The Medici Venus, a Roman copy of a work from the third century BC, in the Uffizi Gallery in Florence, is one of the best known of these sculptures.)

Rubens has changed the position of the left hand of the Venus Pudica: Instead of loosely veiling but also drawing attention to the pubis, it has been lifted to hip level, where it supports the fur wrap draped around the body. He has also adjusted the gesture of the right arm, allowing it to become a mechanism for thrusting the breasts upward and outward rather than, in an ambivalently modest fashion, partly covering them. More significantly, however, Rubens has manipulated the contrapposto stance in such a way that it invests his figure with a degree of dynamism at odds with Hellenistic prototypes. When used in Hellenistic images of Aphrodite, the contrapposto stance serves to organize the weights and masses of the body in an S-like curve, suggesting the figure's potential for movement while simultaneously retaining its unity and internal coherence. In Rubens's depiction of his wife, however, the sense of contained movement evoked by the contrapposto stance has been disrupted through a misalignment of the figure's upper body and legs. John Berger observes that this misalignment

> permits the upper and lower halves of the body to rotate separately, and in opposite directions, round the sexual centre which is hidden: the torso turning to the right, the legs to the left. At the same time this hidden sexual centre is connected by means of the dark fur coat to all the surrounding darkness in the picture, so that she is turning both around and within the dark which has been made a metaphor for her sex.[37]

Segal's freestanding cast would have been unbalanced if he had imitated this misalignment, but he too invests his figure with a degree of dynamism that is out of keeping with the Hellenistic prototype. Rather than sedately depositing her weight on her left side and bending her right leg, Segal straightens the right leg, which seems about to be drawn forward, as if to support the shifting mass of a body in motion. Whereas Rubens disrupted the sense of contained order and unity associated with the contrapposto pose through a

manipulation of elements such as composition and space, Segal allowed the model herself to effect these disturbances. He noted:

I explained to her contrapposto—the serpentine S, with one form going this way and one form going that way. My model burst out laughing and said to me: "Nobody stands like that anymore!" So I grinned from ear to ear and said, "Stand the way you think you should." So that is exactly how I did it. I tend to have these grandiose associations in my head, and I keep getting jarred back to reality![38]

The resulting work not only disrupts the sense of containment and unity that the contrapposto pose normally conveys, it also exposes the ways that stance disguises its own artificiality with a supposed naturalism. Unlike, for example, the conventions used to order the body in Archaic Greek art, the contrapposto pose masks its own constructedness by implying that a subject might naturally relax into an S-like formation, that a graceful distribution of masses of the body along a curved axis can be achieved without effort. While the figure in *Rubens's Women* does not substitute a natural pose for a contrived one (as no stance is ever unmediated), the contrapposto stance orders the body in a manner that prevents it from being readily mimicked by a living model.

The tradition of regulating female bodies in art demands the use of a youthful model; an aged body is not simply out of keeping with long-standing definitions of female beauty, but it is also liable to become permeable and flaccid, to resist being subject to a system of order and containment. Segal's ironical subversion of the messages and meanings inherent in his source is due partly to the fact that his model for the plaster figure in *Rubens's Women* seems as much as thirty years older than Fourment was when she posed, and that her physique does not lend itself to the sort of idealizing aesthetic system that the Flemish artist adapted to suggest the sexual appeal of his young wife.[39] Although Segal's model had a width and mass that relate to Rubens's Fourment, the nodules and crevices on the cast are of a quite different order from the dimples and folds of flesh represented in the Rubens work. Whereas Rubens has substituted for the smoothness of marble a painterly facture that not only suggests the tactility of flesh but could simultaneously be interpreted as a mechanism for buttressing and supporting the figure's body,[40] the grainy and uneven surface of Segal's figure alludes to flesh that has been progressively eroded through time.

In *Rubens's Women*, as in the other works discussed here, Segal appears to depart from, rather than adhere to, the norms and conventions that have underpinned past representations of models in studio settings. Of particular significance are the ways in which these works reveal a disruption of the

notion of the female model as raw matter awaiting shaping by a (male) cultural consciousness. The actual act of life casting—and the particular way in which that process is used by Segal—confounds an understanding of the male artist as a creative genius and the female model as a passive being who plays no role in the translation of her body into Art. More significantly, the female figures in Segal's representations of the Artist's Studio resist being controlled and managed by inherited aesthetic conventions; they seem instead to subject those conventions—and the ideas that underpin them—to a critique or interrogation.

Woman's Art Journal *20, no. 2 (Autumn 1999–Winter 2000): 29–41.*

1 Jan van der Marck, *George Segal* (New York: Abrams, 1979), 82.

2 Brenda Schmahmann, "An Interview with George Segal" (October 13, 1993), in "Representations of Women in the Works of George Segal" (PhD diss., University of Witwatersrand, Johannesburg, 1996), 344.

3 Ronnie L. Zakon, *The Artist and the Studio in the Eighteenth and Nineteenth Centuries* (Cleveland: Cleveland Museum of Art, 1978), 15.

4 Ibid.

5 Carol Duncan, "Virility and Domination in Early Twentieth-Century Vanguard Painting," in *Feminism and Art History: Questioning the Litany*, ed. Norma Broude and Mary Garrard (New York: Harper & Row, 1982), 293–314.

6 Marcia Pointon, *Naked Authority: The Body in Western Painting, 1830–1908* (Cambridge: Cambridge University Press, 1990), 23.

7 Sherry Ortner, "Is Female to Male as Nature Is to Culture?" in *Women, Culture and Society*, ed. Louise Lamphere and Michelle Zimbalist Rosaldo (Palo Alto, CA: Stanford University Press, 1974), 72, 73.

8 Lynda Nead, *The Female Nude: Art, Obscenity and Sexuality* (London: Routledge, 1992), 6, 7.

9 Kenneth Clark, *The Nude* (Hammondsworth, UK: Penguin, 1976), 6.

10 Nead, *Female Nude,* 13.

11 For reproduction, see Frances Borel, *The Seduction of Venus: Artists and Models* (New York: Rizzoli, 1990), 4.

12 Mieke Bal, *Reading "Rembrandt": Beyond the Word-Image Opposition* (Cambridge: Cambridge University Press, 1991), 173.

13 Gill Saunders, *The Nude: A New Perspective* (London: Herbert Press, 1989), 22.

14 Pointon, *Naked Authority,* 23–24.

15 Ibid., 25.

16 For reproduction, see Borel, *Seduction of Venus,* 5.

17 Because there is an implicit assumption that the artist is male, viewers tend to be confounded when presented with an image of a female artist at work. In her introductory essay for *Looking On* (London: Pandora, 1987), Rosemary Betterton reveals a mistake she made when she first viewed Laura Knight's *Self-Portrait with Nude* (1917)—a painting that shows the artist standing in front of her work, representing a female nude, while the model

stands on a dais to one side. Betterton failed to notice the brush in Knight's right hand and thought she "was seeing a woman looking through the window of a gallery or shop" (4). As Betterton observes, her own mistake reveals something about cultural assumptions about women: "While the woman's narcissistic glance in a mirror or a shop window is socially legitimized, her critical and investigative gaze is not" (4). (For Knight's painting, see the cover image of Betterton's book.) Recent women artists have sometimes used the theme of the "artist's studio" to challenge explicitly the kinds of cultural assumptions that encourage a viewer—even a feminist viewer such as Betterton—to deny women possession of a "critical and investigative gaze." Sylvia Sleigh's oil painting *Philip Golub Reclining* (1971) is especially notable. While Philip Golub is posed in the manner of Velasquez's *Rokeby Venus,* the small hand-held mirror in the painting has been replaced with a large wall mirror that reflects Golub's face as well as an image of the artist. Sleigh is seated in front of the canvas, intently surveying her model's reclining body and interpreting her perceptions into visual form. *Philip Golub Reclining* is provocative not simply because it reverses gender roles, but because it exposes the tensions in viewing that such a reversal creates. For Sleigh's painting, see Rozsika Parker and Griselda Pollock, *Old Mistresses: Women, Art and Ideology* (London: Pandora, 1981), 125.

18 Kenneth Clark, *The Romantic Rebellion: Romantic versus Classic Art* (London: John Murray, 1973), 187, argues that this painting, now at the Louvre, is a portrait of a painter named Jamar who lived with Géricault. I prefer the more general title by which this work is usually cited, *Portrait of an Artist in His Studio,* because the individuality of the sitter seems less the focus of the "portrait" than is his identification as a Romantic artist.

19 Elizabeth Hollander, "Working Models," *Art in America*, May 1991, 154.

20 "The Silent People," *Newsweek*, October 25, 1965, 107.

21 Jill Johnson, "Casting for 69," *Village Voice,* January 9, 1969, 35.

22 Henry Geldzahler, "An Interview with George Segal," *Artforum*, November 1964, 27.

23 Malcolm Carter, "Creators on Creating: George Segal," *Saturday Review*, May 1981, 30.

24 While the identity of the sitters for some of Segal's works is known, the majority are not identified. Although Segal does employ models on occasion, most of his sitters are friends or family members, because, he argues, it is essential that a rapport exists between his sitters and himself. As he noted in Gerrit Henry, "The Artist and the Face: A Modern American Sampling," *Art in America* (January-February 1975), 36: "The models have to feel easy with me and I have to feel easy with them, if you're going to touch them physically and put plaster on them." During my 1993 interview with him he commented: "Of necessity my models have to be people who are friends of mine, or who understand what I'm trying to do. I suppose it's no more mysterious than finding a friend. We tend to make friends with people who are on our same wavelength, people who like the kinds of things we like. I tend to be friendly with people who have a strong mental life, who respond to art, and are responsive to tangible ideas." (338)

25 Quoted in *George Segal* (Cologne: Onnasch Galerie, 1971), n.p.

26 Christian Geelhaar, "Marriage between Matter and Spirit: Interview with George Segal," *Pantheon*, July–September 1976, 235.

27 Ibid.

28 Barbaralee Diamonstein, *Inside New York's Art World* (New York: Rizzoli, 1979), 366.

29 Schmahmann, "Interview," 341.
30 Geelhaar, "Marriage Between Matter and Spirit," 235.
31 *Picasso: Vollard Suite* (Madrid: Turespana, 1993), 13.
32 Anita Coles Costello, *Picasso's "Vollard Suite"* (New York: Garland, 1979), 120.
33 Ibid., 117–18.
34 Ibid., 119.
35 "Postscript," in Van der Marck, *George Segal*, 68.
36 For reproductions, see Borel, *Seduction of Venus*, 14.
37 John Berger, *Ways of Seeing* (London: Penguin, 1972), 61.
38 Schmahmann, "Interview," 347.
39 Hélène Fourment was sixteen when she married Rubens in 1630. As Rubens died in 1640, Fourment could have been no older than twenty-six when he painted *Hélène Fourment in a Fur Wrap*, and she may well still have been in her teens.
40 Nead, *Female Nude,* 20–21, notes how Kenneth Clark accommodates Rubens's works into his argument that a containment of the female body through the devices of art prevents it from eliciting an inappropriate level of desire. She refers to Clark's comment that Rubens "learnt what a severe formal discipline the naked body must undergo if it is to survive as art. Rubens' nudes seem at first sight to have been tumbled out of a cornucopia of abundance; the more we study them the more we discover them to be under control."

Karl Haendel

I am the least agitated then when I am in my studio, and I've been told I'm a horrible person to vacation with because I never really like being away. Even when I head to the airport, I park my car at my studio, so I can leave from there and come back right away. With regard to work, some people "call it in" at times and hide out at home. When I was drinking, I occasionally did this, but now I call my home life in, sending a studio assistant to my house if the plumber needs access or some weeding must be done. I realize this probably means I will make a poor husband and an even worse father, and it bothers me at times. But considering that I work seventy hours a week, the chance of either of those scenarios being realized seems slim.

 I usually have a few studio assistants around who help me. Mieke Marple and Justin Smith, on the drawing side, and Martin Dicicco, in the office, have been with me a long time, and I couldn't make my art without their assistance. I care a lot for them and, at least in my head, think of them as a kind of family. I really wish I could afford to pay them more and give them benefits, because they deserve it. As the economy has worsened over the past year, I have had to let some people go, and firing people is just horrible. I have a physical reaction to doing it, with rapid heartbeat, sweaty palms, and a feeling of dread—pretty much the same feeling I get before I break up with a woman. I'm so bad at both. I think it has something to do with mom dying when I was young. I just can't face people leaving me, even if I initiate it.

 I've been averaging about 100 to 150 works a year, the thought being that, while I can't control which ones are going to be successful, the ratio of success to failure is fairly constant. This way I can assure I get enough "good" ones, although, of course, that judgment changes with context and the passage of time. The general process by which we make drawings is with the lights dimmed and the aid of projectors, with everybody concentrating at his own station. It's generally a meditative and self-controlled feeling that prevails. We rarely listen to music; it's NPR or books on tape. Many, many books on tape, in fact. I'd venture to say that Haendel Studio is the best-read, or more

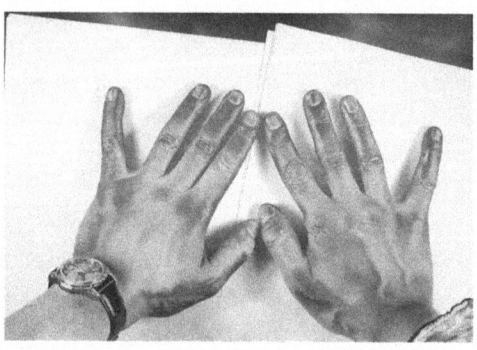

Karl Haendel, composite image of works by the artist: *Karl-o-gram #1*, 2009; *Pencil Stubs #1*, 2009; *Blackhands*, 2008.

accurately, the best-listened studio in LA. I try to pick books that have some thematic relationship to the drawings we are making, hoping that because the ears connect to the brain, and the brain controls the hand, something of their essence will creep into the drawings, so that I can sensibly describe one drawing as Updikey or another as Rothy.

Often, though, much of my studio time is down time—reading the paper, searching the Internet, playing with the cats. But down time in the studio doesn't feel like wasted time, like it does when I am at home; it's a productive wastefulness. And on the occasions when I take an unintentional nap, even if I'm head down on the keyboard, the sleep is more restful than in my own bed. I know it's totally romantic, but I feel an energy in the studio, like the building itself could make art even if I were no longer there. I wonder if it's possible that if I work hard enough, I could somehow engender a chain reaction that would make this come true.

Brian Winkenweder
The Kitchen as Art Studio: Gender, Performance, and Domestic Aesthetics

Even the act of peeling a potato can be an artistic act if it is consciously done.

JOSEPH BEUYS[1]

Art when it is art ... is not separate from life, nor is dishwashing when it is done in this spirit.

JOHN CAGE[2]

Joseph Beuys famously declared that "everyone is an artist," and with his Social Sculpture he hoped to harness the power of art to liberate alienated laborers.[3] In order to accommodate Beuys's dictum, it would be necessary to transform the long-held mythos of the artist to such an extent that it includes those activities that everyone performs.[4] At first glance, this would seem to be a liberating theory, throwing open the studio doors to marginalized individuals otherwise excluded from the privileges of the art world, but instead, writes Martha Rosler, "The figure of the artist as romantic hero reappeared full-blown. Its central organizing features were isolation and genius.... Women, by virtue of their earthliness and closeness to Nature, their involvement with natural birth, were foreclosed from Genius, for, of course, flesh and spirit do not mix."[5] Although Social Sculpture discarded the myth of genius, Beuys let stand the myth of gender essence. Yet to challenge this myth is critical, Rosler argues, if the art studio is to be truly open to everyone: "Part of the project of feminism was a redefinition of subjectivity as socially produced rather than as 'natural.' ... feminists made it their business to show 'weakness,' 'lack,' and exclusion not only as imposed but also as remediable."[6]

 This essay focuses on the use, by Beuys and others, of the metaphor of the kitchen. The hermetic reality of this contested space ossifies gender roles and responsibilities in a patriarchal society unlike no other domestic space, yet Beuys largely ignored the theoretical implications of kitchen praxis. And

he was not alone in doing so. John Cage also cited the kitchen, though in the service of an integrated, Buddhist-informed position of undertaking all aspects of life as consciousness practice: to live in the present and be fully aware.

Perhaps no contemporary artist exploring the kitchen as metaphor has eclipsed its gendered implications as thoroughly as Ilya Kabakov. His early work on this theme, the *Kitchen Series*, consists of ten boards, each comprising three elements: a monochromatic color field, to which is centrally affixed a common kitchen implement—a can opener, a coffee pot, a cup, a grater, a meat tenderizer with, in the upper left and upper right corners, bits of dialogue, exchanges of questions and answers quoted from recordings of the inhabitants of Kabakov's communal kitchen. These Beckettian dialogues emphasize the banal, as Boris Groys has pointed out: "The paintings of the *Kitchen Series* [depict] the tenants of a certain Soviet communal kitchen ... engaged in absurd conversations about the ownership and purpose of the ... insignificant, everyday items in it."[7] Yet, neither is the dialogue "absurd" nor are the objects "insignificant." In the context of the Soviet Union, the ownership of personal possessions ironically underscored the inability to acquire private property, and it is clear that these "everyday items" are not communal property but belong to specific individuals. For example: "Zoya Vladimirovna Koreneva: Whose cup is this?/ Gennadiy Borisovna Savchenko: Anna Prokhorovna's." "Nikolai Ivanovitch Kovin: The coffee pot is all dirty./ Mariya Sergeevna Yelaginskaya: It's Anna Fyodorovna's." Kabakov has suggested that viewers could understand the *Kitchen Series* in two ways, the first literal—"as a dirty, repulsive kitchen [implement] on top of a no less repulsive board"—and the second metaphorical, with "the board represent[ing] the turbid, dense space like a dusty corner, where voice sentences are heard from all sides ... stuck in it forever, like the object placed in the center—and in this case words and object essentially become one and the same thing."[8]

Semiotics, then, informs Kabakov's mode of social critique, with "the kitchen as the center of interaction, conflicts, and mutual surveillance."[9] By displaying signs with their corresponding signifieds, Kabakov uses language as a type of found object. While the central objects draw on the commonplace, the dialogues imply the tensions of communal life in the Soviet Union—and this tension is the primary focus of Kabakov's kitchen work. To obtain the quotations, he hid a tape recorder in his shared kitchen and secretly taped his fellow tenants: "Every thought and word ever pronounced there have accumulated in the air, and together with a thick infusion of different aromas, have stewed and hang there, not flying away.... When hung in one or two rows all ten boards should form an exhibition and thus voices of fourteen or fifteen different people will be 'heard' simultaneously before

the viewer."[10] To imagine this cacophony is to aesthetically experience the din and discontent of a Soviet communal kitchen. The speakers, then, are actors and artists (even authors) within a peculiar static theater with Kabakov as its Barthesian curator.

Kabakov's installation *Kitchen 2, Voices* also utilizes the voices that "accumulated" in his shared kitchen. Eight strings, chest high, run the length of the gallery, and from these, at regular intervals, hangs debris collected from Kabakov's kitchen—sardine tins, packaging materials, small boxes, and other printed matter. Below each fetishized detrital specimen is a placard with a quote from one of the residents. An edited loop of Kabakov's illicit kitchen recordings, consisting predominantly of arguments, adds an audio component to the installation. To fully experience the piece, the viewer must crawl along the floor and look up at the hanging garbage, as if an insect in the kitchen's garbage can. As the *Kitchen Series*, this Kafkaesque installation examines kitchen conflicts, but again gender is not the focus; the tension of communal living (for both sexes) remains Kabakov's concern.

So can the daily rituals of consumption—food preparation and cleanup—truly operate as a space for artistic behavior that takes gender into account? "Many feminists are suspicious about the motivations of those who proclaim, from a position of power and privilege, 'the death of the author,' [or 'Everyone is an Artist']," Jayne Wark cautions.[11] Nancy Miller, for one, argues that the death of the author denies women their ability to establish subjective agency in a discourse free of patriarchal gender constructs: "The postmodernist decision that the Author is dead, and subjective agency along with him, does not necessarily work for women and prematurely forecloses the question of identity for them. Because women have not had the same historical relation of identity to origin, institution, production, that men have had."[12] For Rosler, the "death of an author" (whereby intertextuality occludes subjectivity) neuters the efficacy of resistance to patriarchal social structures: "I was concerned with something like the notion of 'language speaking the subject,' and with the transformation of the woman herself into a sign in a system of signs that represents a system of food production, a system of harnessed subjectivity."[13]

In the work of Rosler the mythology of the artist collides head-on with the mythology of the housewife. Such Sisyphisian clichés as "a woman's work is never done" and "the way to a man's heart is through his stomach" suggest the oppressiveness of this myth. To tell a woman who is socially required to work in her kitchen, who is culturally conscripted to prepare every meal for her family, and who is expected to do the dishes afterward that she is an artist does not necessarily empower her. Sherrie Inness writes, "Cooking provides more than a meal. Food culture contains messages about

OVERLEAF
Ilya Kabakov, *Kitchen 2, Voices*, 1988.

how women and men are supposed to act in our society and what roles they should play. Even today, millions of women are convinced that their place is in the kitchen; millions of men are convinced that their place is anywhere but the kitchen."[14] While men may elect to peel potatoes or do the dishes, these tasks are expected of women.

Reviewing marital sex manuals, Jessamyn Neuhaus outlines the limited roles a wife must perform, and artist has clearly not been one on them: "By tracing the continuities of a discourse—marital sex manuals in the postwar era—where cooking and sexuality merged, we can begin to see that food preparation was more than 'the way to a man's heart.' It was at the heart of being a married woman."[15] Similarly, Marjorie Devault's sociological work clarifies emphatic, if unspoken, expectations regarding who serves and who is served in marriage:

In some cases, the recognition of a husband's claim to service is quite direct (... "I'll make it the way he likes, and everything he likes with it"); in other reports, references to "really decent," "man-sized" meals point toward a more diffuse sense that a husband, because he is a man, deserves special service. Both kinds of statements show how the everyday activities of cooking, serving, and eating become rituals of dominance and deference, communicating relations of power through non-verbal behavior.[16]

Art historian Griselda Pollock clarifies how these observations relate to the making of art: "Femininity was exclusively domestic and maternal. At the same time the bourgeois notions of the artist evolved associating the creator with everything that was anti-domestic."[17]

In contrast to Kabakov and Beuys, Martha Rosler and Olga Chernysheva confront the kitchen specifically as a women's space charged with societal tension, dialectically countering romanticized visions of kitchens.[18] Cooking "is like a symphony," Rosler declares in *A Budding Gourmet*, part one of *Service: A Trilogy on Colonization*. This art project, consisting of three "novels sent through the mail as a postcard, one card about every five to seven days," enables Rosler's audience to experience art about domesticity while in the comfort of their homes. In the first installment, Rosler announces, "I wish to become a gourmet." The term signifies specialization and even implies culinary genius—she pointedly does not wish to become a cook. She frames this goal in artistic terms: "I do this because I feel it will enhance me as a human being.... We can make eating into an *experience*."[19] Rosler thus venerates specialized human experience as art.

The female voice of *A Budding Gourmet* never contests her role as the family's meal maker. Yet, a tension lurks beneath the surface. The wife's reaction to her husband's request that she try preparing exotic foods reveals the

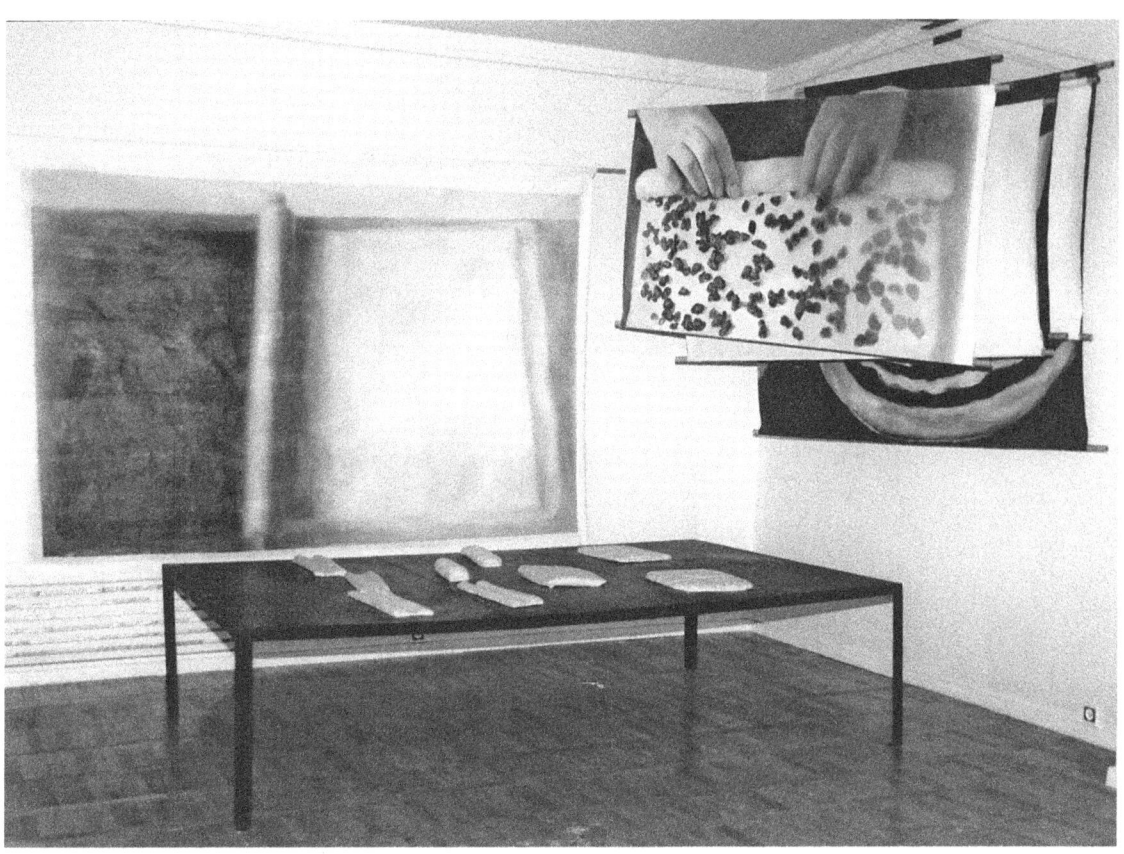

Olga Chernysheva, *Black and White Culinary Book*, 1992.

dialectic between drudgery and creativity in the kitchen: "He said, what if you could make some of this at home.... I had two reactions you know.... I thought, 'The nerve—how could I do this kind of cooking—I don't even know what is in it and think of the time!' But I was also flattered and thought 'why not be creative?'"[20] Rosler, at this moment, equates art with life; but, simultaneously, she represses her initial reaction—"the nerve ... think of the time"—to accommodate the hegemony of domesticity. Justifying this repressive system, she identifies a spiritual responsibility within her socially defined role: "A cook can't just slap things together, you need to have principles in mind. It's like a secret ingredient, a certain spiritual quality.... Chefs are like orchestra conductors.... Art is not an accident."[21] This perspective celebrates a woman's place in the kitchen, elevates it to the level of art. This change is predicated upon a shift in terminology, from "cook" to "chef"—a cook must be cautioned not to "slap things together," whereas a chef, acting with "principles in mind," is expected to use "secret"—or even "spiritual"—

ingredients, to be a maestro. Rosler focuses on such words to stress artistry in the kitchen—she is not a cook but a "budding gourmet." As an artist in the kitchen, she does not merely feed her family. Rather, the food she prepares transcends physical nourishment and enters the realm of intellectual stimulation. In *A Budding Gourmet*, Rosler's work both acquiesces to a patriarchal domestic order and alludes to a capability for release from oppressive patriarchy via artistic production. Her subsequent work ceases to acquiesce to societal expectations at all.

In Rosler's seminal video *Semiotics of the Kitchen*, the repressed rage of the housewife wells up with desublimated urgency. The video begins as a parody of Julia Child's cooking show—the set is contrived *not* to look like a suburban kitchen: "It had to look like some kind of strange set—a sign for a kitchen."[22] At the start, Rosler puts on an apron, holds out a bowl, reaches for a "chopper," and demonstrates its use without actually chopping any food. She then holds up a dish and upends the bowl (with "chopper") on it. Viewers soon realize this is no ordinary cooking show and that Rosler relies on an alphabetic structure to guide her semiotic analysis. The violent subtext of her motions escalates with each new tool—she stabs the air with a fork, jabs an ice pick into the counter, uses a juicer with exaggerated force, and thrusts with a knife. "The protagonist," she explains in an interview, "is seen as aggressive and expressing anger in a situation in which that doesn't usually occur (though women most often murder their husbands in the kitchen)."[23] Through metonymy, the aggressive use of the kitchen tools becomes a means of challenging the institutional order that legitimizes gender roles. By the time she arrives at "tenderizer," her audience too is tenderized (or terrorized); she then becomes language by picking up the fork and knife and uses her body to form the letters U, V, W, X, and Y. For Z, she brazenly slashes the mark of Zorro (and thereby registers an affinity with the character's rejection of colonial authority). Her final gesture is to shrug, which may seem to undercut the power of her performance, but functions as yet another link in a chain of slipping signifiers complicating the work.

Throughout, Rosler's deadpan delivery elicits a nervous laughter: "I've seen this tape function in a liberating way for audiences of women. They laugh, and they recognize the logic of an aggression which is unfocused and undirected.... She's still there at the end ... no further brutalized than at the beginning."[24] This work challenges the "death of the author" at the same time as it acknowledges the central role language plays in shaping our subjectivity. Rosler emphasizes this dialectic: "To suggest that there is no self-determining subject residing within all of these texts is wrong, because language is a primary site of struggle. I feel that the more conscious one is of oppressive namings, the more likely one is to be able to transcend lan-

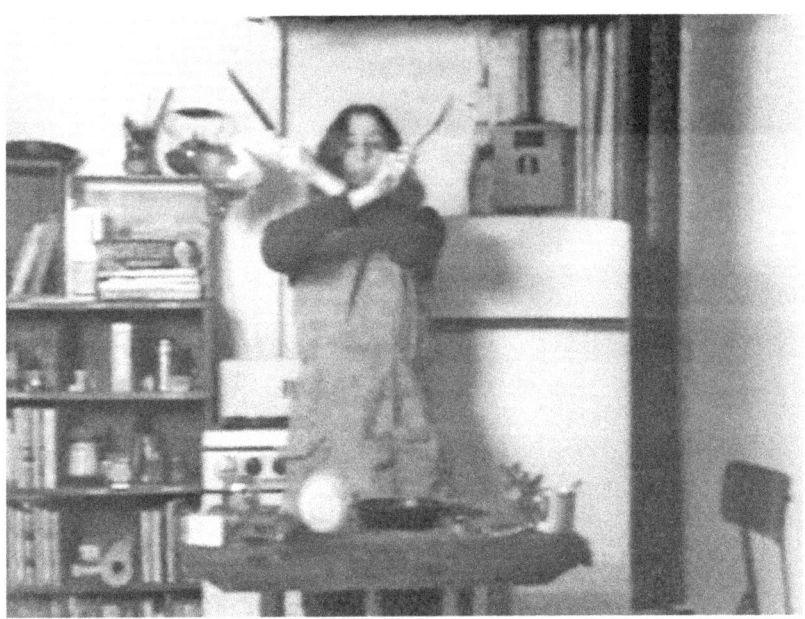

Martha Rosler, *Semiotics of the Kitchen*, 1975.

guage as instrumentality, situated within the self but operating against it."²⁵

Disrupting the hegemonic encoding of domestic settings becomes a common strategy in Rosler's work. In *Bringing the War Back Home: House Beautiful*, a series of photomontages, she juxtaposes photo essays on the Vietnam War from *Life* magazine with depictions of U.S. middle-class residences in *House Beautiful*. This enables Rosler to address metonymically two wars—the manifest conflict in Vietnam War serving as a backdrop for the undeclared war regarding the labor that society expects women to perform in their homes. In *Red Stripe Kitchen* (1966–72) what is missing is as important as what is present. All of the accoutrements in this kitchen imply that a housewife is about to begin work, yet the woman herself is absent. As a synecdoche, Rosler's missing housewife becomes an escaped prisoner of war. The soldiers in this latent war, then, are guards of a patriarchal prison camp, searching for housewives who have escaped through cracks in the house's foundation. This image underscores sociopolitical realities many feminists continue to combat. As Edna Alford and Claire Harris, editors of *Kitchen Talk*, an anthology of women's writings, ask: "Who on earth designated the 'field of battle' as a significant site and the 'field of nurturing' as an insignificant site?"²⁶

Women artists, when referencing kitchens in their work, contest the uneven distribution of domestic labor along gendered lines, whereas male artists more often extol the site as a zone of artistry and elide its gendered

implications. Progressive women artists, unlike their male counterparts, politicize an unsettling dialectic between the kitchen as art studio and the kitchen as prison. As Rosler's work shows, the housewife is often a prisoner on the domestic front in a frequent "war" between the genders. Claire Harris clarifies this tension: "In my personal experience cooking was an art, a place to illustrate a refined sensibility. Or it was a job. In any case it was a woman's place and one escaped as quickly as possible from it to the 'real' world."[27]

The post-Soviet artist Olga Chernysheva, like Rosler and in marked contrast to Kabakov, uses the kitchen as a studio and site of conflict. She focuses on the Soviet Union's expectations of women in the kitchen and what women were actually able to do there. Chernysheva appropriates illustrations from *The Book of Healthy and Wholesome Food*, a 1950s Soviet equivalent to the *Betty Crocker Cookbook*. By focusing on the culinary expectations of Soviet housewives, Chernysheva willfully questions assumptions her culture makes about women's work. Like Rosler, her work examines the kitchen from a dialectical viewpoint. She demonstrates that, in the kitchen, cooks transform themselves into artists. Critic Jamey Gambrell, describing Chernysheva's 1992 installation *The Book of Wholesome Food*, recognizes the link between kneading bread dough and creativity: "The artist showed a slow-motion black-and-white film loop of hands manipulating dough.... After watching the tape for a few minutes you began to feel that you were witnessing a cosmic act of creation."[28] In this installation, at Moscow's Gallery 1.0, Chernysheva also displayed glazed, white porcelain loaves of bread as well as appropriated images of women's disembodied hands at work. Instead of preparing the book's recipes for her family, she copies its illustrations for the art world. On a more place-specific level, Chernysheva's installation lays bare the reality that the recipes of this best-selling cookbook could not be made by most Soviet women, articulating, as Jo Anna Isaak explains, "realizations of what was always a utopian art form because the ingredients for these elaborate dishes were never available."[29] In this way, too, the work presents the disparity between what a woman is expected to do and what she is able to do or wishes to do.

Chernysheva focuses on labor. When asked to define her art, she declared, "I define it as work.... 'Cookery' is a disguise, a pretext.... Basically, I would like to stop making cookery works, but I can't."[30] Although Chernysheva's art questions a woman's restricted role as a cook, she embraces Beuys's "everyone's an artist" theory. When asked how she chose to become an artist, Chernysheva responded, "'Artist' is a word that, for me, denotes a state of mind rather than an occupation. If so, then every (any, to be precise) circumstance is of importance."[31]

In order to tautologically link the term "everyone" with "artist," social

critics must deconstruct the myth of the artist as a heroic genius capable of producing unique objects. To accomplish this goal, an obvious strategy is to pinpoint those activities that everyone must perform and achieve structural change that elevates these performances to the level of art. Yet this strategy is paradoxical: to equate daily life with art may merely reduce the role and value of art in a society that remains unchanged, reinforcing the "outsider" status of artists in relation to a conservative society. Structural impediments and institutionally sustained gender roles do not allow individual agents to enable society to restructure itself in a more equitable manner, and access to subjective agency for marginalized figures, such as women, is denied and neuters any urgency for structural change. As Cheryl Walker puts it: "To erase a woman [artist] as the author of her [art] in favor of an abstract indeterminacy is an act of oppression."[32] Martha Rosler and Olga Chernysheva make art that demands society to reconsider how it distributes domestic chores between the genders.

1 Willoughby Sharp, "An Interview with Joseph Beuys," *Artforum* 7 (1969): 45.

2 John Cage, letter to the editor of *Musical America*, April 1, 1951. Reprinted in *Conversations with Cage*, ed. Richard Kostelanetz (New York: Limelight, 1988), 92–94.

3 Although Beuys asserted this theory throughout his career, the primary bibliographic resource in English is Caroline Tisdall, *Joseph Beuys* (New York: Thames and Hudson, 1979), 6. This catalog of Beuys's retrospective at the Solomon R. Guggenheim Museum reprints his artist's statement outlining his philosophy of Social Sculpture: "The concept of sculpting can be extended to the invisible material used by everyone ... SOCIAL SCULPTURES how we mold and shape the world in which we live."

4 Raymond Williams claimed "we can take the idea of the artist as a special kind of person, and of the 'wild' genius as far back as the Socratic definition of a poet in Plato's *Ion*." Raymond Williams, *Culture and Society: 1780–1950*. New York: Columbia University Press, 1958, 36. In Plato's *Ion*, Socrates refers to artists and poets interchangeably as he describes the divine state of artistic inspiration: "For all good poets, epic as well as lyric, compose their beautiful poems not by art, but because they are inspired and possessed.... so the lyric poets are not in their right mind when they are composing their beautiful strains." (As reprinted in Hazard Adams, ed., *Critical Theory since Plato*, Rev. Ed. New York: Harcourt Brace Jovanovich, 1992, 14.)

5 Martha Rosler, "The Figure of the Artist, the Figure of the Woman," in *Decoys and Disruptions: Selected Writings, 1975–2001* (Cambridge, MA: MIT Press, 2004), 89–90.

6 Ibid., 101.

7 Boris Groys, "Ilya Kabakov," *A-Ya*, 2 (1980): 21. Margarita Tupitsyn first noted the Beckettian nature of this work in "Ilya Kabakov," *Flash Art*, 126 (1986): 67.

8 Ilya Kabakov, "Kitchen Series," *A-Ya*, 6 (1984): 24–25.

9 Margarita Tupitsyn, *After Perestroika: Kitchenmaids or Stateswomen* (New York: Independent Curators Incorporated, 1993), 15.

10 Kabakov, "Kitchen Series," 25–26.

11 Jayne Wark, "Conceptual Art and Feminism," *Women's Art Journal* 22, no. 1 (Spring/Summer 2001): 46. Numerous feminist scholars contest Barthes's theory. See, for example, Cheryl Walker, "Feminist Literary Criticism and the Author", *Critical Inquiry* 16 (Spring 1990): 551–71, and Nancy Hartsock, "Rethinking Modernism: Minority vs. Majority Theories," *Cultural Critique*, Fall 1987, 187–206.

12 Nancy Miller, "Changing the Subject: Authorship, Writing, and the Reader," in *Feminist Studies/Critical Studies*, ed. Teresa de Lauretis (Bloomington: Indiana University Press, 1986), 102–20, 106.

13 Jane Weinstock, "Interview with Martha Rosler," *October*, no. 17 (Summer 1981): 85.

14 Sherrie Inness, "Introduction: Thinking Food/Thinking Gender," in *Kitchen Culture in America: Popular Representations of Food, Gender, and Race*, ed. Sherrie Inness IPhiladelphia: University of Pennsylvania Press, 2001), 9.

15 Jessamyn Neuhaus, "The Joy of Sex Instruction: Women and Cooking in Marital Sex Manuals, 1920–1963" in Inness, *Kitchen Culture in America*, 111.

16 Marjorie Devault, "Conflict and Deference," in *Food and Culture: A Reader*, ed. Carole Counihan and Penny Van Esterik (London: Routledge, 1997), 197.

17 Griselda Pollock, *Vision and Difference: Femininity, Feminism and Histories of Art*. London: Routledge, 1988, 48.

18 Many artists, both women and men, have investigated the kitchen (or food preparation) and its implications of service and consumption, among them Judy Chicago, Alison Knowles, Carrie Mae Weems, Janine Antoni, MK Guth, Paul McCarthy, Wolfgang Laib, William Pope.L, and Rirkrit Tiravanija. In choosing artists to discuss, I do not wish to establish a narrow canon. Clearly, this topic demands more attention than can be provided in a single essay.

19 Martha Rosler, *Service: A Trilogy on Colonization* (New York: Printed Matter, 1978), n.p.

20 Ibid., n.p.

21 Ibid., n.p.

22 Benjamin Buchloh, "A Conversation with Martha Rosler," in *Martha Rosler: Positions in the Life World*, ed. Catherine de Zegher (Cambridge, MA: MIT Press, 1998), 47.

23 Weinstock, "Interview with Martha Rosler," 86.

24 Ibid., 86.

25 Ibid., 87.

26 Edna Alford and Claire Harris, eds., *Kitchen Talk: Contemporary Women's Prose and Poetry* (Red Deer, Alberta: Red Deer College Press, 1992), 12.

27 Ibid., 13.

28 Jamey Gambrell, "Report from Moscow II: The Best and the Worst of Times," *Art in America* 82, no. 11 (November 1992): 57.

29 Jo Anna Isaak, "Reflections on Resistance: Women Artists on Both Sides of the Mir (Feminism and Women Artists in the Soviet Union)," *Heresies* 7, no. 2 (1992): 31.

30 Olga Chernysheva, quoted in "Femininity and Power: Participants' Statements," *Heresies* 7, no. 2 (1992): 97.

31 Ibid., 97.

32 Cheryl Walker, "Feminist Literary Criticism and the Author," *Critical Inquiry* 16 (Spring 1990): 571.

Glenn Adamson
Analogue Practice

The replica is, in a way, the realm of pure craft. It is a vehicle par excellence for bravura displays of craftsmanship since, for one thing, its success is measured by the closeness of its resemblance. The mimetic object has no identity of its own, no proper content or meaning beyond that of what it reproduces, and so the means by which it is made takes on added significance. Its objectness, its materiality, its form absorb the force that would otherwise arise from its "content."[1]

These words, written by Rachel Weiss concerning the work of the Cuban art group Los Carpinteros, are at once perfectly reasonable and somewhat troubling. Copying is not only an example of craftsmanship at its most exacting, as she says; it is also the means by which skills are learned, as when an apprentice mimics the works of a master or a hobbyist works to a set of published plans. It is intrinsic to artisanal culture. But if craft, as a realm of practice, is defined by the replica, then many commonplace claims made on its behalf are unsustainable. The ideal artisan would not be the Gothic carver imagined in John Ruskin's *Stones of Venice*, nor the artful modernist potter, but instead the forger of counterfeit dollar bills. And as that example implies, any ethical notions attached to craft would have to be seen as imposed upon it (for the replica surely has no superior moral status).

Accepting the copy as the quintessence of craft would also have repercussions for criticism. We would have to judge workmanship not on the basis of subjective concerns, such as utility or visual appeal, but objectively, with reference to a preexisting standard. Within art practice, too, craft would have to be seen not as an engine of creativity but as its opposite: constraining rather than generative. In this sense the handmade would find surprising common ground with its seeming opposite, the readymade. Most importantly, we would need to concede the presumption of much aesthetic theory that craft is inherently thoughtless. The copy is the enemy of the discursive; as Stephen Bann puts it, "the quest for the perfect reproduction is simply the quest for an alibi beyond language."[2] A replica theory of craft would ratify

the notion that the ordering forces of art and design are necessary to imbue it with content.

Despite these problems, there is something surprisingly appealing in Weiss's proposal. Not only does it have the benefit of clarity but it sidesteps the ideological superstructure of cultural authenticity and virtue that is built atop craft. Yet a difficulty persists. As Vija Celmins elegantly demonstrated in *To Fix the Image in Memory* (1977–82), for which she replicated eleven stones as nearly as possible in painted bronze, there is no such thing as a perfect copy—at least not one made by hand. Nor, for that matter, is there a perfect original. It may be impossible to tell when examining Celmin's handiwork which are the real rocks and which the fakes, but that does not mean that they are the same. Indeed, seen from a different perspective, it is precisely the inexactitude of craft that makes it a compelling counterpoint to industry. Craft is inherently a practice of approximation. A bricklayer might intend to fabricate each part of a wall identically, but the shifting lay of the land (and, if the bricks are handmade, the minute differences among them) will frustrate that ambition, necessitating a continually adaptive process. The result is what the theorist David Pye called "diversity"—the variations that enliven a crafted product, and whose absence deadens a mass-produced one.[3] Even if craft would be ideally embodied in an exact replica, real-life processes are always more or less distant from that prescriptive model. Craft's great strength, as well as its fatal weakness, is that it cannot play a theme without variation.

What we need, then, is a theory that acknowledges craft as a more or less imprecise rendition of a preexisting standard: as an *analogue practice*. Craft approaches ideal states (the exact copy, the uninflected rendition of a plan, the perfectly smooth surface) while never quite achieving them. It always prompts a comparison in the mind between an actual thing and the thing it might have been. This asymptotic model of production has important ramifications for the consideration of the studio, which I want to interpret here as defined by analogue (rather than serial) production. Unlike a bricklayer, a practitioner in a studio need not face new ground at every step. The terrain is constant. But the studio nonetheless has its limits, and a distinct character engendered by considerations of space, resources, infrastructure, and the skill that can be marshaled within its confines. At a moment when outsourced labor and the frictionless exactitude of the digital are increasingly becoming the stuff of art (as in other spheres of production), articulating those specific features—the qualities of the studio as a productive space—seems ever more vital.[4]

Analogue practice logically assumes the vanguard role in this effort. Though any work will be uniquely distinguished by its means of production,

Vija Celmins, *To Fix the Image in Memory*, 1977–1982.

that is much more explicit in the handmade object. There is a long history of addressing the particularities of studio space in other ways, of course—think of Jackson Pollock's use of the floor, or Carolee Schneemann's performance *Up to and Including Her Limits* (in which the artist, swinging from a tree surgeon's harness, traced arcs with a crayon on a sheet of paper), or Bruce Nauman's spooky night-vision video *Mapping the Studio (Fat Chance John Cage)*. These examples show the diversity of means by which the constraints of the studio can be rendered into content. But emphatically handmade work seems to be our own moment's preferred means of defending the studio space from obsolescence.

Examples of this are legion. There is, first of all, the simple multiplication of labor, the "one thing after another" manner of working perfected by the American sculptor Tara Donovan. In these works, the logic of the near-copy operates on a minute scale, and the work is composed through a multitude of mutually analogous actions. Then there is "sloppy craft," an idiom most often seen in clay but also embracing materials such as printed and woven

fabrics, sequins, paint, and found detritus, as in the work of Josh Faught.⁵ These two strategies are often grouped together under the generalized heading of craft-based art-making, but it is obvious that they are antithetical, not only stylistically but also critically.⁶ An artist like Donovan subscribes to a very traditional theory of value. Her work relies on an unspoken expectation: "I care about this, so you should too." Her skill is put to the service of making charismatic and spectacular objects, in a way that connotes luxury (the embellishment of a Fabergé egg, for example) but also thumbs its nose at the superhuman productions of industry. There is an element of wry comedy to Donovan's sculpture, as well. Her breakthrough work, twenty-seven cubic feet of toothpicks held together by nothing but friction and gravity, is not only an astounding object but a hilarious send-up of Minimalism. This is typical of "one thing after another" art. Variously satirical or evocative qualities can be found in many other artists who work in this mode—the mordant wit of Tom Friedman, for example, or the intimate miniaturizations of Charles LeDray, the street smarts of Chakaia Booker's sculptures made of rubber tire scraps, or the implied global critique of Subodh Gupta's cookware smash-ups. So it would not be right to say that such artists simply reaffirm capitalism's transformation of labor into commodity. But even when such artists critique the normative relations between studio-based craft and mass production, they do nothing to displace those relations.

If every one of Donovan's toothpicks is identical, then every decision in Josh Faught's installation *Endless Night* (2008) is distinguished by a willful disregard for consistency. Even crocheting, a serial craft procedure par excellence, is executed in a flagrantly haphazard way, with meandering lines of erratically sized loops and yarn ends sprouting this way and that, like unruly hairs. The work clearly occupies a radical space within the overall climate of studio-based artisanal activity—Faught's affinity to feminist and queer sensibilities is evident, and is shared by many other sloppy crafters. Yet despite the avant-garde credibility of his work, Faught is the inheritor of the expressionist craft of past decades—most obviously, fiber art by the likes of Lenore Tawney or Claire Zeisler. Though Faught's way of crafting is anything but modernist, his work nonetheless stands firmly within a lineage of makers who transgress the contested boundary of genre that separates the domestic crafts from fine art. The rejection of the copy as an ideal lies at the heart of that tradition. Broadly speaking, then, we have in "one thing after another" art and "sloppy craft," two frontiers of studio-based practice: on the one hand, a multiplication ad infinitum of the analogous, on the other, a denial of its logic in favor of an insistence on the expressive viability of every crafted mark. While terrific art is made at both of these extremes (Donovan's and Faught's included), neither really involves rethinking the studio.

Josh Faught, *Endless Night*, 2008.

On the contrary, they play on themes of obsession and expression respectively, which are the most conventional of studio narratives.

To find a craft-based reinvention of the studio, we need to return to the troubling example of the replica. Take, as an example, the ostensibly identical tables that together make up the work *100*, by the Toronto-based artist Gord Peteran. The parts of the tables are interchangeable, made using tools that belonged to a friendly machinist. ("Ideally," Peteran has said, "the owner of *100* will experience both the structural system as it relates to 'elegance,' and the trust that 'the perfect' can provide with units milled to one-thousandths of an inch.")[7] The title of the work refers to a benchmark in

Peteran's career—it was the hundredth work he made as an artist—but also hints at the subject of mass production. *100* sits firmly in the undefined space that lies between the unique, hand-wrought object and the endless series. As a consequence, it presents us with a conception of value that departs from that seen in Donovan's or Faught's work. The productive system of *100* is indirect, and drastically out of scale with its requirements. It is almost as if, by devoting the tooling required to make a hundred or a million functional objects to only a pair of them, Peteran has rendered a non-art form into an artistic experience of unusual intensity.

How should we characterize the productive space in which Peteran made *100*? While produced on an artisanal scale, it was not made in his studio but rather in a nearby "shop" (a telling difference of terminology). Like the work itself, this shift in the site of production connotes a dialectical relation to seriality. To open up the conceptual space of the work, Peteran (like Celmins) offers us a doubled object. But a similar effect can also be achieved through another artisanal process with a long artistic pedigree: casting. Many sculptural materials, such as bronze, plaster, and plastic, are almost exclusively worked using molds, and many others (clay, soft metals such as silver, and glass) can be cast as well. Casts also occupy a key place within modern art history and theory. Rosalind Krauss famously argues that the cast multiples of Auguste Rodin marked a critical turn in the history of sculpture.[8] By serially replicating his gestural marks, Rodin both undercut traditional notions of artistic expression (the indexical relation between intention and form) and prefigured post-1945 serial practices, ranging from Minimalism to Pop.

We might leave this argument to one side, though, and focus on the quasi-art status of the cast. Here the important precedent is not Rodin but the nineteenth-century practice of creating full-scale plaster replicas of canonical sculpture and architecture. Such objects have had a mixed history in the years since they were made. Many museums destroyed their cast collections in the 1920s and '30s, while others (including my own institution, the Victoria and Albert Museum) retained theirs, long enough to see them become a principal visitor attraction. And since the 1970s, these plasters have seemed to get weirder and better all the time. Their embodiment of art history at one remove has come to seem like postmodernism avant la lettre. Indeed, postmodern artists relied heavily on the plaster cast as a way of marking their fallen state with regard to the past (one thinks particularly of Jannis Kounellis and Giulio Paolini, but one might also consider Manuel Neri, Cy Twombly, Louise Bourgeois, and George Segal in this context).[9]

In more recent years, the historical dimension of the cast has seemed less important than its capacity to mediate between different conditions of production. One way of understanding the studio space is as a theater

of operations in which activities are staged in concert or opposition to one another. Similarly, the studio can be seen as one possible site of art production among others; it can be situated in relation to public, factory, religious, and museum space. The cast, an artisanally made copy, has always migrated between these different environments and can also condense them into a single object. Such is the case, for example, in Sam Durant's recent series of slipcast ceramic chairs, made in Jingdezhen, China. Simulacra of simulacra, these are based on the forms of injection-molded plastic chairs, made in Asia but globally omnipresent. The chairs' monochrome glazes and softly molded edges successfully evoke the quality of cast plastic; on one example, even the faux basket-weave upholstery on the back is reproduced faithfully in a delicate lattice of clay. Where is the real thing here? Perhaps, Durant suggests, only in the specific circumstances of its production. Such is implied by his titles for the chairs, which include the name of every person who contributed to their manufacture. The reality of making is made possible by the analogue nature of the work, which puts something before our eyes without actually materially constituting it.

Many artists—Robert Gober, Janine Antoni, Matthew Barney—use the indirection of the handcrafted cast as a way to navigate the confusing waters of contemporary art practice. Still others, such as Ricky Swallow, Yoshihiro Suda, and Susan Collis, achieve a similar effect by deploying crafts such as woodcarving and embroidery to create preternaturally accurate replicas of mundane objects. And with the recent availability of computer numerical controlled (CNC) machining, one can imagine a near future in which the near-copy serves as a means to triangulate art practice with the realms of the analogue and the digital themselves.

In this short essay, I have attempted to indicate the usefulness of such tactics as means to revivify the studio, interrogating its means while calling its ends into question. As John Roberts put it recently, "there is a broad realization amongst a new generation of artists confronted with the realities of the studio [rather] than the comforts of the seminar room that the tasks of representation and artistic form don't end simply because they are assumed, theoretically, to have ended."[10] Craft is a way of facing up to those realities. Since I have been surveying practices that involve analogy, perhaps I might close with one of my own. Making a perfect handmade copy, if that could ever be achieved, would be something like making an artwork—only more so.

..

1 Rachel Weiss, "Between the Material World and the Ghosts of Dreams: An Argument about Craft in los Carpinteros," *Journal of Modern Craft* 1/2 (Summer 2008): 255–70, 258.

2 Steven Bann, *The True Vine: On Visual Representation and the Western Tradition* (Cambridge: Cambridge University Press, 1989), 19–20.

3 David Pye, *The Nature and Art of Workmanship* (Cambridge: Cambridge University Press, 1968).

4 It is striking to read a recent interview with two of the chief exponents of outsourced industrial sculpture, Richard Serra and Anish Kapoor. Both insist, against considerable evidence to the contrary, that their practice is essentially centered in small-scale craft. "I'm a little cottage modelmaker," says Serra. "I use a hammer and nails!" Kapoor concurs. "I'm very much studio-based. I employ a few people, because you can't do it all yourself, but the studio is all; every problem, every issue is here. I can't solve them in a plane or in my head and I don't believe that intellectual practice is enough. Maquettes are an essential tool, because drawings alone just don't explain it." Ossian Ward, "Size Matters," *TimeOut London*, October 16–22, 2008, 53–54.

5 For a consideration of the "sloppy" aesthetic in ceramics, see my essay "Sloppy Seconds: The Strange Return of Clay," in *Dirt on Delight: Impulses That Form Clay*, ed, Ingrid Schaffner and Jenelle Porter (Philadelphia: Institute of Contemporary Art, 2009).

6 Notably, the two modes were presented side by side in *Second Lives: Remixing the Ordinary*, the Museum of Art and Design's inaugural exhibition in its new building.

7 Glenn Adamson, et al., *Gord Peteran: Furniture Meets Its Maker* (Milwaukee: Chipstone Foundation/Milwaukee Art Museum, 2006).

8 Rosalind Krauss, *Passages in Modern Sculpture* (Cambridge, MA: MIT Press, 1977).

9 For an overview, see Barbara Matilsky, *The Expressionist Surface: Contemporary Art in Plaster* (New York: Queens Museum of Art, 1990).

10 John Roberts, *The Intangibilities of Form: Skill and Deskilling in Art After the Readymade* (London: Verso, 2008), 10.

Amy Granat
1107

Making 16-millimeter film and photos and music and performance, I have had a strange relationship to the idea of an "artist's studio." At first, when people asked to visit my studio, I would get uncomfortable with the idea that by coming to this particular place, they would get some idea of me, that maybe the place should be filled with things and stuff I don't even know. This idea that people I didn't really know would ask if they could come over for a "studio visit," maybe as a way to "get to know" me—it was totally foreign.

But with time (I guess), it became a bit more normal (I guess), and somehow over the past few years the idea that "I am going to show you something" or that there will be any answers has (thankfully) gone out the window. What the studio has developed into, in my case, is a meeting place. A looking place. An extra room in my apartment that is actually not in my apartment at all but two miles down the road. It is where I have friends come by, where Oli and I will run into each other. A place where we can go, where there is freedom. There is emptiness and history, acting together. That is what makes it the pleasant place it is.

It's a place where I store things. It's a place where I can play music really loud and watch 16-millimeter movies. I remember going there almost every day when I first moved to New York. At that time I was visiting Steven there. I would spend hours hanging out with him and Chuck, and Olivier would be there on his way to and from Europe.

The first time I *made* something there, it was a movie Steven asked me to make with him. I made a film called *Cyclotron* and he made a painting, which we intended to be shown together. I think Steven's estate may have thrown my movie away and shown the painting alone at Gagosian Gallery after he died. Memories of Steven still float in this space … and tiny wooden pieces of his crashed stretchers still lay on or are wedged into the floor. This history, my memories, they still insert themselves in this space and, for me, that is important—and not just in art, but in life.

Amy Granat

But objects, studios, movies. I make my films all over the place. And I print my photos in Chinatown. But everyday I walk down Bedford Avenue, turn left onto Manhattan Avenue, and take it to the end, next to the hotel where the sheriff is usually sitting on my doorstep, and I ask him to scoot so I can get to the door, and I go into my studio. Once inside, I look at my stuff or work at the table. Sometimes scratch film pieces; sometimes play the drum set or the guitar.

Today in the studio, March 31, 2009. Rich and Stefan came over and we played music for a few hours. Going between drums, guitar, and keyboard. Then Becket came by to say hi on his way back to his studio after a game of tennis. And then the Time Warner guy stopped by to tell me that he can't hook up the Internet for me until I get access to the backyard. I kept telling him it isn't possible; it isn't our backyard and we can't get access to it. I think it is actually attached to the hotel. But I don't know. I'll have to ask Oli about it next time he comes to New York.

Amy Granat studio, 2009.

David Robbins

The idea of working in a "studio" makes me uncomfortable, always has, as has thinking of myself as an "artist." Both terms presume that my motive is "to make art," whereas much of my career has been dedicated to searching for—and twice discovering—modes of thinking and creating that offer sophisticated alternatives to art, and adding those to the pool of possibilities. I'm not against art; my response to life is just built along other lines. I began as an artist, but over time I came to feel that what we think of as art represents a false freedom: we're allowed to do anything we want *so long as we agree to call it art*. I believe there are other kinds of communication endeavors and production that are yet to be discovered. For all these reasons, I prefer to think of myself as an independent imagination rather than as an artist. I don't like to know where I'm going to end up before I even begin.

Whatever city I've lived in—New York, Cologne, Bruxelles, Milwaukee—I've always worked from home and integrated home life with work life. (I began my career making photographs, and a camera doesn't require much room. I never learned how to print.) Either I made things at the kitchen table or I had them fabricated. I tried having a studio only once, in 1985, when a sculptor friend and I rented an additional apartment in the Hell's Kitchen building where we lived. For me, the experiment lasted just two weeks. I didn't understand maintaining a separate room to which I was to "go and make my art." I hadn't gone to art school and never got into the studio habit. Having a studio made my mind feel boxed-in.

These days I reside in a quiet, leafy suburb of Milwaukee, in a modernist ranch house with great spatial flow. The living room flows into the study. The desk in my study is Swedish, rosewood, circa 1960, of anonymous and rather eccentric design. The chair is a green upholstered swivel chair designed in the mid-1960s by the Danish designer Kay Korbing. Across the room is a comfortable black leather couch designed by a childhood friend, Ted Boerner. It's an environment well-suited for writing books and editing videos, which, being

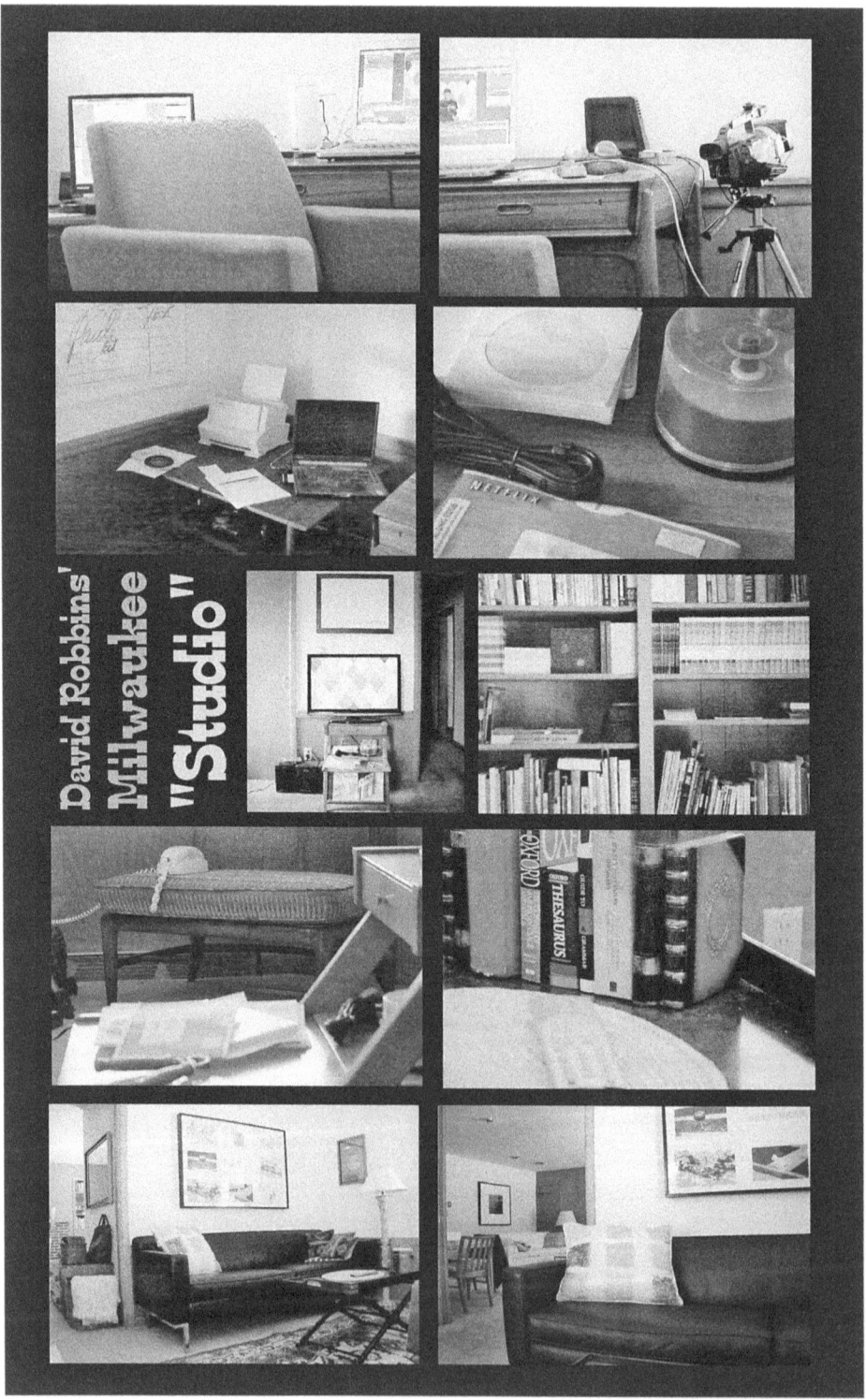

David Robbins studio, 2009.

forms that can travel in the world, in the culture, in the economy, in ways that art does not, I prefer over producing photographs or other art objects.

In the study are tools appropriate to my trades: three laptops and a large television. Each of the laptops is assigned distinct functions. One is reserved for administrative work, career matters, and the Internet; the second is used for Photoshop and video editing; I do my writing on the third, which lays in wait on an ottoman in front of an Eames chair. At least two laptops glow from the time I get up, 6:30 a.m., until I don't have any more work energy in me that day—usually 9 p.m. When I'm editing, the TV functions as a monitor, and then I sit at the center of a semicircle of small screens. Usually the radio is on, too, for added stimulus.

Of course, I have to get the images for the videos somewhere, and all the visuals that comprise my current fascinations—nature, suburbia, physically attractive outdoorsy-looking people, curious or informative juxtapositions of the manmade and the natural—I happen upon outside the confines of home. I keep a video camera in the car, and as I drive around the suburban landscape—going about my business, while keeping my eye sharp and my mind open—I videotape any finds that play to my instincts. Findings are ruled in or out based on the depth of my response to them, informed by intuition and long experience in making things. Some surprising new detail may suggest some unanticipated direction of thought or invention. I am utterly undisciplined, except as pertains to the daily discipline of remaining work-focused, and I am unconcerned about it. There isn't some "problem" that I am using art to "solve." And I recognize no obligations toward art. I am only interested in finding ways to communicate love of life and to self-evolve through that search. My only obligation is to the attention that an audience may give me. That is enough, and it is considerable.

James Welling
Polaroids, 1976

In September 1975 a good friend of mine, Bart Thrall, loaned me his Polaroid 450 camera. After using it for a few weeks, something malfunctioned with the shutter and I foolishly tried to repair it. Never try to repair a shutter. After I bought my friend a new Polaroid, I was left with a shutterless camera body. In January 1976 I realized that I could still take pictures with this camera if I set it on a tripod and removed the lens cap to control the exposure. This I did, and for the next four months I made Polaroid photographs in my studio, in a restaurant I worked at, and at my parents' house in Connecticut. The picture-taking ended in October, when I exhibited the photographs at the Arco Center for Visual Art in downtown Los Angeles. A week after the opening, I bought a real camera, a wooden 4 × 5.

For anyone who knows Polaroid film, there is a large discrepancy between observed color and the color it is able to record. Most Polaroid films have low saturation and are greenish. By carefully studying the data sheet that came with the film, I realized that the developing temperature was extremely important for color rendition. With this in mind, I began to process the Polaroids over my gas stove. Heating the film to over 100 degrees Fahrenheit gave me vivid color but limited me to locations where I had access to a stove—hence home or a restaurant.

The pictures I made in my studio record corners and fragments of things. In a few, such as *Bike at Night*, I refrigerated the film when it was processing to reduce the temperature and accentuate the greenish cast of my fluorescent lights. Among these studio Polaroids are numerous photographs of my green ten-speed bike. Eight months later, this bike would take me around West Los Angeles with my view camera and tripod strapped to its rack. I had finally graduated to serious photography, no longer restricted to interiors. Following the Polaroids of my studio, I would wait thirty years to work in color again, this time photographing farms in the Hudson Valley for a project my brother called "Agricultural Works/Insect Chorus."

James Welling, *Polaroid Photographs*, 1976.

The Studio
as Space and Non-Space

Jon Wood
Brancusi's "white studio"

The last six years have witnessed crucial developments in the history and reputation of the sculptor Constantin Brancusi: first, a major retrospective of his work at the Musée National d'Art Moderne, Centre Georges Pompidou in Paris (then at the Philadelphia Museum of Art) in 1995; second, the new reconstruction of his studio, designed by Renzo Piano, outside the Centre Georges Pompidou, which opened in 1997; and third, the restoration, with the support of the World Monuments Fund, of his large-scale outdoor sculpture the *Endless Column* at Tîrgu Jiu in Romania in 2000.[1] Each of these developments has generated much debate internationally—debate which serves to remind us of the extraordinary, if not unique, heritage of this sculptor, spanning as it does the twentieth century from east to west, from Bucharest to Paris to New York.

At an international conference on the sculptor held in Bucharest to commemorate both his 125th anniversary and the restoration of the *Endless Column*, the speakers were invited to respond to the proposition and question "Brancusi at his zenith: What next?" This article, based in part on the paper given at this conference, is an attempt to look critically at the "whiteness" of Brancusi's studio. In doing so, I give a close reading of one of the most notable aspects of this sculptor's oeuvre, which was much described by many of his contemporaries and which has, in turn, contributed paradoxically both to the mystery and the accessibility of Brancusi's work over the years. The "white studio" is an important part of the myth of this sculptor: it has traveled well and its conceptual implications have, in turn, often been taken for granted. In reconsidering it here I endeavor to show how Brancusi's white studio is not merely to be seen as a proto-white cube but as an elaborate construct that was generated by the artist through his sculpture, through his photography, through his self-conscious crafting of a studio-orientated "artistic identity," and through the characterization of his studio environment by his supporters as a place to stage his art and life. Today, a visit to L'Atelier Brancusi, the new reconstruction outside the Pompidou of the quarters of

his later studio at 11 impasse Ronsin, is a visit to a clean and brilliantly white studio—courtesy of the immaculate white walls and the many white plaster casts of works which he accumulated in his studio and which constituted a good part of the donation to the French state at his death. In this essay, I would like to return to his early years, when the studio was not as obviously "white" as it would later become, and to his first—now "lost"—studio at 8 impasse Ronsin, where he lived and worked from 1916 to 1927. I will look at a range of specific examples within these first years of his success as a sculptor, which lay bare some of the earlier dynamics of this multifaceted workplace, in order to recover some of the germinative origins of the white studio in its images, its contents, and its primary public.

One of the most remarkable and emphatic assertions of the extent to which whiteness was seen as coordinating Brancusi's art and life can be found in words of Margaret Anderson:

Constantin Brancusi lives in a stone studio in the Impasse Ronsin, rue de Vaugirard. His hair and beard are white, his long working-man's blouse is white, his stone benches and large round table are white, the sculptor's dust that covers everything is white, his Bird in white marble stands on a high pedestal against the windows, a large white magnolia can always be seen on the white table. At one time he had a white dog and a white rooster.[2]

Written in the 1960s, whilst referring to an encounter that took place in the 1920s, Anderson's description stands as a telling demonstration of the consistency with which whiteness was seen and deemed to be pursued by the sculptor, as almost a manifesto, throughout his life. This was something which Georges Duthuit also stressed in 1954: "Nothing has changed. Whiteness, more whiteness, whitewash and plaster everywhere, white from chimney to walls to the round tables."[3]

It might be tempting, in the light of such compelling firsthand accounts, to close the file on Brancusi's white studio: it was then, and is now, *white*—no more, no less. As with the notion of simplification and its attendant procedure of seriality, this whiteness was a constituent part of the Brancusi identity and of what has made the sculptor, in the shrewd words of John Golding, "an art historian's dream."[4] Nevertheless, the whiteness of Brancusi's studio, as a concept and as a sculptural material (plaster and stone), can be read as having undergone a number of reappropriations and shifts in emphasis from 1916 to 1957, from his arrival at impasse Ronsin to his death. It does not, despite the contrivances of the sculptor and his supporters, carry the absolute and timeless value with which it was accredited by Anderson and Duthuit.

It was, in particular, the "timelessness" of whiteness, connoting both the

ancient and the modern, that so powerfully facilitated this characterization. Matisse's famous *Red Studio* of 1911, in its attempt to evoke, in "fauve" red, a harmony of objects in relation to the studio interior, did not articulate timelessness. On the contrary, a grandfather clock stood at the very center of Matisse's canvas, while the red serves as a contrast to the studio's green garden surrounds. On the walls of Brancusi's studio there was noticeably no clock. This was a place intended to be without distraction from elsewhere (the sculptor made much of his own furniture and kept a "collection" solely of his own work). As in the windowless and clockless church, casino, or nightclub, all that was required of the studio visitor (-cum-worshipper-cum-dancer-cum-gambler) once over the threshold, was to play and concentrate on the game, not to ask what time it was. Indeed, why should the studio visitor ask? For Brancusi, who was notorious for controlling studio visits, was also famed for offering himself as the register of timelessness amid his work and within the confines of his studios. For he effectively oversaw the construction of a close relationship between himself and his studios' whiteness: in 1916, when Brancusi was forty, he was going gray, and in 1926, the year in which he turned fifty and atavistically sketched himself as "one hundred years old," he was well on the way to being white.[5] As Brancusi got older, not only did his hair and his clothes get whiter (culminating in the famous white burial dress of 1957); so too did his studio. In this way, the whiteness of his beard—more than the sculptor's stereotypical cunning smile and twinkling eyes, favored by Henry James and Rainer Maria Rilke—became one of his central characteristics, one might say, trademarks. It therefore comes as no surprise to find it frequently mentioned in the accounts of studio visitors. He had, by such accounts, the beard of an Arcadian shepherd, of Carlyle, of Whitman, and even of one writer's grandfather.[6] No one, however, was impolite enough to mention that of Rodin. For Rodin was always the measure against which Brancusi judged his work and achievements—as well as, in Brancusi's own words, the "great oak" under which nothing grows. Rodin's beard was without doubt an important precedent and gave authority, gravitas, and seriousness to the status of the sculptor as a "man of letters." Through the lens of his photographers—Steichen and Druet—and in the hands of the other sculptors who portrayed him (Bourdelle, Claudel, and Bouchard), the beard was central to Rodin's "sculptorhood": his self-conscious and represented pose as the master-artist and thinking man.[7] As I will discuss, Brancusi built upon the example of this artistic identity, taking it beyond the sculptural object and portraiture and feeding it into the construction of a studio lifestyle.

It was with his move to the studio at 8 impasse Ronsin in 1916, approxi-

mately a decade after leaving Rodin's studio, where he had been an assistant, that Brancusi first began to construct an identity for his work and for himself as a sculptor.[8] Importantly, his first *vue d'atelier* gouaches and drawings mark the moments that whiteness can be noted as becoming a concern in the characterization of his studio environment. If in his 1915–16 studio photographs, his large-scale wooden *Arch* was photographed as framing Brancusi and work in progress, his 1918 gouache *vue d'atelier* does not frame; rather, it evokes an atmosphere and togetherness in which work and Brancusi himself—through the inclusion of the top of his drawing board, the sculptor's "point of view" in the drawings—is foregrounded. Even when using pen and ink instead of gouache or chalk to create this whiteness—and there is a telling literalism in the chalkiness of such drawings in relation to the whiteness of the studio—he consistently inscribed himself in such views, as Sidney Geist has noted.[9] These first *vues d'atelier* were thus studio views invested with self-portraiture—views in which Brancusi put himself in the picture, in the studio and among his work.

If these curious images mark the beginnings of the white studio, they are by the same token obfuscatory in their subtle insistence on the sculptor's solitude and autonomy, a cliché of modernist creativity. 8 impasse Ronsin was not just a one-man workshop but an intellectual property—a place where hospitality was offered and where ideas were shared and friendships formed. It was during these early years in impasse Ronsin that crucial aspects of this characterization were first formulated and that, through his involvement with Dadaists like Man Ray, Tristan Tzara, Blaise Cendrars, Marcel Janco, and Marcel Duchamp, his studio's whiteness was provided with its first conceptual commentary.

Man Ray was particularly instrumental in this, since in the early 1920s it was he who first helped the sculptor take and develop his own photographs. Indeed, it was through monochrome photography that Brancusi explored with a passion his studio environment as a place of display, complicating the literalism noted earlier. The motif of the lamp, favored by Dadaists (notably Picabia) as evocative of the mystery and magic within the products of technological modernity, figures in many of his photographs as a metaphor for conception and illumination, animating sculptures by highlighting their surfaces and emphasizing their shadows. In the instance of his own studio photographs of himself with Tzara, Duchamp, Man Ray, Mina Loy, Margaret Anderson, and Jane Heap, it was by virtue of the rays of his lamp that the group's togetherness was represented, bound by light in the darkness of his studio. If this lighting strategy recalled Boccioni's "plaster rays" fusing object and environment, what was being fused in Brancusi's case was a

group of avant-gardists in the studio, through the controlling presence and hospitality of their host. Indeed, these were particularly interesting gestures in the context and company of the poet Mina Loy, whose poem "Brancusi's Golden Bird" is a tribute to his use of light and the simultaneous illumination and dematerialization of his bronze sculpture through shine and lighting. Loy described it as "an incandescent curve / licked by chromatic flames / in labyrinths of reflections."[10] Furthermore, following the disappearance of her Dadaist husband Arthur Cravan, Loy managed to continue and fund her work as a poet by starting her own business making designer lamps and light shades.[11]

If photography was the medium used in these early years for the sculptor's explorations, Dada was certainly its intellectual and artistic climate. The relationship between Brancusi and Dada has been addressed before but has usually been seen in terms of his subversion of the traditional function of the pedestal and his use of the base (in stone, wood, and plaster) as an integral part of the work.[12] I shall, rather, draw attention to a shared set of metaphorical concerns. Whiteness was amenable to Dada juxtaposition and subversion: it was amenable to the poetic problematising of binary oppositions, such as black/white, darkness/light, rough/smooth, weight/weightlessness, hot/cold, indoors/outdoors, Western/non-Western.

The Romanian Dadaist Tzara, who promoted the "grinding whiteness" of "Negro Art" in his review of 1917, was a close friend and supporter of the sculptor.[13] His unpublished article on Brancusi, written in 1922 for *Vanity Fair*, begins with the studio's whiteness: "Un grand atelier. Tout blanc rempli de blocs de marbre et de pierres. Des poutres énormes restes de pressoirs de raisin d' il y a plusieurs siècles."[14] Tzara, within Dadaist circles, also took on the self-declared role and persona of a *lampiste* who wrote satirical *lampisteries* (literally, lamp stories).[15] *Lampiste* is the word for both a light technician and a downtrodden underling: a paradoxical guise through which Tzara presented himself not as an artist or poet but as a kind of low-life luminary.

Others in the milieu who were not there might as well have been in terms of this collective characterization of Brancusi's white studio. For Cendrars and Jeanne Robert Foster, his white studio was a cold and snowy place, both terrestrial and extraterrestrial, of the mountains and of the heavens. Their responses are telling in the way that they poetically associate the white environment of the Paris studio they have visited with other outdoor environments. Cendrars wrote to Brancusi from the Alps in 1921, describing himself as "all alone in the snows, as you are in your all white studio."[16] Foster, who was the guest of the sculptor in 1922, wrote in the fifth section of her poem "Dîner avec Brancusi":

We salute the table ... an Asteroid
Caught snowy from frozen spaces of the sky.
(Plaster freshly trowled by Brancusi, Damp to the touch.)
Upon its whiteness
Colour of flame and twilight—
Capuchins, petals of scarlet
Sinking in twilight.[17]

Locating the response of Duchamp, one of the most crucial members of this Dadaist milieu, to Brancusi's white studio is more problematic. Duchamp was central in his intellectual and commercial support for the sculptor, yet little commentary exists regarding their relationship.[18] He supported Brancusi as a dealer, translator, curatorial assistant, and public relations consultant throughout the 1920s and early 1930s. By 1921, the year of his *Why Not Sneeze Rrose Sélavy?*, Duchamp was a familiar of Brancusi's who had frequently visited his studio and had an intimate knowledge of his artistic preoccupations.

It is in this enigmatic cage work that Duchamp's response to Brancusi's white studio can, to my mind, be found. Whilst it is, of course, one of Duchamp's own works, it is one which I read as taking its bearings from and being generated by an imaginative reinterpretation of his friend's studio environment. That Duchamp was referring to the sculptor's studio can be gauged from each of the elements of *Why Not Sneeze Rrose Sélavy?* when viewed in dialogue with the fictions and realities of that studio. Seen as a whole, Duchamp's combinatory box work can be read as a private, portable, and miniaturized homage to Brancusi's white studio. Let us then review its structure, its components, and its title, in order to locate this commentary.

In *Why Not Sneeze Rrose Sélavy?* we are presented with a white-painted metal bird cage, half-full of white marble cubes, with a white cuttlebone and a thermometer. It is an immediately disorienting piece. This is a birdcage that could not possibly accommodate a bird—the marble blocks clutter it up and have taken up what little airspace there is for a bird to fly or spread its wings. As well as an object of containment and display, the birdcage is equipped with a readymade and well-known iconographic currency within a pictorial tradition: a *vanitas* motif and symbol of lost innocence and youth. In the hands of the Surrealists, most notably Giacometti and Ernst, this was to be further explored, but within these and Duchamp's reappropriations the idea of the birdcage as a metaphor for the artist's studio was resonant. Picasso's lost *Self-Portrait with Bird-Cage* of 1919 is a good example of this shift and the way in which the cage reads as the predicament of the studio-

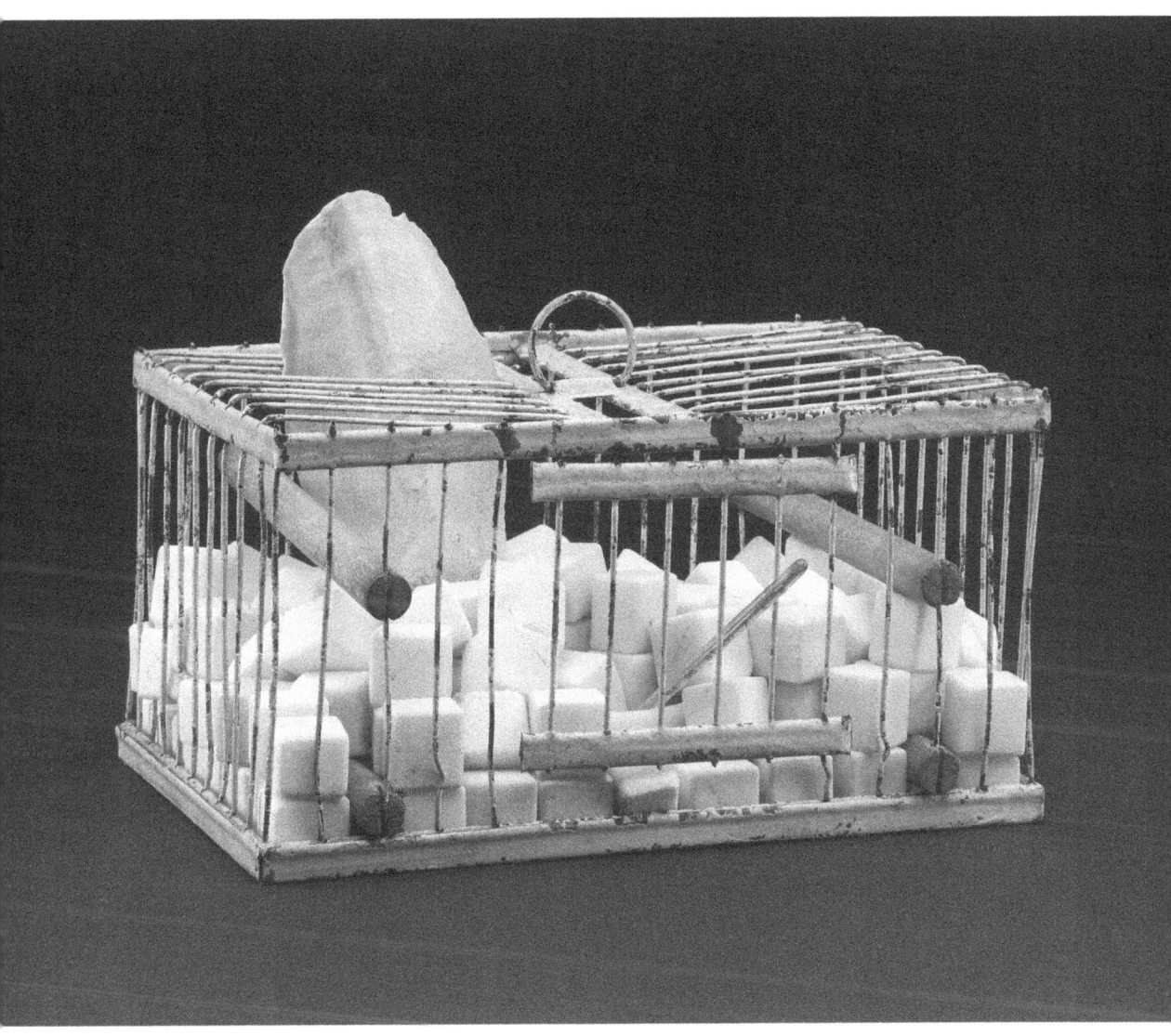

Marcel Duchamp, *Why Not Sneeze Rrose Sélavy?* 1921.

bound artist. This has particular resonance for Brancusi and his work, bound by the physical dimensions of the studio. The key exception to (and escape from) this was, of course, his *Endless Column* in Tîrgu Jiu.

If the cage is to be read as a studio, then what about the elements it contains? Duchamp had had the marble cubes especially made and through this and their singularity as objects, they closely relate to the sample blocks provided by stone retailers, which were ubiquitous in sculptors' studios throughout Paris. For sculptors these blocks showed how hard and durable a material was—and thus how difficult it was to carve—and how a particular type of stone looked when polished. Brancusi had many such sample blocks in his studio. Whether or not Duchamp's selection of them reads as a (rather weak) Dadaist joke on cubist sculpture, these small cubes are objects that mediate and facilitate sculptural decision-making before the physical work begins. Whilst they can be said to have readymade status—and thus function conceptually in relation to the business of "no longer making art"— they are made of marble, a noble sculptural material. Alongside this and in line with the notion of the cage as the studio *in miniature*, it is notable that Brancusi's studio was famously full of stone blocks and boulders, which he used not to carve into but as props upon and around which to display work. This gave the studio at 8 impasse Ronsin, which he had to vacate in 1927 (partly because of damage to the floor caused by the weight of these boulders) the look of a quarry. Through this Duchamp's metaphors are in tune with those employed by some of the studio visitors already mentioned. Duchamp would have been all too aware of this extraordinary strategy for display, and it is telling that it is through these cubes (miniaturized versions of the studio-quarry's blocks) that "studio-work" is connoted.

The cuttlebone is both the most veiled and the most telling component in *Why Not Sneeze Rrose Sélavy?* On the one hand, this beak-sharpening object is a skeletal object and thus one in keeping with the stereotypical funereal character of the sculptor's studio. On the other, it signals an imaginary translocation of the cage environment. The normal places for fish and birds (underwater and in the air) have been inverted here with Dadaist humour. It is a birdcage with a fishbone in it, a birdcage as an aquarium, and, in turn, the studio as a paradoxical place of transformation and a container for imaginary worlds. These animal subjects certainly had an urgent topicality for Brancusi at this particular time. His series of *Bird* works (which had begun before the war with *Maiastra*) was very much in process, and in 1922 Brancusi completed his first marble *Fish*. The relationship between Duchamp's cuttlebone and Brancusi's *Fish* has never been addressed before, which is surprising given their resemblance. Brancusi's sculpture is not a representa-

tion of a fish, with scales and fins, but an attempt to articulate its essence—and its speed and fluidity—in three dimensions. Duchamp's cuttlebone is a telling counterpart: the inner shell of the fish and an "abstract" form. It is a natural readymade brought about through organic elimination of form—it is all that remains after the fish dies. Alongside the heavy marble cubes, the cuttlebone has a delicate lightness resonant of Brancusi's sculptural effects: his *Fish* seems to float, as do cuttlebones. In keeping with this, it was also in the years 1921–22 that Brancusi began to employ mirror bases for the display of his sculpture—for works, hardly coincidently, such as *Fish* in 1922 and *Newborn II* in 1923. That the mirror base was the format used by Duchamp for *Why Not Sneeze,* through which the work's title (printed underneath in reverse) was reflected onto the glass was, I think, significant, given his friendship with Brancusi; it once again suggests exchanges of ideas between the two men.

Sculptor's studios were famously cold and, as the earlier commentaries of Cendrars and Foster serve to remind us, Brancusi's was no exception. The addition of the thermometer, however, takes this evocation of an atmosphere further: this cage environment has a temperature. Like the title of the work, the thermometer poses a question that is asked simultaneously of a body as well as of an object-environment. The answer, of course, is "cold": an answer through which the coalition of studio and studio visitor (here Duchamp as Rrose Sélavy) is playfully articulated.

Finally let us return to the title of the work. *Why Not Sneeze Rrose Sélavy?* poses a question. To answer the question that Duchamp's imaginary double is asked ("why not sneeze?"), the connotations of sneezing (dustiness, coldness, and orgasm) are to be noted in relation to the cage work itself—the cause and context of the question. In this way, Duchamp's title engaged in the discourse of the "sacred dust" of the sculptor's studio, a well-known trope in descriptions of the studios of Rodin, Bourdelle, and many other sculptors at this time. Brancusi himself, unlike Picasso, Giacometti, or of course Duchamp, did not actively engage in this characterization. Dust, however, was a preoccupation of Duchamp's, as can be noted in *Dust Breeding* (1920)—Man Ray's photograph of *Large Glass*—and in Georgia O'Keeffe's recollection of Duchamp's own New York studio in the early 1920s:

It was a few flights up in a dismal, drafty building. It was a very large room—again. It was the room where he made the glass paintings and he evidently lived there while he was making them. The room looked as though it had never been swept—not even when he first moved in ... the dust everywhere was so thick that it was hard to believe. I was so upset over the dusty place that the next day

I wanted to go over and clean it up. But Stieglitz told me that he didn't think Duchamp would be very pleased. He thought he probably liked it to be just as it was. I remember that I was sick with a cold. I just seemed to be sick from having seen this unpleasantly dusty place.[19]

When Man Ray's photograph of *Large Glass* was reproduced in *Littérature* in October 1922, it was captioned, "This is the domain of Rrose Sélavy / How arid it is—how fertile it is—how joyous it is—how sad it is / View taken from an aeroplane by Man Ray in 1921 / Photo of glass in New York studio." The relationship between dust and the studio was a close one for Duchamp at this time, and through it he explored his own studio (with the help of Man Ray's photography) as a place to display work and create miniaturized landscapes on the level. Duchamp's *Why Not Sneeze Rrose Sélavy?* is thus an extraordinary work, which stands as a further qualification of Brancusi's white studio and its mythology and sheds a little more light on the interaction between these two artists and their working environments at a pivotal moment in their careers.

Alongside the characterizations of members of this Paris Dada milieu, perhaps one of the most interesting of Brancusi's *own* attempts to furnish his lifestyle with the accoutrements of whiteness can be seen in his purchase of a white dog, which he called Polaire. He had earlier attempted to keep one of Gabrielle Buffet-Picabia's white roosters in his studio—an attempt that had failed; the animal was returned. In the case of Polaire, the animal was both a pet and company for the sculptor and—in keeping with the anxiety about theft detectable in his fable "Histoire des Brigands" (1925)—would have served as a guard dog for the ramshackle premises.[20] Polaire was also, however, a symbolic studio prop kept to enhance the sculptor's white studio and facilitate his artistic identity. As Golding reminds us, "The only overt relationship he enjoyed was with his white Samoyed bitch Polaire, whom he acquired in 1921. She accompanied him everywhere, even to the cinema; she would accept food from no one but himself and menaced female visitors to the studio. She became, in her own way, a celebrated Parisian beauty and friends would ask after her in their letters."[21] Once again the dual connotations of the celestial and the arctic are to be noted: Polaire both means Polar and is short for the North Star (*l'étoile Polaire*).

An early 1920s photograph of Brancusi with the dog on the steps of 8 impasse Ronsin was published in *De Stijl* in 1927, and Man Ray photographed the sculptor with his dog and Edward Steichen's in 1922.[22] Perhaps the most interesting photograph, however, is a little known one of Brancusi and Polaire taken by the sculptor in his studio in 1921–22. Beyond the example of

the wooden base work *Chien de Garde* (ca. 1922), Brancusi sculpted fish, birds, and turtles but was not, like a number of his contemporaries (and given the popularity of firedogs and andirons), to include these animals with any significance in his repertoire. In this particular photograph, Polaire has been placed on a base and raised up and above the generic connotations of animalia. This by all accounts devoted and protective animal has here been commemorated and platformed as a sculpture in a way similar to that in which the ballet dancer Codreanu and Man Ray were photographed by Brancusi performing as sculptures. In terms of the sculptor's task, this photograph also has a curious bearing on Brancusi's advocacy of truth to materials, as expressed in an interview with Dorothy Dudley in the United States in 1926:

You cannot make what you want to make, but what the material permits you to make. You cannot make out of marble what you would make out of wood, or not of wood what you would make out of stone.... Each material has its own life and one cannot, without punishment, destroy a living material to make a dumb senseless thing. That is, we must not try to make materials speak our language, we must go with them to the point where others will understand their language.[23]

Brancusi's description of truth to materials can be read as exacting a comparison with the taming and domestication of animals, a comparison that closely tallied with his fabling tendencies.

In this quotation, truth to materials was specifically presented as a two-way, interactive process—one of trust and trusting and of bringing out qualities without changing the inherent nature of the material or animal. In this photograph Brancusi has, in a domesticating manner, presented the studio as the domain for such interaction. Poised on a pedestal, Polaire's obedience can be seen to testify to two issues: first, the sculptor's ability to tame and be true to the animate material of his studio home and, second, an acknowledgement and return of that ability. For the fidelity traditionally associated with representations of dogs was here in the studio conducted through sculpture's very own processes, through Brancusi's articulation of truth to materials. His pet's fidelity can be read as having conceptual meaning in relation to his craft.

The power and effectiveness of Polaire as a device through which Brancusi could communicate his preoccupations and artistic identity was not limited to the studio. After Polaire died in 1925, Brancusi visited the United States in 1926, where he was exhibiting in New York and Chicago, borrowing Edward Steichen's dog Stoor, of an identical Samoy breed, to accompany him on his trip. Brancusi and Polaire, as noted already, had been something of a

double act on the Parisian café circuit, and being seen with such a white and wild-looking dog in American cities was no doubt part of the animal's charm, since it exoticized and made enigmatic its owner. Furthermore, given the importance in the popular American imagination of such narratives as Jack London's *White Fang* (1906), a novel precisely about the taming of a wolf, the company of such a dog can be read as having functioned as a kind of mobile studio prop and a facilitator for the sculptor's growing reputation in the United States. As Ann Temkin has noted of Paul Morand's important catalog preface to Brancusi's exhibition in the Brummer Gallery in New York in 1926, the critic revealed something of "his own vision of America" through the sculptor, casting his studio as "an untamed frontier" full of "great blocks of building stone, beams, trunks of trees, boulders and rocks."[24] The shift from *Chien de Garde* to Polaire/Stoor within the early 1920s gives a telling indication of the way in which Brancusi's notion of whiteness was developing conceptually and was being extended out of Dadaist bases, beyond his sculptures into his photography, life, and identity—as a pioneering artist.

Polaire was a short-lived accoutrement within an increasingly broadening scheme that found one of its primary means of expression in Brancusi's own interior decoration. The whitewash with which he covered his fireplace and walls was applied regularly to cover up accumulated traces of soot and dirt. On a pragmatic level, the sculptor maintained that the plastered studio walls provided important insulation and soundproofing as well as contributing to the desired appearance of his quarters. In Brancusi's plans in the late 1920s and early 1930s—which coincided with landlord disagreements and the move from number 8 to 11 impasse Ronsin—to build a new studio at 18 rue Sauvageot, the designs were drawn up with plaster very much in mind. The rue Sauvageot studio was, of course, never realized; however, from the drawings one can imagine how white this studio would have been.[25]

It was thus within impasse Ronsin that the sculptor's wall-bound handling of plaster was confined. Its look was one that Brancusi appropriated with success; the flaky, powdery surfaces of his studio walls were reminiscent of both church interiors and his own work in fresco in the 1920s. In the wall-like surfaces of these frescoes, Brancusi achieved an effect popular among such symbolist painters as Puvis de Chavannes and Gauguin. Heller's account of this mural effect, read through the example of Gauguin's *Garden at Arles* (1888), provides an excellent insight:

The canvas is thick and possesses a heavy textured weave and was primed by Gauguin himself with a matte, white primer apparently mixed by him and creating a highly absorbant, chalklike surface.... Essentially, Gauguin transformed his

easel painting into a 'wall', into an ersatz fresco that used oil paint in order to emulate mural technique. Just as the wet plaster and pigment of a traditional fresco fuse into an inseparable unity, so the thin paint, chalky primer and coarsely textured canvas were fused by Gauguin into an inseparable 'new being'.²⁶

From easel and object to wall and then to environment in the case of Brancusi's studio, his gouaches, frescoes, and walls were all part of a unity crafted and ventured by the sculptor to evoke a way of life. In keeping with the property of plaster itself, the way of life placed subtly on display was a highly absorbant one, which—in contrast, for example, to the wooden, chapel-like decor of Bourdelle's studio and its distracting props—was capable of drawing in and focusing the visitor's attention on the contents of the place, the sculptures on show.

Over the years, Brancusi's sculptural palette, so to speak, would be spotted and plotted with a series of accumulated historical moments and connotations. Within Brancusi's conception of whiteness, the *blanc* of *blancheur* can also, partly as a consequence of this plethora of associations, be read as signaling blank. For in many ways the white studio operated as a cipher, and an extremely successful one at that—highly generative and amenable to imaginative appropriation and projection. "Do not look for mysteries, I give you pure joy," reads one of Brancusi's most quoted statements. For studio visitors, "what they saw" was effectively "what they wanted," as well as "what they got," since Brancusi offered illumination and enlightenment—revealed "joy."

I would argue that "mysteries" too were a significant aspect of Brancusi's studio identity—to be seen in the subtle associations of the sculptor's whiteness to which I have drawn attention. The white studio was a highly successful conceit: it was not only a crucial means of providing Brancusi's sculpture and his own sculptorhood with harmony and autonomy, but also an effective device through which reception could be housed and enhanced. It provided an atmosphere and an accommodating environment in which the studio visitor, once invited as a guest and over the threshold, could not help but become implicated.

..

Sculpture Journal 7 (2002): 108–20. As elsewhere in this volume, British spellings have been Americanized. The author would like to thank Dr. Alexandra Parigoris, Marielle Tabart, and Liz Aston of the Henry Moore Institute for their assistance in the preparation of this article.

1 To mark the studio reconstruction, a new series of publications—Les Carnets de l'atelier Brancusi—has been created by Marielle Tabart.
2 M. Anderson, *My Thirty Years War: The Autobiography* (New York, 1969), 251–52.

3 G. Duthuit, "Brancusi Revisited and the Arensberg Brancusis," *Art News* 53, no. 6 (October 1954): 25.

4 J. Golding, "White Magic: Brancusi," in *Visions of the Modern* (London, 1994), 185.

5 *Portrait of Myself as a Century Old,* 1926, blue pencil on paper; reproduced in N. Dumitresco and A. Istrati, *Brancusi* (Paris, 1986) (English editions: Harry N. Abrams, 1987; Faber & Faber, 1988), 171.

6 W. Carlos Williams, "Brancusi," *Arts* 30 (November 1955): 21; A. Wilson, "A visit to Brancusi's," *New York Times Book Review and Magazine,* August 19, 1923, 17; P. Morand, *Brancusi* (exh. cat.; Brummer Gallery, New York, 1926), n.p.; S. Putnam, *Paris Was Our Mistress: Memoirs of a Lost and Found Generation* (1947; New York, 1970), 199.

7 See, for example, Steichen's *August Rodin in front of the Hand of God,* Musée Rodin, Paris. The Musée Rodin has many portrait sculptures of Rodin in its collection: Claudel's *Bust of Auguste Rodin,* 1892, bronze, 40.7 cm high; Bourdelle's *Bust of Rodin,* 1909, bronze, 67 cm high; and Bouchard's *Rodin,* ca. 1920, bronze, 37 cm high.

8 The ramifications of Brancusi's Romanian background for his artistic identity, in terms of reaction and memory, have been examined most recently by Alexandra Parigoris, "Constantin Brancusi, a Peasant in Paris: A Study of The Persona and Work of Constantin Brancusi from a Post-Symbolist Perspective," PhD thesis, Courtauld Institute of Art, University of London, 1997.

9 S. Geist, *Brancusi: the Sculpture and Drawings* (New York, 1975), 33–34.

10 M. Loy, "Brancusi's Golden Bird," in *The Last Lunar Baedeker,* ed. R. L. Conover (Manchester, 1982), 18.

11 M. Loy's *Etoiles,* reproduced in *Art et Industrie* in 1929, were not so much shades as star-shaped paper envelopes, star configurations with a bulb in the middle.

12 See, most notably, E. Balas, "Brancusi, Duchamp and Dada," *Gazette des Beaux-Arts* 95 (April 1980): 165–74.

13 T. Tzara, *Oeuvres Complètes: Tome I (1912–1924)* (Paris, 1975), 394–95.

14 Ibid., p. 619.

15 For a translation of Tzara's review, see T. Tzara, *Seven Dada Manifestos and Lampisteries,* trans. B. Wright (London, 1984), 57–58.

16 Blaise Cendrars's letter of March 11, 1920, is reproduced in Dumitresco and Istrati, *Brancusi,* 132.

17 J. R. Foster, "Brancusi," in *Rock Flower* (1923).

18 A notable recent exception to this is the catalog of the Atelier Brancusi's exhibition of 2000, M. Tabart, ed., *Brancusi et Duchamp, regards historiques.*

19 A. d'Harnoncourt and K. McShine, *Marcel Duchamp* (exh. cat.;, Museum of Modern Art, New York, 1973), 212–13.

20 "L'Histoire des Brigands" is very illuminating in this context. Not only does it cast the sculptor as an egg-laying chicken, but also, in turn, it can be read as articulating a very real concern (soon after Polaire's death) about the safety and security of Brancusi's sculpture within the cul-de-sac: at once a communal environment and a place busy with the comings and goings of unknown visitors.

21 Golding, "White Magic: Brancusi," 191–92.

22 See Dumitresco and Istrati, *Brancusi,* 169.

23 D. Dudley, "Brancusi," *Dial* 82 (February 1927): 124.
24 F. T. Bach, M. Rowell, and A. Temkin, eds., *Constantin Brancusi 1876–1957* (exh. cat.; Cambridge, MA, 1995), 60.
25 For reproductions of some of these drawings, see Dumitresco and Istrati, *Brancusi*, 181.
26 R. Heller, "Concerning symbolism and the structure of surface," *Art Journal* 45, no. 2 (Summer 1985): 148.

James Welling, *Paris*, 2009.

James Welling
Paris, 2009

A few years ago, I began to think about sculpture in a new way. As I taught a seminar on color theory, I realizad that the one class of objects that is without color is sculpture. Sculpture cannot have color; since the early 1800s it has been thought of as pure "form," which by definition is colorless.

I started photographing Alexander Calder and Tony Smith sculptures. Last year in the spring, Charlie Ray's *Log* was up at Regen Projects, and Michael Asher made an incredible show at the Santa Monica Museum. After I photographed both exhibitions I realized that a sculpture project was coming together. In January 2009 I traveled to Paris for an exhibition and photographed at the L'Atelier Brancusi at the Centre Georges Pompidou.

The Atelier is the third reconstruction of Brancusi's studio. He expanded his workspace over the years, eventually occupying four rooms in a studio complex on the outskirts of Paris. I concentrated on unfinished casts and molds, things that were colorless. The only (warm) color was the brass "Sleeping Child" and the ancient, wooden fiddle.

Caroline A. Jones
Post-Studio/Postmodern/Postmortem

Although earlier instances of mechanomorphic imagery had left artisanal, studio production methods largely intact, by the late 1960s the machine's implied critique of the studio became explicit. Perhaps it was the aggressive industrial scale of these barely "painted" objects; perhaps it was their relentless serial production.[1] Perhaps it was simply that Warhol's silkscreened celebrity canvases, Stella's metallic die-cut–like icons, and Smithson's bins of ore were much closer to commercially manufactured or industrial objects than were the machine-influenced images of earlier decades (say, Umberto Boccioni's *Dynamism of a Figure in Space* or Charles Demuth's *My Egypt*—the former, after all, like the Nike of Samothrace that Boccioni had abjured; the latter a fairly representational portrait of monumental architecture, in this case the type of American grain elevators that were also stimulating Le Corbusier's modernism at the time). Probably for all of these reasons, the art of the early 1960s was so dramatically indexed to objects made outside the studio that artists in Smithson's generation saw no more need for that centralized artisanal space. Art could be jobbed out by blueprint or ordered by phone, pursuing Moholy-Nagy's provocative but ultimately isolated gesture to a far more widespread conclusion.[2] The collapse of the studio was not inevitable, but it was supremely logical, once the machine became the mode, as well as the emblem, of artistic change.

Outside the American context, there is evidence that by the late 1960s the studio was vexed by contradictions internal to the art, and less involved with issues of mechanical production or images of the technological sublime. Yves Klein, Piero Manzoni, and Joseph Beuys, as well as their colleagues in the international Fluxus group, had all engaged in performance art, with the result that the primacy of the object, and the studio to which it had always been linked, had been consistently (if implicitly) challenged. Beuys exemplified this in his theories about pedagogy, to which he committed his professional life:

> I don't believe that an art school ... should lay emphasis on fixed places to work in the school. That sort of thinking is tied up with the idea of art as a craft, with the workbench and the drawing-table. The need for that is only now felt by a few—because the majority is striving for movement and sees the school as a meeting-point.... The most important thing to me is that man not only produce articles but become a sculptor or architect of the whole social organism.[3]

The challenges to the studio in such European artists' work came about largely through such theoretical commitments rather than the tropism toward an industrial aesthetic. Indeed, in Beuys's work it could be argued that the struggle to remain oppositional in face of the German "economic miracle" led him away from industry toward a primitivistic shamanism—but even this role led out of the studio, where artistic shamanism had previously been confined.

The philosophical implications of Minimalism represented another challenge to the studio that emerged in the sometimes more intellectual practice of European artists: if the work's perception was entirely dependent on its situation, that is, if its aesthetics were entirely site-specific, then how could it be generated in one space (the studio) in order to be perceived in an entirely different space (the gallery, museum, or collector's home)? The most trenchant statement on this question was articulated by French artist Daniel Buren in 1971, in an essay entitled "The Function of the Studio" (published in English in 1979 and reprinted in this volume).[4] Intentionally parallel to conceptual artists' late-1960s critiques of the museum, the gallery, and the private home as spaces to display art, Buren wrote: "Analysis of the art system must inevitably be carried on in terms of the studio as the *unique space* of production and the museum as the *unique space* of exposition. Both must be investigated as customs, the ossifying customs of art."[5] That Buren saw the studio in 1971 as potentially still "the *unique space* of production" suggests how powerfully the European studio ideal yet reigned. Buren proceeded to analyze lucidly the functions of this studio as the place in which, and for which, the work of art is made. The inevitable loss of meaning occasioned by the work's removal from the studio is tolerable only when contrasted to the complete absence of meaning if the work never leaves. In his final, polemical conclusion, Buren stated: "The art of yesterday and today is not only marked by the studio as an essential, often unique, place of production; it proceeds from it. All my work proceeds from its extinction."[6] Exactly how to proceed from that extinction was left unsaid in this statement, leaving the reader at that moment with the verbal equivalent of Yves Klein's *Leap into the Void*. Whatever, or whoever, was to catch the artist after the extinguishing act is kept invisible or out of the frame.

The extinction Buren called for so dramatically was unanticipated at the early-1960s moment in which I began my study of the machine in the studio, but by 1971 (after the example of Smithson and others) it could stand as a rallying cry and manifesto. Without access to the deserts of the American West, and unwilling to make art (as Smithson had) from the industrially disrupted landscapes of Europe, Buren's furious call for the studio's demise resulted in some surprisingly elegant art. His site-specific works apply his own trademark stripes (like Stella's bands, but wider and more decorative) to unexpected locations: museum stair treads, subway platform billboards, and fragmented classical columns ranged in a Parisian *place*. Their theoretical sophistication results from Buren's manipulation of discourse—as savvy as Smithson's—so that the repetition of the same motif in changing formats will be seen to destroy uniqueness, quasi-religious idealism, "formal evolution," and so forth.[7] Contemplating Buren's quintessentially respectful solution reminds us that eradicating the studio will achieve results entirely specific to the cultural context of the artist. Critiques of uniqueness, individualism, and idealism will not necessarily entail corresponding claims for universalism (one need think only of theories of race and nation, neither universalist nor precisely individualistic); indeed, postmodernism has made any broad claims for universalism highly suspect. In the end, the remanent cultural specifics of a given locale can be assimilated to claims for authorship, and localism and authority are the legacies of the centralized modernist studio that have proved hardest to dismantle, postmodernism notwithstanding. Which brings us back to Robert Smithson's explicit post-studio critique and its relationship to postmodernism's critique of modernism as a whole.

Smithson used the new phrase "postmodernism" in the last few years before his death, but the references are so glancing that we will never know what he might have meant by the term.[8] As for the working definition here, it should be clear that I am operating with the assumption that there are as many postmodernisms as modernisms (postmodernism being necessarily parasitical upon modernism), but that those postmodernisms nonetheless share enough internal consistency to define a true periodizing break. First, the periodizations that both left- and right-wing theorists have proposed cluster consistently around the decade of the 1960s—significant for my argument that Smithson's work of the mid- to late 1960s participated in the postmodern turn. This consistent periodization occurs politically around the breakdown in colonial structures (the collapsing of French and American control over Vietnam, "British" and "French" Africa, etc.), economically in the shift from primary to secondary or tertiary processes (industrial to "postindustrial," production to consumption, heavy industry to service sectors, colonial domination to market penetration), and culturally in what

Lyotard has famously termed the "breakdown of master narratives," Barthes called the "death of the author," Fredric Jameson viewed as the collapse of depth models, and others have seen generally as the breakdown of fixed structural semiotics into poststructural "slippage of the signifier."[9] This recitation of parallel shifts is not meant as an argument for a Marxian base-to-superstructure alignment between art and the political or economic spheres. Rather, with Jameson, I want to argue for the significance of "homologies between the *breaks* in those forms [art, politics] and their development."[10] Politics and economics are part of the same culture that produces and consumes art; artistic agents can motivate changes in culture that in turn can construct new fields of interpretation for polities and economies, at several scales. There can be no doubt that the industrial production of the postwar period also produced Smithson, but neither can we doubt that Smithson himself constructed elements of the industrial culture of his time.

What is useful about the concept of postmodernism is not so much its putatively prescriptive role (which must seem either apocalyptic or utopian at this millennial juncture). Rather it is postmodernism's descriptive role that allows us to see various modernisms as not inevitable but historically determined, permitting us to read the shifts, ruptures, and collapses in those modernisms as equally contingent.[11] Smithson's role in the collapse of a particular modernism that was centered on the studio yielded complex results, for his own position as an author and for subsequent artists. Briefly, in what remains of this conclusion, I want to anchor Smithson in the discourse of postmodernism and argue for the technological materiality that remains crucial to his work's importance as art. Here my claim will be that the remains of the machine, indexed against the rubble of the studio, are what tie Smithson's work to a specific discourse of technological sublimity, in its newly postmodern form. From the frame established by Smithson's postmodernism, we can see more clearly the roles that Stella and Warhol played in relation to the studio, seeing what remained modern in their production despite (or at times because of) their machines. We can also look back even further to the concerns of my first two chapters on the Abstract Expressionists to see what aspects of their relationship to libido were brought back by Smithson's disarmingly desublimating critique.

The entire structure of Smithson's late essays, such as 1968's "A Museum of Language in the Vicinity of Art," is predicated on an opposition to, or escape from, modernism, and there is in these writings an elegiac, lethargic, and at times apocalyptic tone that resonates clearly with the postmodern writers who would emerge in subsequent decades. But Smithson is finally and most fully implicated in postmodern theory in the 1980s discourse of critics such as Rosalind Krauss, Hal Foster, and Craig Owens, or artists

such as Peter Halley and Mark Tansey. Even here, this implication occurs not through some unequivocal endorsement of Smithson by these writers as "one of them," but through their recurrent fascination with his work and their judgment of him as crucially significant for the postmodern turn. I accept the construction of Smithson as a postmodern artist, then, because it has been largely from a postmodern vantage point that his work has had its deepest cultural resonance—first in the late 1970s, but continuing for artists working at the end of the twentieth century as well.

Craig Owens's 1979 review of Smithson's *Writings* for *October* magazine, titled "Earthwords," cemented the perception of Smithson as a generative source for postmodernism. Owens viewed Smithson's work as effecting "a radical dislocation of art" away from the gallery (and studio) system. Moreover,

> the eruption of language into the aesthetic field—an eruption signalled by, but by no means limited to, the writings of Smithson, Morris, Andre, Judd, Flavin, Rainer, LeWitt—is coincident with, if not the definitive index of, the emergence of postmodernism.... That Smithson thus transformed the visual field into a textual one represents one of the most significant aesthetic "events" of our decade; and the publication of his collected writings constitutes a challenge to criticism to come to terms with ... postmodernism in general.[12]

By 1981, Owens's positioning of Smithson as a postmodernist had become so canonical that it was a dogma that could be fashionably challenged, as when critics such as Dale McConathy asked, "The question is not how Robert Smithson fits into Postmodernism but how he radically departs from it."[13] McConathy's gloss on Owens was not intended to restore Smithson to modernism, but to examine the specifics of Smithson's thought, underscoring the fierce antimodernism that propelled Smithson away from parasitical eclecticism to generate new aesthetic forms. In particular, McConathy argues that Smithson cannot be positioned within art history, with its terms generated by painting and sculpture. Rather he should be seen as a literary, didactic, and metaphysical figure like Bunyan, Locke, or "an Edgar Allen Poe detective from Paterson, N.J., wearing dark glasses and a leather jacket."[14]

My argument does not seek to contradict either Owens's or McConathy's multivalent positioning of Smithson in relation to postmodernism. What I do want to question is their shared emphasis on Smithson's postmodernism as a textual operation, their suggestion that Smithson is a postmodernist because of his writings alone. While Owens makes passing reference to Smithson's works, it is the essays that he sees as determinative, "the definitive index ... of postmodernism." While McConathy illustrates some sculptures, he wants Smithson to be seen within a literary field of production, a kind of

contemporary Anglo-Surrealist poet. I want to insist, on the contrary, upon the materiality of Smithson's critique (in all its discursive polyvocality), and the necessity, for Smithson (and myself), that his art be made visible (and not simply written or conceptualized). As I have argued above, the cartouche works of the early 1960s (worked out well before Smithson's published essays) were crucial. They were among the first objects of that decade to eroticize the industrial aesthetic by exposing the implicit dialectic between humans and machines, polarizing as gendered but constructed *différance* the organic and the crystalline, the flowing and the rigid, the corporeal and the technological. For Smithson, I have argued that these "preconscious," preverbal works established what would remain a compelling insight into the role of libido in the technological sublime.[15]

Like the later site/nonsite works, the cartouche drawings established the dialectical terms with which it became possible for Smithson to fully challenge the modernist studio as a centralized point of origin for art—and they establish that dialectic initially in a nonverbal frame. As the nonsites pointed out of the studio/gallery to a more peripheral location for art's meaning, so the cartouches had located the erotic significance of the image in clues scattered on the periphery (or vanished center) of the page. Ultimately, these physical art objects achieved the critical relationship to subjectivity that is a hallmark of the most innovative postmodern art. Without such material objects, Smithson would doubtless have been a provocative postmodern essayist or conceptual artist, but he could not have surfaced desire as insistently as he did—a desire that stubbornly inheres in objects, even (or especially) technologically mediated ones that read as totems or fetishes of our desiring machines.[16]

Smithson recognized the importance of materialization, commenting in many places that even if conceptual artists attempted to do away with objects as a way of critiquing commodity capitalism, they would still be part of "the system." Eschewing materialization, such artists would merely be engaged in false idealism, playing into capitalism despite the fantasy of being quarantined or cut off from the market-driven art world. Though Smithson does not say so explicitly, it seems likely that he recognized that objects can surface and make explicit the all-important role of the art world in the discourse that makes art's meaning; rather than hide behind a false idealism, such objects can open the very systems of the art world to critical contemplation. Smithson, like the postmodern theorists who find him so salient, knew that artists in a capitalist society will always need the market-driven art world, the world of images it generates, and the access to popular culture that it provides. As he mordantly commented to a sympathetic curator (distinguishing his own more material art from that of his conceptualist friends),

"Conceptual art is like a credit card that has nothing to back it up."[17] Clearly Smithson had nothing against capital, but he wanted its flows to be palpable and well-founded, "good" credit tied to the world of commodities and what economists call "real property," inventory that, for Smithson, would remain dispersed throughout the world's peripheries rather than stockpiled in some central factory of modern art.

While I have argued as strenuously as Owens that the experience of *Spiral Jetty* is a product of discourse, not pilgrimage, it is a crucial aspect of that discursive experience that *we believe* Spiral Jetty *to have existed, to have been made*—and made not "by hand," but by a massive concatenation of earth-moving machines. Certainly this was crucial to Smithson, who praised Frederick Law Olmsted, to the detriment of Thoreau: "Olmsted made ponds, he didn't just conceptualize about them."[18] But in Olmsted's Central Park, which Smithson praised as the first earthwork, the fabricated dells, glades, and ponds were never meant to seem anything but "natural"—more natural, in fact, than the squatters' camps and ragged farm plots that they were designed to replace. Artists such as Smithson, by contrast, wanted to expose and thereby problematize the "made-ness" of their landscapes, using the artifactuality of the man-made to bring both artifice and "the natural" into question.

Those who did make the pilgrimage to the *Spiral Jetty* remained confused about the status of their experience, recognizing that the icon's representations and its physical existence were in some kind of crucial symbiosis—neither replaced the need for the other.[19] That confusion was understandable, and productive: the jetty lives not as a distant object that we once visited, might visit, or can only read about visiting. It lives as a dynamic cluster of images and words and things, each dependent upon the other for legitimation, signification, and value. As I have been at pains to demonstrate, Smithson's work may not have been all objects, but neither was it all talk or all action. The objects were the result of peripatetic actions, which in turn got represented in the talk, and the talk in turn mapped out the goals of the peripatesis and the significance of the objects (and these trajectories could be scrambled or reversed). But the presence of objects in the cluster was crucial. The totem, the fetish, the idol, and the icon must all exist; belief alone does not suffice to attract and mobilize desire.[20]

Lawrence Alloway, one of the critics most responsible for initiating Smithson's "post-studio" reputation, was possessed, in 1972, by the physicality of *Spiral Jetty*'s site and the elaborate performance of its construction. Awed by the complex collaborative labor encoded in its coils, Alloway did not yet question the propriety of using machines to master and rearrange nature (as other critics explicitly did). His review raised one of the screens through

which viewers would have perceived the floating image of the *Spiral Jetty*, reinforcing the brutely material technologism initially undergirding Smithson's sublimity. Only Smithson's more obviously ambivalent film and essay would undercut the technological triumphalism of Alloway's account, which begins with how difficult it had been for Smithson to find a crew big enough for his project:

Finally Parsons Asphalt Inc., Ogden [Utah], took the job.... The working procedure on what was called Job No. 73 was as follows. Front-end loaders (Michigan Model 175) were used to burrow rocks out and to collect sand on the shore. Ten-wheeler dump trucks carried the load to the lake, backed out along the coil, and tipped it off the end. Here truck loaders (Caterpillar Model 955) placed the dumped rocks and tamped them down within the narrow limits set up by guide lines placed by Smithson. The technical difficulties were considerable and called on all the skills of the drivers, including the operational hunch that tells when the ground is too soft and likely to subside. The drivers, far from being ironic about a non-utilitarian project, appreciated the task as a challenge and would bring their families out to the site for picnics at which they could demonstrate their virtuosity. The machines tipped and jostled their way along the spiral as the new embankments grew. A crucial figure in the work was the foreman, Grant Boosenbarck, who responded to the problems of the unprecedented structure with canny skill and maintained the concentration of the workmen by his leadership.[21]

Alloway is determined that the grunts and groans of the earthmovers will leave the "merely" metaphorical realm of dinosaurs and enter the working man's world of tough professional accomplishments. Where Smithson was content to enumerate ingredients ("water, mud, salt ... "), Alloway insists upon detailing the staggering units in which those ingredients are deployed:

It is 1,500 feet from the top of the ridge out to the tip of the coil which measures about 15 feet across, just enough to support the trucks. The fill is made up of 3,500 cubic yards of boulders and earth; each cubic yard weighs 3,800 pounds, which means that a total of 6,650 tons was moved to constitute the embankment. These statistics, which should be read as the equivalent of a technical description, such as oil on canvas or watercolor on paper, indicate scale.[22]

Such enumeration is, of course, crucial to Kant's mathematical sublime: the enormousness of nearly infinite measurements that confound representation. And indeed, intoxicated by that mathematical sublime, Alloway immediately segues into the (Freudian) oceanic: "Walking along the spiral lifts one out into the water into a breathless experience of horizontality. The lake

stretches away until finally there is a ripple of distant mountains and close around one the shore crumbles down into the water."[23] But what made this entire section resonant with its 1972 readers is the technological valence of this sublimity, the fact of the jetty's *made-ness*. The traces of process for Alloway's readers were no longer the ropes of paint, handprints, and even cigarette butts in Pollock's drip paintings—signs of intensity, isolation, and individuation. Now those traces were the literal tracks of frontloaders, the gouges and scrapes left by Grant Boosenbarck's machines. What exhilarates us is not just the "breathless experience of horizontality," but the dramatic expenditure of capital, labor, and low-level technology marshaled for the purposes of art, the supposed frippery of aesthetics being accorded the serious resources of the civil engineer.

The post-studio diatribes Smithson generated in his essays would be interesting, philosophically, without the *Spiral Jetty* or the numerous sites and nonsites he designated and produced. But we glean inklings of the historical source of that post-studio impulse, and sense some of its cultural context, when we read those diatribes through the physical gigantism of the sites and the peripheral emptiness of their locations (and when we go back still further to trace the early sources for the libido still evident in their forms). These peripheries present the visceral field in which the Beat impulse plays itself out, and where the sublime overwhelms. They are akin to the Indian burial mounds and howling wastelands that Abstract Expressionists such as Barnett Newman sought in their pronouncements about the sublime, but it is a kinship that had experienced a postindustrial torque in the peripheries Smithson prowled. These desolate industrial wastelands are bordered by highways and littered with rusting equipment, tumbled rocks and tumbledown shacks, abandoned derricks that are signs not of progress but of dereliction. These outlying, industrially disrupted sites are the continuous goal figured by Smithson's peripatetic narratives, from the imaginary wanderings of Cézanne to the locations for the film, photographs, and essay that represent Smithson's part of the discourse that constitutes the *Spiral Jetty*. Having left the studio, the machine is seen as manifestly incapable of mastery in the vast and indifferent environment of the Utah desert; postmodernism appears here in the guise of an end to (human) history and a dwarfing of its effects.

The desires to preserve a last, apocalyptic and ahistorical sublimity from Smithson's rust-laden critique are still at play, as witnessed by the most recent reproductions of the recently reemerged *Spiral Jetty*. Photographs taken by a local professional in 1994 showed the barely projecting salt-encrusted rocks of the Jetty strung like pearls out into the shimmering lake, a small private plane moving inquisitively overhead. When reproduced in the summer

issue of *Artforum,* however, the photograph was cropped, no longer showing the airplane—returning the jetty to a timeless, oceanic frame.[24] There is nothing inherent about Smithson's desublimating critique; it is as subject to mutation as any discursive product, as capable of recuperation as any destabilizing attempt.

History does make some interpretations less possible than others, however. The leitmotif of Tony Smith's odyssey onto the New Jersey freeway, and the epic journeys of the Beats, which it mimicked in miniature, were encounters with a sublimity that was no longer tenable in its nineteenth-century form, or in the twentieth-century variant animated by Abstract Expressionism. Waterfalls and thunderstorms, canyons and jungles—these had been signs and wonders enough for the late nineteenth-century audience hungry for the frisson of danger remanent in the vanishing American frontier. Even when those landscapes could no longer support literal representation in the art of the New York School, their vastness and existential significance still resonated in the paintings of Pollock, Still, Rothko, and Newman. But for Smith, Smithson, and others like them in the postwar economic boom, sublimity was more forcefully experienced among the stinking smokestacks of Esso-Exxon than in the riparian valleys of the Hudson River. What they sought to record was not merely the look of the expanding postwar industrial landscape that was America, but their experience of it; not merely the iconic recollection of a technological sublime, but a performative reenactment of the ways it had been produced. This was a new goal for American art, and it was fateful for American modernism that it was played out in, and against, the studio.

What interests me about Smithson, and what links him to Stella, Warhol, and other American artists of the postwar period, are both practices and productions. When those practices and productions are viewed comparatively and diachronically, the issue of postmodernism becomes clear. Texts are a way into those practices, they provide a window onto cultural perceptions of the productions, and they can also be practices and productions in themselves (and rarely more so than for Smithson). But they contribute most to our understanding of art's history when they are read against and through the still-marketed objects they accompany, and scanned against the traces of production those objects can convey. Like historians of science who want to move beyond intellectual history to material culture, I have labored to identify links and resonances that become manifest in several registers: the iconic and the performative, the discursive and the productive, the elusively ephemeral trace of meaning and the stubbornly material object to which it is historically and hermeneutically attached.[25] The studio has been our stage for viewing these practices and productions; its disappearance at the end of

this book becomes less the fall of a curtain than the postmodern slippage of a signifier to another discursive plane.

I have argued that the studio was a particularly privileged kind of signifier in the contested discourse on authorship and the industrial aesthetic in the 1960s. Securely modernist in the immediate postwar period, the solitary space of the studio was guarantor of the Abstract Expressionist canvas's authenticity, its presence as an individuating object created (authorized) by an isolated, heroic artist-genius. The films and photographs that constructed such a view of the studio also sutured a particular subject: the viewer of these popularizations was structured as a privileged voyeur, witnessing a deeply private act of creation in the studio that would also be figured on the canvases that issued from it.

But as the cameras themselves whirred away in the "solitary" studio, they became participants in the socialization and expansion of that space. And as the industrial aesthetic emerged in the work of painters such as Stella and Warhol, what happened in the studio became a central issue in the presentation of their art. Stella's rhetoric of executive artistry and Warhol's celebration of his Factory delegations had meaning only when referenced against this established trope of the authorizing studio and when played out in the hardened discourse of their art. Similarly, Smithson's dispersals of the art object, and of the site of production, were staged against the already established backdrop of the machine in the studio. This, then, was where Smithson staged his critique, deconstructing the still-centralized studio and seeking to reorient art to the decaying peripheries of the postindustrial landscape. The union of the iconic and the performative in the place of the studio (and against it) was what gave the 1960s work of these artists its salience, and what has fascinated me here.

The romance of the studio had been predicated on the exclusion of others, and by extension, the critique of that romance might suggest the potential for their inclusion and the possible origin of a practical political result. That "others" might be included only to be dominated is a possibility inherent in any hierarchical productive system, particularly capitalist ones—as implied by Stella's "dictatorial proletarianism," Warhol's management of "the Business Art Business," and even Smithson's copyrighted ownership of the necessarily collaborative labor that went into the *Spiral Jetty* film. But even in such dominated forms, the presence of other authors always shadows the expanded studio's productions—explicitly in Warhol's provocative claim that "Gerard does all my paintings," implicitly in Stella's praise of the executive artist, and visually through the final shot of the editing room that concludes the *Spiral Jetty* film. These shadowy possibilities—for collaboration,

delegation, and even appropriation of others' labor—became major themes for artists emerging after the 1970s, and reveal themselves forcefully as part of the ongoing critique of the studio in American art.

When Sol LeWitt wrote in 1967 that "the idea becomes a machine that makes the art," the studio had already dropped out of his formulation, as his hand had dropped out of his art.[26] The art would be made *outside the studio*, by other hands, the artists' authorship remanent only in an idea that would be performed (and appear) differently with each incarnation. CalArts' *Womanhouse* to Buren's simultaneous but very different critiques in 1971, the studio's vexed status became clear. After the polemical reconstruction of Warhol's Factory in 1984 by appropriation artist Mike Bidlo, the dispersed studio became, in postmodernism, the emptied point of origin for the much-celebrated "death of the author."[27] The dispersal of the studio also figured in the dramatic, post-1970 appearance of collaborative "team artists" (such as Gilbert and George, Anne and Patrick Poirier, Komar and Melamid, Clegg and Guttman, and the Starn Twins). The work of such artists implied a critique of the "original hand of the artist" that was already implicit in Warhol's and Stella's depersonalizing techniques, and made it clear that there would always be more than one individual making the art. In many cases, such collaborations were tied to an "anonymous" photographic technology or located in a literally expanded studio—such as "Tim Rollins + K.O.S.," the symbiotic union of an artist-teacher and the learning-disabled Bronx students who made the art. More cynical "appropriation art" objects, such as Sherry Levine's photographs of reproductions of photographs by Walker Evans (1981) or Jeff Koons's presentations of machine-made objects produced from others' "kitsch" images (1991), are also the beneficiaries of the dispersed studio and its deauthorizing presence in American art.

As is characteristic in the antitotalizing discourse of postmodernism (which has hovered over this book like a ragged aegis), the reemergence of previous forms in different guises and contexts produces different results. During the moment of the 1960s that I have chosen to place at the center of my inquiry, the machines in the studios of Stella and Warhol ground out an industrial aesthetic of tremendous force and cultural resonance; in his dialectics and discursive *Spiral Jetty* Smithson later pushed that aesthetic to one logical, entropic conclusion. The dynamic expansion of capital in the early 1960s, and its conversion into signs and simulacra for the necessary exchanges of an increasingly global consumer culture, are figured in the early years of this industrial aesthetic.[28] The subsequent electronic mobilization of capital and the exhaustion of heavy industry at the end of the decade are elements in the dispersal of that same industrial aesthetic. Dispersal does

not mean demise, however. In the 1980s, the charms of cyberpunk, junk bonds, "smart" bombs, Patriot missiles, and other cultural fantasies attest to the continuing appeal of, and to, the technological sublime.[29]

Where our libidinous attachments to technology will lead us—aesthetically, economically, biologically, militarily—is still very unclear; but art will continue to play a powerful role in charting that path. Chances are, artists won't be drawn back to the studio—but if they are, it will be a radically different place than it was in 1948. Machines are now so deep in our Imaginary that we are cultural, if not yet biological, cyborgs; we are soft-wired for technology in our desiring machines.

..

Machine in the Studio *(Chicago: University of Chicago Press, 1996), 362–73.*

1 Size and scale do bear these associations. Recall that the enormous academic history paintings of the nineteenth-century French salons had been called "machines."

2 See Louis Kaplan, "The Telephone Paintings: Hanging Up Moholy," *Leonardo* 26, no. 2 (1993):165–68. In addition to Alexander Liberman's adoption and extension of Moholy's gesture, there is the example of Tony Smith, described in one reference about a documentary film on him as having "the misleading sobriquet of 'the artist who orders sculpture by telephone.'" See Susan P. Besemer and Christopher Crosman, comps., *From Museums, Galleries, and Studios: A Guide to Artists on Film and Tape* (Westport, CT: Greenwood Press, 1984), 102 (entry 3027).

3 Joseph Beuys interviewed by Georg Jappe, trans. John Wheelwright (1972), in *Art in Theory*, ed. Charles Harrison and Paul Wood (Oxford: Blackwell, 1992), 890.

4 Daniel Buren, "The Function of the Studio," trans. Thomas Repensek, *October* 10 (Fall 1979): 51–58.

5 Ibid., 51.

6 Ibid., 58.

7 See Buren's dense and unepigrammatic essay "Mise en garde" (1969), translated as "Beware" and excerpted in Charles Harrison and Paul Wood, eds., *Art in Theory, 1900–1990: An Anthology of Changing Ideas* (Oxford: Blackwell, 1993), 850 ff.

8 Smithson "was already using the phrase 'post-modern' in the early 70s," according to Peter Schjeldahl. See his "A Nose for the Abyss: Monuments of a Metaphysical Dandy" (review of *The Writings of Robert Smithson*), *Village Voice* supplement, no. 8 (June 1982), 1, 7; clipping in John Weber Gallery Archives.

9 For a good summary of the economic arguments and their connection to the cultural, see Margaret A. Rose, *The Post-modern and the Post-industrial: A Critical Analysis* (Cambridge: Cambridge University Press, 1991); Jean-François Lyotard, *The Postmodern Condition*; Roland Barthes, "The Death of the Author" (1968), in *Image-Music-Text* (London: Fontana, 1977); and Fredric Jameson, *Postmodernism; or, the Cultural Logic of Late Capitalism* (Durham, NC: Duke University Press, 1991). Jameson's theories of postmodernism remain some of the most comprehensive, and I am indebted to them. Regarding the periodization around

the 1960s, see in particular his "Periodizing the 60s," in Sohnya Sayres et al., *The Sixties without Apology* (Minneapolis: University of Minnesota Press, 1984), 178–209.
10 Jameson, "Periodizing the 60s," 179.
11 I am grateful to Peter Galison for our many discussions on this point. Here I differ from Jameson, who states, "History is necessity, ... the 60s had to happen the way it did, and ... its opportunities and failures were inextricably intertwined" (ibid., 178). Surely Warhol could have stayed in advertising, Stella could have gone to law school, and Smithson could have become a scientist—someone would have filled their niches, but perhaps the studio would have survived longer without the compelling onslaughts these artists provided and the seductions of industry would have been less culturally available to the art-viewing public.
12 Craig Owens, "Earthwords," in *Beyond Recognition: Representation, Power, and Culture*, ed. Scott Bryson (Berkeley: University of California Press, 1992), 122, 126, and 128.
13 Dale McConathy, "Robert Smithson and Anti-Modernism: The Rupture of Past and Present," *Artscanada* (March/April 1981): 21; copy in John Weber Gallery Archives.
14 Ibid.
15 In a further project I hope to examine the relationship of Smithson's libidinous technological sublime to that of earlier mechanomorphic art, most notably that of Francis Picabia and Duchamp. Smithson was attracted to this work, and recognized certain commonalities with his own. He was sufficiently anxious about this affinity to excoriate Duchamp whenever possible—see his interview with Moira Roth, anthologized in *The Writings*, for example. I think there are important distinctions between Smithson's attitude and Duchamp's; Caroline A. Jones, *Machine in the Studio* (Chicago: University of Chicago Press, 1996), chap. 5. Most earlier art positioned the machine as radically *other*, outside human reproduction—think of Duchamp's *celibataires*, for example, and his mechanical (virgin) brides. Smithson breaks down the human-machine boundary in ways more in line with Donna Haraway's utopian fantasy of the cyborg (Haraway, "A Cyborg Manifesto: Science, Technology, and Socialist-Feminism in the Late Twentieth Century," in *Simians, Cyborgs, and Women: The Reinvention of Nature* [New York; Routledge, 1991],149–81)—he creates imaginary hybrids in which pipes and injectors can copulate and King Kong has a steel skin. My preliminary work has suggested that this is an attitude more in keeping with Picabia's, where the machine is not an analogue of difference but of hybridity.
16 W. J. T. Mitchell's recent work on the desires we see in objects, pursued in his book *What Do Pictures Want? The Lives and Loves of Images* (Chicago: University of Chicago Press, 2005), has been influential on my thinking in this regard. I am grateful to Tom for sharing early drafts of this work, and arguing with me fruitfully for the volition and autonomy of the art object.
17 In the same letter, written to European curator and critic Enno Develing on September 7, 1971, Smithson goes on at some length: "Art that turns away from physical production to abstract composition [?] strikes me as reactionary.... Art should be an ongoing development that reaches all classes. As it is now artists are treated like colonials, who are systematically ripped off. Of course, there are artists who support this reactionary condition by making abstract paintings and sculpture that can be converted into an exchange currency by the

ruling powers. By making portable abstractions, the middle-class artist plays right into the hands of mercantilist domination. Money itself is a figurative representation reduced to the widest exchange. Portable abstract art is a non-figurative representation reduced to a narrow exchange. The portrait of a king or a president on money ... is for the many. The stripes and grids on an abstract painting is [sic] for the few." Robert Smithson to Enno (Develing), Archives of American Art, Smithsonian Institution, Smithson papers, reel 3833, frames 367–69. Another example of Smithson's perspective: "once something physical is made, it has the power to generate perceptions from many different disciplines." Undated draft of a letter to Gyorgy Kepes written just before a trip to Holland to work on the *Broken Circle/Spiral Hill*, AAA, Smithson Papers, Reel 3833, frame 252.

18 Robert Smithson, "Frederick Law Olmsted and the Dialectical Landscape," in *The Writings of Robert Smithson*, ed. Nancy Holt (New York: New York University Press, 1979), 118.

19 Curator Jan van der Marck wrote about this to Smithson after visiting the jetty in 1971 (he had left the museum world to work on Christo's *Valley Curtain*, which was going up nearby in the Rifle Gap of Colorado): "It is strange to reflect, afterwards, on how public the Jetty is (through films, photos, magazine reproductions, etc.) and yet how private and remote. What is the more real? That dramatic filmed account in glorious colors oozing work and rawness and energy. Or that grayish remote protuberance into the Salt Lake, mistaken by most casual visitors for another abortive attempt to span the lake, find minerals or build a little shack away from it all." Jan van der Marck to Robert Smithson, June 16, 1971, AAA, Smithson papers, reel 3833, frame 333.

20 Again, I cite W. J. T. Mitchell, and express my gratitude for the opportunity to read in manuscript his *What Do Pictures Want?*

21 Lawrence Alloway, "Robert Smithson's Development," *Artforum* 11, no. 3 (November 1972): 59.

22 Ibid., 60.

23 Ibid.

24 See Jean-Pierre Criqui, "Rising Sign," *Artforum* 32, no. 10 (Summer 1994): 81.

25 The historian of science most influential on my thinking is, as always, Peter Galison. See also Norton Wise's narratives of German efforts to make gardens of their machine environments, in "Meditating Machines," *Science in Context* 2, no. 1 (1988): 77–113; and his "Architectures for Steam," in Peter Galison and Emily Ann Thompson, eds., *The Architecture of Science* (Cambridge, MA: MIT Press, 1999). Also influential has been the work of Steve Shapin and Simon Schaffer in *Leviathan and the Air Pump: Hobbes, Boyle, and the Experimental Life* (Princeton, NJ: Princeton University Press, 1985).

26 Sol LeWitt, "Paragraphs on Conceptual Art," *Artforum* 5, no. 10 (June 1967): 80.

27 See Barthes, "Death of the Author." Michel Foucault's "What Is an Author?" is another crucial essay in this developing postmodern discourse. Is the centered studio reemerging in an ironized form? Jason Rhoades's environment for the 1995 Biennial at the Whitney Museum of American Art was suggestive. Called simply *Untitled*, 1995, it comprised an elaborate, goofy, and hilarious layout of donut-making machines, mock donut-making machines, Toro lawnmowers, motorbikes make from Toro lawnmowers and other "small gasoline engines, various tools, and plastic." This entire mechanical manufacty was surrounded by vintage photographs of Constantin Brancusi in his studio, paired with contemporary

color prints of (presumably) Rhoades in his. Unillustrated documentation in Klaus Kertess et al., *Metaphor: 1995 Biennial Exhibition* (New York: Whitney Museum of American Art, 1995), 263.

28 I have been influenced in this reading both by Frederic Jameson's essay "Periodizing the 60s" and by David Harvey, *The Condition of Postmodernity: An Enquiry into the Origins of Cultural Change* (London: Basil Blackwell, 1989).

29 See Rob Wilson's essay "Techno-Euphoria and the Discourse of the American Sublime," *Boundary 2*, 19, no. 1 (Spring 1992): 205–29, for a trenchant discussion of the ideological use of technological sublimity in the realm of politics during the 1992 Gulf War, and the mobilization of fantasies of centralized, national capital behind the façade of the "smart" bombs and Patriot missiles, most of which turned out to be very dumb indeed.

Courtney J. Martin
The Studio and the City: S.P.A.C.E. Ltd. and Rasheed Araeen's *Chakras*

Speaking from Berlin in 1982 about the way that he incorporated film into his practice, Peter Sedgley described London as a studio space:

I produced in 1971, a cinema film in which I tried to convey to West Berlin audiences my reactions to the ambience of London by presenting its contrasting ambiguities and the pace and sometimes boredom of those who live and work there. It is a film collage recording a seemingly endless trip along a motorway, with repeated sequences and superimposed images of the docks of East London, where the S.P.A.C.E. studios are located. The film may have been made as a reaction to my rejection of figurative subject matter in my paintings and sculptures.[1]

The studio that he mentions was most likely the I Site studio, one of the buildings in the S.P.A.C.E. Ltd. studio scheme. The "ambience," London's post-empire dereliction, would have been jarring to anyone who assumed that the city had regained its prewar prominence. By the end of World War II the East End docks, once a major transport hub (with similarly far-reaching names like East India and Cyprus), became spaces of vacancy and vagrancy with little commerce moving through them. As Sedgley suggests, to describe London to Berliners (or anyone) would require a mention of the docks, which stood in as a metaphor for the decline of London's grandeur and power. The docks were a locational and visual record of what the city had once been and what it had become. The metaphor of London as a derelict, postimperial, postcolonial, postindustrial dock was fitting, given that Sedgley had steered a group that pushed the British government to reuse these spaces as artists' studios. But this metaphor was double-faced. If London's fall reduced it to disuse, the city was a massive studio of remnants and refuse—one that artists like Sedgley drew from conceptually (as was the case with his film), formally, and materially.

S.P.A.C.E. Ltd.

S.P.A.C.E. Ltd. grew out of artists Bridget Riley and Peter Sedgley's idea that postwar London produced a population of artists, among others, who were not able to find reasonably priced working space.[2] In their white paper on the subject, they described the situation for artists lacking studios thusly:

> ... the rise in land values and rentals in every urban centre; the development for high-rental residential purposes of those districts traditionally provided with facilities for artists (one thinks, for example, of Chelsea, Hampstead, Kensington, where studios are converted into "desirable" flats and there is no replacement of working studios); the greater scale on which painters and sculptors are working.[3]

All three factors—rising costs, development, and new forms of art-making —contributed to a squeeze on space in London. These factors also defined the ways that industry had altered in Britain in the postwar period. Workers, now employed in different sectors than before the war, looked for homes within the city but were being pushed to its suburban margins or enticed to live in the highrise complexes completed in the mid-1960s.[4] In calling for what might traditionally have been a part of Britain's (or most European governments') social contract with artists, S.P.A.C.E.'s proposal aligned them with industry. Artists were workers whose workplaces needed to be provided and regulated by their employer, the city. As they noted:

> Not to have adequate space can be near-crippling, because capacity and performance alike may be diminished when the available space is too small for work or for showing off work to good advantage, and the resultant tensions in domestic or professional life can retard an artist's development.[5]

Indeed, S.P.A.C.E.'s founders fit this new model. Riley was a large-scale painter, and Sedgley had moved from traditional painting and sculpture into installation and film. Their practices mirrored those of other London artists who needed larger and more flexible workspace. Riley and Sedgley caught a glimpse of a solution in Manhattan, which they visited for the exhibition "The Responsive Eye" at the Museum of Modern Art in 1965. There, they were inspired by the repurposing of industrial and commercial space for artists in downtown Manhattan.[6]

Upon their return to London, they began to organize S.P.A.C.E. Ltd. (Space, Provision, Artists, Cultural and Educational), which was launched

in the fall of 1968 as an incorporated nonprofit, with a board of directors that included W. A. West, Irene Worth, Peter Townsend, and Maurice de Sausmarez. The directors represented the wider field of the arts. Worth was a noted expatriate stage actress; Townsend was the editor of *Studio International*, the most circulated contemporary arts magazine of the time; and de Sausmarez, an artist, was the principal of the Byam Shaw School of Art. Along with de Sausmarez, West, a professor at the University of Reading, gave the group institutional clout.[7] S.P.A.C.E. functioned as a cooperative to obtain short-term leases from the Greater London Council (GLC) on vacant buildings, some set to be demolished for commercial expansion, others simply derelict.[8] With minimal accommodation (the provision of electricity, running water, and heat), these buildings were converted into work-only studio spaces for artists. At the end of the lease (or license, as it was called), S.P.A.C.E. and the artists vacated the property and moved on to another vacancy.

One of the first S.P.A.C.E. endeavors was at St. Katharine Dock, a suite of warehouses just east of the Tower of London and the Tower Bridge in an inlet on the north bank of the Thames River.[9] An active port in the nineteenth century, St. Katharine had been severely damaged during the blitz. S.P.A.C.E. arranged a two-year lease from the GLC for the facility, which comprised "three large water basins of 10 acres surrounded by warehouse buildings covering some 100,000 sq. ft. and rising four and six storeys in height."[10] The main artists' studios and office area were located in a warehouse dubbed I Site, or I Warehouse.

While the original mandate for S.P.A.C.E. outlined affordable studio space for artists, particularly young artists and art students, there was also a clause for studio workshops for "artists of all nationalities working in the visual arts."[11] The latter reflected the utopian component of the undertaking; Riley and Sedgley envisioned the studio program as a communal forum for work wherein socialist values would be combined with internationalism. This clause also recognized the postimperial reality of London. After World War II many residents of former British colonies had relocated to the United Kingdom, many settling in its largest city, London, whose docks had been the major outlet to the country's colonial posts. By 1968, London was a city whose past had returned to it in the form of new citizens.[12] Though Britain did not experience social upheaval like continental Europe in 1968, great social changes resulted from the influx of immigrants.[13] More progressive than the government, which viewed nearly all immigrants as manual laborers, S.P.A.C.E. recognized that some of these new citizens were artists who might share in their ideals about art-making.

"I" SITE at St. Katharine Dock, SPACE Studios, 1968–1970.

Chakras in the Thames

Rasheed Araeen was one of these new arrivals, having reached London in 1964 from Karachi, by way of Paris, with the intention of becoming an artist. Previously a draftsman for British Petroleum, Araeen had moved continents, sacrificed material comfort, and radically altered his career path with the intention of becoming an artist.[14] His work, stemming from his knowledge of engineering and building structures, was interstitial; he was neither a painter nor strictly a sculptor. In the mood of the times, he was exploring what would come to be known as installation through a variety of means. From the outset of his residency, he produced minimalist forms that he called structures.[15] These were gridded, geometric works, often painted, that required a great expanse of space to construct (as well as workshops for wood joinery and welded steel) and to exhibit and store. Thus, following in the manner of the new forms of sculpture being produced at that time, Araeen required a large multifunction space in which to conceive and craft his work. As one of the earliest occupants, he found at I Site a place to develop his work and enjoyed a freedom that Lynn Schafran also noticed during her visit in 1969: "Some areas are partitioned for additional wall space, others function as large, unbroken expanses where groups or neighbors work freely."[16]

The "sheltered water" surrounding the I Site studio was also available for residents' use.¹⁷ Enclosed by commercial buildings to the north, east, and west and a lock that led out to the Thames to the south, St. Katharine Dock was an urban island. The water was relatively calm, though as Araeen noted, it was littered with the detritus of the city:

> It became my obsession there to look at the water and observe the floating pieces of wood and plastics which were drifting from one place to another owing to the action of the movement of water and wind. Every day it was completely a different experience by finding the pieces of wood and plastic etc. in different relationship to each other and at a different place on the water.¹⁸

Like Sedgley's allusion to the dock's captivating contrasts, Araeen's description of the floating objects serves as a metaphor for the city's evolution. London was being altered daily by new arrivals, whose languages, customs, sounds, and movements rearranged its previous patterns. The once eastern European and Jewish immigrant enclaves in East London, for example, were being replaced by Bangladeshi and Pakistani migrants. South London saw large influxes of African and Caribbean populations, while the north of the city housed groups of Turkish and Greek Cypriots.¹⁹ The movement that Araeen noticed in the water was thus replicated on the streets. During this time, he also became involved in community and participatory art events, many of which expressed a commitment to combating the stigmatizing and harassment of immigrants in Britain.²⁰

Begun in 1969 and initiated in February of 1970, *Chakras* was Araeen's first environmental and participatory project at I Site. Araeen invited friends, some other S.P.A.C.E. artists, and passersby to throw disks into the water. In total sixteen red fluorescent plastic disks, each two feet in diameter, were floated in the water. Like the debris that Araeen had seen there, their movement was contingent upon the variable conditions of the water and the wind. Unlike the debris, however, they were consistent in size, color, shape, weight, and buoyancy; eliminating such variations, which Araeen termed "relations," meant that either all of the disks would float or all would sink. In this case, they all floated.²¹

Araeen's later social justice and political art actions position *Chakras* as a comment on the ways in which difference (be it class, race, ethnicity, or gender) was an uneasy fit in Britain in the late 1960s. On one level *Chakras* is a commentary on London's adaptation to its new citizens. The sink-or-swim uncertainty is not without humor, if not also irony. Floating a symbolic object with bodily connotations drawn from Eastern spiritual traditions (chakras occur in both Hinduism and Buddhism) in water that leads to the open sea is a performance of reclaiming, of liberation from imperialism,

Rasheed Araeen, *Chakras* (detail), 1969–1970.

and with it, slavery, colonialism, and all it implies. But was this performance satirical? For this to be done by an immigrant working in a communal art program with utopian overtones, that option has to be considered.

On a formal level, the action sought to resolve a tension Araeen felt between a secure understanding of minimalist form (here shown through uniform, geometric objects) and a more expansive art practice that depended on the participation of others and the coordination of uncontrollable elements: wind, water, and the ever-present possibility of rain in London. Each of these aspects drew attention to the manifest condition of late 1960s London as it confronted urban deterioration amid population regeneration. It was a city falling down and expanding simultaneously.

For Araeen there was also another component, making art that had little or no commercial potential. He described the aims of *Chakras* thusly:

If we want that art should become [an] essential part of our life or that all the people should have access to it, it is essential that first the monopoly of one particular class to own and appreciate the work of art must be destroyed.[22]

Chakras realized this destruction of the "monopoly" by being almost completely intangible. The disks were allowed to float on the water under the terms of "release," a historically weighted synonym for manumission. Like most actions, *Chakras* was a one-off performance that circulated through a few photographs, which Araeen did not edition or sell.[23] (At the time, London had almost no viable art market, particularly for experimental art.)

After the initial release, the individual disks were not retrieved from the water. Like the debris that inspired them, they went with the current, becoming more unmarked remnants of the city.

Making art that could not be sold was itself a release from a certain type of aesthetic pressure. This is not to suggest that Araeen lacked ambition with regard to his work or his career. In the same year that he began work on *Chakras*, he was awarded the second prize at the seventh John Moores Liverpool Exhibition at the Walker Gallery in Liverpool. Araeen's entry, *Boo* (1969), completed at his I Site studio, was one of only a few purchased by the Walker.[24] London, by way of the S.P.A.C.E. program, allowed Araeen and other artists to maintain a conventional studio practice while also inventing and experimenting with new forms.[25] St. Katharine Dock had a metonymic relationship to the city, just as S.P.A.C.E. did to the government from which it funneled resources to artists in the hopes of establishing art and artists as significant features of municipal, if not national, culture. *Chakras* was only one example of the innovations fostered by these interactions. As a new arrival, Araeen's presence in London, and in St. Katharine Dock in particular, challenged the city and the program to live up to its ideals. Within the confines of the S.P.A.C.E. studio program, he was able to harness the potential of the "sheltered water" outside its door, and thus of the surrounding city.

. .

1 Peter Sedgley and Heinz Ohff, "My Kinetic Artworks and Paintings (1971–1982)," *Leonardo* 15, no. 3 (Summer 1982): 184.

2 Despite the ongoing relationship between Bridget Riley and Peter Sedgley, early press releases cite Sedgley as being charged with "most of the organizational work" for S.P.A.C.E. John H. Holloway, "International Science-Art News (Art et Science: Nouvelles de L'Etranger)," *Leonardo* 2, no. 4 (October 1969): 450.

3 "A Proposal to Provide Studio Workshops for Artists," *Studio International* 177, no. 908 (February 1969): 66. This is a shorter version of Space Provision Ltd., "A Proposal to Provide, on an Ultimately Self-supporting Financial Basis, Studio Workshops for Artists, Together with Such Additional Facilities as Areas for Light Projection Work, Workshops for Light Metals etc., and Exhibition Spaces" (1969). A slightly longer version of "A Proposal to Provide Studio Workshops for Artists" was circulated in the same year; see publicity leaflet issued by Space Provision Ltd., Tate Library and Archive.

4 For a longer discussion of architecture in London after World War II, see Peter Murray and Stephen Trombley, eds., *Modern British Architecture since 1945* (London: F. Miller/RIBA Magazines, 1984).

5 "Proposal to Provide Studio Workshops," 66.

6 Jonathan Jones, "Interview with Bridget Riley," *Guardian*, July 5, 2008. Riley incited a great deal of media attention while in New York because her work was taken to be emblematic of the commercial potential in so-called Op art, spawning fashion styles and decoration.

See John Canaday, "The Responsive Eye: Three Cheers and High Hopes," *New York Times*, February 28, 1965. Despite Riley's discomfort with the way that her work was received, it is likely her fame that lent weight to the S.P.A.C.E. project.

7 In 1969 S.P.A.C.E.'s sponsors were Henry Moore, David Benson, Minister of Parliament Niall McDermott, Desmond Plummer (leader of the Greater London Council), and Norman Reid (director of the Tate Gallery).

8 In addition to the GLC, S.P.A.C.E. received public support from the Arts Council of Great Britain and private support from individuals.

9 In 1969, S.P.A.C.E. also proposed to occupy a warehouse at the former Marshalsea Prison. The prison, in which Charles Dickens's father had been locked up for debt, was featured in the novelist's book *Little Dorrit* (1857). Like Marshalsea, St. Katherine's Dock had historical significance. Some of the exterior structures were constructed by Thomas Telford, the engineer. S.P.A.C.E.'s first project was the Stockwell Depot, an abandoned factory in South London. There, unlike St. Katherine's Dock and Marshalsea, S.P.A.C.E. provided the financial and administrative hub for a group of St. Martin's School of Art sculpting students who needed larger workspaces. The sculpture course at St. Martin's grew in prominence in the late 1960s, largely due to the success of Anthony Caro, a tutor there. One of few British artists to be heralded by the American art critic Clement Greenberg, Caro led a revival in sculpture through his engagement with abstraction. His acclaim was extended to his pupils, most notably in *The New Generation: 1965*, an exhibition which was on view at the Whitechapel Art Gallery from March through April 1965. The nine sculptors in the exhibition were David Anesley, Michael Bolus, Phillip King, Roland Piche, Christopher Sanderson, Tim Scott, William Tucker, Isaac Witkin, and Derrick Woodham, only four of whom—Piché, Sanderson, Witkin, and Woodham—were not under Caro's tutelage. The import of the course lasted through the decade. For example, in January 1969, as part of a special issue entitled "Some Aspects of Contemporary British Sculpture," *Studio International* published an article on St. Martin's, complete with photographs and a chart of its tutors and pupils, which showed how each (directly descended from Caro) had pursued an art career. One subsection noted those who had exhibited in "New Generation." "The Sculpture Course at St. Martin's," *Studio International* 177, no. 907 (January 1969): 10–11.

10 Space Provision Ltd., *A Proposal to Provide, on an Ultimately Self-supporting Financial Basis*…, K2. Other press material lists the square footage as 60,000.

11 Ibid.

12 As Dominic Sandbrook demonstrates in *White Heat: A History of Britain in the Swinging Sixties* (London: Little, Brown, 2006), immigration was one of Britain's key issues throughout the decade.

13 One of Britain's major conflicts in 1968 occurred around art school education. In a battle between education administrators and students, along with some tutors, students sought to have more input into their education. The most important of these battles took place in May at the Hornsey College of Art in north London. Students there staged a sit-in that led to some curriculum changes for the nation. Riley taught at Hornsey from 1960—1961. During the exhibition, *Hornsey Strikes Again* at the Institute of Contemporary Arts in July, which was a corollary to the sit-in, she was invited to speak in support of changes to art education. Her involvement with Hornsey was simultaneous with setting up S.P.A.C.E. and

may account for the attention paid to students in the S.P.A.C.E. proposal. For a longer discussion of the Hornsey College of Art revolt, see Lisa Tickner, *Hornsey 1968: The Art School Revolution* (London: Frances Lincoln, 2008).

14 Interview by the author with Rasheed Araeen, November 1, 2006. In addition to his art practice, Araeen (b. 1935) founded the journal *Black Phoenix* (1978–79), which continued as *Third Text* (1989). In 1989 he curated the first major museum exhibition of Asian and black artists in Britain, "The Other Story: Afro-Asian Artists in Post-War Britain," at the Hayward Gallery.

15 For a longer discussion of Araeen's structures, see Rasheed Araeen, *Making Myself Visible* (London: Kala Press, 1984), and *Minimalism and Beyond: Rasheed Araeen at Tate Britain* (Third Text/Tate Britain, 2007).

16 Lynn Schafran, "'I' Site and Westbeth: Two Solutions to One Problem," *Members Newsletter* (The Museum of Modern Art, New York) no. 7 (Winter, 1969–1970): 5.

17 Guy Brett, "Introduction," in Rasheed Araeen, *Making Myself Visible* (London: Kala Press, 1984): 8.

18 Rasheed Araeen, "Karachi, April 11, 1974," in Araeen, *Making Myself Visible* (London: Kala Press, 1984): 64.

19 For a longer discussion of postwar immigration in Britain, see V. G. Kiernan, "Britons Old and New," in *Immigrants and Minorities in British Society*, ed. C. Holmes (London, 1978).

20 Araeen's most prominent social justice connection was with the British branch of the Black Panther Party, which he officially joined in 1973. Interview by the author with Rasheed Araeen, November 1, 2006.

21 Rasheed Araeen, "Karachi, April 11, 1974," in Araeen, *Making Myself Visible*, 65.

22 Ibid.

23 Interview by the author with Rasheed Araeen, November 1, 2006.

24 Memorandum from Hugh Scrutton, C.B.E., to the Arts and Recreation Committee of the Walker Art Gallery, undated. John Moores Exhibition archive, Walker Art Gallery. See also Gail P. D. Engert, "Acquisitions of Modern Art by Museums," *Burlington Magazine* 113, no. 815 (February 1971): 118.

25 In 1971, the year after S.P.A.C.E. vacated St. Katherine's Dock, Araeen exhibited in "Space: Paintings and Sculpture from St. Katherine Dock" at Marble Hill House in Twickenham. It was the sixth exhibition organized for S.P.A.C.E. artists by Sedgley and the Art Information Registry (A.I.R.), an off-shot of S.P.A.C.E. I am thankful to Alicia Miller for sharing her knowledge of the S.P.A.C.E. archive, particularly the history of the A.I.R. For more on experimental art in Britain after 1968, see David Curtis, *A History of Artists' Film and Video in Britain* (London: BFI, 2007); Neil Mulholland, *The Cultural Devolution: Art in Britain in the Late Twentieth Century* (London: Ashgate, 2003); and John A. Walker, *Left Shift: Radical Art in 1970s Britain* (London: I. B. Tauris, 2002).

Katy Siegel
Live/Work

Felix Gonzalez-Torres. *When I first started making art in 1987, I had no money. I had a little tiny studio smaller than this kitchen.*

Ross Bleckner. *The size of the studio is not particularly relevant to the work you do, Felix, is it?*

Felix Gonzalez-Torres. *That was a studio apartment, not my studio.*[1]

Since the mid-1960s, "the studio" has been associated with a variety of outdated or suspect ideas—painting, handcraft, genius, expression, autonomy, commercialism—as opposed to ostensibly more serious values: public life, concept, criticality, sociality, refusal. Critics and historians as well as artists have criticized and demythologized this institution. These arguments themselves have now become old-fashioned to a certain extent, and the studio is currently enjoying a revival among critics, historians, artists, and curators. It's all too easy to make fun of some of the more high-minded charges against studio practice. The ideal of the artist as genius has transferred seamlessly to a long roster of post-studio artists, while, equally obviously, post-studio art has not proved particularly resistant to the market; installations, performances, and site-specific work of all kinds have garnered enormous financial and social success. Pushing aside these judgments, pro and con, the studio is most continually interesting for the way in which it embodies two things: the relation between the production of art and other kinds of production in a society at a given moment, and the relation between work and life.

For me, and I think for many artists, the studio as it has existed historically is not one of the "frames, envelopes, and limits" that, as Daniel Buren wrote, "enclose and constitute the work of art." On the contrary, the studio is attractive precisely because it represents expanse, an expanse both temporal and spatial. What has always attracted me to the studio as a kind of place was something closer to the original meaning of the studio *apartment*.

This form of real estate now carries a slightly pathetic whiff: a tiny single room for a single person who can afford not to have roommates and hasn't formed a more communal living arrangement (although during real estate peaks, people share these apartments as well). In New York at the turn of the twentieth century, however, "studio apartment" meant an apartment for an artist, built to accommodate both domestic and artistic needs, usually within a cooperative building arrangement.[2] Often but not always one room, these apartments usually featured double-story ceilings to accommodate large artworks and tall windows for light. Even as the studio apartment drifted away from this earliest purpose, one aspect lingered: rather than having a dining room, a living room, and a bedroom, different rooms dedicated to different functions, the occupant does everything in the same room—sleeping, eating, and "living," whatever that means. Because the space is small (and also perhaps because it is occupied by only one person), the architecture and the occupant are freed from the rigid social divisions that usually order daily life.

This condition of flow was even more true for the studio proper. Just as the studio apartment was originally a home to work in, the studio was and for a long time continued to be a workplace to live in. This was true of the New York artist's studio in the 1910s and 1920s (on the Upper West Side), the 1940s and 1950s (Greenwich Village, Union Square), the 1960s and early 1970s (Soho), the late 1970s and 1980s (Tribeca), and the 1980s and 1990s (Williamsburg). The fact that in New York many artists have lived and made art in concentrated clusters has largely passed without comment in histories and critiques of the studio, even though this condition has crossed generational and ideological divides—from the Dadaist Duchamp in the early twentieth century to postwar painter Willem de Kooning to 1960s performance artist Carolee Schneemann. After the 1930s, the studios were often barely converted manufacturing lofts, and often illegal; when legal, they came to be known as live/work spaces. Artists put in their own wiring and plumbing, establishing the rudimentary conditions necessary for bathing and sleeping and sometimes eating, often elaborating on these basic conditions rather than decamping if they became more successful.

Photographs of these studios tend to focus on the glamour of raw spaces and industrial architecture, to depict artists as exotic or brooding. But the real interest lies elsewhere: more than anyone else in this society, the artist and her art integrate work with life—material, time, and energy, in all their possible configurations. While these possibilities are primarily manifested as art objects, they are also materialized in the conditions of the studio and how it is used. In general, the studio allows us to see the choices an individual makes (however socially conditioned) with regards to how she will spend her

time. In particular, the live/work space presumes a deep engagement with one's work, an identity between work and life.[3] Even Donald Judd, hailed by Robert Smithson as an early emigree from the studio for his excursions to factories and plastics manufacturers, built his ideal world in Marfa based on the integration of work and life.

In daily life, this integration might mean working sporadically, for days at a time or in the middle of the night—the freedom to follow the course of an idea with no constraints but the artist's mental and physical stamina. Over the course of years, it meant, "No vacations, real artists don't take vacations," as painter Bill Jensen and so many older artists have said. Not because they couldn't afford it, but because they did not want a vacation from their lives, did not seek relief from work; for them, vacationing, not working, was time spent doing things they didn't want to do.[4] For most people in the United States, even for the midcentury middle class, life meant fifty weeks a year doing something you *had* to do, and two weeks doing what you *wanted* to do. Famously, leisure itself, even the "free time" spent on something a worker wanted to do, became not an escape from but a requirement of capitalism, as detailed by many social critics. The artist's odd relationship to work stood in opposition to the standard social divisions of time and self, to what Harold Rosenberg called the "split man."[5]

Today the nature of work, particularly professional work, is changing, and our lives are losing this midcentury split nature. More and more people are telecommuting or working "flex-time," or are on furlough, in the positive spin of the day. We are perpetually freelancing, working, not nine to five, but whenever we can: "on demand," at night, on the weekends, in coffee shops, at home. To succeed in a world of flexibility and impermanence, where one must constantly sell oneself to the next employer, appear poised for the next opportunity, we feel compelled to use our spare moments to think of new strategies and ways to "shine." This means erasing the line between work and life, not just temporally and spatially but psychologically. In fact, both tacitly and overtly, the positive spin on this constant work is that we are working the way artists work. We are urged to greet every task as if it were a chance not just for self-advancement but for self-realization—to take "the artist's way."[6] Current success manuals advise us not so much to do what we love as to love what we do ... which is quite a different matter.

People who are working like artists need to live like artists. In the early 1970s, living like an artist meant having a loft apartment downtown instead of a suburban ranch house or a classic six divided into bedroom, dining room, living room, and so on, with a sophisticated lifestyle to match one's sophisticated real estate.[7] That lifestyle did not include working at home. Today, living like an artist means something slightly different, something relevant to

the middle-class professional as well as the bohemian wealthy, building on the legacy of loft gentrification:

With more and more people working at home at least part of the week, it's perhaps not surprising that condo developers around the country are beginning to promote live-work units as part of their mix of offerings. Though the concept harks back to days when the corner grocer lived in rooms above the store, the design usually owes more to the artist's loft that has proliferated over the past few decades in renovated commercial buildings found in resurrected downtowns. In addition to sculptors and painters, these modern, at-home workspaces target professionals and entrepreneurs.[8]

An urban think-tank member adds, "In a way, it's a bit of a hype, because a lot of people work at home at least part of the time. So you could say most Americans reside in live-work units."[9] Doesn't sound so great when you put it that way.

It's the artists who aren't really living—or, therefore, working—like artists today. Successful artists increasingly have studios separate from their homes, where they keep regular hours between traveling and appointments, and these are, of course, run by managers and an assortment of employees. But it's not like this for most artists. A studio visit with a young artist or an artist with limited or no commercial success in a major U.S. city often still happens in an industrial building, but under very different conditions from those of the 1970s. The event is usually staged in a small room with plywood or sheetrock walls. Pan out to the hallway: a row of doors, one after another, with names on each one, along a wall of un-sheetrocked studs. Pan out again to see floor after floor just the same, a whole building of stacked studios. And again: an entire neighborhood with some residential space and the occasional bodega punctuating run-down light-manufacturing buildings, each with six, seven, eight floors of ten or twelve or twenty small studios. This environment crosses two unpleasant labor forms of the early and late twentieth century: the sweatshop and the office cubicle. Just as the loft studio of the 1960s took on the conditions of one disappearing form of work (light manufacturing), this studio takes on something of (now) older forms, even as they too morph and fade.

A young artist I know recently took a studio in one of these crowded buildings in Sunset Park, Brooklyn, a newish location for artists, far from the older art centers in Manhattan or even in Brooklyn. He complains that the building manager sold him on the idea that he was joining a "community," but in fact everyone spends so much time working to make a living and then traveling to their studios, that when they find time to get there, they just go in and shut the door. Is shutting the door a relief? The chance to briefly

reclaim one's production and autonomy? That closed door looks more like isolation than autonomy. Long after Nicolas Bourriaud has moved on to greener pastures and newer neologisms, "relational aesthetics" has found its greatest popularity and meaning with these young artists, and not young but also not successful artists (struggling, perhaps—or perhaps not—to "emerge"). The party, the apartment living performance, the sports activity with fanciful rules, the fort-building project that is actually an art installation continue to thrive, as do collectivism and artworks that reference one's social connections to other artists. While it's easy to relate these phenomena to new habits of connectivity, social networking, and the Internet, I believe this more social art also expresses a survival instinct amid work conditions that foster isolation.

These artists cannot afford to live and work in the same place—quite a different condition from post-studio artists who chose not to have a studio on principle, like Felix Gonzalez-Torres (whose conceptual practice allowed him nonetheless to bring his life and work together, keeping a studio "under his bed," as he put it).[10] For the average artist today, working in whatever medium, work is split from living—no waking up in the middle of the night to change or add to or destroy something, no working time metered only by the duration of energy or ideas. Under financial and temporal constraints, the ideal work of making art takes on many of the attendant pressures of "real," professional or wage labor work (although often without monetary compensation), as well as its temporal form: the necessity of working in regular, limited blocks of time. It is one thing for an artist to mimic the aesthetics of administration or to use office technology like Photoshop or laserjet printers; it is quite another for him to *live* like an office worker—the old kind of office worker. Like the other dominant strategies in artistic production today—refusal and overproduction—the interest in collectivity is a symptom of the straits artists find themselves in.

The recent ubiquity of post-studio art and the cyclical search for relief from the status quo may have inspired curators and critics to return to the subject of "the studio." But that studio barely exists any more, and in any case, the finite, permanent nine-to-five job, which it explicitly resisted, has newfound appeal amid current social and economic conditions. In fact, both institutions are fading. It might be time instead to look ahead.

..

1 Ross Bleckner, "Felix Gonzalez-Torres," *Bomb* 51 (Spring 1995).

2 The most famous, and perhaps the first, of these buildings in New York was 33 W. Sixty-seventh Street, where Duchamp lived and worked in a single room with a bath. (It was also the address of the luxurious apartment of his patrons, the Arensbergs.)

3 Although artists since the nineteenth century have romanticized the "ordinary" worker, in postwar America the concept of art as work has been particularly strong. The most obvious symptom is the way artists, particularly those born just before World War II, talk about their "work." "How's your work going?" one will commonly ask another. The more contemporary equivalent would be "practice." For an interesting discussion of work in relation to Soho, see Stephen Koch, "Reflections on Soho," in *Soho: Downtown Manhattan*, ed. René Block (Berlin: Akademie der Künste/Berliner Festwochen, 1976), 105—141.

4 Artists who boast of having a "nine to five" routine, from Stella to John Baldessari to Chuck Close, do so to signify a range of attitudes, from detachment to work ethic. Despite their sincerity in identifying with "regular" workers, this is a somewhat ironic stance—they are much more enmeshed with their work than the average shift worker (Baldessari, for example, does not take weekends)—if anything, they are more like doctors and other professionals in intellectually engaging and socially rewarding work. Of course, it must be added, an artist cannot keep nine-to-five hours unless his art production generates a living or he is independently wealthy.

5 Rosenberg discussed the conditions of life in a society that demands both long hours devoted to a hectic, regimented work schedule and slower, more loosely paced leisure time, to be spent pursuing personal satisfaction. These two modes of attention have tended to produce a "split" within the lives of ordinary American workers as well as artists pressured not only to create but to *succeed*. Rosenberg, like many in the affluent 1950s and 1960s, foresaw the end of work, courtesy of automation, and wondered what its effect on forms of creativity and attention would be. Harold Rosenberg, "Leisure and the Split Man," *Vogue*, February 1966.

6 More than one person began to note the advantages—for employers—of the model of the artist as worker, which seems to have begun appearing in business articles and books in the mid-1990s. For an interesting if brief analysis of this phenomenon, see Micki McGee, *Self-Help, Inc.: Makeover Culture in American Life* (Oxford: Oxford University Press, 2005), 126–30.

7 Sharon Zukin, *Loft Living: Culture and Capital in Urban Change* (Rutgers, NJ: Rutgers University Press, 1989), 82.

8 "Live-work condos offer dual-purpose space," http://realestate.msn.com/article.aspx?cp-documentid=13108477.

9 Ibid.

10 In addition to the post-studio artist focused on producing for specific exhibition situations, artists without studios have often been women tied to domestic roles, like Ree Morton, who "made art behind the washer/dryer," or *gesamtkunstwerk* eccentrics like Lucas Samaras, whose art-filled home represents the fusion of his art and life.

Suzanne Lacy
Beyond Necessity:
The Street as Studio

The studio as metaphor for a space of contemplation, reflection, and invention epitomizes a human desire that goes beyond artists—a desire that is far less attainable for the poor and working classes of the world. In *Full Circle*, a work I created for Chicago's Jane Addams Hull House Museum, economist Devaki Jain said that when poor women in India were asked what they wanted, they replied, "We want to think. We want to dream."[1]

Within the studio there is silence, waiting. There we attempt to be present, in a specific place and at a particular moment, by paying attention: suspending perceptual closure and judgment, resisting conventional ways of knowing, being deeply curious about and open to what arises. Free, if only for seconds, from external disruption, many thoughts or sensations are possible: staring pleasurably, meditating, daydreaming, inventing, imagining nonsense, creating images, focusing intently, or unexpectedly resolving a problem.

The despair of artists everywhere is the absence of time in this place. Distraught after working by day as a bureaucrat, Franz Kafka wrote in his diary, "I finish nothing, because I have no time, and it presses so within me."[2] American writer Tillie Olsen used blank white spaces on her pages to remind us of the silencing of those "consumed in the hard, everyday essential work of maintaining human life."[3]

The poverty of poverty is not only lack of food. It is the loss of the possibility of ever entering, even imagining, the studio.

As a working-class woman from what I suspect is a long line of thwarted creativity, I have made uneasy peace with the desire for a removed and isolated studio in which to think and dream, and the necessity—because of personal economics and values—to find a studio in the streets.

In this studio, a space where reflection and production are sometimes indistinguishable, negotiation is an important method of "making." Besides negotiating between various perceptions, factions, and political realities, there is also a personal negotiation that takes place internally as I listen deeply to what is presented by others, all the while protecting some essential aspect of

LETON
DWARE

Neighborhood
Activity
Center

Suzanne Lacy

PREVIOUS PAGES
Suzanne Lacy, *Reunión/ Reunion*, 2008–2009. A project of Otis MFA Public Practice students and faculty led by Suzanne Lacy, which drew attention to the main street of Laton, a rural farming community in California.

my own pleasure. Perhaps others manage this balancing act more graciously; I need a place of retreat, whether a small loaned room in the middle of a devastated main street or a place in my imagination where an image can gather urgency and meaning.

Artists committed to a social practice encounter the street with openness, pay attention to the details and images and bits of information, and seek connections according to our personal histories and political perspectives. Like lifting a bucket from a well, hand over hand, we pull out meaning from many conversations and shape individual narratives into a whole one. This process of "making" privileges time and relationships, giving us a way to shape the nontraditional aspects of our work into a metaphor that reveals the relational, social, and/or political forces at work in the street.

This studio has its pleasures too: the pleasure of relationship and, if one is lucky, of a precise, inspiring, and visually exciting image executed under difficult and unpredictable circumstances—just the kind of circumstances under which the majority of the world's people spend their entire lives.

1 Suzanne Lacy and Coalition of Chicago Women, "Full Circle," in *Culture in Action*, ed. Mary Jane Jacob, Michael Brenson, and Eva M. Olson (Seattle: Bay Press, 1995), 64.
2 Tillie Olsen, *Silences*, 25th anniversary ed. (New York: Feminist Press at CUNY, 2003), 15.
3 Shelley Fisher Fishkin, "The Lessons *Silences* Has Taught Us," in Olsen, *Silences*, xv.

Walead Beshty
Studio Narratives

It is clear that the world is purely parodic, in other words, that each thing seen is the parody of another, or is the same thing in a deceptive form.

GEORGE BATAILLE, *The Solar Anus*[1]

June 16, 2007

After being in Europe for a month and a half, I return to the U.S. on Lufthansa, which is in an ominous-sounding "Star Alliance" with my national carrier. I think of the star and Bataille's rectal inverse. Air travel is one of the few places where class structure is rendered so vulgarly apparent; it is a mix of contradictions, a unity of base physicality and total detachment. Passing through business class on the way to coach, I feel lumpen, heaving bags, sweating, and looking at the passengers who are reclining, sipping orange juice, already settled in and prepared for the seven-hour confinement. It's hard not to envy them. They meet your gaze, but quickly avert their eyes. First class, on the other hand, is sheer phantasmagoria, virtually invisible to those seated in coach, their comforts left to be speculated upon, fantasized about, evidenced only in the pages of the in-flight magazine and the shadows momentarily revealed when a flight attendant passes through the dividing curtain. Business class is there for us to ogle; visibility is the clearest separation between business and first. Business-class passengers are made comfortable but at the cost of being on display; showiness is their concession. I imagine the march of the coach passengers serves as a telling reminder to those who had barely made it into the business cabin, the ones who slid in with miles or complementary upgrades; without the benevolent rewards for their brand loyalty, they could find themselves back with the masses.[2] In coach everything is a monetary exchange; we are internally divided. There is no brotherhood in our collective abjection; the airline makes sure we are turned against one another, share a common loathing, struggling for storage space, jostling for armrests, resenting each others' bodies. I find myself noting the infirm in my head, the tall, the sweaty, the fat,

the old. Boarding is broken down by numbers printed boldly on our tickets, I can't resist glancing at other passengers' boarding passes to make sure no one usurps the benefits bestowed by the "1" printed on my stub. I am proud of my numeral and push past the 2s and 3s. *Brave New World* comes to mind, and when I finally make it to my seat with my fellow Omegas, I take two Ativan and consume a few Bloody Marys before descending into blackout. I wake up as the plane is landing at JFK.

June 17, 2007

I head upstate to a small liberal arts college (the same one that gave me a BA), where I'll be housed in a dorm, carless, just as it was when I was there as a student. One of the current students picks me up from the train station and I convince her to take me to Walmart to pick up essentials, as I know the opportunity to get a ride will be fleeting. She is from Texas. I purchase three pounds of Café Bustello, a Braun coffee maker, Poland Spring bottled water, Ortega beef jerky, Blue Valley blueberries, hangers, a 3M iron, a Norelco beard trimmer, Sudafed, and Walmart brand scissors, denim patches, and sewing kit. I feel like I'm camping. My companion tells me that it is in vogue in the business world to refer to the arrangements of products in commercial environments as exhibitions.[3] Walmart is ideal because their return policy is lenient, and their employees are not invested in checking everything that comes in for return. It feels as if there is a tacit agreement, shared by customers and employees, that one can exploit any lapse in the store's workings without moral hesitation. Doing so feels like stealing back a little of the autonomy that is stolen from you in such places; it keeps me coming back.

While it was always rather clunky, the campus is now an even more extreme pastiche of building types, from mid-nineteenth-century neoclassical to contemporary prefab (with some high architecture sprinkled about): it feels like a full-scale miniature golf course, complete with manicured flora and paved pathways. I am staying in a dorm complex called "The Village." My dorm, number 3, has the look of a suburban tract home stretched to the scale of a mansion, and the surrounding complex feels like one of those outlet malls that is forced to try to blend in because it's in a residential area. "The Village" was also the name of the island prison on the BBC serial *The Prisoner*, a quintessentially 1970s paranoiac fantasy in which the main character, played by Patrick McGoohan, is abducted by a faceless international conspiracy after he quits the secret service. At The Village—which is disguised as a holiday resort (it was shot in a real resort: Hotel Portmeirion, Penrhyndeudraeth, North Wales)—his name is replaced by a number, and he is subjected to psychological manipulations of an imaginative yet harmless variety; a recurring scene has

Walead Beshty, The Village, Bard College, Annandale-on-Hudson, New York.

him being chased by a gurgling balloon when each episode's escape plan inevitably fails. Each episode begins with the following exchange, as McGoohan (Number Six) confronts his new warden (the revolving role of Number Two):

Prisoner Where am I?

Number Two In The Village.

Prisoner What do you want?

Number Two Information.

Prisoner Which side are you on?

Number Two That would be telling. We want information, information, information ...

Prisoner You won't get it.

Number Two By hook or by crook we will.

Prisoner Who are you?

Number Two The new Number Two.

Prisoner Who is Number One?

Number Two You are Number Six.

Prisoner I am not a number. I am a free man.

Number Two Ha, ha, ha, ha ...

The show is a rather obvious allegory for a certain type of postmodern alienation: even though the conditions are comfortable, Number Six is under constant surveillance and control. Evil plots lie beneath user-friendly architectural regionalism. It makes going to Walmart feel like a heroic confrontation. I hope I can get a ride back to return all this stuff. I couldn't help but reflect on this nightly, falling asleep to the hum of air conditioning and the residual stink of the cigarettes I was feebly trying to conceal having smoked in the room.

July 7, 2007

Since I am stuck on campus all the time, I decide to try to make some work. I want to develop the color film I shot while traveling, but the nearest color lab is forty-five minutes away by car and takes three days to process film. The lab tech at the college allows me to experiment with their color processor, since no one in the program is using it regularly. I process all the film from Europe, plus photographs of the machine itself and of the technician. The film turns odd colors in the processor, which wasn't designed for film. My rough handling causes a multitude of scars from uneven development. I am pleased with the results. It is my first time hand-processing color film.

July 16, 2007

After a month of this, I manage to get another ride to Walmart, where I return all the goods I purchased except for the perishables (to my surprise they take back even the used sewing kit and the half-used denim patches). I never touched the jerky, and they accept that too.

July 17, 2008

I decide to check into the Bonaventure Hotel in downtown Los Angeles, because the heat and disarray of my apartment became too distracting for me to complete the two overdue essays I am working on. The three nights are a birthday gift, accepted out of desperation and justified by the cheapness of the reservations (a bargain procured via Priceline at $75 a night). It seems the Bonaventure has some difficulty filling its enormous structure. The hotel is a thirty-five-story, glass-enclosed cylinder with four smaller cylindrical towers around its periphery. The complex comprises 1,354 guest rooms, 94 suites, and 41 hospitality suites. Its entrances are scattered at several levels, and once one

is inside, it's unclear which is ground level. I keep confusing the name of the Bonaventure's mastermind, John Portman, with that of Joseph Paxton, who delivered an equally phantasmagorical piece of architecture to the inhabitants of London in 1851, which itself spurred a global franchise that reached as far as Portman's.[4] A mug in the shape of the hotel can be obtained from the rotating bar on the top floor. While I imagine spending a couple evenings up there consuming drinks from the commemorative mug, I never make it. The whole place feels like a 1980s furniture store: black and purple carpeting is accented by gold-chromed fittings.[5] Events on this particular weekend include the "International Youth Competition," and middle-aged parents can be seen shepherding groups of children around the building with small national flags clipped to their backpacks. When I check in, preteens are wandering around the lobby, wearing ballerina outfits, marching band uniforms, sequined tuxedos, and the like. One child is dressed as a puffy metallic dinosaur; I try to imagine what competition he might be a part of and what his chances are of winning.

Frederic Jameson famously used the Bonaventure as an example of "the cultural logic of late capitalism." I had read that Jameson essay while an undergraduate at the aforementioned small liberal arts college. His descriptions offered a mental respite from the humid, mosquito-infested, not air-conditioned, gothic melancholia of upstate New York in the summertime. They made me salivate. I dug up the book in preparation for my trip and found a passage underlined in ballpoint pen:

The Bonaventure aspires to being a total space, a complete world, a kind of miniature city (and I would want to add that to this new total space corresponds a new collective practice, a new mode in which individuals move and congregate, something like the practice of a new and historically original kind of hyper-crowd). In this sense, then, the mini-city of Portman's Bonaventure ideally ought not to have entrances at all (since the entryway is always the seam that links the building to the rest of the city that surrounds it), for it does not wish to be part of the city, but rather its equivalent and its replacement or substitute.... The Bonaventure ... is content to "let the fallen city fabric continue to be in its being" (to parody Heidegger); no further effects—no larger protopolitical utopian transformation—are either expected or desired.

Rereading this passage prompted me to extend my stay. Moreover, I decided to forego bringing any provisions and to avoid setting foot outside of the hotel.[6]

July 18, 2008

The hotel towers are coded red, yellow, green, and blue, which makes me think of Rodchenko's monochrome paintings, *Pure Red Color*, *Pure Yellow Color*,

and *Pure Blue Color* of 1921. These were Rodchenko's "last paintings," and the building itself feels like the last of something.[7] There is a plaque in front of the red elevator that informs the visitor that *True Lies* was filmed here, but it is unclear whether or not it is referring to the lobby, the hotel, or this particular elevator. *True Lies* was shot when Schwarzenegger's career had hit its plateau; failures like *Eraser* and his transformation into a socially liberal Republican governor were still years off. The hotel itself feels like this late version of Schwarzenegger: overtanned, with overly taut skin whose plasticine quality speaks to its age and a physique inappropriate for a sixty-year old.

I decide to try the fitness track, which circles the main column of the hotel and is fully visible (yet unreachable) from the decrepit lunch counters that in turn surround it, at a distance of about fifty feet. I didn't count on how alienating it would be to jog while office workers, eating their egg-and-cheese breakfasts and deprived of anything else to look at, stared. On the way back to my room, I take the wrong elevator and end up in the Blue Tower, in the midst of a hospitality suite where gaggles of little girls in variously colored costumes are waiting in line for something.

Later, I decide to go back downstairs to avoid the cost of room service. I get off on a fourth-floor landing where I remember seeing a coffee shop. It looked as though the shop was on this floor, but it turns out that it isn't. The elevators stop only on odd-numbered floors below six. From my vantage point, the coffee shop is only a short distance away, but getting there requires a counterintuitive walk through several zigzagging stairways. From one of the third-floor landings, the coffee shop is again visible, and after some time I find my way to it. Again, I think of Jameson:

Here the narrative stroll has been underscored, symbolized, reified and replaced by a transportation machine which becomes the allegorical signifier of that older promenade we are no longer allowed to conduct on our own.

Thinking of the building as a massive onanistic machine gives me some comfort. He goes on:

I am more at a loss when it comes to conveying the thing itself, the experience of space you undergo when you step off such allegorical devices into the lobby or atrium, with its great central column, surrounded by a miniature lake, the whole positioned between the four symmetrical residential towers with their elevators, and surrounded by rising balconies capped by a kind of greenhouse roof at the sixth level. I am tempted to say that such space makes it impossible for us to use the language of volume or volumes any longer, since these last are impossible to seize.

I had thought I might write about the hotel, but I find that Jameson was right about its being indescribable. The building itself feels like watching an old

movie about a future time that happens to be the time, or before the time, you're watching it in. Feeling exhausted by the book, I leave it at the Italian Coffee Express. The coffee is awful. When I return the next day, the book is still on the table where I was sitting, as is my cup. The shops located on the third and fourth floors feel half abandoned; the fourth is in better shape in part, I believe, because it has the only recognizable chain restaurant, a Subway sandwich shop. The majority of the other lunch places serve an odd mishmash of food—falafel, Chinese, pizza—and all have these strange cheese sandwiches wrapped in cellophane. There is one lunch counter with a sign that says it offers smoothies, but it never seems to be open.

July 19, 2008

I'm glad my copy of the Jameson was still at the table. He writes:

This diagnosis is, to my mind, confirmed by the great reflective glass skin of the Bonaventure, whose function might first be interpreted as developing a thematics of reproductive technology.... The glass skin achieves a peculiar and placeless dissociation of the Bonaventure from its neighbourhood: it is not even an exterior inasmuch as when you seek to look at the hotel's outer walls you cannot see the hotel itself, but only the distorted images of everything that surrounds it.

I wonder if Jameson has seen the Gehry's Disney Music Hall, located just a few blocks away. Instead of reflecting its surroundings, Gehry's brushed-metal surface reflects only blinding light. This is why it has become so popular for photo shoots; the building acts as an enormous reflector, guaranteeing even lighting to the models and cars positioned in front of it. It makes me think of Bataille's *The Solar Anus*, a blinding vortex, a massive pucker. Gehry's building sits at the intersection of First and Grand, and people have complained that it blinds drivers moving through the busy intersection and that cooling costs have gone up in the adjacent office buildings. I return to the room and consider one of the other books I brought: Patrick Beaver's *The Crystal Palace* from 1973. There is a print of a Rothko painting on the wall of my room. I try to revise a section of text that I've repurposed several times, to start things going on my overdue essay. I wonder if this is cheating. It's my third time rewriting it.

July 20, 2008

At about four in the morning, I wake up, startled by the noise of the televised gunfire in an episode of *Star Trek*, part of a twenty-four-hour marathon on TBS. After checking imdb.com, I find it aired just a year after Portman's first space-

ship-cum-hotel, the Hyatt Regency Atlanta, a sister structure to the 1976 Bonaventure.[8] Back to Jameson:

Towards the end of art, of course, and the abolition of the aesthetic by itself and under its own internal momentum, the self-transcendence of the aesthetic towards something else, something supposedly better than its own darkened and figural mirror—the splendour and transparency of Hegel's utopian notion of philosophy itself, the historical self-consciousness of an absolute present (which will also turn out to be that selfsame allegedly prophetic notion of the so-called "end of history")—in short, the shaping power of the human collectivity over its own destiny, at which point it founders (for us here and now) into an incomprehensible, unimaginable, utopian temporality beyond what thought can reach.

… marching as they do from the only obscurely and unconsciously figural, through the assumption of the sheer autopoeisis of the play of figuration as such, towards the sheer transparency of an end of figuration in the philosophical and the historically self-conscious, in a situation in which thought has expunged the last remnants of figures and tropes from the fading and luminous categories of abstraction itself.

My zero point would come at L.A. Prime, the steakhouse on the top floor of the hotel. There a surprise party awaited me, a crown on the birthday excursion.[9] I realize I've gone days without having a face-to-face conversation lasting more than a minute.

..

1 "Subjected to a gentle form of possession, to which he surrenders himself with more or less talent or conviction, he tastes for a while—like anyone who is possessed—the passive joys of identity-loss, and the more active pleasure of role-playing. What he is confronted with, finally, is an image of himself, but in truth it is a pretty strange image. The only face to be seen, the only voice to be heard, in the silent dialogue he holds with the lanscape-text addressed to him along with others, are his own: the face and voice of a solitude made all the more baffling by the fact that it echoes millions of others." Marc Auge, *Non Places*.

2 In the airport, the airplane, in customs and security queues, the relation between the abstract rule of law and the movement of bodies is realized with vulgar immediacy. I am not speaking in the classic sense of abstraction or materialism within art (especially not in the sense that the term "abstract" is misused to mean "nonfigurative," or that materialism has come to be synonymous with a claim for ontological purity) but of how abstractions are manifest in the quotidian, how they govern our experience of the "real," or more exactly, how they become concrete, and how this becoming produces moments of friction and error. Concepts as amorphous as subjecthood (as constituted in the right to privacy, of personal property, free speech, etc.) are rendered specific and given edges simply by their being momentarily suspended or amended. In these marginal connective tissues, tacit hierarchies become spatial, physical: one's belongings are inspected, one's body relegated to queues, numbers, compartments, "class." Normally, the fragility of the state's guarantees manifest themselves only in moments of direct conflict and massive collapse (such as the

recent credit crisis, or the revelations regarding conditions in the American military prisons at Guantanamo Bay or Abu Ghraib), but in the case of air travel, the fragile malleability of social order is always close at hand, delineated by post-and-rope stanchions, bracketed by pavilions and kiosks in linoleum-topped chipboard, by color-coded wall-to-wall carpeting, by the eye of the X-ray machine. It is common knowledge that one is more likely to cry while watching a movie on an airplane due to the implicit trauma of air travel—the fear of death, of crashing, which leaves us emotionally vulnerable. But the trauma of air travel is quite literally one's confrontation with one's tenuous grasp on autonomy, its little humiliations emphasizing the conditional nature of individual autonomy: an alchemical transformation that allows inalienable rights to become suddenly alienable, subject to revocation. This suspension is put on display, and listlessness becomes exhibitable.

3 From the early 1500s on, the term "exhibition" had only a specialized legal meaning, referring to a giving of evidence: it meant literally to "hold out." With the Great Exhibition of 1851 and the world's fairs that followed, the antiquarian meaning and implications of the term blossomed. Born of the nascent consumer culture of Victorian England, world's fairs were a key distillation of modernity, uniting technological innovation, immersive spectacle, nationalist ideology, and a forewarning of the borderless world of global capital. In short, they were an instrumental expression of modern life by symbolic metonymy, a safari of capitalism staged in an interior.

4 The Crystal Palace was the prototype of modern steel and glass open-frame, curtain-wall architecture, providing the template for what would become the modern museum, the corporate complex, and the department store. The structure took the industrial dream of endless production and limitless expansion as its defining principles, eschewing the monolithic stone construction and revivalist pastiche that was then popular, it opted for a modular structure of four-foot-square wrought-iron cells. Despite its immense scale (it was over eighteen hundred feet in length and covered nineteen acres) and industrial construction, it had an overall feeling of "lightness," the reflections in the glass panes alternating between blue sky and surrounding greenery. As one critic observed, "It is, in my opinion, extraordinarily difficult to arrive at a clear perception of the effect of form and scale in this incorporeal space." Another visitor wrote, "There is no longer any true interior or exterior, the barrier erected between us and the landscape is almost ethereal." He continued, "If we can imagine that air can be poured like a liquid, then it has, here, achieved solid form." Inside and outside, the real and the likeness, thoroughly conflated, emerged as a shimmering chimera.

5 If Joseph Paxton's Crystal Palace, which housed the Great Exhibition of 1851, was the first building to fully capitalize on the theatrical spectacle of exhibition, turning architecture into pure display (a glass box) and the objects it contained into images, the readymade was the first art object to be constituted solely by theatrical distance. With the readymade the ritual act of viewing became the artwork's material, the object itself a hollow shell, a decoy, an effigy of the quotidian. Thierry de Duve put it succinctly when he wrote that, in the wake of the readymade, the only truth to which the art object could attest was the power of its own name, rendering palpable the "pact that would unite the spectators of the future around some object … that added nothing to the constructed environment and did not improve on it but, quite the contrary, pulled away from it, bearing no other function than that of pure signifier."

6 It seems no coincidence that just as Duchamp brought the foundational theatricality of art objects to the fore, the "zero point" of painterly materialism would surface thousands of miles away as a theatrical backdrop. In 1913 Kazimir Malevich was asked to contribute costumes and set designs for the Cubo-Futurist play *Victory over the Sun*. Aside from the almost unwearable costumes, Malevich produced a series of concept drawings for the sets which, in stark black and white, appear like preparatory sketches for the Suprematist canvases he would begin producing just a year later. When asked about his tautologically titled *Black Square* (1914/15) and its placement at 45 degrees in the top corner of the room of the 1915 exhibition "0.10," Malevich referred back to these set designs as its origin. The monochrome was, thus, situated as both the material negation of the painterly image (an object that operated by pictorial resemblance) and the symbolic negation of the very thing that made vision possible.

7 While *Black Square* is often credited with being the first monochrome, that is not the case (not that being first matters). This milestone of total materialist refusal was realized by the poet Paul Bilhaud, in an exhibition staged in the apartment of writer Jules Lévy some thirty years earlier, in October 1882. Such modernist notables as Edouard Manet, Pierre Auguste Renoir, Camille Pissarro, and Richard Wagner were given a peek at what would be framed as their legacy. Bilhaud contributed a small black painting titled *Combat de nègres dans une cave pendant la nuit* (*Negroes Fighting in a Cellar at Night*), a joke that was stolen not once but twice: first by Alphonse Allais, who produced a book titled *Album Primo-Avrilesque* (1897) that expanded the series to a range of color swatches (and made no mention of Bilhaud, despite their acquaintance), and later by Malevich, who in the same year as *Black Square* produced the painting *Red Square*, which included a Bilhaudian parenthetical addendum in its title (*Painterly Realism of a Peasant Woman in Two Dimensions*). The invisibility of the site of work was here matched by the invisibility of the marginalized, both relegated to infrastructural obscurity. The ability to represent daily life was again scathingly parodied, the quotidian again displayed in absentia. Such mistrust of images has become a staple of modern life (that is not to say that images aren't an ancient bugbear, with golden calves and the like operating as the exemplar of societies on their downward spiral), although for the past half century, photography, not painting, has been the primary recipient of this ritual derision. Stoic deconstructive critique and hedonistic celebrations of nihilism often result in identical outcomes; only the captions change. One is prompted to wonder how many times we can restage this anxious war on images to satisfactory effect.

8 In the 1968 *Star Trek* episode "Spectre of the Gun," Captain Kirk and crew set out under strict orders to contact an advanced yet unknown race called the Melkotians. Warned off by an automated buoy, they proceed to the surface of the planet, since their superiors had stipulated that this mission of peace must be accomplished "at any cost" (peace at any cost being an American hallmark). On the planet the crew members find themselves in a schematic version of the American Old West, specifically the moment of the shoot-out at the O.K. Corral, and realize that they have been given the role of the losers. Although the scene is notably fictitious (even to the crew), death is not. As Dr. McCoy observes: "In the midst of what seems so unreal, a harsh reality. This is not a dream." (Deforest Kelly, who played Dr. McCoy, had previously acted in a film about the gunfight at the O.K. Corral for the same studio, presumably on the same lot.) No matter what explanations they offer to the inhabitants

of this virtual world, no one believes they are who they say they are, instead referring to them by the names of the men that the Earp brothers and Doc Holliday vanquished on that day. Instead of being seen as purveyors of peace, they are seen as familiar enemies who refuse to leave despite the townspeople's warnings (a nod, perhaps, to Vietnam, which now makes me think of the war in Afghanistan). The world was wrested from Kirk's mind, released when the aliens scanned his brain, and Kirk goes on to explain that the history into which they had been thrust was a character-defining moment in his ancestral line. The Old West town is partial (missing walls, facades, and other architectonic necessities), and within the narrative this is attributed to gaps in Kirk's knowledge of the site and his own history; yet the other, more pragmatic explanation is that the show's budgetary restrictions forced the producers to recycle parts of Old West sets on Paramount's studio back lot, cobbling together half-built saloons, and freestanding façades. The scene of the crew's confrontation with its own historical mythology (they were after all, space cowboys, colonizing "the final frontier") is enacted in remnants of past Hollywood narratives, a bricolage of past fantasies, past scenes, past viewpoints. As the crew waits for the impending showdown, it is reasoned that the only way to transcend this prison is to reject the fiction all together, an insight that comes from their condescending superego in residence, science officer Spock. As Spock goes on to warn, "The bullets are unreal, without body, they are illusions only, shadows without substance. They will not pass through your body for they do not exist. Unreal, appearances only, they are shadows, illusions, nothing but ghosts of reality. They are lies, falsehoods, spectres, without body. They are to be ignored. The slightest doubt, and the bullets will kill you…" But realizing this is not enough, for the crew members cannot eliminate the last kernel of doubt about the reality of what they see, and this doubt, or more exactly, this belief in the facticity of images, is exactly what will kill them. Only after a "mind-meld" with Spock does the crew become immune to the weapons used against them. Having transcended the "false consciousness" of the world of images, they are finally allowed audience with the timid yet advanced aliens, an audience we never see on-screen, for we are still in the world of sets and allegories, capable perhaps of understanding fictions, but not able to ignore them. An alien world that is beyond images is also beyond representation, a zero point that the crew of the *Enterprise* has proved itself worthy of, but that we, as viewers, have yet to attain. Perhaps the commonplace understanding of the politics of an art object is akin to the phantom bullets; those who believe in them are subject to the false transformation of the politics *of* representation into the absurdity that politics *is* representation.

9 But what of Malevich's zero point, and its proposed transcendence? With the climate in postrevolutionary Russia progressing into Stalinism, the proposition of materialist abstraction (and the collective failure to live up to the utopian proposal of Unism) had become a symbol of bourgeois elitism. Malevich returned to his pre-Suprematist foundations, producing canvases that aped his antecedents, first Cubo-Futurism and, at its most extreme, impressionism. Stranger still, Malevich backdated these works, so that his Suprematist works remained the forgone conclusion of these styles, turning his own progression into an ellipse, doubling back on itself. He was trapped in his own Wild West origin story of false starts and primordial violence. Since he held to the conviction that he had reached the endpoint of painting, the height of purism in form, there was nowhere to go but backward.

Andrea Bowers

I can spend three hundred to four hundred hours making one drawing. I draw by sitting on the floor with my paper attached to the wall. It's pretty cramped quarters and a lonely process of endurance. The loneliness becomes heightened late at night. I often find company in Skype conversations with an artist friend of mine, Tucker Stilley. These conversations seem like the perfect format for a discussion about the artist's studio. Tucker is a multimedia artist living and working in Los Angeles. He is now almost completely paralyzed with ALS (amyotrophic lateral sclerosis, better known as Lou Gehrig's disease). He uses his computer to create his ongoing hyper-sigil artwork called *The Permanent Record of Newjack Rasputin*.

Andrea Bowers Most people think about the studio in terms of a physical space.

Tucker Stilley It's really more a question of the creative space, the skeleton you hang stuff on.

AB Your definition seems to internalize the studio, removing any need for the physical or architectural: the site of the studio isn't a location; it's inside the artist. Personally, I've never really needed a classic "studio" except for studio visits and storage. I sit on the floor and draw, sit in bed and research on my computer, sit at your computer or Fil Rüting's and edit. A curator once told me that I didn't need a studio, just a hallway.

When I was at CalArts, I took this famous class called "Post-studio Production"; it's taught by the conceptual artist Michael Asher. The goal of the class was to focus on idea development and minimize production of physical forms. Your definition of the studio makes me think about the point of that class in an entirely different way.

TS Now I have so much process invested in quirky modifications that I'm not able to be very effective anywhere else.

AB Do you want to talk about those quirky modifications?

TS Not here. They are constantly on the verge of spinning out of control. It's all on my website.

AB Do you consider your computer, wheelchair, and other "quirky modifications" as your studio, or are you completely uninterested in the physical aspect of a studio?

TS Yes to both: my studio is sort of an outgrowth of my broken nervous system. I'm like an anime character from *Ghost in the Shell*, where I sit in semi-darkness hooked up to machines, tended by assistants, and eating through a tube. So in the sense that an oyster shell is an oyster's studio for making pearls, that's what I have. I mean, you don't really find oysters out and about, making pearls on the run.

AB With the Asher class, it was about not using a traditional studio and promoting the idea of the dematerialization of the art object, but your definition makes that point moot.

TS Well, what is the difference between the studio and the office?

AB Conceptualists love the office as a workspace. But I hate offices. I've been trying to avoid them my whole life. Why would you want an office? Cubicles! It's like playing professional or capitalist.

TS And who's most responsible for that—the Bauhaus or Silicon Valley?! I did time in offices. I was the tech-A/V-slave for HBJ [Harcourt Brace Jovanovich] for five long, glorious years. Had my own underground bunker/office. Bars on the windows—very nice view of the underside of my motorbike. I failed to thrive in cubicles however. Seriously.

AB When did you begin to define the site of the studio as a creative thought process? Have you always thought of it this way?

TS When I realized how, much of the time, the physical studio was a crutch. I would put off important moments—waiting for everything to line up just right. I was supposedly all hot for the studio. Now that I spend all my time in the studio, I realize that the nonstudio time was very productive.

AB Are you talking about procrastination or the desire for perfection when you say "waiting for everything to line up just right"? I seem to use my studio only for studio visits with museum groups. It's a performance space for a magic trick, an illusion.

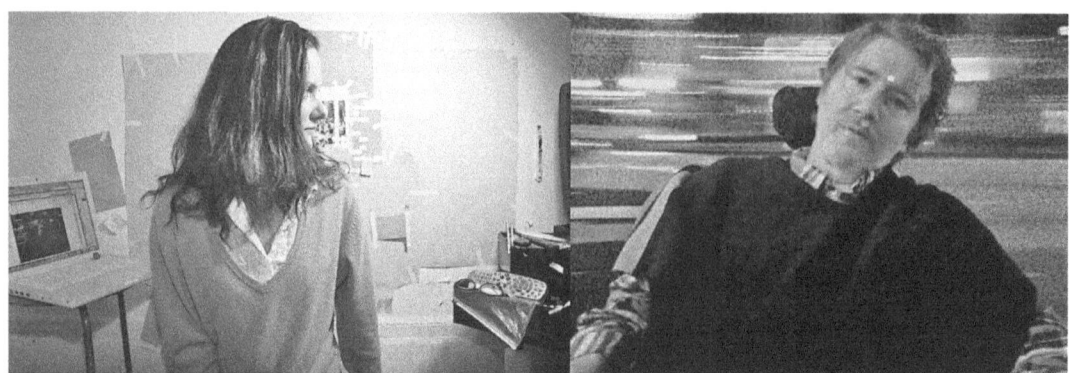

Andrea Bowers, 2009. Tucker Stilley, Sunset Boulevard, 2008.

TS Ah, studio as ... theater! There we are.

AB How does the "studio" function for you these days? Are you more adjusted about your studio practice than I am?

TS It's starker.

AB Is that starkness functioning well? Or is it a drag? Honestly Tucker, it's got to suck but there must be some unexpected revelations or at least inventions?

TS Yes, definitely. Be careful what you wish for! I'm learning what the actual limit of my creativity is—divided by time. It turns out to be a very different mix than I thought. I always just assumed that, given the correct circumstances, there would be no limit to my creative capacity. It's silly, I know. And wrong. I guess my thinking went something like this: "When I finally get to the studio, I will magically be able to think. All the restrictions I felt because I didn't have access to my physical tools will melt away, and I will join the superflow ..." Well—I was right—that's what happens, but then you have to wrestle with your real limitations, and they are crushing—I don't care who you are. To that extent, the studio is inside you. It's a stark edge if you push it far enough—what can be done. Not just time, but who you are.

AB My creativity is driven by what I'm afraid of. I can stretch out an idea or project because it takes me so long to confront my fears.

TS Maybe you are a process artist after all! But I second that—although my fears tend to turn out to be boring.

AB Well my fears are about voice. Do I have the guts to say this or that or believe in more radical ideas? It's tough for me to get past self-censorship. For

example, I had a hard time accepting that women were teaching a digit (finger) method for self-induced abortions prior to Roe v. Wade. When I first found out, I buried the info. Later I made work about it.

TS I take it back—conquering fear is interesting.... Supposedly I don't have the luxury of fear. I tell myself that.

AB So, if your fears are boring to you, what drives your own work?

TS Curiosity—things calling out to be—the opposite of fear, I suppose. You know ideas have their own lives in information space!

AB But Tucker, if an idea falls in the woods does anyone hear it? I know I'm making a seventies feminist point that might sound retrograde, but I don't believe ideas can be autonomous from the body, emotions, sensations, etc.

TS I think we have proof that everything we touch is an idea.

AB That's phenomenology. The minute we touch something it is also a feeling, emotion, sensation, etc.

TS Our brains are ideas. I bet ideas were our best ideas! Ideas replicate, they mutate, they have a self-preservation drive.

AB But what about emotions? Are they different?

TS I think emotions are very biochemical ideas, like an idea from the dawn of time. I take them very seriously—ideas that don't use words.

AB Beautiful, I agree with you. Hey, are we in our studios now?

TS Figuratively—definitely. Right now, I'm in my living room.

AB Well, that's a place to start tomorrow: metaphor, figures of speech, forms of artwork. I'm in my living room, too.

TS ... wishing that somebody would happen along with some wine.

AB I can come over with some wine.

..

The author would like to thank Susan Morgan for her assistance in editing this interview.

Judith Rodenbeck
Studio Visit

"Of all the frames, envelopes, and limits—usually not perceived and certainly never questioned—which enclose and constitute the work of art (picture frame, niche, pedestal, palace, church, gallery, museum, art history, economics, power, etc.) there is one rarely even mentioned today that remains of primary importance: *the artist's studio.*" This remark, penned in 1971 by the French Conceptualist Daniel Buren, throws new light on that complex refuge, the studio. For if the atelier has been both the site and the subject of representation, the space of world-making, then an undercurrent in recent art provides a new address both to what Svetlana Alpers has called the "forward, probing lean" of traditional studio practices—that is, their future-oriented creative tilt—and to the static framing of their results by the museum.

A project at the Whitney Museum of American Art in New York this past fall posed an extraordinary meditation on the studio's fecundity, while preserving some of its antic, mutable poetics. Corin Hewitt's *Seed Stage*, in the museum's lobby-level gallery, presented viewers with an unusual reconfiguration of the relation between the studio artist and the space of display. The central volume of the gallery was taken up with a large white structure, a functionalist shack roughly twice as long as it was wide; the pristine exterior walls of this studio left only a narrow corridor around the gallery's perimeter in which visitors could circulate. The corners of the studio had been cut away, leaving shoulder-width gaps through which the interior could be seen. Inside what might be thought of as the architectural "core" of the project, the artist carried on his daily activities, eating, reading, cooking, moving objects about, storing them or retrieving them, arranging and photographing them in a kind of continuous puttering. He also tended boxes of worm-filled compost, grew vegetables from the seeds of those he'd eaten, and returned leavings (fruit skins as well as photographs) to the boxes of mulch. These activities in turn yielded photographs of maquettes made with foodstuffs and modeling putty and anything else at hand. The latter images, at least those that survive, serve as the documentary residue of the piece itself.

Scattered around the periphery of the gallery, the photographs functioned both as the "fruit" of the labors taking place inside the studio and as "seeds," inasmuch as they were as often as not returned to that space to be rephotographed or bottled or mulched, serving, by implication, as the visual ground for new elements.

The studio itself was capped by a frieze of color swatches, while the walls and floor of the space were tinted gray. A large, three-dimensional color wheel made of modeling putty provided the material from which copies of food were made; both palette and storage dump, this object testified to the mutability of materials—nothing went unused, everything provided fodder. "I keep remaking things and eating things," Hewitt explained during an interview. "Before I cook a squash I make a sculpture of it out of Plasticine and then I eat the squash and I'm left with the sculpture, which I then boil down and reuse by putting it back on my color wheel, so that my color wheel keeps getting fed."

On weekends, the artist was visually accessible to viewers through the slits at each corner of his studio, each of which provided a limited if wide-angle view onto the set. The slit "was a solution to finding an image-based relationship to a physical space," Hewitt explains. This understanding of the studio-laboratory through photography renders the chamber itself as a camera, that is, a small room with a limited view. "I'm trying to create a language of photography where it can be redigested very quickly," says Hewitt, "so photographs that now go up come back in and you never know as a viewer how long they've been there, how long they will be there, what order they were taken in, only that they have a relation to the site."

Indeed, Hewitt conceived of *Seed Stage* in quasi-theatrical terms. The rectangular enclosure contained about ten feet of workshop space, at the end of which was a kitchen counter that also marked the beginning of the "stage," the elevated platform under, behind, and in front of which various activities take place. Underneath the stage was a root cellar and water system; above, a set of rolling shelves with canned and dried goods. As with nearly every dimension of the Whitney installation, these built elements were generated through a form of retooling, taking the Breuer profile of the Whitney's building, mutating it at the scalar and planar levels, and rendering it horizontally (as flooring-stage) and vertically (as shelving).

The performed dimension of *Seed Stage* most immediately seems to reward notions of solitary artistic mystery and the inaccessibility of the creative impulse. But while Hewitt is interested in the work of Caspar David Friedrich (among many others), rather than arguing for a return to the romantic model of the isolated artist, his work throws that notion into the tub along with significant doses of Kurt Schwitters's Merzbau. If anything, he

distills an alternative, possibly even dialectical, way of thinking about the artist's material working space. "I want it to be a sense of agency both in the perception of what's happening [and] in the action that's being taken," he says. *Seed Stage* is, then, a place of productive and perceptual mobility, addressed to "the very open relational possibilities between things, but also to the limits of reproduction and the anxieties of reproduction."

This evocation of limits and anxieties, as well as the recasting of the artist in terms of agency rather than pure creativity, is emblematic of a sea change in the conception of what takes place in an artist's studio. Where Gustave Courbet's 1855 painting *The Artist's Studio* showed, as the painter put it, "the whole world coming to me to be painted," a little over a hundred years later Courbet's equation between the world and its representation was revisited and thoroughly transformed in several signal pieces of what would come to be known as institutional critique. Perhaps most influential among these is Marcel Broodthaers's 1968 staging, in his Brussels apartment, of his *Musée d'Art Moderne, Département des Aigles, Section XIXe Siècle*, an extended tongue-in-cheek display of art-packing crates, postcards, and museum signage, all inaugurated by a press conference. In 1975 Broodthaers duplicated the apartment from memory in plywood at a one-to-one scale, inscribing it with words in place of objects. (This restaged "museum fiction," entitled *La salle blanche*, would become the template for, among many other contemporary projects, Rirkrit Tiravanija's various restaged live/work spaces.) The Belgian was not alone in this reconception of the studio. In 1962 the Swiss artist Daniel Spoerri had produced his *Topographie anécdotée du hasard*, a meticulous documentation of all the elements to be found on a table in room 13 of the Hotel Carcassonne in Paris, where he was then staying. Like Broodthaers, Spoerri revisited and revised this project in 1964 on a visit to New York, when he opened his room at the Chelsea Hotel to gallerygoers, who would find therein the clutter of everyday living alongside various of his signature "snare pictures" and assemblages. The conceptualist Edward Krasinski, whose signature mark of standard blue adhesive tape placed at a height of 130 centimeters elided Constructivism and Surrealism, worked on converting his Warsaw studio into a complex and living artwork from 1988 until his death in 2004, circumscribing the entirety of its space (save one small room) with blue tape. This act combined the order of high-end and even metaphysical geometric abstraction with the clutter of the everyday, from leftovers to sentimental tchotchkes to other works in progress. Like Spoerri's seaming of the lived, including leftover meals, and the displayed, or Broodthaers's various "domestications" of the museum, Krasinski's procedure linked his studio to his exhibitions by literally taping them together, via the blue strip of

"length unknown," as he put it, in a continuous line that began in the 1960s. His studio, on the eleventh floor of an Iron Curtain–era apartment block, has been preserved as the Avant-Garde Institute.

While the dominant legacy of these conceptual projects has been the "post-studio" explorations of artists like Renee Greene or Andrea Fraser, which take up the museum as a discursive site or, as with the ateliers of Olafur Eliasson or Erik van Lieshout, reconceive a studio practice in terms more akin to a think tank or design workshop, another direction, which is gaining momentum of late, is the exploitation of the studio as a generative space. These new and mostly process-based projects (such as Hewitt's) address with pointed obliquity the private exertions, the obscurity, and the sheer doggedness of creative work that those post-studio works have tended to skirt. Jean Silverthorne's 1999 installation at the Whitney Altria, *The Studio Stripped Bare, Again*, presented a one-to-one cast-rubber rendering of her studio space. In a 2009 show at the SculptureCenter in Queens, New York, artist Melanie Gilligan's *Prison for Objects*, a two-person performance that takes place between the scrap heap of a fictional artist's workspace and a fictional art critic's laptop asks directly and metaphorically about the dynamic of creative reproduction.

Installation is one way of bringing the studio into the museum, but large-screen projection and photography tend to be the mediums of choice. The ecology of the studio has been a topos in several stunning video projects. Bruce Nauman's *Mapping the Studio I (Fat Chance John Cage)* (2000) features an immersive four-screen projection of surveillance video of his rural studio in New Mexico, in which the nighttime predation of his studio cat, along with fleeting views of scurrying mice, perversely reiterates that "primordial" sense of things "being experienced"—in this case, the experience being the very tension of attention. Gillian Wearing's work with the vagrants who pass their days outside, and sometimes in, her working space, has yielded a number of monumental and desperate works, most importantly the rather horrifying large-screen triptych projection *Drunk* (2000), as well as a pendant photographic series. Hilary Lloyd's *Studio* (2007), takes up where Wearing's oddly wrenching critique of expressionism leaves off in exploring the stray marks left behind by the unknown abstract painter who previously inhabited her working space. This wall-scale video diptych literally tracks the creative residue of the absent artist, using the remnants of his process as visual scaffolding, while its exhaustive documentation of these expressive marks unravels the very premise of video documentary.

As spectacular as these projects are, and as voyeuristic their initial propositions, the surveillance strategies on which they rest present the promise

of a lapse into chaos—hence the need for the apparatus of discipline and control. The creepy banality of their fascination with the potentially disobedient other merely heightens, of course, our awareness of our own attractions to, filiations with, and rejections of disorder. Bringing these private and obsessive workspaces into the museum, if anything, posits a dysfunctional collaboration with the audience: we are voyeurs rather than relational participants, and the studio, whether the artist's or that of a fictional persona, is a generative but fundamentally opaque site. And yet—Courbet was right, somehow—we are implicated within it.

This makes for an interesting set of tensile gray areas, as the viewer's position oscillates between identification with and rejection of both artist and object. This is one of the most compelling issues raised by Corin Hewitt's project: Which fruit to eat, the luscious one made of Plasticine or the juicy organic one? Each time a lump of colored putty is returned to the color wheel, the base color moves further toward gray. Yet Hewitt demurs that his project is abjectly entropic: "Very few things to me seem abject." The operative term, more precisely, is "composting," the most alchemically poetic of biointensive processes. Indeed, the gray of *Seed Stage's* interior was derived from a vast mixology of annual colors (Martha Stewart pinks; Ralph Lauren beiges) "composted" into a "fertile gray," while other elements were pigmented in tonal ranges rather than in extremes. "I tried to get rid of polarities," Hewitt explains. "I was interested in the ways that grays and browns can be 'compost.'" *Seed Stage*, then, is an environment that curves back on itself, from the integration of the Whitney's Breuer profile to the absorption of photographic subject matter. Perhaps this notion of the studio as fragile ecosystem is one that encompasses the viewer also, so that, when encountering a work that closely approximates an artist's studio, he or she becomes activated by the creative process.

"Perception is a choice," says Hewitt.

...

Modern Painters *21, no. 2 (March 2009): 53–57.*

Lane Relyea
Studio Unbound

Nearly lost within the sprawling five-hundred-page catalog for the similarly sprawling 1999 exhibition "Laboratorium" (which "declared the whole city of Antwerp a lab")[1] are a few pages devoted to a reprint of Daniel Buren's 1971 essay "The Function of the Studio." It would stand to reason that curators Hans Ulrich Obrist and Barbara Vanderlinden included it for historical contrast, to differentiate between art world attitudes toward the studio then and now, except that contrasts, oppositions, distinctions, and any other means by which to order and determine thought were precisely what was annihilated by "Laboratorium"'s inclusive onslaught of information and programming. Whereas Buren helped shape the premises of institutional critique by speaking of artists' studios and exhibition sites as belonging to a system of "frames, envelopes, and limits," Obrist and Vanderlinden talked about "establishing ... networks, fluctuating between highly specialized work by scientists, artists, dancers and writers"; about "the laboratory within the museum, but also the question of the museum as a laboratory"; about the museum having "multiple identities"; and ultimately about "a creative blur between the making and the exhibiting of work."[2]

Buren's essay has continued on something like a revival tour up to the present, although more often than not it's cited precisely for the sense of historical irony it now provides. For example, in a recent issue of *Modern Painters* devoted to the studio, Judith Rodenbeck pitted Buren's characterization against the updated studio Corin Hewitt advanced in his Whitney Museum of American Art installation *Seed Stage* (2009).[3] In the museum's lobby gallery Hewitt constructed a fully functioning workspace, in which he spent his days not only crafting art but also cooking food, sometimes making sculptural replicas of his food, and photographing both food and art before sorting the two into containers to which were affixed the printed-out photos, even maintaining a compost bin in which worms and microbes digested both leftover meals and discarded printouts. Built as a room within a room, *Seed Stage* left a thin corridor for visitors to circumnavigate its

OVERLEAF
Corin Hewitt,
Seed Stage, 2008.

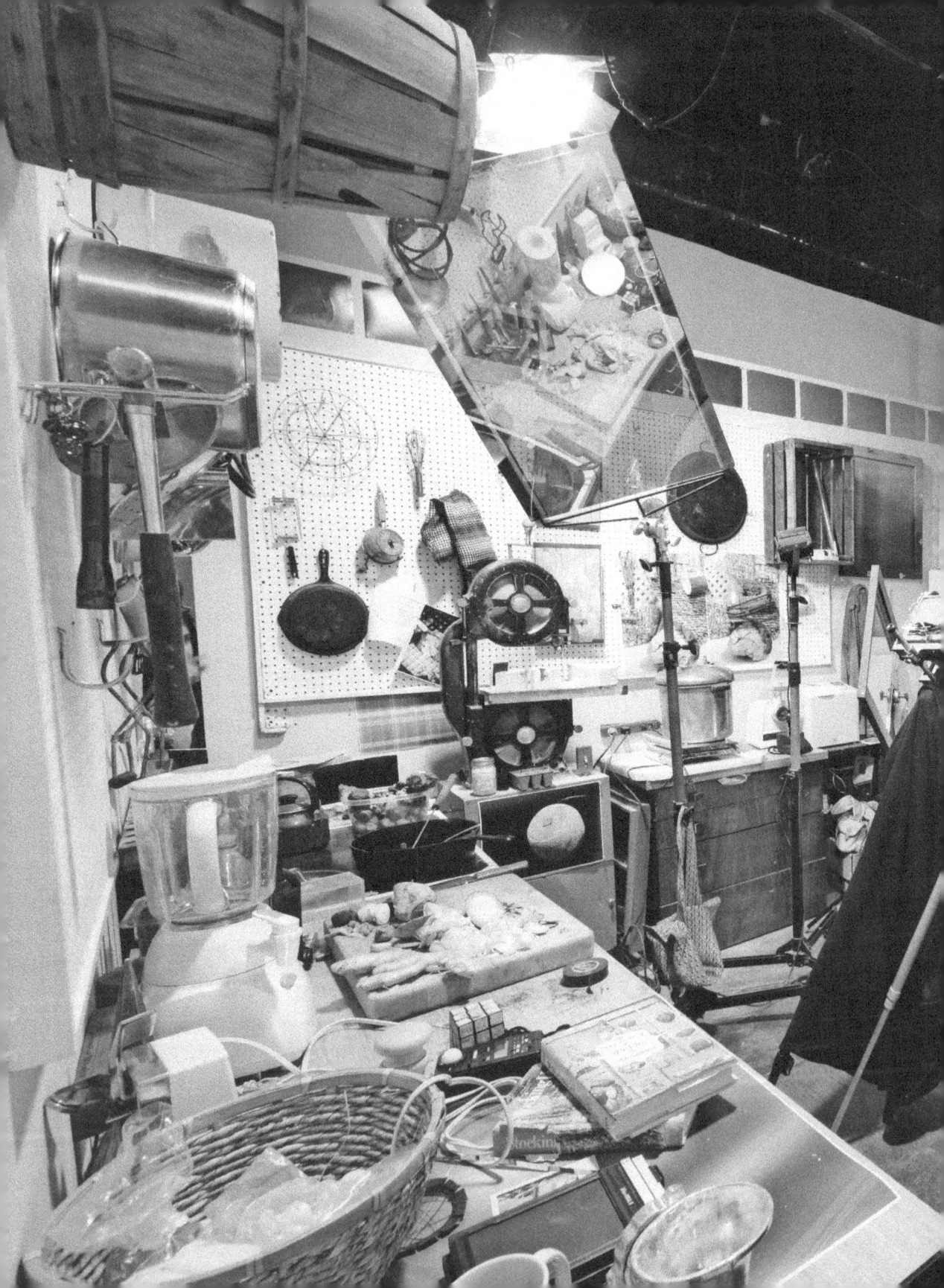

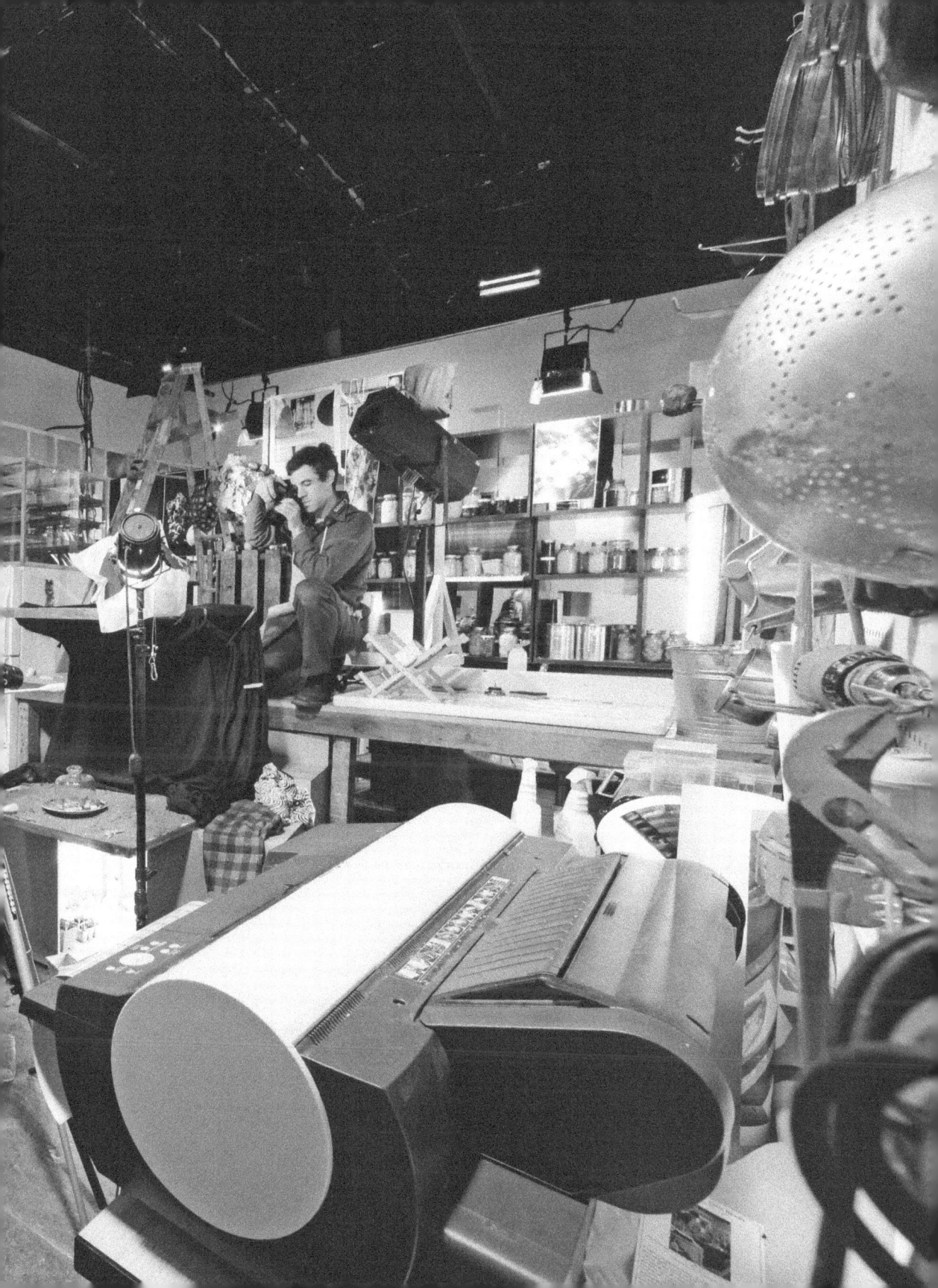

perimeter, from which they could either peer inward through narrow vertical openings at Hewitt busying himself or turn their gaze instead toward the few photographs he had selected to mat and frame and have hung on the outer gallery walls. Studio and museum, inside and outside, public and private, organic and inorganic, original and reproduction, production and consumption, art and life—all these former oppositions were eroded, made continuous, as if so many conjoined and provisional states traveled through in a process of relentless conversion and transcription, one stop after another on a directionless procedural itinerary, an endless circuitry within which any sense of ultimate reference, of a final relay or destination—like an answer to the question "What's the point?"—remained obscure at best. Like Jasper Johns's famous dictum—"Take an object. Do something to it. Do something else to it"—looped to infinity.

Claire Bishop has recently remarked on the channeling of resources into new project spaces and *kunsthallen* so as to accommodate just this kind of work, projects that are time-based, open-ended, and interactive, which Bishop claims "is essentially institutionalized studio activity"—the studio made into a showroom display, a tableau vivant.[4] Gone are the days of antagonism and stalemate between the artist's studio, with its presumed autonomy, and the recuperating museum, with its permanent collection representing "official" or canonical culture. Today studio and museum are superceded by more temporal, transient events, spaces of fluid interchange between objects, activities, and people. Exhibition venues increasingly rely on residencies and commissions, on more flexible approaches to display (Obrist, for example, has advanced the notion of the "evolutionary exhibition") and place greater emphasis on information, discussion, and gatherings (from the audio-tours, interactive data kiosks, and loungelike reading rooms that have become standard museum fare to the more elaborately arrayed assortments of publications and symposia that accompany the larger biennials and fairs). Commercial galleries are also known to host re-created artists' workspaces; think of Rirkrit Tiravanija's projects with 303 Gallery and Gavin Brown. In the March 2003 issue of *Text zur Kunst*, another theme issue about the studio, Bennett Simpson reviewed Gareth James's 1999 show at MWMWM Gallery in Williamsburg, in which the artist erected a makeshift bar out of some drywall and lumber and ornamented the results with beer bottles, art magazines, and unfinished or crumpled-up ink-on-paper drawings. Visitors drank, socialized, and graffitied the walls. This half-pub, half-studio was "like a threshold between private and public, actuality and potentiality, the individual and the social," Simpson writes, "a place where meanings, properties and behaviors fluctuate radically."[5]

So what is the function of this new kind of space? Much like when Buren

penned his essay, interest today focuses not only on the studio but on the art school and the international exhibition, all looked at in terms of their roles within a larger array of interlocking functions, each with its own scale and modality for activity and production and with its own capacities for input and output (some larger and more formal, some more intimate and everyday, all with different placement possibilities within the city). But this art world map or itinerary to which the studio belongs, braided within channels of connection, distribution, and circulation, now seems purely practical or technological, as if without political content. No longer does the studio appear as an ideological frame that mystifies production, a space where the realities of social or mass production are supposedly held at bay in favor of an antiquated craft model that showcases the individual artist's creative genius. And no longer is the studio seen as belonging to a "system" such as Buren described, as a space characterized by boxlike enclosures, of "frames and limits," each assigned a discreet place in some rigid, stable, and all-determining structure or order. What system or structure does exist today is more properly described as a *network*.

In contrast to enclosures, networks are characterized by what Gilles Deleuze has called "modulation, like a self-deforming cast that will continuously change from one moment to the other, or like a sieve whose mesh will transmute from point to point."[6] Along with the rise of networks comes a new ideology, one that advertises agency, practice, and everyday life. Networks are said to be inherently democratic and egalitarian, this because of their horizontal, multidirectional, and reciprocal capacity, the fact that, compared to more hierarchical forms of organization, in the network, it's relatively easy for any one node to communicate with any other. This means that the forces governing networks appear more quotidian, immanent, and dispersed, rather than concentrated in transcendent executive positions. By the same token, the characteristic flexibility and informality of network structures, the way they depend on the constant, relatively independent movement of their participating actors, is taken as evidence of diminished structure and greater agency. Thus networks are often championed for how they accommodate self-styled independent actors who, because their movements and decision-making are supposedly less embedded in and dictated by governing structure and context, are more loosely affiliated within a dispersed field. It's because of this kind of cosmopolitan character or effect of the network that people today can boast of being both insiders and do-it-yourselfers at the same time.

As with the larger network itself, what is thought to fill the studio today is technical or pragmatic, simply an artist's everyday practice. Hence the popularity of practical design, or folksy sculptural craft, or painting recon-

ceived as a daily studio practice. This turn to practice can be considered part of an ongoing repudiation of "theory" since the late 1980s, when art and criticism were supposedly preoccupied with consumer culture or spectacle or ideology—that is, with rigid, all-encompassing structure. Employed as theory's opposite term, practice is said to emphasize individual, concrete acts, their specific materiality and temporality, all of which are said to defy the sweeping, abstract, and static totalizations of dominant structures. A good example of this shift can be found in a recent string of sculpture surveys that shared several of the same artists—artists like Isa Genzken, Rachel Harrison, and Lara Schnitger. In her catalog essay for one of these shows, "The Uncertainty of Objects and Ideas," mounted by the Hirshhorn in 2006, curator Anne Ellegood writes that the reason such sculpture appears so attractive today is that it features "a mode of production rooted in the material and the physical"; it "give[s] us something tangible rather than streams of data." Such works "embody physical exertion and dirty hands; they are the evidence of actions—composing, building, constructing, stacking, bending, connecting and adorning."[7] The very title of a similar show mounted by the Hammer Museum a year earlier—"Thing"—makes obvious this preference for indexicality over lexicality. The catalog for "Thing" also included photographs of the participating artists' studios, as well as references to critic Libby Lumpkin's 1997 essay "The Redemption of Practice." And in the catalog for "Unmonumental," yet another look-alike exhibition, which the New Museum opened in 2007, cocurator Massimiliano Gioni refers to the last few years of art-making as inaugurating a "headless century"—another metaphor for today's sense of increasingly decentralized activity in the wake of ebbing dominant structure.[8] The Hirshhorn's Ellegood nodded in agreement: "These artists have found sculpture to be the most meaningful medium in which to explore and represent the complexity, rapidity, and ultimately the confusion of contemporary life ... the feeling that beliefs and meanings are continuously unmoored and in flux."

And yet what was put forward by these sculpture shows, despite their emphasis on the studio and on the individual fabrication of physical things, were not autonomous objects. The bricolaged everyday materials that constitute the work of Genzken, Harrison, et al., though personalized through hands-on artistic intervention, still remain opened out and available to larger communities and cultures, continuous and interwoven with larger systems of exchange. Their constituent parts are never so transformed as to lose their prior, independent identities; the results are conglomerations of heterogeneous, loosely related items—in short, object networks. But such work also never goes so far as to suggest installation. Instead each sculpture remains enough of an independent, mobile unit to dissociate itself from the

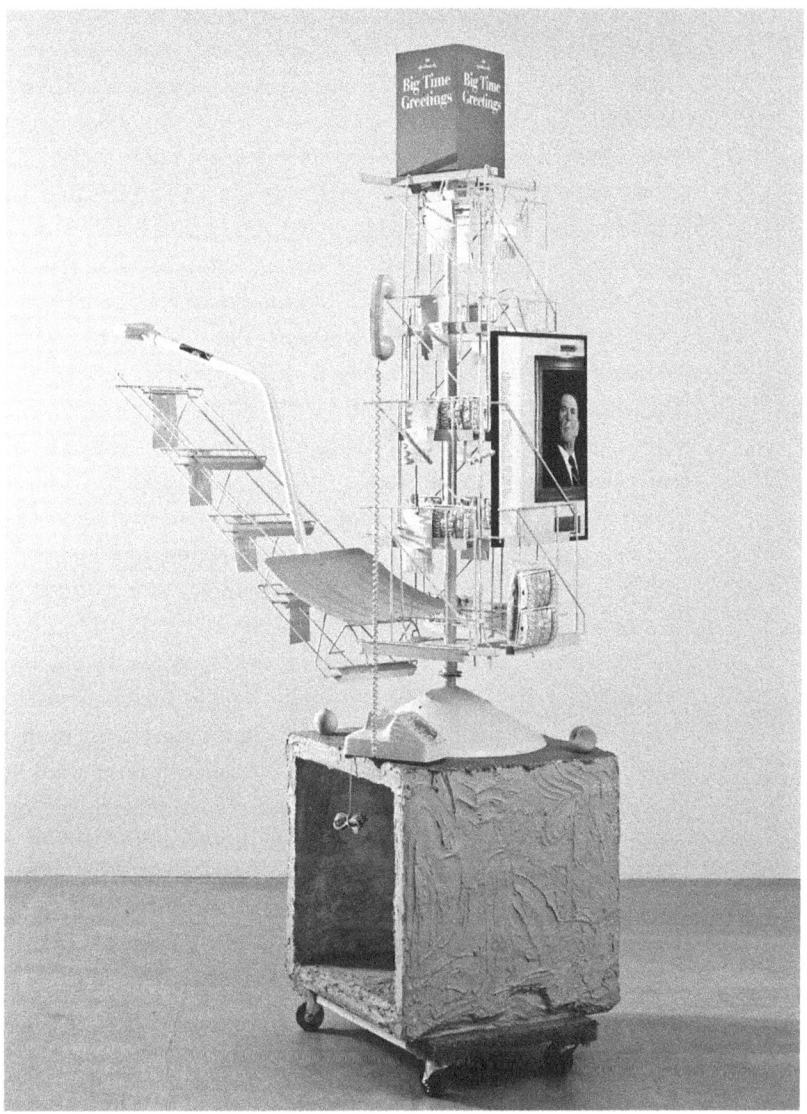

Rachel Harrison, *Nice Rack*, 2006.

fetters of contextualizing site and circumstance. The work is too internally diverse and intersected to be characterized as unified and consistent, and in its heterogeneity and flexibility it refuses to commit to just one identity. Nor, in its mobility, will it commit to staying in only one place.

In this way the new bricolaged sculpture demonstrates a striking continuity between studio and post-studio approaches, as both increasingly manifest themselves as "practices" that repurpose already existing objects,

sites, and discourses, the aim being to access and link various databases and platforms—maybe immaterial social acquaintances or information, maybe more material pop-culture inventories like old record collections or the intimately biographied yet anonymous cast-offs accumulated in thrift stores. Just as no single TV show or pop song is as hot today as the TiVo boxes and iPods that manage their organization, so too with art it is the ease and agility of access and navigation through and across data fields, sites, and projects that takes precedence over any singular, lone *objet*. And the new sculpture celebrated in shows like "Thing," "Unmonumental," and "The Uncertainty of Objects and Ideas" doesn't contradict this. It doesn't stand in defiance of network forces but rather proves their further extension by measuring how these forces have subsumed and changed the way we think about objects, have subsumed the very opposition between the single and multiple, the enclosed and interpenetrated.

Similarly changed are our notions of the solitary studio and the lone artist. Being part of a network that privileges itinerancy and circulation over fixity, that diminishes hierarchies and boundaries in favor of mobility and flexibility across a more open, extensive environment, also subordinates the studio and the individual practitioner to a general communicational demand, a decentralizing and integrative logic of interface and commensurability. Networks are both integrative and decentralizing in that they privilege casual or weak ties over formal commitments so as to heighten the possibility of chanced-upon links that lead outward from any one communicational nexus or group. Under such conditions both subjects and objects are obliged to shed not only pretences to autonomy but also long-term loyalties and identifications, and instead to become more mobile, promiscuous operators that mesh seamlessly with the system's mobile, promiscuous operations. Deleuze calls the new mobile creator who emerges in this transition from an industrial to information-based society a "dividual," someone who is not a "discontinuous producer" (making discreet objects one at a time) but is "undulatory, in orbit, in a continuous network."[9] Artists who are more "dividualistic" discover themselves not by securing a role within the historical narrative of a chosen medium but by integrating into a more diffuse ecology that involves not only making art but also putting on shows, publishing, and organizing events, teaching, networking, maybe belonging to one or more semicollectives, even adopting one or more pseudonyms. As the late Jason Rhoades, an early public exhibitor of the private studio, remarked in 1998, "Museum director, curator, collector, artist—none of that means anything anymore."[10]

Much the same goes for the studio. It no longer offers retreat. It's no longer, as in Buren's earlier analysis, "an ivory tower," no longer "unique," or

"private." The studio now integrates. It no longer defers or resists instrumentalization, no longer distances the artist from society, no longer holds out that kind of separate identity to the artist, one supposedly distilled from the privacy and depth of the sovereign individual who occupies it, just as the studio no longer identifies as separate and resistant or self-determining the artist's materials or medium or labor. Rather the studio is all exterior. It offers a purely negative difference premised on sameness, places the artist as a like item within an integrative inventory or database, gives the artist a mailing address and a doorstep, thus providing the means for one to show up within the network. The studio is now that place where we know we can always find the artist when we need to, where she or he is always plugged in and online, always accessible to and by an ever more integrated and ever more dispersed art world.

..

1 "A Rule Of The Game: A Talk with Hans Ulrich Obrist," *Edge* (June 5, 2008), http://www.edge.org/3rd_culture/obrist08/obrist08_index.html.

2 Hans Ulrich Obrist and Barbara Vanderlinden, eds., *Laboratorium* (Antwerp: DuMont, 2001), 17–21. This catalog contains a new translation of Buren's essay; for the first English translation of "The Function of the Studio," see *October* 10 (Fall 1979): 51–58.

3 Judith Rodenbeck, "Studio Visit," *Modern Painters* 21, no. 2 (March 2009): 52.

4 Claire Bishop, "Antagonism and Relational Aesthetics," *October* 110 (Fall 2004).

5 Bennett Simpson, "Can You Work as Fast as You Like to Think?" *Text zur Kunst* 49 (March 2003).

6 Gilles Deleuze, "Postscript on the Societies of Control," *October* 59 (Winter 1992): 4.

7 Anne Ellegood, *The Uncertainty of Objects and Ideas* (Washington, DC: Hirshhorn Museum and Sculpture Garden, 2006), 19.

8 Massimiliano Gioni, "Ask the Dust," in *Unmonumental: The Object in the 21st Century*, ed. Richard Flood, Laura Hoptman, and Massimiliano Gioni (London: Phaidon, 2007), 65.

9 Deleuze, "Postscript," 5–6.

10 "A Thousand Words: Jason Rhoades Talks about His Impala Project," *Artforum* 37, no. 1 (September 1998): 135.

CONTRIBUTORS

Glenn Adamson is deputy head of research and head of graduate studies at the Victoria and Albert Museum, where he leads a graduate program in the history of design. He is coeditor of the triannual *Journal of Modern Craft* and the author of *Thinking through Craft* and *The Craft Reader*. His other publications include *Industrial Strength Design: How Brooks Stevens Shaped Your World* and *Gord Peteran: Furniture Meets Its Maker*. Presently he is working on an exhibition about postmodernism, to be held at the Victoria and Albert in 2011.

Svetlana Alpers is professor emerita of the history of art, University of California, Berkeley, and visiting scholar in the Department of Fine Arts, New York University. Her books include *The Art of Describing: Dutch Art in the Seventeenth Century*, *Rembrandt's Enterprise: the Studio and the Market*, *The Making of Rubens*, *The Vexations of Art: Velázquez and Others*, and, with Michael Baxandall, *Tiepolo and the Pictorial Intelligence*. As an artist, she collaborated with James Hyde and Barney Kulok on a series of photographic prints entitled *Painting Then for Now*.

Art & Language, a collective of conceptual artists with shifting membership, was founded in the late 1960s and in 1968 launched the journal *Art-Language*. Currently the group comprises Michael Baldwin, Mel Ramsden, and Charles Harrison. Art & Language has exhibited in three installments of Documenta, the 1976 Venice Biennale, and many other solo and group exhibitions. Books on Art & Language include Charles Harrison's *Essays on Art & Language* and *Conceptual Art and Painting: Further Essays on Art & Language*, Michael Corris's *Conceptual Art*, and Anne Rorimer's *New Art in the 60s and 70s: Redefining Reality*.

John Baldessari was born in National City, California; studied at San Diego State University, Otis Art Institute, Chouinard Art Institute, and the University of California, Berkeley; and taught at the California Institute of the Arts (1970–1988) and the University of California, Los Angeles (1996–2007). His artwork has been featured in more than two hundred solo exhibitions and nine hundred group exhibitions in the United States and Europe. Recent projects include books, films, and a curatorial project at the Smithsonian Hirshhorn Museum, Washington, DC. The latest of many retrospectives opened at the Tate Modern, London, in 2009 and travels to the Museu d'Art Contemporani de Barcelona, the Los Angeles County Museum of Art, and the Metropolitan Museum of Art, New York, in 2010–2011.

Alice Bellony-Rewald, born in West Africa, was raised and studied in France. While living in the United States with her husband, the American art historian John Rewald, she translated Rewald's book *The Post-Impressionism* and was a correspondent for French-language newspapers in France and Switzerland. During the late 1960s and early 1970s, she interviewed many notable American artists, from Duchamp to Warhol, for the Voice of America. Back in France, Bellony-Rewald published *The Lost World of the Impressionists*, cowritten with Michael Peppiatt, and several memoirs, including *Une soirée avec Giacometti et Avec Balthus à la villa Medicis*.

Mary Bergstein is professor and chair of the History of Art + Visual Culture Department at the Rhode Island School of Design. Her publications on Renaissance sculpture and Florentine history include *The Sculpture of Nanni di Banco*. Bergstein's cross-disciplinary writings on photography, psychoanalysis, and the arts are also published widely. Her most recent book is *Mirrors of Memory: Freud, Photography, and the History of Art*.

Walead Beshty, born in 1976 in London, is an artist and writer living in Los Angeles and associate professor at Art Center College of Design. He is a regular contributor to *Texte zur Kunst* and *Afterall*. Beshty's work has been exhibited internationally, with solo exhibitions at Thomas Dane Gallery, London; the Hirshhorn Museum and Sculpture Garden, Washington, DC; the University of Michigan Museum of Art, Ann Arbor; Wallspace, New York; Galerie Rodolphe Janssen, Brussels; the Hammer Museum, Los Angeles; and P.S.1/MoMA Contemporary Art Center, New York. His work is included in many public collections including the Museum of Modern Art, Solomon R. Guggenheim Museum, and Whitney Museum of American Art, New York; the Museum of Contemporary Art, Chicago; the Hammer Museum, Los Angeles; and the Victoria and Albert Museum, London.

Andrea Bowers is an artist who lives, works, and teaches in Los Angeles. She earned her MFA from the California Institute of the Arts and is a 2008 United States Broad Fellow and a 2009 Louis Comfort Tiffany Foundation grant recipient. She is represented by Susanne Vielmetter Los Angeles Projects; Andrea Kreps Gallery, New York; Galerie Mehdi Chouakri, Berlin; Galerie Praz Delavallade, Paris; and Van Horn, Düsseldorf.

Daniel Buren was born in 1938, in Boulogne-Billancourt, France. He lives and works in situ.

Rochelle Feinstein lives and works in New York and has exhibited her works internationally. A painter whose work is known to cross media, she has been professor of painting and printmaking at the School of Art, Yale University since 1995. In 2008, she had solo exhibitions at Art Production Fund LAB Space, New York; Momenta Art, Brooklyn; and The Suburban, Oak Park, Illinois.

David J. Getsy is the Goldabelle McComb Finn Distinguished Chair in Art History and associate professor at the School of the Art Institute of Chicago. His research focuses on European and American art from the late nineteenth century to the present. He is the author of *Body Doubles: Sculpture in Britain, 1877–1905* and the forthcoming *Rodin: Sex and the Making of Modern Sculpture*, and the editor of *Sculpture and the Pursuit of a Modern Ideal in Britain, c. 1880–1930* and the forthcoming anthology *From Diversion*

to *Subversion: Games, Play, and Twentieth-Century Art*. Other publications include essays on Harry Bates, John Chamberlain, Henri Gaudier-Brzeska, Alberto Giacometti, Ernesto Pujol, and David Smith.

Michelle Grabner is an artist who has exhibited widely in the United States and Europe; a writer whose work has appeared in *Artforum, Modern Painters, Frieze, X-tra, Art Press, Teme Celeste,* and other journals; and the founder and director of The Suburban, an artist-run project space in Oak Park, Illinois. *Can I Come Over to Your House*, a catalog with essays by Grabner and Michael Newman, marks the gallery's tenth anniversary. She has taught at the University of Wisconsin–Madison, Cranbrook Academy of Art, and the Yale Norfolk Program. She is currently professor and chair of the Painting and Drawing Department at the School of the Art Institute of Chicago.

Rodney Graham was born in 1949 in Vancouver, where he continues to live and work. As a conceptual artist exploring the human experience, he has worked in many mediums and is particularly fascinated by the optics of light and seeing. The camera obscura has become the focus of much of his work in photography, with its inverted imagery serving as a personal metaphor for the modern world. Graham's work can be found in major private and public collections, including the Museum of Modern Art, New York; the National Gallery of Canada; and the Van Abbe Museum, the Netherlands. Among his many honors was being selected to represent Canada in the Venice Biennale in 1997.

Amy Granat makes work that combines film, sound, performance, photography, and installation through distinctly poetic and formal juxtapositions. Drawing inspiration from early cinema, noise music, abstract painting, and beat literature, she simultaneously embraces and reflects on the culture of the avant garde. Solo exhibitions of her work have been held at P.S.1 Museum of Contemporary Art, New York; the Kitchen, New York; Eva Presenhuber Galerie, Zurich; and Le Confort Moderne, Poitiers. She has also been featured in numerous group exhibitions. She lives and works in New York.

Karl Haendel received a BA from Brown University in 1998 and a MFA from the University of California, Los Angeles in 2003. He also studied at the Whitney Museum Independent Study Program and the Skowhegan School of Painting and Sculpture. His work has been included in group exhibitions at the Museum of Modern Art, New York, the Whitney Museum of American Art, New York; the Astrup Fearnley Museum of Modern Art, Oslo; and Serpentine Gallery, London. In 2006 he was the subject of a solo exhibition at the Museum of Contemporary Art, Los Angeles. He is represented by Susanne Vielmetter Los Angeles Projects and Harris Lieberman, New York.

Rachel Harrison was born in 1966 in New York, where she currently lives and works. Recent solo exhibitions have taken place at Portikus, Frankfurt; the Hessel Museum of Art, Bard College; Galerie Meyer Kainer, Vienna; Le Consortium, Dijon; Migros Museum für Gegenwartskunst, Zurich; Kunsthalle Nürnberg; and Greene Naftali Gallery, New York. She participated in the Venice Biennale (2003, 2009); the Tate Triennial, London (2009); and the Whitney Biennial, New York (2002, 2008), among other group exhibitions.

Lynn Lester Hershman is an artist and filmmaker who pioneered the use of new technologies in her investigations of identity in a time of consumerism and privacy in an

era of surveillance, interfacing of humans and machines, and the relation between real and virtual worlds. Her three feature films—*Strange Culture, Teknolust*, and *Conceiving Ada*—have been part of the Sundance and Berlin International Film Festivals. A Guggenheim Fellowship is supporting her forthcoming documentary *Women Art Revolution: The Turbulent and (Formerly) Secret History of the Feminist Art Movement, 1968-2009*. In 2004 Stanford University Libraries acquired her working archive, and *Secret Agents Private I: The Art and Films of Lynn Hershman Leeson* was published by the University of California Press (2005). She lives and works in San Francisco, where she is chair of the Film Department at the San Francisco Art Institute.

Mary Jane Jacob is a professor in the Department of Sculpture and executive director of Exhibitions and Exhibition Studies at the School of the Art Institute of Chicago. Once chief curator of the Museums of Contemporary Art in Chicago and Los Angeles, she has shifted her workplace from the museum to the street, critically engaging the discourse around public space, organizing such site and community-based programs as "Places with a Past" in Charleston, "Culture in Action" in Chicago, and "Conversations at the Castle" in Atlanta. Her books include *Buddha Mind in Contemporary Art* (2004) and *Learning Mind: Experience into Art* (2009), both coedited with Jacquelynn Baas. In 2010 she was awarded the Women's Caucus for Art Lifetime Achievement Award and the Award for Achievement in the Field of Public Art from Public Art Dialogue.

Caroline A. Jones studies modern and contemporary art, with a focus on its technological modes of production, distribution, and reception. Professor of art history and director of the History, Theory, Criticism program in the Department of Architecture at the Massachusettes Institute of Technology, she has also worked as an essayist and curator, most recently with MIT's List Visual Art Center on *Video Trajectories* (2007) and *Hans Haacke 1967* (2011). Her exhibitions and films have been shown at the Museum of Modern Art, New York; the San Francisco Museum of Modern Art; the Hirshhorn Museum and Sculpture Garden, Washington, DC; and the Hara Museum, Tokyo; among other venues. She is the author of *Eyesight Alone* and *Machine in the Studio*, editor of *Sensorium*, and coeditor of *Picturing Science, Producing Art*. Her next book, *Desires for the World Picture: The Global Work of Art*, investigates the place of art in world's fairs, national pavilions, and biennial culture.

Kimsooja is a Korean-born artist based in New York. Her work, incorporating mediums ranging from fabric to video to performance, has been exhibited internationally and featured in numerous solo and group shows, including biennales in Kwangju (1995), São Paolo (1998), New York (Whitney Biennial, 2002), Busan (2002), Sydney (1998), Istanbul (1997), Lyon (2000), Valencia (2003), and Venice (1999, 2005). Recent solo exhibitions have been held at the Crystal Palace, Reina Sophia, Madrid; La Fenice, Venice; Kunsthalle Wien; P.S.1/MoMA Contemporary Art Center, New York; Kunsthalle Bern; Rodin Gallery, Seoul; and InterCommunication Center, Tokyo.

Suzanne Lacy is an artist and writer whose work includes large-scale public performances and installations, photos, videos, and texts on issues of social equity and art. She exhibits internationally and is the subject of a new book by Sharon Irish, *Suzanne Lacy: Spaces Between*. A proponent of audience engagement and artists' roles in shap-

ing public agendas, Lacy's early practice foreshadowed many themes in current debates on relational, research-based, and publicly sited practices. In 1995 she edited *Mapping the Terrain: New Genre Public Art*, and some of her many published essays will be included in the forthcoming book *Leaving Art: Performances, Politics and Publics, The Collected Essays of Suzanne Lacy*. Lacy is chair of the Master's in Fine Arts: Public Practices at Otis College of Art and Design.

Thomas Lawson, an artist with a diverse, project-driven output, has been showing paintings and developing temporary public works internationally since the late 1970s. From 1979 to 1992 he published and edited, with Susan Morgan, *REAL LIFE Magazine*. His essays have appeared in various journals and exhibition catalogs. A book of selected writings, *Mining for Gold*, was published by JRP/Ringier Kunstverlag (2004), and Primary Information released an anthology of *REAL LIFE Magazine* (2007). He recently mounted shows at David Kordansky Gallery, Los Angeles, and Participant Inc., New York, and has been included in surveys of the 1980s at the Metropolitan Museum, New York, and Magasin Grenoble.

Shana Lutker is a Los Angeles–based artist who had solo exhibitions at Susanne Vielmetter Los Angeles Projects; The Suburban, Oak Park, Illinois; Room Gallery, University of California, Irvine; Artists Space, New York; and Wetterling Gallery, Stockholm. Her work was included in the 2008 and 2006 California Biennials and recent group exhibitions at Massachusetts Museum of Contemporary Art; the Tang Museum, Saratoga Springs, New York; the CCA Wattis Institute for Contemporary Arts, San Francisco; and Harris Lieberman and D'Amelio Terras galleries, New York. She received her MFA from the University of California, Los Angeles, and is managing editor of *X-tra* magazine.

Annika Marie is assistant professor of art history in the Art + Design Department at Columbia College Chicago. She has written art criticism for publications including *Art issues* and *X-tra* and is working on a manuscript titled *The Most Radical: Working towards a Materialist Aesthetic in Harold Rosenberg, Barnett Newman, and Ad Reinhardt*.

Courtney J. Martin, a Chancellor's Postdoctoral Fellow in the History of Art at the University of California at Berkeley, completed her doctorate at Yale University in twentieth-century British art. Previously, she was a fellow at the Getty Research Institute and at the Henry Moore Institute; before entering Yale, she served as interim head curator at the Cold Spring Harbor Whaling Museum, Cold Spring Harbor, New York, and worked in the media, arts, and culture unit of the Ford Foundation on an international, sustainable arts portfolio. She has served as a consultant for the Ford Foundation in the areas of arts education and cultural reorganization in the Gulf region. Martin has also written for *Art Asia Pacific*, *Art Papers*, *Contemporary*, *Flashart*, *Frieze*, and *NKA* and is a regular contributor to Artforum.com.

Carrie Moyer is a Brooklyn-based painter and writer. She founded the ongoing lesbian public art project *Dyke Action Machine!* with photographer Sue Schaffner in 1991. Her paintings and public art projects have been widely exhibited in museums and galleries, both nationally and internationally. Her writings appear regularly in *Art in America*,

Modern Painters, and *Brooklyn Rail*, among other journals. In 2009 Moyer received the Anonymous Was a Woman Award and the Joan Mitchell Grant. Her work is represented by Canada Gallery, New York. Moyer is assistant professor and graduate coordinator of the painting department at the Rhode Island School of Design.

Bruce Nauman was born in 1941 in Fort Wayne, Indiana. His practice spans a wide range of media, including sculpture, photography, neon, sound installation, multichannel video, performance, and drawing. He first garnered critical attention with exhibitions in California soon after completing his MFA in 1966; in 1968 he made his solo debut at Leo Castelli Gallery, New York. His first major survey was coorganized by the Los Angeles County Museum of Art and the Whitney Museum of American Art in 1972. Subsequent museum exhibitions have continued to map his practice. In 2009 Nauman represented the United States at the 53rd Venice Biennale. He resides in New Mexico, where he works alongside his wife, the painter Susan Rothenberg.

Michael Peppiatt graduated from Cambridge University in 1964 and became an art critic for the *Observer* in London. Moving to Paris in 1966, he worked as arts editor at *Le Monde* and various other publications before relaunching *Art International* magazine. After returning to London with his wife and children in 1994, he published *Francis Bacon: Anatomy of an Enigma*, which was named a *New York Times* Book of the Year. Peppiatt has organized numerous exhibitions, notably of Bacon, Giacometti, and Tàpies. Awarded a doctorate by Cambridge University for his published work, Peppiatt continues to write and lecture widely on modern art.

David Reed is an artist, born in 1946 in San Diego, California. He moved to Lower Manhattan in 1971, where he continues to live and work. Since 1976 he has been represented by Max Protetch Gallery, New York. Recently he has also exhibited works on paper at Peter Blum Gallery, New York. His work has been shown nationally and internationally in museums and galleries. Recent publications include *Rock Paper Scissors* (Kienbaum Artists' Books) and the catalog of the exhibition *David Reed, Lives of Paintings* at his alma mater, Reed College.

Lane Relyea is associate professor in the Department of Art Theory and Practice at Northwestern University. His writing has appeared in *Art Journal, Art in America, Artforum, Afterall, Frieze*, and *Parkett*. He has published monographs on Polly Apfelbaum, Richard Artschwager, Jeremy Blake, Vija Celmins, Toba Khedoori, Monique Prieto, and Wolfgang Tillmans, among others, and contributed to such exhibition catalogs as *Helter Skelter* and *Public Offerings*. He has delivered lectures at New York's Museum of Modern Art, Harvard University, and the Art Institute of Chicago. His book *D.I.Y. Culture Industry* is forthcoming from MIT Press.

David Robbins has had three dozen solo exhibitions of his work in the United States and Europe. His work has been included in numerous group exhibitions, most recently at the Tate Modern, London. A book of his collected essays and interviews, *The Velvet Grind*, was published by JRP/Ringier Kunstverlag (2006). He currently lives in Milwaukee.

Judith Rodenbeck holds the Noble Foundation Chair in Art and Cultural History at Sarah Lawrence College, where she teaches modern and contemporary art. Her writ-

ing on contemporary art has appeared in magazines such as *Grey Room*, *Artforum*, and *Modern Painters*, and she served as editor in chief of *Art Journal* from 2007 to 2009. Author of numerous catalog essays on the neo-avant-garde, she is coauthor (with Benjamin Buchloh) of *Experiments in the Everyday: Allan Kaprow and Robert Watts—events, objects, documents* (2000). Her book *Radical Prototypes: Allan Kaprow and the Invention of Happenings* will be published by MIT Press (2010).

Joe Scanlan is an artist and writer living in New York and director of the Visual Arts Program at Princeton University. "Passing Through," an exhibition with an accompanying monograph, was mounted in 2008 by the Kunstsammlung Nordrhein-Westfalen, Düsseldorf. He is represented by Galerie Martin Janda, Vienna; Galerie Micheline Szwajcer-Tob, Antwerp; and Chez Valentin, Paris. Scanlan is a frequent contributor to *Artforum*, *Frieze*, and the website thingsthatfall.com. He is also the publisher of Commerce Books, an ongoing series of books, media, and Internet publications dedicated to economically motivated works of art.

Brenda Schmahmann is professor of art history and visual culture at Rhodes University in South Africa. Her work from the last decade has addressed issues of gender, with particular focus on works by contemporary women artists in South Africa. In addition to articles in various journals and essays in exhibition catalogs, her publications include *Material Matters*, *Mapula: Embroidery and Empowerment in the Winterveld*, and *Through the Looking Glass: Representations of Self by South African Women Artists*, for which she won the Rhodes Vice Chancellor's Book Award. She and Marion Arnold coedited *Between Union and Liberation: Women Artists in South Africa 1910-1994*.

Carolee Schneemann is a multidisciplinary artist whose video, film, painting, photography, performance art, and installation works have been shown at the Los Angeles Museum of Contemporary Art and the New Museum of Contemporary Art, New York, as well as in Europe. A new multichannel video was presented at the Tate Liverpool's "Abandon Normal Devices" festival (2009). *Imaging Her Erotics—Essays, Interviews, Projects* was published by MIT Press (2002); *Correspondence Course*, edited by Kristine Stiles, will be issued by Duke University Press (2010). Previous books include *More Than Meat Joy: Complete Performance Work and Selected Writing* (1979, 1997).

Barry Schwabsky is an American art critic and poet living in London. He writes regularly for *The Nation* and for *Artforum*, where he is also coeditor of international reviews. His books include *The Widening Circle: Consequences of Modernism in Contemporary Art* and *Vitamin P: New Perspectives in Painting*, and he has contributed to books and catalogs on artists, including Henri Matisse, Alighiero Boetti, Jessica Stockholder, and Gillian Wearing.

Katy Siegel is associate professor at Hunter College, City University of New York, editor in chief of *Art Journal*, and a contributing editor at *Artforum*. She is a coauthor of *Art Works: Money* and the author of *"Since '45": The American Condition and Contemporary Art*. She has written extensively on contemporary art, including artists Richard Tuttle, Jeff Koons, Dana Schutz, Takashi Murakami, Rineke Dijkstra, David Reed, Fabian Marcaccio, Lisa Yuskavage, Mark Bradford, and Bernard Frize and subjects such as the collector, youth, and the public. In 2006, she curated *High Times, Hard Times: New York Painting, 1967–1975* and edited the accompanying catalog.

Howard Singerman is the author of *Art Subjects: Making Artists in the American University* and the forthcoming *Art History, After Sherrie Levine*. He has contributed to numerous museum catalogs, including *Public Offerings* (2001), *A Forest of Signs: Art in the Crisis of Representation* (1989), and *Allan Ruppersberg: The Secret of Life and Death* (1985), all from the Museum of Contemporary Art, Los Angeles, where he was museum editor from 1985 to 1989. Singerman has published criticism in *Artforum*, *Parkett*, *Emergences*, *La Part de l'Oeil*, *October*, and the *Oxford Art Journal*, and teaches at the University of Virginia.

Michael Smith is a performance/video/installation artist who has shown his work extensively in the United States and Europe at museums, galleries, universities, festivals, and nightclubs, on television, and in the streets. His awards include the Louis Comfort Tiffany Foundation Grant and fellowships from the New York Foundation for the Arts, the National Endowment for the Arts, and the Guggenheim Foundation. Smith received his BA from Colorado College and attended the Whitney Museum Independent Study Program. Currently he is an associate professor at the University of Texas, Austin, and splits his time between Austin and Brooklyn.

Buzz Spector is an artist and writer whose art makes frequent use of the book, as both subject and object, and who is concerned with relationships between public history, individual memory, and perception. His art criticism has been published in *Artforum*, *Art Issues*, *Art on Paper*, *New Art Examiner*, and other magazines and journals. A survey of Spector's recent work with handmade paper opened at the Urban Institute for Contemporary Arts, Grand Rapids, Michigan, in December 2008. Spector is dean of the College and Graduate School of Art in the Sam Fox School of Design and Visual Arts at Washington University.

Frances Stark is an artist and writer living in Los Angeles, where she is assistant professor of painting and drawing in the Roski School of Fine Art at the University of Southern California. She is the author of the short book *The Architect & The Housewife* which explores, among other things, Daniel Buren's essay "The Function of the Studio," and of *Collected Writing: 1993–2003* and *Frances Stark: Collected Works*. She has had survey exhibitions at Nottingham Contemporary; Center for Contemporary Art, Glasgow; Stedelijk Van Abbemuseum, Eindhoven; Fonds Régional d'Art Contemporain (FRAC) Bourgone, Dijon; and Culturgest, Lisbon. She has also had solo exhibitions at the Secession, Vienna; Portikus, Frankfurt; the Hammer Museum, Los Angeles; and Kunstverein, Munich.

Robert Storr is an artist, critic, and curator who currently serves as the dean of the Yale University School of Art. Previously he was a curator and then senior curator in the Department of Painting and Sculpture at the Museum of Modern Art, New York (1990–2002), and the first Rosalie Solow Professor of Modern Art at the Institute of Fine Arts, New York University (2002–2006). Mr. Storr has also taught at the Graduate Center, City University of New York; the University of Texas, Austin; Harvard University; the Maryland Institute College of Art; the Rhode Island School of Design; and the New York Studio School. In 2007 he was director of the Venice Biennale.

Charline von Heyl was born in 1960 in Germany and has been living and working in New York since 1996. She has taught as an adjunct professor at Columbia University

and Yale University. She has had solo shows at the Secession, Vienna; Dallas Museum of Art; and Consortium, Dijon, with another upcoming at the Institute of Contemporary Art, Philadelphia. From 1990 to 1993 she exhibited at Christian Nagel Gallery and subsequently at Borgmann/Capitain Gallery, both in Cologne. Currently she is represented by 1301PE, Los Angeles; Gisela Capitain Gallery, Cologne; and Friedrich Petzel Gallery, New York.

Marjorie Welish has had recent shows in New York, Chicago, and Philadelphia, as well as at the Miami University Art Museum, Oxford, Ohio. She was included in a group show at the Museo de Arte Contemporáneo Esteban Vicente, Segovia, Spain. Welish is the recipient of grants and fellowships from the Adolph and Esther Gottlieb Foundation, the Trust for Mutual Understanding, and the Pollock-Krasner Foundation, among others; in 2007 she received a Fulbright Senior Specialist Fellowship to teach at the University of Frankfurt, where she also worked in collaboration with James Siena on *Oaths? Questions?*, a limited-edition art book. *Of the Diagram: The Work of Marjorie Welish* is a compilation of papers given at a conference held at the University of Pennsylvania in 2002 devoted to her writing and art. Her art criticism is collected in *Signifying Art: Essays on Art after 1960*, and Welish writes regularly for *Art Monthly* and *Bomb* magazine.

James Welling works in the intersection of photography and photographic technology. Originally associated with the Pictures Generation in the early 1980s in New York, Welling worked and exhibited extensively in Europe in the late 1980s and early 1990s. In 1995 he joined the Department of Art at the University of California, Los Angeles. His recent photographs investigate architecture, color, sculpture, and landscape. His book *Light Sources* was recently published by steidlMACK.

Brian Winkenweder is associate professor of art history and chair of the Department of Art and Visual Culture at Linfield College. He has contributed essays to such journals as *Art Criticism*, *Reconstructions*, and *Limina*. He recently published *Reading Wittgenstein: Robert Morris's Art-as-Philosophy* and is coeditor of *Dialectical Conversions: Donald Kuspit's Art Criticism*. Winkenweder's research focuses on intersections between philosophy, literary theory, and artistic praxis with an emphasis on word/image interactions. He is completing a manuscript that examines the myth of "Action Painting" by disentangling the braid linking Harold Rosenberg to Hans Namuth's photographs of Jackson Pollock's studio activity.

Jon Wood is an art historian and curator specializing in twentieth-century and contemporary sculpture, with a particular interest in the sculptor's studio. He has recently published essays on the studios of Brancusi, Moore, Picasso, and Giacometti. He studied at the Courtauld Institute of Art and now works at the Henry Moore Institute, Leeds, England, where he coordinates the academic research program and curates exhibitions. He is also a lecturer at Leeds University. Recent publications include *Articulate Objects: Voice, Sculpture, and Performance* (with Aura Satz), *Against Nature: The Hybrid Forms of Modern Sculpture*, *Modern Sculpture Reader* (with Alex Potts and David Hulks), *With Hidden Noise: Sculpture, Video and Ventriloquism*, and *Close Encounters: The Sculptor's Studio in the Age of the Camera*.

ILLUSTRATION CREDITS

xii Seurat, *Models*. Oil on canvas, 78¾ × 98⅜ in. (200 × 249.9 cm). BF811, Main Gallery. © 2009. Photo reproduced with permission of the Barnes Foundation.

xiv Keegan, *Work from Home*. Courtesy of the artist and D'Amelio Terras, New York.

3 Gericault, *Portrait of an Artist in His Studio*. Oil on canvas. Collection of the Louvre, Paris, France/Lauros/Giraudon. Courtesy of the Bridgeman Art Library.

3 Wright Home and Studio, drafting room. Frank Lloyd Wright, architect. Collection of Frank Lloyd Wright Preservation Trust. Photo: Jon Miller, Hedrich-Blessing.

9 Albers in his studio. © 2009 Estate of Rudy Burckhardt/Artist Rights Society (ARS), New York.

10 Fischli/Weiss, *In the Studio II*. Hand-carved polyurethane and acrylic paint. 9 × 35⅝ × 29½ in. © Peter Fischli/David Weiss. Courtesy Matthew Marks Gallery, New York.

11, 12–13 Ross-Ho, studio and *Frauds for an Inside Job*. Courtesy Cherry and Martin, Los Angeles; Mitchell Innes and Nash, New York. Photos: Robert Wedemeyer, Los Angeles.

19, 20 Spector studio. Courtesy of the artist. Photo: Lindsey Glover.

22 Feinstein, *Before and After*. Courtesy of the artist.

25 Lutker studio. Courtesy of the artist.

29 Smith, *A Typical Day*. Courtesy of the artist. Photo and layout: Lindsey Dorr-Niro.

34–35 Baldessari studio. Courtesy of the artist. Photo © Gautier Deblonde.

41 Evergood, *Nude by the El*. Oil on canvas. Collection Hirshhorn Museum and Sculpture Garden, Smithsonian Institution, Gift of the Joseph H. Hirshhorn Foundation, 1966. Photo: Lee Stalsworth.

44 Nauman, *Failing to Levitate in My Studio*. Photo, 20 × 24 in. Courtesy of the artist, Donald Young Gallery, Chicago, and Sperone Westwater, New York. © 2008 Bruce Nauman/Artists Rights Society (ARS), New York.

47 Stark in her studio. Courtesy of the artist. Photo: Karin Gulbran.

51 De Kooning in his studio. Courtesy Center for Creative Photography, University of Arizona, and the Willem de Kooning Foundation/Artists Rights Society (ARS), New York. © 1991 Hans Namuth Estate.

54 Chamberlain studio. Courtesy Pace-Wildenstein, New York. Courtesy John Chamberlain/Artists Rights Society (ARS), New York. Photo © Peter Foe, Fotoworks.

57 Martin. Courtesy PaceWildenstein, New York. © 2009 Agnes Martin/Artists Rights Society (ARS), New York. Photo: Charles S. Ruston.

63–67 Nauman, *Setting a Good Corner*. Video stills, single-channel video transferred to DVD, 59:30 minutes. Courtesy

Donald Young Gallery, Chicago. © 2009 Bruce Nauman/Artist Rights Society (ARS), New York.

77 Smith at work on *Canopic Head*. © Estate of David Smith/Licensed by VAGA, New York, NY. Photo: David Smith.

82 Steindorf, *In Action*. Video still. Courtesy of the artist.

86 Kimsooja, *An Album: Hudson Guild*. Courtesy Kimsooja Studio. © Kimsooja 2009. Photo: Jaeho Chong.

90 Hsieh, *One Year Performance*. © 1981 Tehching Hsieh, New York.

92 Courbet, *The Artist's Studio*. Oil on canvas, 361 × 598 cm. Collection Musee d'Orsay, Paris, France. RF2257. Courtesy of the Réunion des Musées Nationaux/Art Resource, New York. Photo: Gérard Blot/Hervé Lewandowski.

93 Pearlstein, *Two Models in a Window with Cast Iron Toys*. Oil on canvas, 72 × 72 in. Gift of the James F. Dicke Family, Smithsonian American Art Museum, Washington, DC. Courtesy of the Smithsonian American Art Museum, Washington DC/Art Resource, New York. © Philip Pearlstein.

101 Reconstruction of the Bacon studio. Photo: David Getsy.

118 Reed studio. Courtesy of the artist. Photo: Eli Ping Weinberg.

122–23 Lawson studio. Courtesy of the artist.

124 Von Heyl studio. Courtesy of the artist and Friedrich Petzel Gallery, New York.

131 Vermeer, *The Art of Painting*. Courtesy of the Kunsthistorisches Museum, Vienna.

151 Graham, *The Gifted Amateur, Nov 10th, 1962*. Three painted aluminum light boxes with transmounted chromogenic transparencies, each 112½ × 72 × 7 inches. Edition of four and one artist's proof. Courtesy of the artist, Donald Young Gallery, Chicago, and the Rennie Collection, Vancouver, Canada.

152 Woolford in her studio. Courtesy of the artist. Photo: Frank Heath.

155 Schneeman studio. Courtesy of the artist. Photo: Marielle Nitoslawska

167 Moyer studio. Courtesy of the artist.

168 Welish studio installation. Courtesy of the artist. Photo: Becket Logan.

203 Brassaï, *L'objet invisible*. Silver print. A.234F © Estate Brassaï–RMN. Private Collection. Courtesy of the Réunion des Musées Nationaux/Art Resource, New York. Photo: Michèle Bellot.

216 Harrison, *Untitled (studio view)*. Courtesy of the artist. Photo: Rachel Harrison.

218 Lester Hershmann, collage. Courtesy of the artist, bitforms gallery, New York, and Paule Anglim Gallery, San Francisco.

221 Segal, *Picasso's Chair*. Plaster, wood, cloth, rubber, and string, 73½ × 60 × 36½ inches (186.7 × 152.4 × 92.7 cm). Solomon R. Guggenheim Museum, New York. Gift of Dr. Milton D. Ratner, 1976. 76.2279. © The George and Helen Segal Foundation. Licenced by VAGA, New York, NY.

238 Haendel, composite image: *Karl-o-gram #1*, courtesy of the artist and Susanne Vielmetter Los Angeles Projects, *Pencil Stubs #1*, courtesy of the artist and Milliken Gallery, Stockholm; *Blackhands*, collection Jon Miler, New York, courtesy of the artist and Harris Lieberman, New York.

242–43 Kabakov, *Kitchen 2, Voices*. Installation view. Courtesy of Ilya and Emilia Kabakov.

245 Chernysheva, *Black and White Culinary Book*. Installation view, Gallery 1.0, Moscow. Courtesy of the artist.

247 Rosler, *Semiotics of the Kitchen*. Video still. Courtesy of the artist.

253 Celmins, *To Fix the Image in Memory*. Stones and painted bronzes, eleven pairs. Gift of Edward R. Broida in honor of David and Renee McKee. (679.2005.a-v.vwl). Collection of the Museum of Modern Art, New York, NY. Digital image © The Museum of Modern Art. Licensed by SCALA/Art Resource, New York.

Illustration Credits

255 Faught, *Endless Night*. Courtesy of the artist and Lisa Cooley Fine Arts, New York.

260 Granat studio. Courtesy of the artist.

262 Robbins studio. Courtesy of the artist.

265–66 Welling, *Polaroid Photographs*. Courtesy of the artist and Donald Young Gallery, Chicago.

275 Duchamp, *Why Not Sneeze Rrose Sélavy?* Marble, thermometer, cuttlebone, bird cage, 11.4 × 22 × 16 cm. Philadelphia Museum of Art. © 2010 Artist Rights Society (ARS), New York/ADAGP, Paris/Succession Marcel Duchamp.

284 Welling, *Paris*. Courtesy of the artist and Donald Young Gallery, Chicago.

305 "I" SITE at St. Katharine Dock. Courtesy of SPACE Studios, London.

307 Araeen, *Chakras*. Courtesy of the artist.

318–19 Lacy, *Reuniōn/Reunion*. Courtesy of the artist. Photo of Maria Acevedo by Raul Vega.

323 Beshty, *The Village*. Courtesy of the artist.

334 Bowers: courtesy of the artist, photo Jeremy Rall. Stilley: courtesy of the artist, photo Tucker Stilley.

342–43 Hewitt, *Seed Stage*. Installation view (October 3, 2008–January 4, 2009) at the Whitney Museum of American Art, New York, NY. Photo: Sheldan C. Collins.

347 Harrison, *Nice Rack*. Courtesy of the artist and Greene Naftali Gallery, New York.

INDEX

Page numbers in italics refer to illustrations.

Abramovic, Marina, 88
"Action Painting Fourfold" (Marie): arenas of the action painter and the etymology of "thing," 83; critiques of Rosenberg, 81–82; popularity of Action Painting among American artists, 80; the studio as an actor-network, 84; the studio as equal in importance to the canvas, 81; Rosenberg's description of Action Painting, 84; Rosenberg's introduction of term, 81; Rosenberg's theory of the act of art, 83–84
actor-network theory (ANT), 83, 84
Adamson, Glenn, 8, 251. *See also* "Analogue Practice" (Adamson)
Adler, Judith, 45n10
Albers, Josef, *9*
Album Primo-Avrilesque (Allais), 330n7
Alford, Edna, 247
Allais, Alphonse, 330n7
Alloway, Lawrence, 40, 292–94
Alpers, Svetlana, 2, 5, 126, 336. *See also* "View from the Studio, The" (Alpers)
Althamer, Pawel, 153
American type of studio. *See under* studios
"Analogue Practice" (Adamson): analogue practice theory and craft, 252–53; copying as craftsmanship, 251, 257; craft-based reinvention of the studio, 255–56; craft's unavoidable diversity as a strength, 252; handmade work as a means of defending the studio space, 253–54; implications of copying viewed as a craft, 251–52; relation between casting and copying, 256; "sloppy craft" and rejection of the copy as an ideal, 253–55; the studio as theater of operations, 256–57

Anatomy, An (Picasso), 230
Anderson, Margaret, 270
ANT (actor-network theory), 83, 84
Antoni, Janine, 257
Araeen, Rasheed, 305, 306–8, 310n25
Armajani, Siah, 56
Ars magna lucis et umbrae (Kircher), 129
"Art & Language Paints a Picture" (Art & Language), 8, 104–17
Art and the Industrial Revolution (Klingender), 56
Artist and Model Reflected in Mirror (Matisse), 224–25
"Artist in His Studio, The" (Bergstein): artistic production equated with virility, 212; association of masculinity with production and femininity with consumption, 196; magazines' promotion of gender roles, 210–11; masculine sexuality as a vehicle to artistic expression, 200; negative influence of dominant women on masculine creativity, 208; photographs' ability to present the private moment of artistic transformation, 204; the studio as artist's inner sanctum, 196–97. *See also* Brassaï; Liberman, Alexander
Artist in His Studio, The (Liberman), 211
Artist's Model, The (Gérôme), 224
Artists of My Life, The (Brassaï), 196
Artist's Studio, The (Courbet), *92*, 93, 338
Artist's Studio, The (Segal), 220. *See also* "Cast in a Different Light" (Schmahmann)
Art of Painting, The (Vermeer), 130, *131*, 134–35, 138
Ash Can School, 73
Asher, Michael, 40, 332

Ashton, Dore, 184, 185–86, 188, 189, 191
Astronomer (Vermeer), 139, 143

Bacon, Francis, 5, 62, 164. *See also* "Reconstruction of the Francis Bacon Studio in Dublin, The" (Getsy)
Bal, Mieke, 224
Baldessari, John: studio spaces, 30–36; post-studio art course, 60; program at California Institute of the Arts, 40
Bann, Stephen, 251
Barney, Matthew, 257
Barthes, Roland, 43
Battle of Chosroes (Piero della Francesca), 138
Baudelaire, Charles, 177
Bazille, Frédéric, 133
Before and After (Feinstein), 22
Bellony-Rewald, Alice, 5, 68. *See also* "Studios of America" (Peppiatt/Bellony-Rewald)
Berger, John, 232
Bergstein, Mary, 6, 195. *See also* "Artist in His Studio, The" (Bergstein)
Beshty, Walead, 8, 321. *See also* "Studio Narratives" (Beshty)
Betterton, Rosemary, 234n17
Beuys, Joseph, 6, 239, 249n3, 286–87
Bidlo, Mike, 297
Bierstadt, Albert, 70–71
Bihaud, Paul, 330n7
Bike at Night (Welling), 264, *265*
Bingham, George Caleb, 71
Bishop, Claire, 344
Black and White Culinary Book (Chernysheva), *245*
Blackhands (Haendel), *238*
Black Square (Malevich), 330n6
Blake, William, 56
Boccioni, Umberto, 286
Bonaventure Hotel, 324–28
Bonnard, Marthe, 201–2
Bonnard, Pierre, 206–7
Boo (Araeen), 308
Booker, Chakaia, 254
Book of Healthy and Wholesome Food (cookbook), 248
Book of Wholesome Food, The (installation; Chernysheva), 248

Boosenbarck, Grant, 293, 294
Bowers, Andrea, 332–35,
Bragg, Melvyn, 100
Brancusi, Constantin, 6, 161–62, 165
"Brancusi's 'white studio'" (Wood), 6; accounts of Brancusi's white beard, 271; adherence to whitewashed walls, 280–81; advocacy of truth to materials, 278; Brancusi's attention to his art, 269; construction of an identity for his work and himself, 272, 282n8; dog Polaire's meaning in regard to his craft, 278–80, 282n20; Duchamp's homage to Brancusi's studio, 274, *275*, 276–78; impact of the studio on visitors, 281; myth of the white studio, 269–70; re-creation of the studio, 269–70; relation to Dada, 273; sense of timelessness conveyed by whiteness, 270–71; staging of light in studio photographs, 272–73; visitors' later references to the studio's whiteness, 273–74; Welling's visit to reconstructed studio, 285; whiteness seen as coordinating Brancusi's art and life, 270
Brassaï, 6; alliance with artist as seen in Giacometti photo, 200–201; attitude toward his own work, 200; belief that feminine presence stimulates artistic production, 198; character of his work, 198; coding of the urban environment as feminine, 200; collection of studio photographs, 196; depiction of women's studio role as silent and submissive, 205; depictions of Giacometti's studio, 202–3; depictions of Henry Miller, 199–200, 214n17; fiction in his photography, 205; MoMA exhibit, 198–99; photos of Matisse's home and models, 204; reinforcement of dominant male viewer in photographs, 204; representation of the artist's studio as one with his art, 201, 214n22; representation of women, 201, 202; theme of masculine sexuality as a vehicle to artistic expression, 200; thesis of his work, 195, 212n1, 213n2; treatment of his subjects, 200; use of photographic pairings to convey meaning, 199; use of text to corroborate visual material, 201–2; voyeurism

in depictions of Matisse's studio and model, 205–6
Bridgman, Frederic A., 72
Bringing the War Back Home: House Beautiful (Rosler), 247
Broodthaers, Marcel, 338
Budding Gourmet, A (Rosler), 244–46
Burckhardt, Rudy, *9*
Buren, Daniel, 2, 3, 8; on the function of the studio, 41, 42, 163–65 (*see also* "Function of the Studio, The" [Buren]; "Function of the Studio Revisited, The" [Buren])

CAA. *See* College Art Association (CAA)
Cage, John, 6, 59, 240
California Institute of the Arts, 40, 60
Callon, Michel, 83
Caravaggio, 130, 132, 139
Carmencita, 72
Carter, Malcolm, 227
"Cast in a Different Light" (Schmahmann), 6; association of women with nature and men with culture, 222–23; critique of female figure in *The Artist's Studio* (Segal), 225–26; critique of *Self-Portrait with Head and Body*, 228–29; female figures' resistance to control in Segal's sculpture, 234; female painters' reversal of gender roles, 234–35n17; gender hierarchy as implicit in images of studio, 224–26; meaning of Segal's work, 220; the model's role in Segal's casting process, 227–28; prevalence of female models in depictions of male artists' studios, 222; representation of a female model by Picasso, 230; Segal and theme of the artist's studio, 220, 222; Segal's art-making methods and materials, 225; Segal's belief in the physiological consistency of the model, 228; Segal's preference for friends as models, 235n24; Segal's take on Rubens's contrapposto stance in *Rubens's Women*, 231–33; Segal's translation of Picasso's female model in *Picasso's Chair*, 230–31; Segal's use of body casting, 226; sexual domination reflected in the process of body casting, 226; view of women underlying female nudes in Western art, 223
Cedar Tavern, 76

Celmins, Vija, 252, *253*
Cendrars, Blaise, 273
Certeau, Michel de, 2, 4
Cézanne, Paul, 136, 142, 143
Chakras (Araeen), 306–8, *307*
Chamberlain, John, 53–55
Chardin, Jean-Siméon, 133, 142
Chase, William Merritt, 5, 49, 68, 72
Chernysheva, Olga, *245*, 248
Christ in the House of Mary and Martha (Vermeer), 139
chronicle of studio spaces: Baldessari, 30–36; Feinstein, 21–22; Spector, 17–20
Church, Frederic Edwin, 68, 69–70
Clark, Kenneth, 223, 235n18, 236n39
Close, Chuck, 52
Cole, Thomas, 68–69
College Art Association (CAA): concerns over isolation inherent in a private studio, 42–43; guidelines for MFA programs in studio art, 39–40
Collis, Susan, 257
Commissioned Paintings (Baldessari), 94
copying and craft. *See* "Analogue Practice" (Adamson)
Cornell, Joseph, 186
Corot, Jean-Baptiste-Camille, 141
Courbet, Gustave, 91–92, 93, 121, 140, 141, 338
craft versus copying. *See* "Analogue Practice" (Adamson)
Cravan, Arthur, 273
critics and the studio artist: Alloway on *Spiral Jetty*, 292–94; perceptions of Smithson as a postmodern writer, 289–90; Rosenberg and Action Painting, 81–84; Storr on studio visits as a critic, 185, 189, 191. *See also* "Artist in His Studio, The" (Bergstein); "Studio Revisited, The" (Welish); "Studio Visit, The" (Welish)
Cropper, Elizabeth, 149
Crystal Palace, 329nn4–5

David, Jacques Louis, 170
"death of the author," 246, 289, 297
Degas, Edgar, 133, 136
De Hooch, Pieter, 129–30
De Keyser, Raoul, 61

De Kooning, Elaine, 53, 76, 89, 91
De Kooning, Willem, *51*; arrangement of studio by his wife, 50–52; discomfort with success, 52; first use of a loft as a studio, 78–79; preference for natural light, 79; sculpture studio, 78; wife's attention to replenishing his supplies, 53
Delacroix, Eugene, 177
Deleuze, Gilles, 345, 348
Della Francesca, Piero, 73, 137–38
Dempsey, Charles, 149
Demuth, Charles, 286
De Neuville, Alphonse, 150
De Sausmarez, Maurice, 304
Devault, Marjorie, 244
Dewey, John, 3
Diana and Nymphs (Vermeer), 135, 139
Dicicco, Martin, 237
Dime, Mustapha, 56
Discursive Studio, 169
Disney Music Hall, 327
"Does Reality Possess Practical Character" (Dewey), 3
Donovan, Tara, 253
Draughtsman Drawing Nude (Dürer), 224
dream studio. *See* "Index: Dream Studio" (Lutker)
Dresden, 133
Drunk (Wearing), 339
Dubuffet, Jean, 207
Duchamp, Marcel, 312, 315n2, 330n6; explanation of "art," 91, 93, 95; on "making something," 89; response to Brancusi's white studio (see *Why Not Sneeze Rrose Sélavy?* [Duchamp])
Dudley, Dorothy, 278
Duncan, Carol, 222
Durant, Sam, 257
Dürer, Albrecht, 224
Durrell, Lawrence, 198
Dust Breeding (Duchamp), 277
Duthuit, Georges, 270
Duve, Thierry de, 329
Dynamism of a Figure in Space (Boccioni), 286

Eakins, Thomas, 72
Eighth Street Club, 76
Eliasson, Olafur, 339
Ellegood, Anne, 346
Endless Column (Brancusi), 269, 276

Endless Night (Faught), 254, *255*
Ernst, Max, 166–67
European type of studio. *See under* studios
Evergood, Philip, *41*
Expressive Studio, 169

Failing to Levitate in My Studio (Nauman), 44–45
Fallico, Arturo, 178
Faught, Josh, 254, *255*
Fede, Lucrezia del, 208
Feinstein, Rochelle: chronicle of studios, 21–22
Female Nude (Nead), 236n39
Finding of Moses (Vermeer), 139, 143
Fischli, Peter, *10*, 11
Fish (Brancusi), 276–77
Forge of Vulcan (Velázquez), 134
forms of the studio. *See* "Room of One's Own, A" (Storr)
Foster, Hal, 289
Foster, Jeanne Robert, 273–74
Fourment, Hélène, 236n39
Francken, Frans, 132
Fraser, Andrea, 339
Fraser, Kennedy, 210, 211
Frauds (Ho), 11, 12, 13
Fried, Michael, 43
Friedman, Tom, 254
Friedrich, Caspar David, 132
Full Circle (Lacy), 317
function of the studio: overemphasis on traditional artist's studio, 286–87; projection and photography used to bring the studio into the museum, 339–40; refiguring the studio through conceptual projects, 338–39; relation between studio artist and display space, 336–38, 340; romanticized view of the studio, 296; the studio as a fragile ecosystem, 340; the studio as generative space, 339; the studio as integral to the meaning of art created there, 287; technology and art, 298, 301n29; union of the iconic and the performative, 296–97. *See also* "Function of the Studio, The" (Buren); "Function of the Studio Revisited, The" (Buren); "Possible Contradiction, A" (Singerman); "Room of One's Own, A" (Storr); "Studio Unbound" (Relyea)

"Function of the Studio, The" (Buren), 2, 41; American type of studio, 157, 162n3; artwork's private origin versus public display, 158–59, 161; Brancusi's refusal to allow museum display of his works, 161–62, 162n5; creating art to accommodate museum display, 160; European type of studio, 156, 162n2; prevalence of electric lights in American studios and museums, 157, 162n4; relation between studio and museum, 159–60; the studio as a convenience for the organizer, 157; the studio defined, 156, 287; the studio as place of multiple activities, 157; the studio as place where artwork is closest to its own reality, 158, 287–88; the studio as unique space of production, 2

"Function of the Studio Revisited, The" (Buren): artistic implications of having no studio, 165; consistency in function of studios, 164–65; modern artists' awareness of the art market, 164; site artist's option to integrate work into the site, 163; studio artist's duty to produce work that can be shown anywhere, 163

Galison, Peter, 144, 145, 299n11, 300n25
Gambrell, Jamey, 248
Gasquet, Joachim, 149
Gauguin, Paul, 280–81
Geelhaar, Christian, 228
Gehry, Frank, 327
Genius and Lust (Mailer), 199
Genzken, Isa, 346
Géricault, Théodore, 2, 3, 225
Gérôme, Jean-Léon, 72, 224
Getsy, David J., 5, 99. *See also* "Reconstruction of the Francis Bacon Studio in Dublin, The" (Getsy)
Giacometti, Alberto, 134, 202–4
Giacometti, Annette, 209–10
Gifford, Stanford, 71
Gifted Amateur, The (Graham), *151*
Gilbert-Rolfe, Jeremy, 182–83, 187, 188, 191
Gilligan, Melanie, 339
Gilot, François, 126
Gioni, Massimiliano, 346
Giorgione, 133
Girlfriends, The (Segal), 227
Glackens, William, 73

Gober, Robert, 257
Golding, John, 270
Gombrich, E. H., 146
Gonzalez-Torres, Felix, 61, 62, 119, 315
Goodman, Paul, 81
Gorky, Arshile, 5, 53, 73–74
Grabner, Michelle, 1
Graham, Rodney, 11, 150–51
Granat, Amy, 259–60
Greene, Renee, 339
Guernica (Picasso), 2, 3, 132
Gupta, Subodh, 254
Guston, Philip, 59, 155, 186

Haendel, Karl, 11, 237–38, *238*
Hague, Raoul, 53–55
Halley, Peter, 290
Harris, Claire, 247, 248
Harrison, Rachel, *216*, 346, *347*
Hawthorne, Nathaniel, 72, 78
Heade, Martin, 71
Head with a Lilac Nose (Dubuffet), 207
Heart of the Andes (Church), 70
Heda, Willem Claesz., 132, 133
Heidegger, Martin, 83
Held, Al, 94
Hélène Fourment in a Fur Wrap (Rubens), 232
Henri, Robert, 73
Heron, Patrick, 40
Hershmann, Lynn Lester, *218*, 219
Hertel, Christiane, 148
Hesse, Eva, 61
Hewitt, Corin, 6, 336–38, 341
Ho, Amanda Ross, 11
Hollander, Elizabeth, 226
Homer, Winslow, 71
Hsieh, Tehching, 7, 88–89, *90*, 91, 95
Huebler, Douglas, 40
Hugh Lane Gallery, 99. *See also* "Reconstruction of the Francis Bacon Studio in Dublin, The" (Getsy)

In Action (Steindorf), *82*
"Index: Dream Studio" (Lutker): collections, 23, *25*; the outdoors and the studio, 24; sharing and the studio, 26–27; underground studio, 24; visitors, 26; working in the studio, 23–24
Ingres, Jean Auguste Dominique, 73
Inness, George, 71

Inness, Sherrie, 241
Interpretation of Cubism, The (Roskill), 192
In the Studio II (Fischli/Weiss), *10*
Ion (Plato), 249n4
Isaak, Jo Anna, 248
isolation versus interchange. See "Possible Contradiction, A" (Singerman)
Italian mural painting, 137–38

Jacob, Mary Jane, 30–36
James, Gareth, 344
Jameson, Fredric, 289, 298n9, 325, 326–28
Janssens, Pieter Ellinga, 129, 146
Jerusalem (Church), 70
Johns, Jasper, 344
Johnson, Jill, 227
Jones, Caroline, 4, 7, 126, 286; machines, the studio, and postmodern art (*see* "Post-Studio/Postmodern/Postmortem" [Jones])
Jones, Ernest, 208
Jones, Thomas, 141–42, 149
Judd, Donald, 313

Kabakov, Ilya, 240, 241
Kafka, Franz, 317
Kapoor, Anish, 258n4
Karl-o-gram (Haendel), *238*
Kemp, Martin, 39
Kim, Hee-Young, 81
Kimsooja, 86, *87*
Kircher, Athanasius, 129
Kitchen 2 (Kabakov), 241, *242*, *243*
"Kitchen as Art Studio, The" (Winkenweder), 6; cultural expectation that women belong in kitchen, 241, 244; depictions of femininity as domestic and artist as anti-domestic, 244; depictions of kitchen as site of conflict regarding gender expectations, 247, 248; depictions of kitchen as a women's space charged with societal tension, 244–46, 250n18; difficulty of avoiding gendered roles, 241; elevation of women's place in kitchen to art, 245–46; Kabakov's use of mundane items and dialogue, 240–41; linking of the terms "everyone" and "artist," 248–49; metaphor of gender roles, 239–40; myth of male dominance in the studio, 239; Rosler's video depiction of housewife's repressed rage, 246–47; women artists' questioning of cultural assumptions, 248; women artists' versus male artists' referencing of kitchens, 247–48
Kitchen Series (Kabakov), 240
Kitchen Talk (Harris and Alford), 247
Klein, Melanie, 136
Klein, Yves, 286
Klingender, F. D., 56
Knight, Laura, 234–35n17
Koons, Jeff, 164, 297
Kramer, Hilton, 81
Krasinski, Edward, 338
Krauss, Rosalind, 256, 289
Kuhn, Richard, 178

Lacemaker, The (Vermeer), 130
Lacy, Suzanne, 317–20
Lady Writing a Letter with Her Maid (Vermeer), 139, 143
landscape and the studio: academic emphasis on painting landscapes inside, 141–42; Cézanne and landscape as still life, 142; landscape painting split between outside and in-studio work, 141; the studio as in or of the mind, 143
Large Glass (Ray), 277, 278
Large Nude in Red Armchair (Picasso), 126
Las Meninas (Velázquez), 135, 138, 140
Latour, Bruno, 83, 84
Law, John, 83
Lawson, Thomas, 121–22
LeDray, Charles, 254
Leonardo da Vinci, 130
Le temps retrouvé (Proust), 137
Lethève, Jacques, 93, 94
Leutze, Emmanuel, 71
Levine, Sherry, 297
LeWitt, Sol, 65, 297
Liberman, Alexander, 6, 298n2; interviewed, 211–12; investigation of artist's interior mind, 207; photos of Bonnard's studio and his posing of female bodies, 206–7; photos of Giacometti's studio capturing his wife's passivity, 209–10; photos of Utrillo depicting male dominance relinquished, 207–8; popularity of photo essays, 196; stated aim for collected

photographs of artists, 195; thesis of his work, 195, 212n1, 213n2; use of photographed detail to interpret an artist's work, 206; view of fashion as displayed in *Vogue*, 195–96

light and the studio: artists' preference for natural light, 79; Brancusi's staging of light in studio photographs, 272–73; Caravaggio's cellarlike depictions, 130, 132; de Hooch's investigations of light, 129–30; depictions of windows and withdrawal from the world, 132; discontinuity of nudes painted in studio light but shown in natural light, 133; Janssens's depiction of natural light, 129; lit objects' purpose as studio markers, 133–34; in lofts, 78–79; prevalence of electric lights in American studios and museums, 157, 162n4; still life and studio light, 132–33; Vermeer's study of light, 130

Liseuse au Fond Noir (Matisse), 205

"Live/Work" (Siegel): artists' eschewing of vacations, 313, 316nn4–5; constraints on artists' living conditions, 315; integrating work and life in the studio space, 312–13, 316n3; meaning of "working like artists," 313–14; other workers' erasure of line between work and life, 313; the studio apartment, 311–12, 315n2; the studio as live-in workplace, 312; the studio as sweatshop or cubicle, 314, 333

Lloyd, Hilary, 339

L'object invisible (Brassaï), *203*

Looking On (Betterton), 234n17

Lord, James, 134

Louis, Morris, 150

Loy, Mina, 273

Lumpkin, Libby, 346

Luncheon in the Studio (Manet), 132

Lutker, Shana. *See* "Index: Dream Studio" (Lutker)

Machine in the Studio (Jones), 4

machines, the studio, and postmodern art. *See* "Post-Studio/Postmodern/Postmortem" (Jones)

Mailer, Norman, 199

Maillol, Aristide, 196–97

Malevich, Kazimir, 328, 330n6, 330n7, 331n9

Malraux, André, 198

Manet, Édouard, 132, 133, 177

Mantegna, Andrea, 73

Manzoni, Piero, 286

Mapping the Studio (Nauman), 45, 46n14, 60, 253, 339

Marble Faun, The (Hawthorne), 78

Marck, Jan van der, 300n19

Marie, Annika, 7, 80. *See also* "Action Painting Fourfold" (Marie)

Marple, Mieke, 237

Martin, Agnes, 56–58

Martin, Courtney J., 7, 302. *See also* "Studio and the City, The" (Martin)

Marx, Leo, 56

masculinity and art. *See* "Artist in His Studio, The" (Bergstein); Brassaï; "Cast in a Different Light" (Schmahmann); "Kitchen as Art Studio, The" (Winkenweder)

Masheck, Joseph, 183, 184, 187, 190–91

Matisse, Amélie, 211

Matisse, Henri, 132, 204, 205, 210–11, 224–25

Matisse with Serpentine (Steichen), 204

McConathy, Dale, 290

McGoohan, Patrick, 322

Meissonier, Jean-Louis-Ernest, 222

Meurent, Victorine, 133

Miller, Henry, 199

Miller, Nancy, 241

Milner, Marion, 148

Mimetic Studio, 169

Mitchell, Joan, 59

Mitchell, W. J. T., 299n16

Model and Surrealistic Sculpture (Picasso), 230

MoMA (Museum of Modern Art), 198

Mondrian, Piet, 175

Monet, Claude, 141

Montaigne, Michel de, 139

Moore, Henry, 56

Morton, Ree, 316n10

Motherwell, Robert, 50

Mount, William Sidney, 71

Moyer, Carrie, 166–67

Musée d'Art Moderne (Broodthaers), 338

Museum of Modern Art (MoMA), 198

museums and the studio: artists' creating to accommodate museum display, 160; Brancusi's refusal to allow museum display of his works, 161–62, 162n5; Brassaï's exhibit at MoMA, 198–99; Hewitt's *Seed Stage*, 336–38; Hugh Lane Gallery, 99; prevalence of electric lights in American studios and museums, 157, 162n4; projection and photography used to bring the studio into the museum, 339–40; reconstruction of Bacon's studio, 100; relation between, 159–60; Whitney Museum of American Art, 336
My Egypt (Demuth), 286

Nauman, Bruce: *Mapping the Studio*, 46n14, 253, 339; New Mexico studio, 58; recording of his empty studio, 60, 62; view of himself as an artist, 44–45. *See also* "Setting a Good Corner" (Nauman)
Nead, Lynda, 223, 236n39
Negroes Fighting in a Cellar at Night (Bihaud), 330n7
Neuhaus, Jessamyn, 244
Newman, Barnett, 294
Nice Rack (Harrison), *347*
Nude by the El (Evergood), *41*
Nymphéades (Monet), 141

Oath of the Horatii, The (David), 170
Objectivist Studio, 169
O'Brien, Elaine, 81
Obrist, Hans Ulrich, 341, 344
office versus studio, 45n10; Baldessari's studio spaces, 33, 35; constraints on artists' living conditions, 315; Stark's office and studio, 47, 48f; the studio as sweatshop or cubicle, 314, 333
Ofili, Chris, 92
Ogden, Perry, 100
O'Keeffe, Georgia, 277
Olana, 70
Olmsted, Frederick Law, 292
Olsen, Tillie, 317
100 (Peteran), 255–56
One Year Performance (Hsieh), *90*
Ortner, Sherry, 222–23
Orton, Fred, 81
Owens, Craig, 289, 290

Painter's Studio, The (Courbet), 140, 141
Paris (Welling), *284*
Paxton, Joseph, 329n4/5
Pearlstein, Philip, 93
Pencil Stubs (Haendel), *238*
Peppiatt, Michael, 5, 68. *See also* "Studios of America" (Peppiatt/Bellony-Rewald)
performance art: in London's S.P.A.C.E. Ltd., 306–8; Rosler's video depiction of housewife's repressed rage, 246–47; *Seed Stage* (Hewitt), 336–38, 341; *Spiral Jetty* (Smithson), 292–95, 300n19; union of the iconic and the performative in the studio, 296–97. *See also* "Reconstruction of the Francis Bacon Studio in Dublin, The" (Getsy)
Permanent Record of Newjack Rasputin, The (Stilley), 332
Peteran, Gord, 255–56
Philip Golub Reclining (Sleigh), 235n17
photography and the artist's studio: ability to make public moment of artistic transformation, 204; Brancusi's staging of light in studio photographs, 272–73; projection and photography used to bring the studio into the museum, 339–40; Welling's manipulation of Polaroids, 265. *See also* Brassaï; Liberman, Alexander
Picasso, Pablo, 2, 126, 132, 197, 230, 274
Picasso's Chair (Segal), 220, *221*, 230–31
Pinnault, François, 62
Plato, 249n4
Pointon, Marcia, 222, 224
Polaire, 278–80, 282n20
Polaroid Photographs (Welling), *264*
Pollock, Griselda, 244
Pollock, Jackson, 5, 74–75, 253
Porbus, François, 1, 2
Portrait of an Artist and Lay Figure (Degas), 136
Portrait of an Artist in His Studio (Géricault), 2, 3, 225, 235n18
Portrait of Jean Dubuffet (Liberman), 207
Portrait of the Artist as Fountain (Nauman), 45
"Possible Contradiction, A" (Singerman): artists' need for both solitude and interchange, 39–40; CAA concerns over isolation of a private studio, 42–43; post-

studio system, 40–41; the studio as central to the practice of art, 45; the studio as both private and shared space, 40; the studio as not just a room, 43; the studio space and the reality of the artist's work, 41; the studio versus the office, 45n10

postmodern art: influence of industrial settings on American artists, 295; perceptions of Smithson as a postmodern writer, 289–90; postmodernism's role in understanding modernism, 289, 299n11; postmodernists' use of text to enhance their productions, 295–96; Smithson's concept of postmodernism, 288–89. *See also* "Post-Studio/Postmodern/Postmortem" (Jones)

post–post-studio practice, 153

"Post-Studio/Postmodern/Postmortem" (Jones), 4–5; Buren's call to eradicate the studio, 288; dispersal of the studio and appearance of team artists, 297–98; influence of industrial settings on American artists, 295; out-of-the-studio art in the 1960s, 286; overemphasis on traditional artist's studio, 286–87; perceptions of Smithson as a postmodern writer, 289–90; postmodernism's role in understanding modernism, 289, 299n11; postmodernists' use of text, 295–96; romanticized view of the studio, 296; Smithson's erosion of human-machine boundary, 299n15; Smithson's challenge to the studio, 291; Smithson's concept of postmodernism, 288–89; Smithson's recognition of the importance of materialization to artists, 291–92, 299n17; *Spiral Jetty* as manmade art-by-machine, 292–95, 300n19; the studio as integral to the meaning of art created there, 287; technology and art, 298, 301n29; union of the iconic and the performative, 296–97

Poussin, Nicolas, 138, 139, 149

Pragmatic Studio, 169

Prendergast brothers (Maurice and Charles), 73

Prisoner, The (television show), 322–24

Prison for Objects (Gilligan), 339

Proust, Marcel, 137, 148

Pygmalion myth, 224, 229

Ramljak, Suzanne, 211, 212

Ray, Man, 272, 277, 278

Reading Studio, 169

"Recipe: Perfect Studio Day" (Smith), 28–29

reconceptualizing of the studio. *See* "Studio Visit" (Rodenbeck)

"Reconstruction of the Francis Bacon Studio in Dublin, The" (Getsy), 5; absence of art in the display, 102–3; cataloging and moving the studio, 99; database's value, 103; description of museum display, 100; shortfall in presenting a static moment, 103; studio's contribution to Bacon's art, 99–100; studio's role in perpetuating stereotype of Bacon, 102; viewer's experience, 101–2

Red Square (Malevich), 330n7

Red Stripe Kitchen (Rosler), 247

Reed, David, *118*, 119–20

relation between studio and artist. *See* "View from the Studio, The" (Alpers)

Relyea, Lane, 10, 341. *See also* "Studio Unbound" (Relyea)

Rembrandt van Rijn, 135, 138, 139

Reunión/Reunion (Lacy), *318*, 319

Rhoades, Jason, 300n27, 348

Rhode, Robin, 80

Riggins, Bill, 64

Riley, Bridget, 303, 308n6, 309n13

Rimbaud, Arthur, 89

Robbins, David, 261–63

Roberts, John, 257

Rodenbeck, Judith, 6, 336, 341, 344. *See also* "Studio Visit" (Rodenbeck)

Rodin, Auguste, 256, 271

"Room of One's Own, A" (Storr): approaches to studio criticism, 189; artists as teachers, 60–61; artists' discomfort with success, 52–53; artists' work as solitary activity, 59; Baldessari on "art production," 60; Chamberlain's "junk" becoming art, 53–55; Close's arrangement of his space, 52; combined work- and showrooms in the nineteenth century, 49; continued belief in importance of studio, 61–62; de Kooning's arrangement of his space, 50–52;

"Room of One's Own, A" (Storr) (*continued*)
Elaine de Kooning's replenishing of husband's supplies, 53; forms of the studio, 49; Hague's work and its rural setting, 55–56; Martin's departure from New York, 56–58; Motherwell's re-creation of his favorite studio, 50; Nauman's recording of his empty studio, 60; new settings and inspiration, 56; Rothenberg's and Nauman's New Mexico studios, 58–59; Smith's studio-as-factory, 56; storage and supplies issues in studios, 53; studioless practice, 61; the studio as sales room, 50; on studio visits as a critic, 185; surroundings favored by "conceptual" artists, 59

Rosenberg, Harold, 7, 313, 316n5; critiques of his critical abilities, 81–82; description of Action Painting, 84; introduction of the term "action painting," 81; theory of the act of art, 83–84

Roskill, Mark, 192
Rosler, Martha, 239, 241, 244–47
Rothenberg, Susan, 58
Rothko, Mark, 79
Rubens, 138
Rubens's Women (Segal), 220, 231–33
Ruskin, John, 251
Russell, John, 81

Samaras, Lucas, 316n10
Sandler, Irving, 52
Sargent, John Singer, 72
Sarto, Andrea del, 208
satirization of studio working process, 104–17
Saunders, Gill, 224
Scanlan, Joe, 153
Schafran, Lynn, 305
Schapiro, Meyer, 42, 134
Schmahmann, Brenda, 220. *See also* "Cast in a Different Light" (Schmahmann)
Schneemann, Carolee, 154–55, 253
Schnitger, Lara, 346
Schwabsky, Barry, 7, 88. *See also* "Symbolic Studio, The" (Schwabsky)
Sculpture (magazine), 212
sculpture studios, 76–78; de Kooning's, 78; the studio as the artist's everyday practice, 345–48; Welling's photographs of

colorless sculpture, 285; *Why Not Sneeze Rrose Sélavy?*'s reference to a sculpture's studio dust, 277–78. *See also* "Cast in a Different Light" (Schmahmann)

Sedgley, Peter, 302, 303
Seed Stage (Hewitt), 6, 336–38, 340, 341, 342, 343
Segal, George, 6, 220, *221*. *See also* "Cast in a Different Light" (Schmahmann)
Sehgal, Tino, 153
Self-Portrait (Poussin), 139
Self-Portrait (Rembrandt), 135
Self-Portrait at the Age of Twenty-Four (Ingres), 73
Self-Portrait with Bird-Cage (Picasso), 274
Self-Portrait with Head and Body (Segal), 220, 228
Self-Portrait with Nude (Knight), 234–35n17
Semiotics of the Kitchen (Rosler), 246–47, *247*
Serra, Richard, 258n4
Service: A Trilogy on Colonization (Rosler), 244
"Setting a Good Corner" (Nauman), *63*; approach to setting up film shot, 64–65; finding enjoyment in a mundane task, 66; focus on getting work done well, 65; professionalism and assessment of quality of work, 66; purpose of the task, 64; structuring time as aspect of the task, 63–64
7 Reece Mews: Francis Bacon's Studio (Ogden), 100
Siegel, Katy, 311–14. *See also* "Live/Work" (Siegel)
Silverthorne, Jean, 339
Simpson, Bennett, 344
Singerman, Howard, 6–7, 39. *See also* "Possible Contradiction, A" (Singerman)
Siqueiros, David Alfaro, 75
Sleeping Venus (Dresden), 133
Sleigh, Sylvia, 235n17
"sloppy craft" concept, 253, 254–55
Smith, David, 56, 76–78, 77f
Smith, Justin, 237
Smith, Michael, 28–29
Smith, Tony, 295, 298n2
Smithson, Robert: breaking down of human-machine boundary, 299n15; challenge to the studio as point of origin

for art, 291; concept of postmodernism, 288–89; perceived as a postmodern writer, 289–90; recognition of importance of materialization to artists, 291–92, 299n17; *Spiral Jetty* as manmade art-by-machine, 292–95
Social Sculpture (Beuys), 239, 249n3
South Bank Show, 100
Soviet society's view of kitchens, 240, 248
S.P.A.C.E. Ltd.: as communal workspace, 304; immigrants' move to London and, 306; purpose and project proposal, 303–4, 308n2, 309nn9–13; success of, 308. *See also* "Studio and the City, The" (Martin)
Spector, Buzz, 17–20
Spiral Jetty (Smithson), 292–95, 300n19
Spoerri, Daniel, 338
Stark, Frances, 47, *48*
Star Trek (television show), 328, 330–31n8
Steichen, Edward, 204
Stein, Gertrude, 73
Steindorf, Nicholas, 80, *82*
Stella, Frank, 286, 289, 295, 296, 297
Stilley, Tucker, 332–35
Still Life with Plaster Cast of Amor (Cézanne), 136
Stones of Venice (Ruskin), 251
Storr, Robert, 49; forms of the studio (*see* "Room of One's Own, A" [Storr]); role as a critic, 185, 189, 191
"Street as Studio, The" (Lacy), 317–20
studio: American type, 157, 162n3; European type, 156, 162n2; modernist model, 2, 3–4; places versus spaces and, 4–5; postmodern, 4; relation to practice, 5; romantic archetype, 2; as site of attention, 3; seventeenth-century depictions of, 126–27; status as unique workplace, 2. *See also specific essays, esp.* "Function of the Studio, The" (Buren); "Possible Contradiction, A" (Singerman); "Room of One's Own, A" (Storr)
Studio (Lloyd), 339
"Studio and the City, The" (Martin), 7; *Chakras* as commentary on changes in Britain, 306–8; Sedgley's description of London's studio space, 302. *See also* S.P.A.C.E. Ltd.
studio as instrument: Cézanne's landscapes and cloud-chamber experiment, 144–45; cloud experiment demonstrating imitation and analysis, 144; the studio as experimental instrument, 145–46
studio as lived-in space: Haendel's feeling that his studio is home, 237–38; Harrison's working environment, 217; Hershman on creating one's own relics, 219; Robbins on working at home, 261–63; Spector's studios, 17–20; studio's development into a meeting place, 259–60; Welling's studio manipulation of Polaroids, 265. *See also* "Analogue Practice" (Adamson); "Artist in His Studio, The" (Bergstein); "Cast in a Different Light" (Schmahmann); "Kitchen as Art Studio, The" (Winkenweder)
studio as resource: Baldessari's studio spaces, 30–36; Feinstein's childhood studios, 21–22; Lutker's dream studio, 23–27; Smith's perfect studio day, 28–29
studio as retreat: artist's attempts to lessen isolation of the studio, 139–40; bringing history painting into the studio, 138–39; Courbet's attempt to deny studio limits, 140; studio works versus on-site murals, 138; workplace's function as studio for mural paintings, 137–38
studio as set and setting: Kimsooja's conflation of body and studio, 86; Rosenberg and Action Painting, 80–85; Singerman on isolation versus interchange, 39–45; Stark on office and studio, 47, *48*; Storr's typology of studios, 49–62. *See also* "Setting a Good Corner" (Nauman); "Studios of America" (Peppiatt/Bellony-Rewald); "Symbolic Studio, The" (Schwabsky)
studio as space and non-space: Lacy on the street as studio, 317–20; the studio as nonphysical space, 332–35; Welling's photographs of colorless sculpture, 285. *See also* "Brancusi's 'white studio'" (Wood); "Live/Work" (Siegel); "Post-Studio/Postmodern/Postmortem" (Jones); S.P.A.C.E. Ltd.; "Studio Narratives" (Beshty); "Studio Unbound" (Relyea); "Studio Visit" (Rodenbeck)

studio as stage: Bowers's view of the studio visit, 333; concept of post–post-studio practice, 153; function of the studio, 163–65; Graham's amateur studio, 150–51; Lawson on qualities of the best studio, 121–22; Reed on studio as place, time spent, or feeling, 119–20; satirization of studio working process, 104–17; Schneemann on the studio as both static and in motion, 154–55; *Seed Stage* (Hewitt), 336–38, 341, *342–43*; studio as a place where accumulated images are brought forth, 166–67; theories of the studio, 169; von Heyl on the studio as separate from creative work, 125. *See also* "Function of the Studio, The" (Buren); "Reconstruction of the Francis Bacon Studio in Dublin, The" (Getsy); "Studio Revisited, The" (Welish); "Studio Visit, The" (Welish); "View from the Studio, The" (Alpers)

"Studio Narratives" (Beshty): campus visit reminiscent of *The Prisoner*, 322–24; Jameson on the Bonaventure Hotel, 325, 326–28; politics of the art object as illustrated by *Star Trek*, 331n8; social realities of airplane seating, 321–22, 328n2; stay at the Bonaventure, 324–28; Walmart and exhibitions, 322, 324, 329n3, 329n4; zero point, 328, 331n8, 331n9

"Studio Revisited, The" (Welish), 7; approaches to studio criticism, 187–89; artists' belief that studio visit indicates critical approval, 181–82; artist's responsibility to know critic's work, 184; artists' resistance to critique, 188–89; contract implicit in studio visit, 189–90; critic's desire for reciprocal learning, 183; critic's disdain for self-promoting artists, 184; critic's resentment if treated as art tourist, 184; expectations when artists visit each other, 182–83; first studio visit defined by discussion, 187; intentionality of critic, 192; meaning of criticism, 186–87; perspective of a critic/artist, 185; purpose of studio visit, 186, 190–91; rapport, 185–86; responsibility of critic to comment on something, 190; Storr's approach to studio criticism, 189, 191, 192; studio visit as occasion for sharing art with critic, 185; studio visits by writers not trained in art, 184–85; tales of sadistic critics, 190; type of artist that gets the most from a critic's visit, 183; working definition of studio visit, 182

"Studios of America" (Peppiatt/Bellony-Rewald): American artists' reliance on Europe in late nineteenth century, 72–73; artists' efforts to create inspirational studios, 70–71; artists' meeting places outside of studios, 76; Church's ability to create landscapes from memory and research, 69–70; Church's Hudson River studio, 70; Cole's early inspiration from nature, 68–69; Cole's failure to be impressed by European tradition, 69; conceptions of the American studio, 68, 79; first use of a loft as a studio, 78–79; Gorky's transition to a specifically American art, 73–74; move away from European studio standards, 68; Pollock's barn studio as integral to his method, 74–75; portable studios used to capture business, 71; preference for natural light, 79; sculpture studios, 76–78; West Tenth Street studio building, 71–72

Studio Stripped Bare, Again (Silverthorne), 339

"Studio Unbound" (Relyea): Buren's view of function of the studio, 341; function of modern studio space, 344–45; notions of solitary studio and lone artist, 348; Rodenbeck's challenge to Buren's description of the studio, 341, 344; the studio as everyday practice as evidenced by modern sculpture, 345–48; the studio as integrating the artist into a network, 348–49; the studio as showroom, 344; the studio as network, 345

"Studio Visit" (Rodenbeck): projection and photography used to bring the studio into the museum, 339–40; refiguring the studio through conceptual projects, 338–39; relation between studio artist and display space, 336–38, 340; the studio as fragile ecosystem, 340; the studio as generative space, 339

"Studio Visit, The" (Welish), 7; artist's expectations when inviting a visit, 170–71;

artist's position to manipulate the critic, 178–79; artist's reactions governed by sense of entitlement, 174; artist's use of social ties to impress a critic, 172; celebrity artist's solipsism, 179; critic's and artist's desire to reach an understanding, 171; critic's assessment of how much criticism an artist can take, 171–72; critic's positioning to provide an informed opinion, 179–80; intellectual engagement between artist and critic, 175–77; narcissism and the artist, 174–75; risk entailed in opening studio to the public, 170; questioning artists' perception of success in realizing their intellectual agendas, 172–73; success of visit tied to artist's ability to take risks in dialogue, 177–78; tactics of the effective critic, 173; visit viewed as a privilege by art critic, 170

Suda, Yoshihiro, 257

Swallow, Ricky, 257

"Symbolic Studio, The" (Schwabsky), 7; art as simply indicating something real, 94; artists' openness to visitors, 92–93; de Kooning's parody of artists' choices, 89, 91; Duchamp's explanation of art, 91, 95; Hsieh's decision to "not do art," 89; Hsieh's studio space, 89; Hsieh's use of studio in determinate negation of art, 91; the studio as meeting place, 93–94; the studio as symbol, 91–92, 95; timeline of Hsieh's art, 88

Tansey, Mark, 290
Tawney, Lenore, 254
Temkin, Ann, 279
"Terminal Iron Works," 76
Thayer, Abbott, 72
Thiebaud, Wayne, 60
Tiepolo, G. B., 138
Tillim, Sidney, 81
Tiravanija, Rirkrit, 344
Titian, 133
To Fix the Image in Memory (Celmins), 252, 253
Topographie anécdotée du hasard (Spoerri), 338
Townsend, Peter, 304
Tropic of Cancer (Miller), 199
Tuymans, Luc, 61

Two Models in a Window with Cast Iron Toys (Pearlstein), *93*
Typical Day, A (Smith), *29*
Tzara, Tristan, 273

Uccello, Paolo, 73
Untitled (Rhoades), 300n27
Untitled (studio view) (Harrison), *216*
Up to and Including Her Limits (Schneemann), 253
Utrillo, Maurice, 207

Vallore, Lucie, 208
Vanderlinden, Barbara, 341
Van Lieshout, Erik, 339
Vasari, Giorigio, 208
Velázquez, Diego, 134, 135, 138, 140
Vermeer, Johannes, 127, 130, 133, 134–35, 137, 138, 143
"View from the Studio, The" (Alpers): artists' representations of their hands, 134–35; Caravaggio's cellarlike depictions, 130, 132; connotations of words used for artists' spaces, 126–27; de Hooch's investigations of light, 129–30; depictions of windows and withdrawal from the world, 132; discontinuity of nudes painted in studio light but shown in natural light, 133; human psychology represented in the studio, 136–37; Janssens's depiction of natural light, 129; lit objects' purpose as studio markers, 133–34; modern dissatisfaction with the artist in a studio, 126; pictorial ambiguity in paintings, 135–36; relation between the artist and objects/models in the studio, 134; relation between practice of art and of science in seventeenth century, 127–28; social construction of the studio, 128; still life and uses of studio light, 132–33; studio experience likened to laboratory experience, 128; Vermeer's study of light, 130. *See also* landscape and the studio; studio as instrument; studio as retreat
View of Delft (Vermeer), 127, 137
Vogue magazine, 195–96, 210–11
von Heyl, Charline, 1, 125

Waldorf Cafeteria, 76
Walker, Cheryl, 249

Warhol, Andy, 126, 127, 289, 296, 297
Wark, Jayne, 241
Wearing, Gillian, 339
Weir, J. Alden, 72
Weiss, David, 10f, 11
Weiss, Rachel, 251
Welish, Marjorie, 7; theories of the studio, 169. *See also* "Studio Revisited, The" (Welish); "Studio Visit, The" (Welish)
Welling, James, 265, *284*, 285
West, W. A., 304
West Tenth Street Studio Building, 69, 70, 71–72
white studio. *See* "Brancusi's 'white studio'" (Wood)
Whitney Museum of American Art, 336
Why Not Sneeze Rrose Sélavy? (Duchamp), 275; birdcage as metaphor for artist's studio, 274, 276; description, 274; meaning of marble cubes, 276; question posed by thermometer, 277; relation between cuttlebone and Brancusi's *Fish*, 276–77; title's reference to studio dust, 277–78
Wilde, Oscar, 5
Williams, Raymond, 249n4
Wilson, C. T. R., 144
Winkenweder, Brian, 6, 81, 23. *See also* "Kitchen as Art Studio, The" (Winkenweder)
Winnicott, D. W., 135, 136–37

women and the studio: belief that feminine presence stimulates artistic production, 198; Brassaï's representation of women, 201, 202; coding of urban environment as feminine, 200; masculine sexuality as a vehicle to artistic expression, 200; photo of Bonnard's studio and his posing of female bodies, 206–7; photos of Giacometti's studio capturing his wife's passivity, 209–10; photos of Utrillo depicting male dominance relinquished, 207–8; reinforcement of dominant male viewer in Brassaï's photographs, 204; women depicted as flesh and art genius as spirit, 239; women's studio role as silent and submissive, 205. *See also* "Artist in His Studio, The" (Bergstein); "Cast in a Different Light" (Schmahmann); "Kitchen as Art Studio, The" (Winkenweder)
Wood, Jon, 269. *See also* "Brancusi's 'white studio'" (Wood)
Woolford, Donelle, *152*, 153
World of Sex, The (Miller), 199
Worth, Irene, 304
Wright, Frank Lloyd, 3

Zakon, Ronnie, 222
Zeisler, Claire, 254
Zmijewski, Artur, 153

www.ingramcontent.com/pod-product-compliance
Lightning Source LLC
Chambersburg PA
CBHW042006200526
45172CB00030B/1326